CHARLES WHITE
A RETROSPECTIVE

Edited by Sarah Kelly Oehler and Esther Adler

With essays by Esther Adler, Ilene Susan Fort, Kellie Jones, Sarah Kelly Oehler, Mark Pascale, and Deborah Willis and a preface by Kerry James Marshall

The Art Institute of Chicago

The Museum of Modern Art, New York

Distributed by Yale University Press
New Haven and London

Charles White: A Retrospective was published in conjunction with an exhibition of the same title organized by the Art Institute of Chicago and The Museum of Modern Art in collaboration with the Los Angeles County Museum of Art.

Exhibition dates

The Art Institute of Chicago
June 8, 2018–September 3, 2018

The Museum of Modern Art
October 7, 2018–January 13, 2019

Los Angeles County Museum of Art
February 17, 2019–June 9, 2019

Lead foundation support for the Art Institute of Chicago presentation is provided by the Henry Luce Foundation.

Lead individual sponsorship for the Art Institute of Chicago presentation is generously contributed by Denise and Gary Gardner.

Corporate Sponsors

Annual support for Art Institute exhibitions is provided by the Exhibitions Trust: an anonymous donor; Neil Bluhm and the Bluhm Family Charitable Foundation; Jay Franke and David Herro; Kenneth Griffin; Caryn and King Harris, The Harris Family Foundation; Liz and Eric Lefkofsky; Robert M. and Diane v.S. Levy; Ann and Samuel M. Mencoff; Usha and Lakshmi N. Mittal; Sylvia Neil and Dan Fischel; Thomas and Margot Pritzker; Anne and Chris Reyes; Betsy Bergman Rosenfield and Andrew M. Rosenfield; Cari and Michael J. Sacks; and the Earl and Brenda Shapiro Foundation.

Support for the presentation at The Museum of Modern Art is provided by the Annual Exhibition Fund with major contributions from the Estate of Ralph L. Riehle, Alice and Tom Tisch, The Marella and Giovanni Agnelli Fund for Exhibitions, The Contemporary Arts Council of The Museum of Modern Art, Mimi and Peter Haas Fund, Brett and Daniel Sundheim, Franz Wassmer, Karen and Gary Winnick, and Oya and Bülent Eczacıbaşı.

All exhibitions at LACMA are underwritten by the LACMA Exhibition Fund. Major annual support is provided by Kitzia and Richard Goodman, with generous annual funding from Jerry and Kathleen Grundhofer, Lauren Beck and Kimberly Steward, the Judy and Bernard Briskin Family Foundation, Louise and Brad Edgerton, Edgerton Foundation, Emily and Teddy Greenspan, Marilyn B. and Calvin B. Gross, David Schwartz Foundation, Inc., and Lenore and Richard Wayne.

Presenting Partner

Charles White: A Retrospective is part of Art Design Chicago, an initiative of the Terra Foundation for American Art exploring Chicago's art and design legacy, with presenting partner The Richard H. Driehaus Foundation.

The exhibition at the Art Institute of Chicago and The Museum of Modern Art is funded by the Terra Foundation for American Art.

First edition
Printed in Italy

ISBN: 978-0-300-23298-1 (hardcover)

Library of Congress Cataloging-in-Publication Data
Names: Oehler, Sarah Kelly (Curator), editor. | Adler, Esther (Curator), editor. | Marshall, Kerry James, 1955– writer of preface. | Art Institute of Chicago, organizer, host institution. | Museum of Modern Art (New York, N.Y.), organizer, host institution.
Title: Charles White : a retrospective / edited by Sarah Kelly Oehler and Esther Adler; with essays by Esther Adler, Ilene Susan Fort, Kellie Jones, Sarah Kelly Oehler, Mark Pascale, and Deborah Willis ; and a preface by Kerry James Marshall.
Description: Chicago : The Art Institute of Chicago, 2018. | Published in conjunction with an exhibition of the same title organized by the Art Institute of Chicago and The Museum of Modern Art. | Includes bibliographical references and index.
Identifiers: LCCN 2017057656 | ISBN 9780300232981 (hardback)
Subjects: LCSH: White, Charles, 1918-1979—Exhibitions. | African Americans in art—Exhibitions. | BISAC: ART / Individual Artists / Monographs. | ART/ History / Contemporary (1945–). | ART / American / African American. | ART / Collections, Catalogs, Exhibitions / General.
Classification: LCC N6537.W44 A4 2018 | DDC 704.03/96073—dc23
LC record available at https://lccn.loc.gov/2017057656

Published by
The Art Institute of Chicago
111 South Michigan Avenue
Chicago, IL 60603-6404
www.artic.edu

Distributed by
Yale University Press
302 Temple Street
P.O. Box 209040
New Haven, CT 06520-9040
www.yalebooks.com/art

Produced by the Department of Publishing, Art Institute of Chicago, Gregory Nosan, Executive Director

Edited by Maia Rigas, Sara Carminati, and Lisa Meyerowitz

Production by Lauren Makholm, Joseph Mohan, and Rachel Edsill

Photography research by Katie Levi

Unless otherwise noted, photography of works of art is by Aidan Fitzpatrick, Robert Lifson, and Craig Stilwell, and postproduction by Jonathan Mathias, Department of Imaging, Art Institute of Chicago.

Proofreading by Juliet Clark

Indexing by Scott Smiley

Design and typesetting by Roy Brooks, Fold Four, Inc.

Separations by Professional Graphics, Inc., Rockford, IL

Printing and binding by Conti Tipocolor, Florence, Italy

Details (all by Charles White):

Jacket cover: *J'Accuse #1*, 1965 (pl. 80).

Jacket reverse: *Wanted Poster Series #12*, 1970 (pl. 93).

P. 2: *Our Land*, 1951 (pl. 37); p. 8: *Harvest Talk*, 1953 (pl. 43); p. 10: *Untitled (Four Workers)*, 1940 (pl. 8); p. 14: *Black Pope (Sandwich Board Man)*, 1973 (pl. 99); p. 20: Study for *Struggle for Liberation (Chaotic Stage of the Negro, Past and Present)*, 1940 (pl. 10); p. 38: *Worker*, 1944 (pl. 19); p. 68: *Oh, Mary, Don't You Weep*, 1956 (pl. 51); p. 84: *Gospel Singers*, 1951 (pl. 38); p. 122: *Wanted Poster Series #6*, 1969 (pl. 88); p. 140: *Sound of Silence*, 1978 (pl. 104).

The quotation by Charles White that appears on the back is from Jeffrey Elliot, "Charles White: Portrait of an Artist," *Negro History Bulletin* 41 (May–June 1978): 825.

CONTENTS

 Presenting Partner

Charles White: A Retrospective is part of Art Design Chicago, an initiative of the Terra Foundation for American Art exploring Chicago's art and design legacy, with presenting partner The Richard H. Driehaus Foundation.

The exhibition at the Art Institute of Chicago and The Museum of Modern Art is funded by the Terra Foundation for American Art.

Lead foundation support for the Art Institute of Chicago presentation is provided by the Henry Luce Foundation.

Lead individual sponsorship for the Art Institute of Chicago presentation is generously contributed by Denise and Gary Gardner.

Corporate Sponsors

Annual support for Art Institute exhibitions is provided by the Exhibitions Trust: an anonymous donor; Neil Bluhm and the Bluhm Family Charitable Foundation; Jay Franke and David Herro; Kenneth Griffin; Caryn and King Harris, The Harris Family Foundation; Liz and Eric Lefkofsky; Robert M. and Diane v.S. Levy; Ann and Samuel M. Mencoff; Usha and Lakshmi N. Mittal; Sylvia Neil and Dan Fischel; Thomas and Margot Pritzker; Anne and Chris Reyes; Betsy Bergman Rosenfield and Andrew M. Rosenfield; Cari and Michael J. Sacks; and the Earl and Brenda Shapiro Foundation.

Additional support for the presentation at The Museum of Modern Art is provided by the Annual Exhibition Fund with major contributions from the Estate of Ralph L. Riehle, Alice and Tom Tisch, The Marella and Giovanni Agnelli Fund for Exhibitions, The Contemporary Arts Council of The Museum of Modern Art, Mimi and Peter Haas Fund, Brett and Daniel Sundheim, Franz Wassmer, Karen and Gary Winnick, and Oya and Bülent Eczacıbaşı.

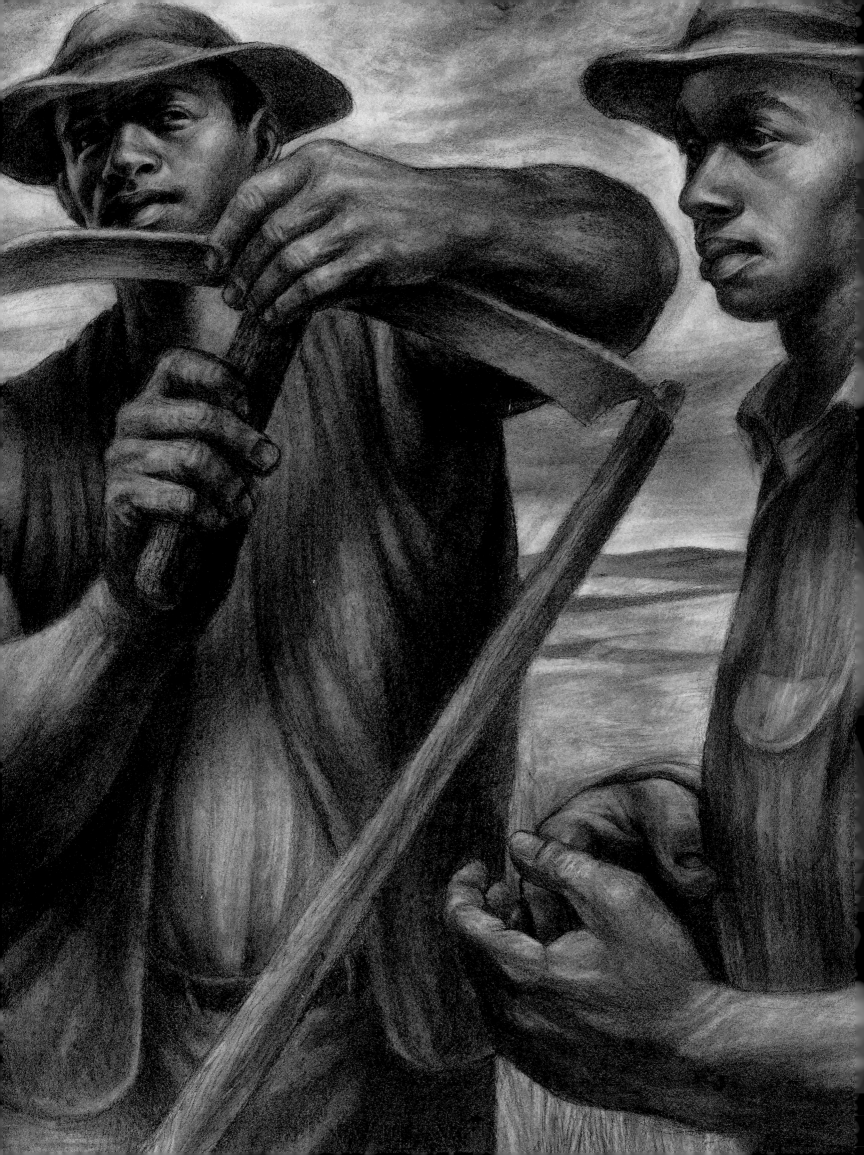

FOREWORD

Charles White (1918–1979) powerfully interpreted African American history and culture over the course of his four-decade career. A superbly gifted draftsman and printmaker as well as a talented mural and easel painter, he developed a distinctive and labor-intensive approach to art making, remaining committed to a representational style at a time when the art world increasingly favored abstraction. His work magnified the power of the black figure through scale and form, communicating universal human themes while also focusing attention on the lives of African Americans and the struggle for equality. This exhibition—the first major retrospective of White's work in more than thirty-five years—showcases a gifted and influential artist whose work continues to resonate amid today's national dialogues about race, work, equality, and history.

White, a native Chicagoan, sketched in the galleries of the Art Institute of Chicago as a child. In grade school he received an award to attend drawing classes at the museum and in high school earned a scholarship to the School of the Art Institute of Chicago. White had won other scholarships that were revoked because of his race—few prominent art academies then accepted African American students. The Art Institute's support was critical in White's path to becoming a professional artist, as it also offered him early exhibition opportunities, including the display of *Native Son No. 2* (pl. 12) in the museum's Twenty-First International Exhibition of Watercolors in 1942. It was also in Chicago that he found his first job, as a WPA easel painter and muralist. His murals soon brought him to the attention of The Museum of Modern Art through curator Dorothy Miller, who saw and admired them in 1941.

Both museums have continued their early interest in and commitment to White's work. The Art Institute purchased the exquisite charcoal drawing *Harvest Talk* (pl. 43) in 1991 and now boasts a collection of fifty works by White. His virtuosic oil-wash drawing *Black Pope (Sandwich Board Man)* (pl. 99), which The Museum of Modern Art acquired in 2013, was the subject of a monograph by Esther Adler and featured in the 2017 exhibition *Charles White—Leonardo da Vinci. Curated by David Hammons*. We are delighted to present this retrospective in the three cities that the artist called home: Chicago, New York, and Los Angeles.

Sarah Kelly Oehler, Field-McCormick Chair and Curator of American Art at the Art Institute of Chicago, and Esther Adler, Associate Curator in the Department of Drawings and Prints at The Museum of Modern Art, have shown exemplary dedication in bringing this catalogue and exhibition to fruition. Kerry James Marshall contributed a moving statement about his mentor. Our colleagues at the Los Angeles County Museum of Art, led by director Michael Govan, have embraced the project. Special recognition is due to the many private and institutional lenders who entrusted us with the care and display of their artworks. Crucially, the exhibition could not have been realized without the blessing of White's family. C. Ian White, the keeper of his father's legacy, offered enthusiastic support from the beginning. His willingness to facilitate research and loans has been vital, and we are grateful.

In Chicago, lead funding was provided by the Henry Luce Foundation and Denise and Gary Gardner. We also thank corporate sponsors Allstate and ComEd. Annual support for Art Institute exhibitions is provided by the Exhibitions Trust. *Charles White: A Retrospective* is part of Art Design Chicago, and we acknowledge the Terra Foundation for American Art and its partner, The Richard H. Driehaus Foundation, for their support. The Terra Foundation has also provided critical funding for the presentation of the exhibition in New York, as have significant donors who contribute to MoMA's Annual Exhibition Fund.

White never abandoned the activism that inspired his art, which was animated by an enduring hope that change is possible. He articulated this belief eloquently in a 1970 statement: "My work takes shape around images and ideas that are centered within the vortex of a black life experience, a nitty-gritty ghetto experience—resulting in contradictory emotions: anguish, hope, love, despair, happiness, faith, lack of faith, dreams. Stubbornly holding on to an elusive romantic belief that the people of this land cannot always be insensible to the dictates of justice or deaf to the voice of humanity." It is our privilege to honor White's legacy by sharing his voice with new generations.

James Rondeau
President and Eloise W. Martin Director
The Art Institute of Chicago

Glenn D. Lowry
Director
The Museum of Modern Art, New York

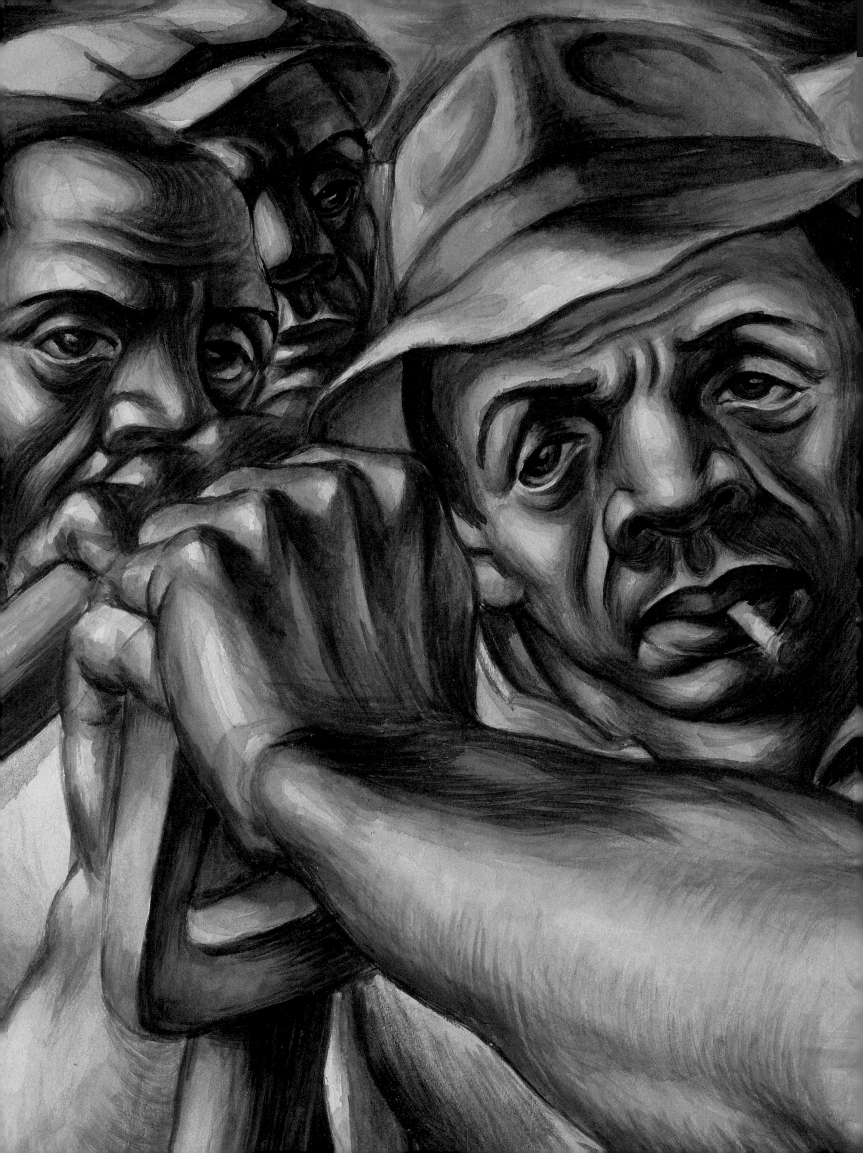

ACKNOWLEDGMENTS

Charles White's career was shaped by communities of talented, dedicated people who shared his vision and values. It is not surprising, then, that a similar community has come together to organize the first major reconsideration of his art since 1982. The collaborative spirit shared by curators, scholars, collectors, and admirers has served the project brilliantly. That White's work inspired this partnership is a testament to its power and continuing relevance.

Our greatest debt of gratitude is due to the people who knew White best—his family, especially C. Ian White of the Charles White Estate. Ian has been a steadfast and generous advocate for this exhibition. He accommodated endless research requests with extraordinary good humor and patience. We thank him, his wife Virginia, and their son Gordon for their enthusiasm. We also thank Charles White's daughter Jessica for her support.

White's former students are an equally dedicated group, and their willingness to discuss his work, his teaching methods, and his influence on them has contributed significantly to this exhibition. We thank especially David Hammons, Judithe Hernández, Kerry James Marshall (who also contributed the preface to this catalogue), Kent Twitchell, and Richard Wyatt Jr. In addition, we are grateful to Ulysses Jenkins, Timothy Washington, Stanley Wilson, and others who shared their experiences.

In our research on White we have benefited from the many scholars who have come before us and whose thoughtful approach to his work and career set a high standard we strove to meet. We extend special thanks to Peter Clothier and Lucinda Gedeon for their significant early research into White's life and, most important, their interviews with the artist; and to Andrea Barnwell Brownlee for her 2002 monograph on him. Many colleagues shared invaluable input; in particular, we recognize those who participated in a research convening at the Art Institute of Chicago in 2016: Julia Tatiana Bailey, Andrea Barnwell Brownlee, Erik Gellman, Laura M. Giles, Adam Green, Melanie Herzog, Darlene Clark Hine, Kellie Jones, Amy Mooney, Daniel Schulman, Mary Helen Washington, and Ian White. One of our proudest accomplishments is the publication of this major exhibition catalogue on White's work. Catalogue authors Ilene Susan Fort, Kellie Jones, Kerry James Marshall,

Mark Pascale, and Deborah Willis contributed insightful essays that will introduce White to a new generation of readers. Ilene and her colleague Devi Noor at the Los Angeles County Museum of Art have been essential partners in bringing this exhibition to the city that was so critical to White's later life and career. Additional research assistance was graciously provided by archivists and librarians around the country, including Lesley Martin, Chicago History Museum; Cynthia Fife-Townsel, Michael Flug, and Morag Walsh, Chicago Public Library; DeLisa A. Minor Harris, Franklin Library at Fisk University, and Cara Moore, National Archives and Records Administration at Saint Louis. We also thank Jan Abbot; Kirill Chunikhin; Erica Moiah James, Yale University; and Jim Parker.

The following colleagues at museums throughout the United States provided critical support as we traveled to view and research White's work; they also generously agreed to our requests for loans: Andrew Walker and Shirley Reece-Hughes, Amon Carter Museum of American Art; Rena M. Hoisington, the Baltimore Museum of Art; Carter Foster and Veronica Roberts, Blanton Museum of Art; Maurita Poole, Clark Atlanta University Art Collection; Sharon Corwin, Elizabeth Finch, and Justin McCann, Colby College Museum of Art; Margi Conrads, Crystal Bridges Museum of American Art; Curlee R. Holton and Dorit Yaron, David C. Driskell Center for the Study of the Visual Arts and Culture of African Americans and the African Diaspora, University of Maryland; Tracee Glab, Flint Institute of Arts; Sara Arnold, the Gibbes Museum of Art; Martha Tedeschi and Elizabeth Rudy, Harvard Art Museums; Michael Rooks, High Museum of Art; Gwendolyn H. Everett and Scott Baker, Howard University; James Glisson, the Huntington Library, Art Collections, and Botanical Gardens; Cherise Smith, Lise Ragbir, and Sonja Reid, John Warfield Center for African and African American Studies, University of Texas at Austin; Patrick Shepler, Library of Congress, Washington, DC; Leslie Jones and Sarah Newby, Los Angeles County Museum of Art; Sheena Wagstaff and Cynthia Iavarone, the Metropolitan Museum of Art; Gail Stavitsky and Osanna Urbay, Montclair Art Museum; Helen Burnham, Museum of Fine Arts, Boston; Edmund Barry Gaither, Museum of the National Center of Afro-American Artists; Stephanie Knappe, the Nelson-Atkins

Museum of Art; Margaret O'Reilly and Jenny Martin, New Jersey State Museum; Andrea Ko, Newark Museum; Shelley Langdale, Philadelphia Museum of Art; Laura M. Giles, Princeton University; Melissa Wolfe, Saint Louis Art Museum; Stacy Walsh, Sheldon Museum of Art, University of Nebraska; Virginia Mecklenberg, Smithsonian American Art Museum; Maséqua Myers, South Side Community Art Center; Andrea Barnwell Brownlee, Spelman College; Hannah Moshier, UCLA Library Conservation Center; and Adam Weinberg, Whitney Museum of American Art.

Private collectors of White's works are particularly attached to them, and we thank those who graciously lent prized paintings, drawings, and prints: Pamela and Harry Belafonte; Merill C. Berman; the Davidsons; Harold Davis, MD; The Harmon and Harriet Kelley Foundation for the Arts; William M. and Elisabeth M. Landes; Estate of Norman Lewis; Michael Rosenfeld and Halley K. Harrisburg of Michael Rosenfeld Gallery LLC, New York; Maryanne Mott and curator Stephanie James, Mott-Warsh Collection; Mr. and Mrs. Salz; Mr. and Mrs. Richard Wyatt Sr.; and Charles M. Young of Charles M. Young Fine Prints & Drawings, LLC, Portland, Connecticut, as well as those who have chosen to remain anonymous.

A project of this scale and complexity would be impossible without the support of visionary funders. In Chicago, lead funding was provided by the Henry Luce Foundation and Denise and Gary Gardner. We also thank corporate sponsors Allstate and ComEd. *Charles White: A Retrospective* is part of Art Design Chicago, an initiative of the Terra Foundation for American Art exploring Chicago's art and design legacy, with presenting partner The Richard H. Driehaus Foundation. The exhibition at the Art Institute of Chicago and The Museum of Modern Art is funded by the Terra Foundation for American Art. Annual support for Art Institute exhibitions is provided by the Exhibitions Trust: an anonymous donor; Neil Bluhm and the Bluhm Family Charitable Foundation; Jay Franke and David Herro; Kenneth Griffin; Caryn and King Harris, The Harris Family Foundation; Liz and Eric Lefkofsky; Robert M. and Diane v.S. Levy; Ann and Samuel M. Mencoff; Usha and Lakshmi N. Mittal; Sylvia Neil and Dan Fischel; Thomas and Margot Pritzker; Anne and Chris Reyes; Betsy Bergman Rosenfield and Andrew M. Rosenfield; Cari and Michael J. Sacks; and the Earl and Brenda Shapiro Foundation. Additional support for The Museum of Modern Art presentation is provided by significant donors who contribute to MoMA's Annual Exhibition Fund.

The unparalleled staff of our two institutions, led by James Rondeau and Glenn D. Lowry, made our collaboration on this important exhibition a success. We thank both James and Glenn for their encouragement. At the Art Institute of Chicago, early support from then deputy director Martha Tedeschi and her successor Sarah Guernsey was crucial. We thank the generosity of our colleagues in the Department of Prints and Drawings, led by Kevin Salatino: Mary Broadway, Kristi Dahm, Christine Conniff O'Shea, Antoinette Owen, Maria Christina Rivera Ramos, Margaret Sears, and Emily Ziemba all contributed tremendously to the success of the exhibition through loans, conservation, and preparation. Mark Pascale was a crucial partner; his knowledge, dedication to Charles White, and amiability have enriched this project from the beginning. Vital conservation support also came from painting conservator Allison Langley and book conservator Christine Fabian.

In the Department of American Art, Julie Warchol and her predecessor Denise Mahoney served as highly capable exhibition managers, while Tim Roby and Christopher Shepherd expertly led the installation team. Former Mellon Undergraduate Fellow Sheridan Tucker Anderson was critical in the early days of research. Finally, we are entirely indebted to research associate John Murphy, whose intellect, research skills, and sheer tenacity have made this catalogue a far superior resource for future scholars.

Staff in the Project Management and Registration Departments, including Zahra Bahia, Jennifer Paoletti, and Joyce Penn, adroitly managed the budget, oversaw contractual arrangements, and organized the safe transport and handling of the works, along with countless other details. Exhibition designer Samantha Grassi conceived of the physical space of the exhibition with skill and finesse; her vision was executed with care by the talented carpenters, painters, and electricians of Museum Facilities, led by Joe Vatinno. Graphic design was beautifully presented by Cassie Tompkins. In the Department of Learning and Public Engagement, overseen by Jacqueline Terrassa, many colleagues contributed to the success of interpretation and programming, including Erica Hubbard, Nenette Luarca-Shoaf, Kamilah Rashied, and Fawn Ring, by engaging our audiences in compelling ways. Michael Neault and his team in Digital Experience, in particular Kelly McHugh and Kyle Obriot, likewise embraced the project with enthusiasm.

Catalogue research was aided by the staff of the Ryerson and Burnham Libraries, particularly director Douglas Litts, librarian Autumn Mather, archivist Deborah Webb, and former reference librarian Anne Danberg. We also thank former Mellon Fellow Kathleen Tahk for her assistance with translations. Members of the Department of Publishing, led by Greg Nosan, then oversaw production of this elegant catalogue. We thank Rachel Edsill, Lauren Makholm, and Joseph Mohan for their dedication to the publication's quality;

Katie Levi for her hard work as photography editor, and the extraordinary editorial team of Sara Carminati, Lisa Meyerowitz, and Maia Rigas for their keen eyes and insightful suggestions. Editorial intern Kenny Guay provided assistance at various stages. P. D. Young and his colleagues in Imaging assisted with catalogue photography. Roy Brooks of Fold Four designed the stunning catalogue. Juliet Clark assisted with proofreading and Scott Smiley with indexing.

At The Museum of Modern Art, thanks are due to Nancy Adelson, Quentin Bajac, Ramona Bannayan, Todd Bishop, Stuart Comer, Leah Dickerman, James Gara, Patty Lipschutz, Peter Reed, Rajendra Roy, Martin Stierli, and Ann Temkin. Michelle Elligott and Jennifer Tobias in Archives, Library, and Research Collections provided critical research support, while Mack Cole-Edelsack and Lana Hum in Exhibition Design and Production have ensured that the exhibition looked its best, together with registrars Regan Hillman and Stefanii Ruta-Atkins, Rob Jung and the team of preparators, and framer Peter Perez. Chloe Capewell, Jennifer Cohen, Cate Griffin, Rachel Kim, and Erik Patton in Exhibition Planning and Administration managed myriad collaboration details. We extend warm thanks to Meg Montgoris and Sara Beth Walsh in Communications; Ingrid Chou, Claire Corey, and David Klein in Graphic Design; Robert Gerhardt, Robert Kastler, and Jennifer Sellars in Imaging and Visual Resources; and Christopher Hudson and Maria Marchenkova in Publications. It has been a pleasure to work with our colleagues in Education on the programming surrounding this exhibition, and we are grateful for their enthusiasm and creativity. Special acknowledgment is due to Sara Bodinson, Pablo Helguera, Sarah Kennedy, Jenna Madison, and Jess Van Nostrand, led by the fearless Wendy Woon.

In the Department of Drawings and Prints, chief curator Christophe Cherix gave this exhibition his unwavering support, and curators Samantha Friedman, Jodi Hauptman, and Sarah Suzuki offered critical counsel. Kiko Aebi, Alexandra Diczok, Emily Manges, and John Prochilo all provided assistance during the course of planning the exhibition, for which we are very grateful. Laura Neufeld in Paper Conservation was a generous partner in the research and planning of the show, often traveling with the curators to see particular works by Charles White, and we thank her for her insight and good cheer. A number of interns and fellows assisted in the considerable amount of research for the exhibition, including Virginia McBride and Jared Quinton. Ashley James was an engaged and enthusiastic partner and also contributed significantly to the catalogue. Megan Kincaid managed the complexities of the exhibition with tremendous organizational skill and forethought.

Finally, we cherish our own communities at home for providing the support and inspiration we need—Christopher "Hopper" Oehler and Gary, Mason, and Lily Kessler.

Sarah Kelly Oehler
Field-McCormick Chair and Curator of American Art
The Art Institute of Chicago

Esther Adler
Associate Curator, Department of Drawings and Prints
The Museum of Modern Art

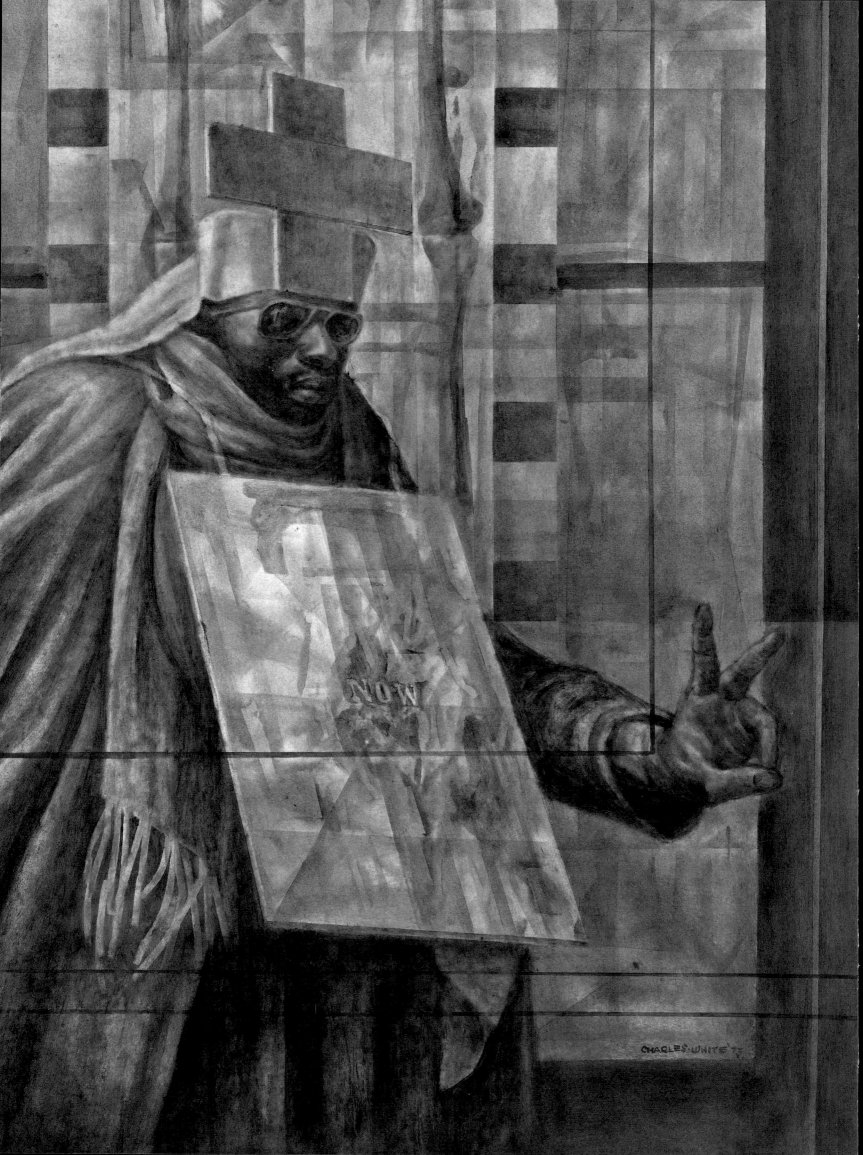

A BLACK ARTIST NAMED WHITE

KERRY JAMES MARSHALL

This sorcery is not a game we play for pleasure or praise.
—Ursula K. LeGuin, *Wizard of Earthsea*

I have been a stalwart advocate for the legacy of Charles White. I've said it so often, it could go without saying. I have always believed that his work should be seen wherever great pictures are collected and made available to art-loving audiences. He is a true master of pictorial art, and nobody else has drawn the black body with more elegance and authority. No other artist has inspired my own devotion to a career in image making more than he did. I saw in his example the way to greatness. Yes. And because he looked like my uncles and my neighbors, his achievements seemed within my reach. The wisdom he dispensed to the many aspiring artists who gathered around him was always straightforward: do your work with skill and integrity, everything else is superfluous. It is a right time for him to be considered again in the fullness of his expertise. And fitting that he should be recognized with a survey in three of the best museums in the world.

A close friend of mine described me as a radical pragmatist. I embrace this no-nonsense distinction wholeheartedly. It is a character trait that matches the sense of myself I've had from as far back as I can remember. I am not one who goes in much for magical thinking. I don't believe in destiny, fate, or things like divine guidance, either. Material reality has spirit enough for me. I do appreciate the bewildering sensation induced by magicians performing tricks, but that has more to do with the cleverness and dexterity with which they execute the act than any mystical fantasy of conjuring something from nothing. That being said, I am acutely aware, and have to admit, that some eerie and uncanny episodes have marked just about every phase of my relationship with Charles Wilbert White, which I so cherish. From my discovery of him in 1965 until now, our journeys as artists have seemed inextricably linked. He was the first living artist I knew of, the first black artist, and the first famous artist who was accessible

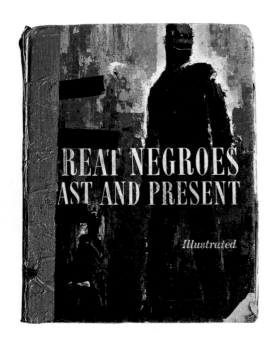

FIG. 1
Russell L. Adams, *Great Negroes,*
Past and Present, with illustrations
by Eugene Winslow (Chicago: Afr.
Am. Publishing, 1964). Author's
personal copy.

to me. I have been tempted at times to say that our meeting was meant to be. It is a little strange, too, that I somehow ended up in Chicago, where he began. Strange!

I stumbled upon Charles White purely by chance while looking through a book, *Great Negroes, Past and Present* (fig. 1), in the library at 49th Street Elementary School in South-Central Los Angeles. I was in the fifth grade. It was Negro History Week, and I was researching historical figures for a report due that Friday. The book was filled with biographies of the black history heroes and sheroes you might expect: Harriet Tubman, Booker T. Washington, Marcus Garvey. Predictably, the visual artists were in the back of the book, so if I had not had a prior interest in art, I would likely have chosen somebody closer to the front. Nothing about "Charlie's" page stood out as particularly beautiful or powerful. The drawings (not photographs) representing all the subjects profiled were serviceable illustrations, uniform, and uniformly uninspired. I suppose the simple contradiction of a black man named White in a book about "negroes" struck me as ironic. I have a healthy ego, so I like to imagine that I knew the meaning of such a term back then, though I probably didn't. Some of his contemporaries, Jacob Lawrence and Richmond Barthé, Charles Alston and Richard Hunt, also made the list of visual artists, but for whatever the reason, White's name alone stuck in my mind. It would be three more years before the significance of that early encounter became clear in my life.

Every step on my way to becoming an artist seemed preordained. The right people were always in the right places at the right times to boost me to the next level. I was fortunate to be selected for a summer drawing class offered to teens at the Otis Art Institute of Los Angeles County. Mr. Romiti, my teacher at George Washington Carver Junior High, thought I would make good use of the opportunity even though it was designated for upperclassmen. Before then I didn't even know there were schools that taught nothing but art. When I walked onto that campus, I felt at home. This was where I belonged. I saw the book *Images of Dignity: The Drawings of Charles White* for the first time in that class. Even more meaningful—and spectacular—we were told by our instructor, George DeGroat, that Charles White taught at Otis, and he had agreed to let us see the studio he had on campus. When that door opened, the scales truly fell from my eyes. There before me was revealed the secret of the masters. I saw finished works next to half-finished drawings. There were also works just under way, barely sketched in. In that instant, I understood that artists were not wizards, that the work they do can seem magical but in reality is achieved through knowledge, a deep understanding of the principles governing representation, and a willingness to engage in the intensive labor required to effectively render the images you envision.

This faith in the primacy of work is axiomatic for me regardless of the medium or era in which artists ply their craft. In his notes to young artists, Leonardo da Vinci instructed novices to first find a "good master and copy his work. This way you will train your hand to good form."[1] I was lucky to find my exemplar early, and I diligently hewed to the task. In fact, that afternoon I was copying a drawing of Frederick Douglass from the book when the artist himself walked into our classroom. Right then I resolved to be an Otis student as soon as I graduated high school. Mind you, I was just about to start eighth grade in September, but my mind was totally made up. In the meantime, I immersed myself in everything Charles White. Indeed, the very first oil painting I made at fifteen (fig. 2) was an attempt at producing an original work in White's early planar style of the 1940s. Mine was even executed on a discarded window shade because I

read that he had done the same for his first oil painting. Simply emulating his work wasn't enough for me; I tried to be Charles White in every way I could.

By the time I enrolled at Otis as a full-time student in January 1977, a revolution was under way. A catchall department called Intermedia, where conceptual art, video, performance, installation, and land art were routine, was advancing the newest wave of art theory. Those insurgents had just about completed their dismantling of traditional, humanist craft workers. The final stroke was the takedown of a medieval bronze statue in the campus quad of the she-wolf suckling Romulus and Remus, dragged down by a rope tied to the bumper of a truck driven by the chairman of that department. When the dust settled, everything I was drawn to Otis and Charles White to learn seemed to crumble as well.

Life drawing was a specialty at Otis, and Charles White was the effective dean of figure drawing. His classes were the most popular, and always full to capacity. His Tuesday and Thursday evening class attracted students from other schools in town, as well. This is where I met artists like the late Houston Conwill, who was in the graduate program at the University of Southern California at the time, and Richard Wyatt Jr., who inherited the design of the Golden State Mutual Life Insurance Company calendar after Charlie's death.

Like me, all of the black students who attended Otis were there primarily because of White. He was a kind of spiritual father for many of us. To be sure, his reputation as a great draftsman and teacher was universally appealing, but when there were so few black artists of his stature to lean on it just meant more.

It is important to mention here that of the four black students enrolled at Otis and circulating around him at the time—three graduates and myself, the lone undergraduate—I was the only one committed to drawing and painting. I am also the only one who has established a professional career built primarily on figuration, broadly speaking. Like David Hammons and Timothy Washington, who had their first major exhibition with Charlie at the Los Angeles County Museum of Art in 1971, most of the black artists who sought his advice went on to do other things.

Charlie himself remained steadfast in his commitment to representational art through all the shifts and changes in the contemporary art world of his era. He was not taken up in the rush toward abstraction, and what art historian Thomas McEvilley called the "misconceived belief that abstract art represented a kind of nothingness that made it seem the final term in a semantic series."[2] Maybe he understood McEvilley's final point that this belief that abstract art had no content was "a means to hide its content as ideology . . . becoming in time a repressive belief, denying the honest meanings in human life."

It was always clear with Charlie that to make good work, one had to know a thing or two about more than how to draw or paint. He had a scholar's interest in history, which informed the work he made. He often said your work should be about things that mattered, but reminded us all to concentrate on making the best drawings we could, adding, "the ideas will take care of themselves." Similarly, art historian and theorist Rosalind Krauss, writing about conceptual photographer Cindy Sherman, critiques the tendency of analysts to privilege meaning in an artist's work over the mechanisms that structure our comprehension of it: "Sherman's doll photos are a statement of what it means to refuse to an artist the work that he or she has done—which is always work on the

FIG. 2
**KERRY JAMES MARSHALL
(AMERICAN, BORN 1955)**

Untitled, 1971. Oil on window shade; 76.2 × 61 cm (30 × 24 in.). Courtesy of the artist.

FIG. 3
ROGIER VAN DER WEYDEN (NETHERLANDISH, 1399/1400–1464)

Portrait of a Lady, c. 1460. Oil on panel; painted surface: 34 × 25.5 cm (13 ⅜ × 10 ¹⁄₁₆ in.); overall panel: 37 × 27 cm (14 ⁹⁄₁₆ × 10 ⅝ in.). National Gallery of Art, Washington, DC, Andrew W. Mellon Collection, 1937.1.44.

FIG. 4
JACKSON POLLOCK (AMERICAN, 1912–1956)

Lucifer, 1947. Oil and enamel on canvas; 104.62 × 267.97 cm (41 ³⁄₁₆ × 105 ½ in.). Anderson Collection at Stanford University, gift of Harry W. and Mary Margaret Anderson, and Mary Patricia Anderson Pence, 2014.1.019.

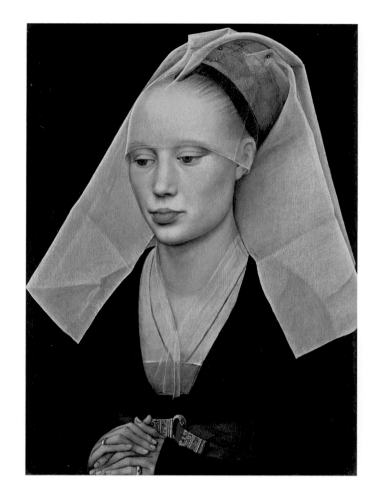

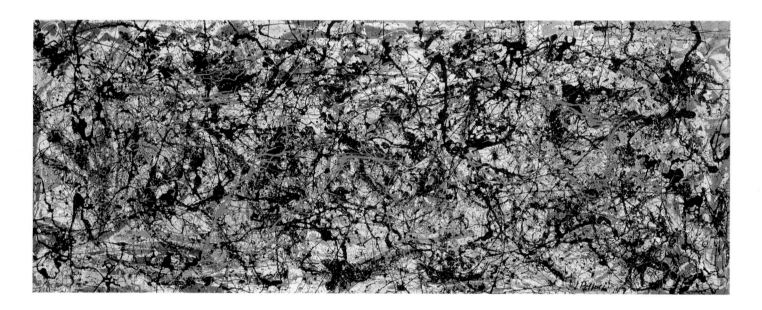

signifier—and to rush headlong to the signified . . . the constructed meaning, which one then proceeds to consume as myth."[3]

The labor, the work, in Charlie's drawings is palpable. One can follow the process through his technique and understand exactly how the image came to be on the page or the canvas. His most accomplished drawings achieve true perfection. The effect is dazzling, efficient, and never extravagant. An atmosphere of stillness and quietude envelops the space in and around the work. I can't help remembering a Shaker motto I read somewhere that governs their sense of piety and discipline: "Hands to work, hearts to God." The terms *art* and *work* gain embodied meaning in the best of his pictures.

Twenty-four years after I first read his name, the chain of coincidences linking me to my mentor closed full circle with the miraculous appearance of that *Great Negroes* book in a shuttered building I bought for my studio in Chicago, the city of his birth. There it was atop a pile of papers in a desk drawer left behind by the previous owners, worn and tattered, held together with duct tape (see fig. 1). My eyes popped and my heart pounded just as they had at his studio door at Otis. Just thinking about that moment sends a shiver through my body.

That physical sensation, a shiver induced by the mere sight of a thing, is the elusive charge sought after, rarely achieved, and even more difficult to sustain by any artists trafficking in the allure of images. This is the ineffable dimension of art often labeled "the sublime." Thought of this way, fine art is a kind of secular religion. Indeed, the emotional tone of the best artworks can honestly be described as spiritual though not purposely driven by ecumenical intent. Many of my favorite paintings operate in this register where beauty, perfection in form and execution, can be described as divine. The solid-gold coffin mask of Tutankhamun presents itself in this way. Artworks that achieve this intensity include Rogier van der Weyden's *Portrait of a Lady* (fig. 3), Henri Matisse's *Joy of Life* (1905; Barnes Foundation, Philadelphia), Jackson Pollock's *Lucifer* (fig. 4), Barnett Newman's *Stations of the Cross* series (1958–66; National Gallery of Art, Washington, DC), and Gerhard Richter's *Eight Student Nurses* (1966; Crex Collection, Zurich), *Betty*, and the entire *October 18, 1977* series (1988; Museum of Modern Art, New York). To this list of powerful pictures, I would add Charlie's *Black Pope (Sandwich Board Man)* (pl. 99), now in the permanent collection at the Museum of Modern Art, New York, and *Seed of Love* (pl. 84) at the Los Angeles County Museum of Art. There are others to be sure but these two stand, for me, as the most poignant creations of Charlie's oeuvre. Put those alongside Francisco de Zurbarán's *Saint Serapion* (fig. 5) and *Saint Francis of Assisi according to Pope Nicholas V's Vision* (c. 1640; Museu Nacional d'Art de Catalunya, Barcelona), and you can see that Charles White kept common cause with the great masters of art history, holding up his end and passing the torch to the generations that followed him.

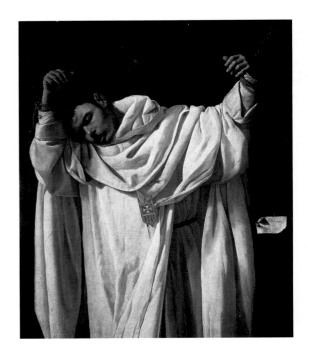

FIG. 5
FRANCISCO DE ZURBARÁN (SPANISH, 1598–1664)

Saint Serapion, 1628. Oil on canvas; 120.2 × 104 cm (47 5/16 × 40 15/16 in.). Wadsworth Atheneum Museum of Art, Hartford, CT, Ella Gallup Sumner and Mary Catlin Sumner Collection Fund, 1951.40.

1. "Moral Precepts for the Student of Painting," pt. 1 of ch. 10, "The Practice of Painting," *The Notebooks of Leonardo da Vinci*, vol. 1 (New York: Dover, 1970), IX.I.483, p. 243.
2. Thomas McEvilley, "The Figure and What It Says: Reflections on Iconography," in *Focus on the Image: Selections from the Rivendell Collection*, ed. Nina Felshin, exh. cat. (n.p.: ITA Corp., 1985), 16.
3. Rosalind Krauss, "Cindy Sherman: Untitled," in Krauss, *Bachelors* (Cambridge, MA: October Books/ Cambridge, MA: MIT Press, 1999), 156.

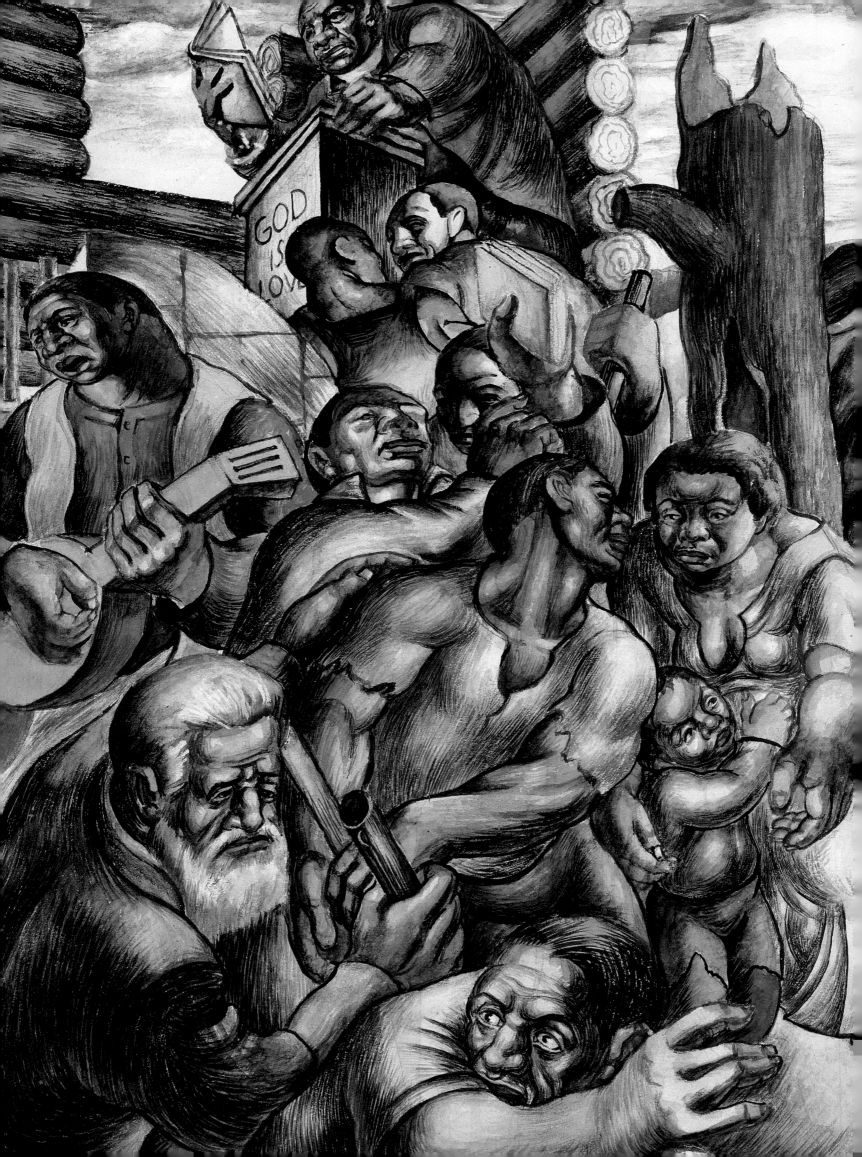

YESTERDAY, TODAY, TOMORROW: CHARLES WHITE'S MURALS AND HISTORY AS ART

SARAH KELLY OEHLER

The American Negro must remake his past in order to make his future.
—Arthur A. Schomburg, "The Negro Digs Up His Past"[1]

In 1968 Charles White produced an extraordinary drawing called *Nat Turner, Yesterday, Today, Tomorrow* (pl. 85), an ecstatic image of the nineteenth-century slave rebellion leader. The title, notably, situates Turner within a progression of time, implying that his actions still resonated in White's present and would continue to resonate in the future. By 1968 White, who was born in 1918, had witnessed and participated in many of the radical social upheavals and political events of twentieth-century America: the Great Migration, the Great Depression, World War II, McCarthyism, the civil rights era, and the rise of the Black Power Movement. Not content merely to be mindful of the past, White made it his most important artistic theme. He worked in a variety of media—mural and easel painting, drawing, and printmaking—to champion African American history, which he felt was unacknowledged by mainstream American society. He returned to the past again and again for aesthetic inspiration, explicitly harnessing his creative energies to educate his fellow citizens and promote social equality by producing and displaying inspiring images of historical figures.

This essay examines the four murals that White produced during the late 1930s and early 1940s, three intended for Chicago locations, the fourth for Hampton Institute (now University) in Hampton, Virginia. All intentionally framed events from African American history as compelling new narratives. Yet, as the later title of *Nat Turner, Yesterday, Today, Tomorrow* suggests, White's understanding of history was by no means limited to the past. In 1940 he discussed his artistic goals with author Willard F. Motley:

> I do know that I want to paint murals of Negro history. That subject has been
> sadly neglected. I feel a definite tie-up between all that has happened to the

Negro in the past and the whole thinking and acting of the Negro now. Because the white man does not know the history of the Negro, he misunderstands him.[2]

As this observation indicates, and as the murals themselves demonstrate, White understood history as a continuum of events that directly led to the harsh realities faced by black people in his day. He mined historical texts and turned to sociological research—the study of the present—that documented the pressing needs of the African American community. He took these cues from members of the black intelligentsia such as Arthur A. Schomburg, a Puerto Rican–born writer of African descent who had dedicated his life to the promotion of African American history. In "The Negro Digs Up His Past," Schomburg exhorted the reader to "remake his past in order to make his future." This challenge presupposed that the progress of black Americans required the reclamation, redefinition, and advancement of their own history.[3] White's Chicago-era murals were inspiring images, replete with identifiable portraits and symbols. But they also relied on complex narratives of past and present, with the visual reminder of the passage of time underscoring the significance of history—"yesterday, today, tomorrow" writ large.

"A NEW WORLD OF FACTS AND IDEAS"

White's lifelong preoccupation with history is evident in how he narrated his own life and career. It was a story he told and retold, first in his autobiographical essay, "Path of a Negro Artist," published in the Marxist journal *Masses and Mainstream*.[4] He cast himself as the young hero on a journey from ignorance to enlightenment, from innocent child to angry youth to determined artist-historian. White used this opportunity to reflect upon the historical, social, and institutional structures—both positive and negative—that shaped his own development. This compelling identity was to be a touchstone for White, and it serves as a critical window onto the challenges he faced as a black student and, later, artist who chafed at the racial restrictions of American society before learning how to subvert them through his art.

In "Path of a Negro Artist," White described how his mother, who worked as a domestic servant, would leave her young son "for two or three hours in the public library."[5] Becoming an avid reader, he had exhausted the children's section and graduated to the adult section by the time he was twelve years old. "I read practically every book on the shelves," White continued, explaining that he browsed until he "accidentally came across books that had information which had never been imparted to me in school." A key text for the young White was Alain Locke's *The New Negro: An Interpretation*, a groundbreaking anthology published in 1925. Along with poetry, fiction, and essays, it reprinted Schomburg's essay "The Negro Digs Up His Past."

Reading the work of Locke, Schomburg, and others as a fourteen-year-old instilled a nascent awareness of and pride in African American history, as White recounted: "I discovered that the Negro people had played a proud role in history. . . . I had never realized that Negro people had done so much in the world of culture, that they had contributed so much to the development of America, that they had even been among the discoverers of the continent."[6] White initially kept these realizations to himself, explaining that this discovery represented a "secret life, a new world of facts and ideas in diametric opposition to what was being taught in the classrooms and textbooks as unquestionable truth." He soon began to openly question this omission in the curriculum at Englewood High School, where he was enrolled. In another retelling, White recounted being angered by the minimal representation of African Americans in "Professor Beard's book"—probably Charles A. Beard's *History of the United States*, first published in 1921 and used at Englewood as a textbook.[7] He pressed his teachers

to cover revolutionary-era figure Crispus Attucks, slave revolt leaders Denmark Vesey and Turner, and others, only to be labeled a troublemaker by instructors who "smugly and often angrily" told him to "sit down and shut up."[8] White recalled that he continued to speak out against this biased system. He skipped school, visiting the Art Institute of Chicago with dreams of becoming an artist. His mother had to meet with school officials; he risked being expelled.

Ultimately, as his autobiographical essay makes clear, he understood these acts of intellectual and historical repression as part of a through line of discrimination from the past into his present. His solution was to make history central to monumental public murals that would simultaneously correct the imposed narrative and uplift his audiences. In this, White was not alone. The opportunity to construct meaningful accounts of past events was of crucial significance during the 1930s, as hundreds of painters, authors, cultural critics, and others sought to redefine the American past—or pasts—at a time of national emergency.[9] Numerous black artists of his generation, among them Aaron Douglas and Jacob Lawrence, likewise challenged mainstream narratives by celebrating African American accomplishments in their work.[10] White's use of a naturalistic, if occasionally stylized, form of figuration reflected the prevailing aesthetics of social realism. The term describes the works of artists on the political left who used their art to draw attention to the injustices and inequalities of social and political conditions in the United States. White employed this style to create powerful, complex visualizations of history uniquely his own.

In telling his origin story, White suggested that he came to his interest in history on his own and that he taught himself through hours spent at the library. While this is surely true, White's interests were soon supported by others. As a young man he joined a multiracial circle of leftist artists in Chicago whose members shared his love of history and commitment to the cause of racial equality. His high school friend artist Margaret Burroughs recalled, "During this time, Charles got to know and learned much from artists and sculptors like Marion Perkins (who was a mentor to all of us), Si Gordon, Mitch Siporin, Aaron Bohrod and Morris Topchevsky, to name a few. . . . As a member of the Artists Union and the John Reed Club, Charles participated in 'rap' sessions sometimes hosted by 'Si' and 'Toppy,' which acquainted him with such black heroes as Denmark Vesey, Harriet Tubman, Sojourner Truth, Nat Turner and Frederick Douglass."[11] Although it is likely White was already familiar with these historical figures by the time of these conversations, Burroughs's recollection underscores the fact that his cohort of artist-mentors and students reinforced his desire to employ history as a force for change.

WHITE AND SOCIOLOGY: THE HISTORY OF THE PRESENT

White's work of the 1930s leading up to his mural commissions can be positioned within a social realist paradigm: as a committed leftist with communist inclinations, he sought to expose the injustices of the world around him.[12] His awareness of past and present structures of discrimination was corroborated by the sociological research then flourishing in Chicago, spurred in part by the city's violent race riots of 1919. The local black population was the focal point of numerous studies on race and segregation, from Charles S. Johnson's *The Negro in Chicago* (1922) to E. Franklin Frazier's *The Negro Family in Chicago* (1931), a copy of which White owned. A monumental work on the subject was St. Clair Drake and Horace Cayton's pioneering book, *Black Metropolis: A Study of Negro Life in a Northern City*, based on research financed by the Works Progress Administration (WPA) and conducted between 1935 and 1940. Drake and Cayton prefaced their discussion of contemporary life by detailing the history of black people in Chicago beginning in 1835. Having established this historical context, the

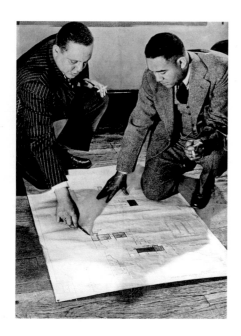

FIG. 1

Horace Cayton and Richard Wright examining census maps of the South Side, 1941. Horace Cayton Papers 015, Vivian G. Harsh Research Collection of Afro-American History and Literature, Chicago Public Library.

authors then turned to aspects of black life on the South Side—where the majority of African Americans lived—including labor and jobs, religion, politics, business, and class distinctions.

Drake and Cayton examined the topic of housing extensively, in particular, "kitchenette" living—the segregated reality of Chicago's South Side black neighborhoods. As black southerners relocated to the city during the Great Migration, they were met with discriminatory practices such as restrictive housing covenants that prevented them from moving into white neighborhoods. Population density in black neighborhoods increased dramatically as a result, and African Americans were forced to live in overcrowded, subdivided apartments called kitchenettes. These were inferior spaces, run-down and lacking in basic amenities, and they became a particular symbol for the artists and writers of the Black Chicago Renaissance, the flourishing of black culture, arts, and literature in the 1930s and 1940s.[13] Cultural producers found in *Black Metropolis* a scientific basis with which to channel their outrage into art. Author Richard Wright (see fig. 1), then living in Chicago, lent his support to *Black Metropolis* by contributing a preface, and he vehemently denounced kitchenettes in books such as *12 Million Black Voices* (1941). White's *Kitchenette Debutantes* (pl. 3) of 1939 represents perhaps his most striking effort in what can be described as a sociology-driven, social realist paradigm. Here the artist depicted two black women, dressed only in slips, posed in a window. They appear to be prostitutes: one primps with a mirror while the other, breasts uncovered, looks out the window and is on display. The title makes an ironic reference to society debutantes; these women are "coming out," not in the context of a ball but rather in a kitchenette. White's connection to the network of African American sociologists is signaled by Cayton's purchase of *Kitchenette Debutantes* from him. And the lessons White learned from sociology—the truth of the present—informed his murals by enabling him to merge themes of past events and present structures into powerful narratives of African American history.

ART FOR THE PEOPLE

In September 1938 White joined the easel division of the WPA's federal Illinois Art Project (IAP).[14] After proving both his artistic ability and lack of financial resources, he received a monthly stipend in exchange for producing paintings such as *Card Players* (pl. 5) for the government. After a year of working for the IAP, White transferred to the mural division. There, he could finally take on the role as advocate for black history he had envisioned as a teenager. Between 1939 and 1943 White worked on four murals, completing three.[15] Two were executed under the auspices of the IAP: *Five Great American Negroes* (pl. 7) was made for a fund-raiser for the nascent South Side Community Art Center (SSCAC) and *Struggle for Liberation* (also called *Chaotic Stage of the Negro, Past and Present*) was intended for the George Cleveland Hall Branch of the Chicago Public Library but was never installed. In 1940 he painted *The History of the Negro Press* for the Associated Negro Press (ANP) booth at the American Negro Exposition. This commission was funded by Claude Barnett, head of the ANP. Because it was not a WPA-sponsored project, White left the IAP temporarily to work on *History of the Negro Press*; he later asked for Barnett's help in getting reinstated.[16] Finally, in 1942, he received a fellowship from the Julius Rosenwald Fund to paint a mural for Hampton Institute, *The Contribution of the Negro to Democracy in America* (1943; Hampton University).

White wanted to promote African American history to combat mainstream white narratives that ignored or obscured black contributions. He also wanted to counteract

racist visual culture, as he later described: "I find, in tracing the course of the portrayal of the Negro subject in art, a plague of distortions, stereotyped and superficial caricatures of 'uncles,' 'mammies,' and 'pickaninnies'; notwithstanding the fact that the cultural tradition and historical background of the Negro in America follow the same basic pattern as that of American democracy in general."[17] He began to deploy history as an advanced form of protest, layering in sociological concepts as needed. As he stated in 1940, "I am interested in the social, even the propaganda, angle in painting. . . . Paint is the only weapon I have with which to fight what I resent. If I could write I would write about it. If I could talk I would talk about it. Since I paint, I must paint about it."[18] Moreover, he envisioned his works as public history lessons: "Art is not for artists and connoisseurs alone," he noted. "It should be for the people. A mural on the wall of a commonly used building is there for anyone to see and read its message."[19]

White's engagement with black history during this time coincided with a flourishing of the discipline that had its roots in Chicago. In 1915 the historian Carter G. Woodson and black civic leaders met in Chicago to found the Association for the Study of Negro (later, African American) Life and History. The organization's two publications, the *Negro History Bulletin* and the *Journal of Negro History*, showcased the vitality of this new area of study and amassed a rich documentation of the key figures, events, and conditions that shaped black history and race relations in the United States.[20] The *Journal of Negro History*, in particular, offered black historians and other historically minded writers the opportunity to publish.[21] Woodson also published the results of his own research in book form, including *The Education of the Negro prior to 1861*, *The History of the Negro Church*, and *African Myths Together with Proverbs* (White owned copies of all three titles; see the inventory of White's library in this volume).

By the mid-1930s Chicago had become an epicenter for the study of black history, particularly through venues like the George Cleveland Hall Branch Library (see fig. 2), the intended location of White's mural *Struggle for Liberation*. The Hall Branch opened in 1932 as the local library for the African American neighborhood of Bronzeville and vicinity. The pioneering founding director, Vivian G. Harsh, embarked upon a crusade to make it a thriving community center that hosted debates and lectures on African American history, literature, and politics. Harsh also built one of the most significant collections of African American–related books outside of the Schomburg Collection of Negro Literature, History and Prints located at the 135th Street Branch Library (now the Schomburg Center for Research in Black Culture).[22] Located at 4801 South Michigan Avenue, the Hall Branch was only six blocks from White's childhood home at 210 East 53rd Street. It opened when White was fourteen, and thereafter it undoubtedly became his preferred library. Indeed, White was present for one of the library's most momentous events, an evening talk given by poet Langston Hughes on April 1, 1938. The artist captured the poet in a quick but penetrating pencil portrait in his sketchbook (fig. 3), inscribing it with his name and a

FIG. 2
Opening day, George Cleveland Hall Branch Library, Jan. 1932. Vivian Harsh, center. Chicago Public Library.

FIG. 3
CHARLES WHITE (AMERICAN, 1918–1979)
Portrait of Langston Hughes. From White, Sketchbook, 1937–42, p. 24. Graphite with smudging on ivory wove paper, inscribed with pen and black ink. The Art Institute of Chicago, 2006.259. Cat. 2.

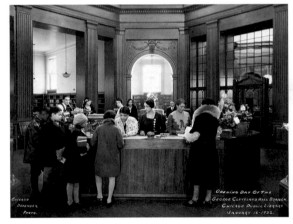

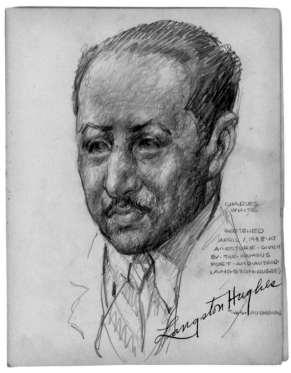

description: "Sketched April 1, 1938 at a lecture given by the famous poet and author Langston Hughes." White then had Hughes sign the drawing, which White annotated as "His autograph" with an arrow. The Hall Branch's robust book review and lecture program often featured noted intellectuals discussing important books; between 1937 and 1942, participants included sociologists Cayton and Drake, author Arna Bontemps, and poet Margaret Walker on topics ranging from Abraham Lincoln to Toussaint Louverture, and from capitalism and socialism to black participation in the labor movement.[23] As the locus of black intellectual, historical, and cultural life in Chicago, the Hall Branch therefore offered White crucial experiences, research materials, and literature that became the basis for his mural projects.

FIVE GREAT AMERICAN NEGROES

White executed *Five Great American Negroes* (pl. 7; see fig. 4), his first mural project, in October 1939. He needed to work quickly because the mural had to be finished in time for the first annual Artists and Models Ball at the Savoy Ballroom on October 23, 1939. White's canvas was a centerpiece of the evening.[24] The event raised money for the SSCAC, a WPA-sponsored institution that would find a permanent home the following year at 3831 South Michigan Avenue; its first exhibition was held in December 1940. Peter Pollack, a sympathetic white gallerist who showed African American artists at his North Michigan Avenue gallery, was head of the Community Art Center program for the WPA, and he enlisted White, Burroughs, and other members of the Art Crafts Guild to found the center in Bronzeville. Once the center opened, White taught life-drawing classes, participated in exhibitions, and donated his own works, including *Spiritual* (pl. 11), to the SSCAC's permanent collection.

Five Great American Negroes depicts Sojourner Truth, Booker T. Washington, Frederick Douglass, George Washington Carver, and Marian Anderson in a sweeping scene that reads from left to right, moving generally from past to present. The subjects of the canvas were determined by a poll conducted by the *Chicago Defender*, the city's preeminent African American newspaper, asking readers to name "those who have contributed most to the progress of the Race."[25] Washington topped the list. White

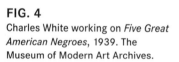

FIG. 4
Charles White working on *Five Great American Negroes*, 1939. The Museum of Modern Art Archives.

conceived the overall structure as a series of separate vignettes, allocating each leader his or her own portion of the canvas while connecting the scenes visually through their gestures. Truth, an emancipated slave who became a noted advocate for black people and women during the 1850s, occupies the left side of the mural. White depicted her leading a procession that curves into the distance. The tail of the group leads the eye to the orating figure of Washington, while Truth, in the foreground, points with strong, outstretched hands to her left, where three seated middle-class figures take in his words. Washington, another former slave who achieved fame as an educator, author, and orator, stands directly in front of the abolitionist Douglass, who, in turn, embraces a shirtless man, presumably a slave or escaped slave. White unified Truth, Douglass, and Washington through their poses, underscoring their symbolic power as historic leaders in the struggle for equality.

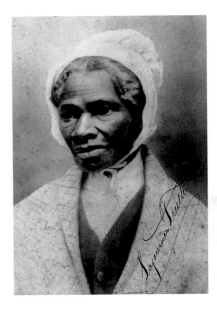

White researched his subjects extensively, creating likenesses based on period sources and photographs. Crucially, his depictions demonstrate his familiarity with African American historiography of the era. Truth, for example, is popularly remembered as an orator, yet White portrayed her as a leader of people.[26] This imagery likely stemmed from his reliance on the biography *Sojourner Truth: God's Faithful Pilgrim*, published by Arthur Huff Fauset in 1938 to acclaim by the black intelligentsia.[27] It epitomized the new African American historiography. White owned a copy of the book and clearly based Truth's head on the photographic portrait of her used as its frontispiece (fig. 5).[28] Fauset emphasized Truth's attempts to resettle former slaves in Kansas in the early 1870s, after emancipation failed to substantially change their economic status. Truth viewed this as a sacred mission: "'I believe as much in [the move to Kansas] as I do in the moving of the children of Egypt going out of Caanan [*sic*].'"[29] Indeed, during the Exodus of 1879, when thousands of black people from across the South moved to Kansas, Truth traveled there in support.[30] Picking up on Fauset's emphasis, the leftist press of the 1930s began to represent Truth in this way: Ralph Ellison, reviewing the biography for *New Masses*, described her as a "leader of the underground railroad" and underscored her role in the Kansas resettlement plan.[31] White's portrayal of Truth at the head of a procession thus reflected an understanding of her as an advocate for migration and resettlement.

White dedicated the right side of the composition to the black heroes of his own day. The figures represent famed scientist Carver and singer Anderson. Carver appears with the tools of his profession, a microscope and test tubes, symbols of his education and research. Above him, Anderson sings into microphones before a vivid blue background. The Daughters of the American Revolution had recently denied her the right to sing at Constitution Hall in Washington, DC. In response, she performed in a concert at the Lincoln Memorial on April 9, 1939, an event organized with the help of First Lady Eleanor Roosevelt—a pioneering moment in the advancement of civil rights. Two additional, anonymous figures stand at far right. They further connect Anderson and Carver—symbols of culture and learning—and reinforce White's pedagogical agenda: art as education. But their presence at the edge also underscores the union of past and present and its ongoing impact on everyday black citizens. Advances in racial equality would come by visually unpacking the past to better understand its effect on the present, enabling African Americans in the United States to flourish intellectually and culturally in the future.

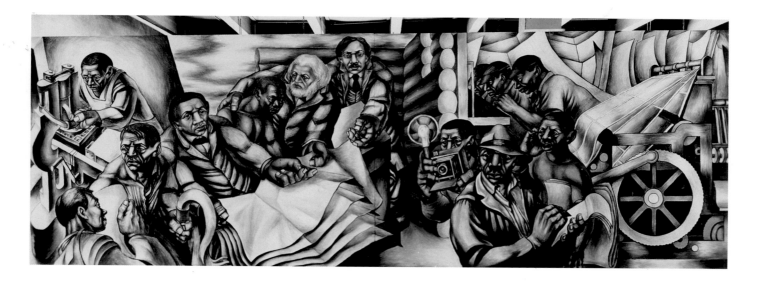

THE HISTORY OF THE NEGRO PRESS

White completed his second mural, *The History of the Negro Press* (see fig. 6), between April 18 and June 28, 1940, in time for the opening of the American Negro Exposition on July 4, 1940.[32] This massive celebration of the seventy-fifth anniversary of the Thirteenth Amendment, which abolished slavery, was held at the Chicago Coliseum on the Near South Side. It showcased the progress of African Americans through hundreds of exhibits, from historical dioramas to agricultural and other educational displays. Locke, Howard University Gallery of Art curator Alonzo Aden, and a group of jurors curated an exhibition of historical and contemporary painting, sculpture, and works on paper in the on-site Tanner Art Galleries.[33] White showed *There Were No Crops This Year* (pl. 9), which won an award for black-and-white work; *Fellow Workers, Won't You March with Us* (location unknown), which received honorable mention in watercolor; and *Through the Years of Poverty a Passionate Tune of Woe Was Born* (location unknown).[34] All three artworks affirm the artist's commitment to activism through art and to social realism by highlighting the plight of workers. Separate from the art exhibition, White's mural hung on the outside wall of the press display, which brought together nine African American newspapers to tell the history of black journalism from 1827 to 1940.[35] As in *Five Great American Negroes*, White here employed a large-scale format to emphasize the progressive potential of history, literacy, and journalism to uplift African Americans.

The site was a long, narrow space, and the artist exploited these dimensions again to show—in a lateral sweep from left to right—forward movement from past to present. White began the composition on the left with three anonymous newspapermen, including one who operates an old-fashioned movable-type printing press. Instead of dispersing famous individuals across the mural, he united three historically significant black journalists in the near center of the composition, creating a triangle that implies rising advancement over time. While it is unknown which sources he consulted to research the topic, books such as *The Afro-American Press and Its Editors* (1891) contained historical information, biographical sketches, and photographs of the three newspapermen that could have informed his aesthetic decisions. In the center left, flanked by the man setting type by hand, he depicted John Brown Russwurm, the publisher of *Freedom's Journal* (founded 1827), the first newspaper owned and operated by an African American. Russwurm holds a pile of broadsides, which draws attention to his muscular hands; White used this overall motif to connect the themes of

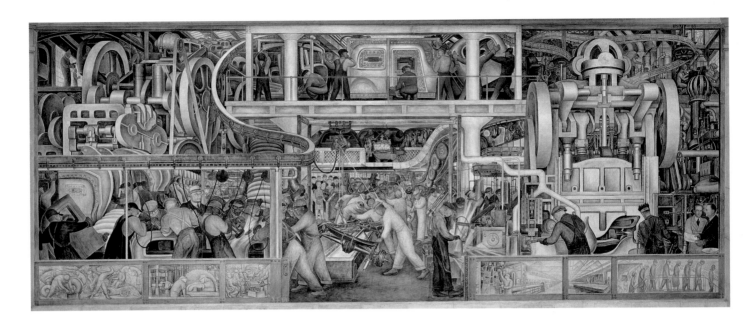

FIG. 7
DIEGO RIVERA
(MEXICAN, 1886–1957)

Detroit Industry, South Wall, bottom register, 1932–33. Fresco; 539.8 × 1371.6 cm (212 ½ × 540 in.). Detroit Institute of Arts, gift of Edsel B. Ford, 33.10.S.

journalism, education, and power. Adjacent to Russwurm is Douglass; as he did in *Five Great American Negroes*, White paired him with a ragged man. Yet instead of simply embracing the man, Douglass shows him a newspaper. Douglass had started the abolitionist newspaper the *North Star* in 1847, titling it after the direction given to escaped slaves: follow the North Star to the northern states. White honored Douglass's legacy as a newspaperman by implying that the information contained in the *North Star*, rather than the celestial star itself, will save the man. Finally, rising even higher above Douglass is T. Thomas Fortune, owner of the *New York Age*, which had the largest circulation of a black newspaper in the late nineteenth century. Described as "the most noted man in Afro-American journalism," Fortune used his publication to agitate loudly for equality, education, and other rights for African Americans.[36]

White employed the motif of a log cabin wall to divide these historical pioneers from contemporary newspapermen, who are positioned on the right side of the composition. These anonymous journalists take photographs and record observations in a notepad with a large newspaper press behind them.[37] His inclusion of this modern printing press, with its bold circular flywheel, recalls Diego Rivera's murals, especially his *Detroit Industry* fresco cycle of 1932–33 (see fig. 7), which depicted the Ford Motor Company's massive production machines.[38] White's dedication to constructing a heroic and monumental black history through murals found compelling models in Mexican modernists such as Rivera, José Clemente Orozco, and David Alfaro Siqueiros. These artists espoused radical politics and sympathy for the working class and championed Mexican history and folklore.[39] White had a deep interest in the imagery and techniques of Mexican muralists long before his first trip to Mexico in 1946. He owned a copy of a 1937 interpretive guide to the murals by Rivera, Orozco, and others in the Escuela Nacional Preparatoria (National Preparatory High School).[40] In early 1940 the artist studied fresco painting at the Hull-House Settlement with Edward Millman, who, in turn, had studied with Rivera.[41]

Throughout *The History of the Negro Press*, White employed stylized, angular forms—in some cases repeated, as with the three visor-wearing printers at the upper right—that called out the modernity of his subject matter. The mural thus demonstrates progress through people and machines, from singular publishers such as Douglass to the many unnamed but valorized professionals of the past and present, and from old printing presses to the most advanced technologies of the day.

FIG. 8
GORDON PARKS
(AMERICAN, 1912–2006)

Charles White in front of *Struggle for Liberation*, 1940–41. Charles W. White fellowship file, Julius Rosenwald Fund Archives, box 456, file 6, John Hope and Aurelia E. Franklin Library, Special Collections and Archives, Fisk University, Nashville, TN.

STRUGGLE FOR LIBERATION

White worked on his third mural, *Struggle for Liberation*, in 1940 and 1941. It was intended for the adult reading room of the George Cleveland Hall Branch of the Chicago Public Library.[42] A color sketch (pl. 10) is the only recorded version of both sides of the two-panel project, which was never completed. White referred to the entire work as *Struggle for Liberation* in 1941, although in later years his wording changed.[43] Scholars have applied many titles to the work: "Chaotic Stage of the Negro, Past and Present," "Revolt of the Negro during Slavery," "Chaos of Negro Life," and "Techniques Used in the Service of Struggle."[44]

White began work in early 1940, executing the color study by March of that year. He accounted for the architecture of the space, which was divided into two halves by a narrow transom, by separating the composition into two large panels. A month later, the Chicago Public Library approved the sketch and authorized the expenditure.[45] The *History of the Negro Press* commission that summer undoubtedly delayed White's work and, moreover, temporarily cut him off from his IAP salary. Once his funding was reinstated, in August 1940, White made progress on the left panel, which Gordon Parks memorialized in a series of photographs (see fig. 8; see also fig. 1, p. 87). White finished the left panel by November 1941.[46] He then moved out of Chicago in January 1942, and his employment in the IAP was terminated in March 1942. It appears he never developed the right panel beyond a very preliminary stage, and the project was officially canceled in July 1943. The canvases were slated for storage, and the final disposition of the mural remains unknown.[47]

When Carl Roden, chief librarian of the Chicago Public Library, notified Hall Branch librarian Harsh in July 1943 of his decision to cancel the project, he expressed his doubt about its "fitness for a library."[48] His concerns departed from his earlier enthusiasm; when he had initially reviewed the color study, he had found it entirely fitting, given that Hall Branch was a major center for African American education in the city.[49] His change of heart was undoubtedly informed by increasing controversy about whether public murals were appropriate in schools and libraries—a dispute over how history is told and under whose authority. Conservative critics and politicians had fostered suspicions about possible communist influences within the IAP, and recently completed murals by Millman at Lucy Flower Technical High School had already been painted over.[50] Moreover, the entrance of the United States into World War II had rallied the country against an exterior enemy; a public work critiquing African American inequality could appear unpatriotic.

Roden's fears were not entirely misplaced: White's mural indeed reflected his challenging new approach to history. No longer a celebration of heroic individuals, his composition confronted the racial violence at the root of the black struggle.[51] The color study and IAP-commissioned documentary photographs of the left panel (see fig. 9) demonstrate his significant evolution as an artist and historical thinker. The IAP assignment had been open-ended, mandating only that the artwork address African American history and be appropriate for the location. And as there was no pressing deadline, White took much more time than he had for his two earlier murals. He had to work within the constraints of the library's architecture, but the nearly square format of each half afforded him more compositional flexibility than the long, frieze-like canvases of his previous murals. This allowed him to compose horizontally and vertically, and he created an active array of connected bodies bursting with energy and strength.

In the left panel, White depicted competing historical forces of violence and resistance, anchored by the solid figure of John Brown, the radical white abolitionist, in the lower left corner. The artist had created an earlier charcoal sketch of him that informed the mural (pl. 4), and he would later produce other portraits of Brown (see pl. 32). Brown initiates the composition's movement by thrusting a gun forward, leading the charge of revolt. Above him a man holds a guitar. Posed against a jail-cell window, he is possibly the blues musician Lead Belly (Huddie William Ledbetter), a popular symbol of African American culture and resistance. Like Brown, Lead Belly was a favored subject of White's, featuring in later paintings such as *Goodnight Irene* (pl. 41). In the center of the panel, a family of three represents the everyday citizens who strive for a better world. The man—wearing a vivid blue shirt, according to the color study—appears to be armed, torn between the militancy of John Brown and the domesticity of his family. Above them a man thrusts a book in the air, perhaps asserting the significance of education over violence in the struggle for equality, while at the pinnacle of the composition, a preacher orates from the pulpit, introducing the power of religion. As in *The History of the Negro Press*, White used the motif of a log cabin to frame this group, but just beyond the wall is a destroyed tree with a horrific burden: the body of a lynched man, the personification of racial terror. Underscoring this theme, a fleshy, well-dressed overseer looms over a man in shackles. The scene conveys a clear message: historically, violence and oppression suppressed African American progress.[52]

The right panel, known only from the color sketch, suggests modern resistance through politics and protest, on the one hand, and the continuation of repression, on the other.[53] The scene is the Depression era, evident from the sign on the right advertising a relief station, together with a line of weary figures. Significantly, White clearly conceived of the two panels as expressing the continuing theme of past and present. To emphasize the passage of time, he paired elements from the left panel with counterparts on the right: the log cabin with an industrial factory, and the guitar player with a pianist. The preacher at left becomes the orator at right who urges people— perhaps ironically—to "Vote for Honest Joe Goon," a white politician.

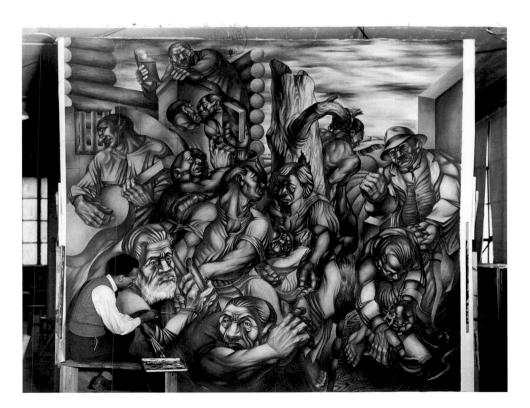

FIG. 9
Charles White working on the left panel of *Struggle for Liberation*, 1940–41. Chicago Public Library.

The heart of the composition, however, is the couple embracing. Dressed in bright-blue and mustard-yellow outfits, they appear to be the mature version of the parents in the left panel. Behind them, a policeman lays hands on a muscular African American man brandishing a protest sign. Given the man's proximity to the pair and the purplish color of his outfit, White may have intended this figure to represent the child from the left panel, now grown to adulthood. Perhaps recalling Frazier's sociology, White enshrined the institution of the family, as they face the forces of reaction that surround them. Whereas in the left panel violence rules and John Brown brandishes a gun, here the weapon of choice is a protest sign, and organized resistance is the modern way to effect change.[54]

In the right panel, the protester stands poised near a man with a pickax, symbolizing a politically conscious working class. This was critical for White, who championed the rights of the worker as ardently as he did equality for African Americans. He reprised the subject in contemporaneous works, most notably his 1940 *Untitled (Four Workers)* (pl. 8), which features three laborers flanked by a man with a sign. In this work, the man with the pickax is identical to the one in the study. It brilliantly demonstrates White's aesthetic vision at this time: he created dynamic, muscular figures using sweeping brushwork that animates their surroundings. White presumably visualized a similar message in *Fellow Workers, Won't You March with Us*, the painting that he exhibited to acclaim at the American Negro Exposition.[55] This work has not yet been conclusively identified, and it is possible, in fact, that it is *Untitled (Four Workers)*. This gesture toward a collective activism, present in both his easel paintings and *Struggle for Liberation*, derived from his communist leanings.

White thus offered a far more complex version of history in his Hall Branch mural than he had in *Five Great American Negroes* or *The History of the Negro Press*. The first two portray historical change as a linear progression through time, reliant upon individual actors. *Struggle for Liberation* visualizes a more dimensional understanding of historical struggle—an all-encompassing, expansive rising up that unites past and present in a nuanced fashion. Although historically significant individuals such as John Brown make an appearance, White's leftist approach to group action speaks to a shift in his ideology toward the agency of anonymous people working together to protest the conditions of the past and the present. Art and culture once again join with history to act as forces of education and enlightenment. But White did not shy away from the challenges faced by African Americans in his era. The figure of a wealthy man holding a bag covered with dollar symbols suggests the corrupt influence of capitalism. His location near a row of corn plants could imply that his money comes from exploitation of sharecroppers or tenant farmers, a theme White also explored in *There Were No Crops This Year* (pl. 9). He depicted capitalism, politics, institutional power, and violence as responsible for the ongoing injustices faced by African Americans as they demanded their rights. Mural painting offered White an outlet for his dual goals: making art as a means of fighting inequality and educating the masses—and *Struggle for Liberation* strikingly accomplished both, using a complex and dynamic visual language.

THE CONTRIBUTION OF THE NEGRO TO DEMOCRACY IN AMERICA

White brought these lessons and compositional strategies to bear on his final historical mural of the period, *The Contribution of the Negro to Democracy in America* (fig. 10), painted on-site at Hampton Institute.[56] The project was supported by the Julius Rosenwald Fund, which awarded White a twelve-month fellowship grant in 1942. In his application, White had proposed a mural that would illustrate "the role of the Negro in the development of a democratic America."[57] The massive tempera fresco depicts

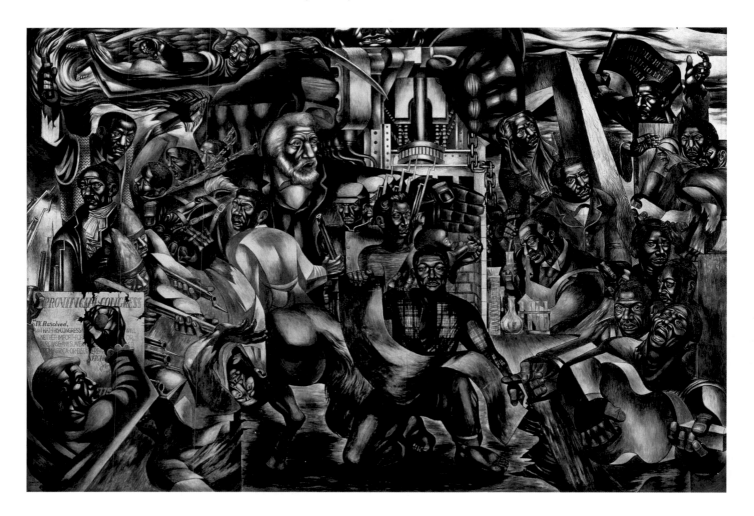

fourteen identifiable historical figures, including many he had long been interested in: Marian Anderson, Crispus Attucks, George Washington Carver, Frederick Douglass, Lead Belly, Paul Robeson, Peter Salem, Peter Still, Ferdinand Smith, Sojourner Truth, Harriet Tubman, Nat Turner, Denmark Vesey, and Booker T. Washington.[58] The composition also includes many anonymous individuals as well as an avenging angel along the top left and, at top center, a colossal, almost unseen figure partially cropped out. Its massive hands hold shackles (some in use, others empty) and a large industrial machine. This behemoth again recalls Rivera's murals, in particular *Detroit Industry* and *Pan-American Unity* (1940; City College of San Francisco).[59]

In his fellowship application White also expressed a desire to paint "numerous easel paintings, touching the vital problems of Negro life and depicting his efforts for economic security and social elevation." White thus connected history and sociology in his work; as he noted, "this contemporary material would be infused with historical data."[60] He outlined an itinerary that included five months studying fresco painting at the Escuela Nacional de Pintura y Escultura (National Academy of Painting and Sculpture) "La Esmeralda" in Mexico City, three months traveling in the South for research, and four months at Hampton producing the mural. However, as a draft-eligible man during wartime, White was required to secure permission from the draft board to travel to Mexico, and his request was denied.[61] Instead, he enrolled at the Art Students League in New York and studied mural painting with Harry Sternberg, after which he continued his original course of action (on this, see Esther Adler's essay in this volume).[62] His fellowship was renewed in 1943, and he used the money to produce a series of works that explored the subject of black people in the military and on the home front (see, for example, pls. 21–23).

FIG. 10
CHARLES WHITE
(AMERICAN, 1918–1979)

The Contribution of the Negro to Democracy in America, 1943. Tempera mural; 360 × 510 × 5 cm (142 × 201 × 2 in.). Hampton University, Hampton, VA.

Hampton allocated the back wall of the stage of its Wainwright Auditorium for White's project.[63] This was the first time that the artist had the opportunity to execute a mural on-site, painting directly on the wall with tempera instead of with oil paint on a canvas support. He researched the topic at the Schomburg Collection; the Library of Congress in Washington, DC; and the library at Hampton. He resolved the component parts in an early pencil drawing (1943; Hampton University Museum), later completing a work in tempera that he used as a reference when he executed the mural (see pl. 18). In these sketches he conceived a structure—reminiscent of the one he used in *Struggle for Liberation*—that portrayed history as a composite of layered, overlapping, and ascending figures. Numerous figural drawings in pencil and charcoal that White used to determine exact features and proportions survive. These include a double study of Truth and Washington (pl. 15), the head of Vesey (pl. 17), and the outlined head and shoulders of Robeson (pl. 16). In all, White's technique was efficient—he only planned out the portion of the figures that would be visible in the final version.

This monumental work presented, as a press release put it, "the Negro's active protest against those antidemocratic forces which have sought to keep a stranglehold upon the common people through economic slavery and social and political frustration."[64] The mural advances ideas White had developed in previous murals, notably, the equal treatment of venerable and anonymous figures as historical actors. The latter include black Civil War soldiers, arrayed in a rhythmic line near the commanding figure of Douglass. Their timely inclusion likely alluded to the "Double V" campaign: in 1942, the African American newspaper *Pittsburgh Courier*, reporting on discrimination against black soldiers in the armed forces, began pressing for equal rights on the home front and in the military, using the slogan "Victory at Home, Victory Abroad."[65] White's reminder about the heroic service of African American troops during the Civil War thus connected past and present, underscoring the ongoing importance of the fight for equality.

The historical figures depicted in *The Contribution of the Negro to Democracy in America* all advocate resistance and liberation. These included Attucks, the first martyr of the American Revolution; Vesey, who planned a major slave insurrection in 1822; Turner, the leader of an important slave rebellion in 1831; and Still, a runaway slave who, in the mural, bears a flag with the inspiring motto "I will die before I submit to the yoke." White's emphasis on such leaders paralleled a growing literature on the subject. The leftist historian Herbert Aptheker, for example, published *Negro Slave Revolts in the United States, 1526–1860* in 1939, followed by *American Negro Slave Revolts* in 1943.[66] Still also became a popular topic, particularly with the 1942 reissue of Kate R. Pickard's study *The Kidnapped and the Ransomed* (1856), which recounted Still's escape from slavery. It was reissued by the Negro Publication Society, a newly formed group dedicated to reprinting historical texts about African Americans.[67] The mural thus signals and expands upon White's earlier endorsement of history as a narrative of struggle for liberation—made particularly critical by its timing in the middle of World War II.

In a distinct structural departure from his first two murals, however, White orchestrated a circular movement within the composition, distributing historical and contemporary individuals around a large, central figural group: a kneeling man flanked by a woman and child. The presence of this apparent family recalls the imagery from *Struggle for Liberation*, yet in the Hampton mural, White depicted the man as composed rather than agitated. Bearing a long scroll of blueprints, he wears white-collar attire—a checked shirt and tie—to connote his ascendancy within the ranks of workers. He has been described by one scholar as "the architect of the future," building a better society through democracy and education.[68] In a telling detail not often noted, however,

this architect gazes directly out of the composition, breaking through the pictorial plane along with several others. Joined by Vesey, Anderson, and Robeson, the man addresses the viewer with a frank gaze, perhaps meant as a challenge to join the fight for freedom. They invite us to stand with anonymous and famous figures alike in the struggle for equality. History, in White's telling, is not simply the sum of biographies of notables but instead a living entity to be shaped by all—including the artist.

YESTERDAY, TODAY, TOMORROW

In "The Negro Digs Up His Past," Schomburg wrote, "History must restore what slavery took away, for it is the social damage of slavery that the present generation must repair and offset."[69] White took on his own restoration with this multiyear mural painting project. Dissatisfied with the omission of African American history in schools, he visualized it for all to see. Although his art making soon moved away from murals, he never abandoned history—he simply gave it new shapes. This reflected his developing knowledge and artistry: "The more I learn of the history of my people and country, the more I experience of the stirring events of our time, the more are there subjects which clamor for realization."[70] White's determination to interweave the past and the present, the historical and the sociological, in his murals and beyond was consistently meaningful and important. Works such as *General Moses (Harriet Tubman)* (pl. 79) and *Nat Turner, Yesterday, Today, Tomorrow* (pl. 85) translated the monumentality of the mural into single-figure compositions that emphasize the power and exceptional nature of these individual actors. The *Wanted Poster Series* (see pls. 88–93) incorporated a new language, drawn from the past—matter-of-fact advertisements that underscore the terrible reality that human beings were sold as property. Commercial work illustrated new stories and historical narratives. As the history of the twentieth century unfolded, White continuously engaged with it, as he sought to remake the past and present in service of a better future: a world in which the accomplishments of African Americans would be proclaimed with pride.

1. Schomburg, "The Negro Digs Up His Past," 670; also printed in Locke, *The New Negro*, pp. 231–37.

2. White quoted in Motley, "Negro Art in Chicago," 22.

3. Schomburg, "The Negro Digs Up His Past."

4. White, "Path of a Negro Artist." A near-identical version appears in the Charles W. White Papers, Archives of American Art, Smithsonian Institution, Washington, DC (hereafter CWP, AAA), where it was described by Frances Barrett White as "Translation of article or article with Charlie after our return from Europe, 1950s." Rather than a translation, it appears to be a near-final draft of "Path of a Negro Artist," which was then published in German as "Mein Weg zur Kunst," in Sidney Finkelstein, *Charles White: Ein Künstler Amerikas* (Dresden: VEB Verlag der Kunst, 1955), 47–65. White reprised many of the same ideas in later interviews and publications; for example, see White, oral history interview with Hoag, Mar. 9, 1965, AAA. Throughout this essay, other biographical information is drawn from the chronology in this volume and from Barnwell, *Charles White*, the most recent biography of the artist.

5. White, "Path of a Negro Artist," 35.

6. Ibid.

7. White describes "Professor Beard's history" as the "standard textbook for all U.S. history students in Chicago at least." White, interview by Clothier, Sept. 20, 1979, transcript, 29.

8. White, "Path of a Negro Artist," 36.

9. Such ideas stem in part from Van Wyck Brooks's seminal concept of a "usable past"; Brooks, "On Creating a Usable Past." See also A. Jones, "The Search for a Usable American Past in the New Deal Era"; Grieve, *The Federal Art Project and the Creation of Middlebrow Culture*, particularly the chapter "Inventing a Usable Past"; and Madsen, "Revising the Old and Telling Tales."

10. For Douglas, see Ater, "Creating a 'Usable Past' and a 'Future Perfect Society.'" Scholarship on Lawrence is extensive; see, for example, Hills, *Painting Harlem Modern*.

11. Burroughs, "He Will Always Be a Chicago Artist to Me."

12. White's affiliations with the Communist Party of the United States reveal a deep sympathy for its cause, as Mary Helen Washington has pointed out; see Washington, *The Other Blacklist*. White was committed to working on behalf of the working class through his art, and among other things, his embrace of questions of social justice led him to produce illustrations for the socialist press such as *The Return of the Soldier (Dixie Comes to New York)* (pl. 27), an illustration for a *Daily Worker* pamphlet. He also joined organizations such as the progressive and interracial Chicago Artists Union, which organized protests on behalf of black and working-class artists.

13. According to Alain Locke, the Black Chicago Renaissance was distinct from the Harlem Renaissance of the 1920s in its emphasis on what he termed the "sober realism" and the "deeper truths of life"; see Locke, "The American Negro Exposition's Showing of the Works of Negro Artists," in American Negro Exposition, *Exhibition of the Art of the American Negro (1851 to 1940)*, n.p. For more on the Black Chicago Renaissance, see Hine and McCluskey, *The Chicago Black Renaissance*; and Bone and Courage, *The Muse in Bronzeville*. Eldzier Cortor also recalled White's participation in the Black Chicago Renaissance; see Cortor, "He Was at Home Creatively in Any Locale."

14. Civilian personnel record for Charles W. White, Works Progress Administration, National Personnel Records Center, National Archives and Records Administration at Saint Louis.

15. The murals have been subject to varying degrees of scholarly attention in recent years, although the exact circumstances of the four mural commissions have been somewhat shrouded in mystery, which this essay attempts to resolve. One good analysis of White's mural practice can be found in Morgan, *Rethinking Social Realism*, 48–71.

16. White to Claude Barnett, July 23, 1940, Claude Barnett Papers, Chicago History Museum. White asked Barnett, his most recent employer, to confirm for the IAP that he had received and executed a commission for the ANP.

17. White, "Statement of Plan of Work," White fellowship file, Julius Rosenwald Fund Archives, box 456, file 6, John Hope and Aurelia E. Franklin Library, Special Collections and Archives, Fisk University, Nashville, TN.

18. White quoted in Motley, "Negro Art in Chicago," 22.

19. "Art Today," *Daily Worker*, Aug. 28, 1943, reel 3195, CWP, AAA.

20. See, for example, Darlene Clark Hine, "Carter G. Woodson, White Philanthropy and Negro Historiography," *History Teacher* 19, no. 3 (May 1986): 405–25; and Pero Gaglo Dagbovie, "Making Black History Practical and Popular: Carter G. Woodson, the Proto Black Studies Movement, and the Struggle for Black Liberation," *Western Journal of Black Studies* 28, no. 2 (2004): 372–82.

21. See Goggin, "Countering White Racist Scholarship."

22. The Hall Branch was also a significant site for youth education; Charlemae Hill Rollins, the children's librarian, pioneered efforts at promoting responsible images and stories for black children. See Burt, "Vivian Harsh, Adult Education, and the Library's Role as Community Center"; and Tolson, "Making Books Available."

23. This overview was compiled from the Book Review and Lecture Forum folders, box 5, George Cleveland Hall Branch Archives, Harsh Collection, Chicago Public Library (hereafter CPL).

24. It has often been said that the mural was installed at the SSCAC, but this claim cannot be proven. The building was purchased in July 1940, and over several months the apartments were converted into gallery and work spaces. The first exhibition opened on December 15, 1940 (and included other works by White), but *Five Great American Negroes* was not among them. It had already been shipped to Washington, DC, for the exhibition *Creative Art of the American Negro* at the Library of Congress; see the selected exhibition history in this volume. In November 1941, Dorothy Miller noted that the mural was still unallocated; Painting and Sculpture Artists Records, series I, folder 347, Museum of Modern Art Archives, New York. In 1943, it was sent to Fort Huachuca, Arizona, for an exhibition of WPA art by black artists; the catalogue notes that the entire collection would be installed permanently at the fort's Mountainview Club. The mural remained at Fort Huachuca until it was decommissioned in 1947, at which point it was given, along with a number of other works, to Howard University.

25. "Washington Tops List of Race Leaders," *Chicago Defender*, Oct. 14, 1939, 23.

26. Barnwell has noted that depicting Truth at the head of a procession was an unusual choice because she was famed for her oratory, not, like Harriet Tubman, as a leader of people. Barnwell suggests that White deliberately conflated ideas about Truth and Tubman. See Barnwell, "Sojourner Truth or Harriet Tubman?," 55–66.

27. See, for example, the glowing review by Alain Locke; Locke, "The Negro: 'New' or Newer, Part 2," *Opportunity: Journal of Negro Life* 17, no. 2 (Feb. 1939): 37. This article reviewed African American scholarly literature.

28. Truth had commissioned the carte de visite photograph in 1882, selling this and many others to raise funds for her activities. Grigsby, *Enduring Truths*, 187.

29. Fauset, *Sojourner Truth*, 175.

30. Nell Irvin Painter, *Sojourner Truth: A Life, a Symbol* (New York: W. W. Norton, 1996), 244–45. Truth's 1879 trip to Kansas was one of several she took during her later life in support of resettlement there.

31. Ralph Ellison, "Practical Mystic," *New Masses*, Aug. 16, 1938, 25.

32. White described his dates of employment in White to Barnett, July 23, 1940 (n. 16 above).

33. The Tanner Art Galleries, the section of the exposition dedicated to art, was named in tribute to Henry Ossawa Tanner, represented in the show by eleven works.

34. For the art exhibition, see American Negro Exposition, *Exhibition of the Art of the American Negro (1851 to 1940)*.

35. "Editors Plan Exhibit for Exposition," *Chicago Defender*, May 11, 1940, 9; "Exposition Mural Depicts History of Negro Press," *Chicago Defender*, Aug. 10, 1940, 5. It has been suggested that *The History of the Negro Press* won an award, but there is no evidence of this in contemporary newspaper articles or White's papers, including his Rosenwald application in the fall of 1941, in which he carefully lists his accolades and awards. See White fellowship file (n. 17 above).

36. Penn, *The Afro-American Press and Its Editors*, 133.

37. Washington, *The Other Blacklist*, 71.

38. White surely knew of the massive wheeled stamping presses depicted by Rivera on the south wall; for analysis of the murals, see Downs, *Diego Rivera*.

39. LeFalle-Collins, "African-American Modernists and the Mexican Muralist School," 55–56. For a discussion of the intersections between Chicago's artistic institutions and Mexican modernism, see Oehler, *They Seek a City*, 53–58. See also Hemingway, *Artists on the Left*, 172–74.

40. *Frescoes in Ntl. Preparatory School by Orozco, Rivera and Others*, with critical notes by Carlos Mérida (n.p.: Frances Toor Studios, Mexico, 1937).

41. For his study with Millman, see Motley, "Negro Art in Chicago," 22; and White, Rosenwald fellowship file (n. 17 above). White also gained firsthand experience working on a tempera-on-plaster mural at this time; in his 1965 oral history, White recalled working on an IAP project with an unnamed muralist. Research suggests this artist was Arthur Lidov, a now little-known artist who executed a mural, *Characters from Children's Literature*, for the Walter S. Christopher School on Chicago's West Side; White, oral history by Hoag. My thanks to John Murphy for making this connection.

42. The black artist Charles Davis received a separate commission for a mural for the children's room. See Vivian G. Harsh to Carl Roden, Dec. 11, 1941, Carl Roden Papers, CPL. Davis's mural was well under way in December 1941 but was never completed, seemingly due to an illness and his consequent dismissal from the WPA in spite of attempts by Roden to get him reinstated so he could finish. See Carl Roden to Amelia Baker, Dec. 24, 1941, Roden Papers, CPL.

43. White first used *Struggle for Liberation* in his Rosenwald Fellowship application, which was submitted in 1941 and thus is exactly contemporary with his work on the mural. Accordingly, this volume will use *Struggle for Liberation* as the title. See White fellowship file (n. 17 above). Around 1955, in an unsuccessful application for a Guggenheim Fellowship, White described it as "the causes and technics [*sic*] used to fight for the abolition of slavery." White, Guggenheim Fellowship application, CWP, AAA.

44. The title *Chaotic Stage of the Negro, Past and Present* was put forth by Daniel Schulman, who based it on the following article from May 1940: William Carter, "The Art Notebook," *Chicago Bee*, May 26, 1940 (copy in CWP, AAA). See Schulman, "African American Art and the Julius Rosenwald Fund," 65, 78n49. For "Revolt," see Gedeon, "Introduction," 64; for "Chaos," see Barnwell, *Charles White*, 26; for "Techniques," see Morgan, *Rethinking Social Realism*, 57; and Washington, *The Other Blacklist*, 82. Morgan suggests that *Techniques* came from White but does not cite his source. A far more prosaic variant was "History Negro Race," used by the state supervisor of the IAP in correspondence with the CPL; see George G. Thorp to Carl Roden, Apr. 30, 1940, Carl Roden Papers, CPL.

45. The *Defender* reported that White was preparing a sketch; Mary E. Jackson, "Art and the People," *Chicago Defender*, Jan. 20, 1940, 10. The verso is inscribed *March 1940*. This was presumably the sketch approved in April; see Annual Reports and Official

Proceedings from the Library's Board of Directors, Apr. 24, 1940, Harold Washington Library Center, Special Collections, CPL.

46. Dorothy Miller, a curator at the Museum of Modern Art, New York, saw the completed left panel in November 1941, describing its dimensions as ten feet eight inches wide by nine feet, six inches high. She was then considering including White in an exhibition, likely *Americans 1942: 18 Artists from 9 States*, Museum of Modern Art, New York, in 1942, although ultimately he was not included. See Painting and Sculpture Artists Records, series I, folder 347, Museum of Modern Art Archives, New York.

47. Carl Roden noted that one mural panel was largely complete (White's left panel), one was in the "preliminary stage of outline drawing" (presumably White's right panel), and one was underway (Charles Davis's mural). See Roden to Vivian Harsh, July 15, 1943, Carl Roden Papers—Hall Branch, CPL. A WPA shipping order signed by Peter Pollack authorized the shipment of two mural rolls intended for the Hall Library to the main branch; this presumably included White's left panel along with Davis's unfinished mural. Shipping order, Feb. 17, 1943, Carl Roden Papers—WPA, CPL.

It is likely that the mural no longer exists. Anecdotal recollections of past librarians suggest that it was, decades later, damaged by water and thrown out. I thank Morag Walsh of the CPL for her help on the issue of its possible disposition.

48. Roden to Vivian Harsh, July 15, 1943, Carl Roden Papers—Hall Branch, CPL.

49. Roden stated to George Thorpe, IAP state supervisor of art: "This promises to be a very fine piece of work." Carl Roden to George E. Thorpe, Jan. 31, 1941, Carl Roden Papers—WPA, CPL.

50. See, for example, "Alien Influence, Bad Art Seen in WPA Paintings," *Chicago Tribune*, Dec. 20, 1940, 18; "Critics Assert WPA Art Is Ugly and Subversive," *Chicago Tribune*, Dec. 19, 1940, 1; and "'Dismal!' So High School Murals Are Painted Out," *Chicago Tribune*, Nov. 5, 1941, 7.

51. Washington, *The Other Blacklist*, 82.

52. Ibid., 83–84.

53. Because the right mural panel was not executed, it has been subject to little analysis. One exception is Morgan, *Rethinking Social Realism*, 57–61.

54. My reading differs from that of Stacy Morgan, who emphasizes militancy in the right panel; Morgan, *Rethinking Social Realism*, 59.

55. *Fellow Workers* won an honorable mention at the American Negro Exposition, and a contemporary review admiringly likened it to the murals of Diego Rivera: "Charles White has achieved a strength akin to Diego Rivera in his massive "Workers." See [C. J. Bulliet], "Around the Galleries: Negro Art at Coliseum," clipping in CWP, AAA.

56. In 1978, a year before his death, White completed a mural celebrating Mary McLeod Bethune (fig. 11, p. 136), the famed educator and activist, for the Dr. Mary McLeod Bethune Regional Library in Exposition Park. Featuring a tripartite composition, it lacks the dynamism of his earlier murals.

57. For information on the Rosenwald Fund and its grants to African American artists, see Schulman, "African American Art and the Julius Rosenwald Fund."

58. For identification of the figures, see Zeidler, "1993: Anniversary Year for Three Renowned Paintings," 21. Another valuable resource is LeFalle-Collins, "Contribution of the American Negro to Democracy," 39–41.

59. On this figure, see Robertson, "Pan-Americanism, Patriotism, and Race Pride in Charles White's Hampton Mural."

60. White, "Statement of Plan of Work," White fellowship file (n. 17 above). The Julius Rosenwald Fund Archives at Fisk University include these statements, along with references, correspondence, funding receipts, and other supporting material.

61. White to William C. Haygood, June 8, 1942, White fellowship file (n. 17 above).

62. White, "Report of a Year's Progress and Plan of Work for a Renewal of a Julius Rosenwald Fellowship," White fellowship file (n. 17 above).

63. Zeidler, "1993: Anniversary Year for Three Renowned Paintings," 20.

64. Press release, Hampton Institute, quoted in ibid., 61.

65. For an overview of the Double V campaign and African American participation in World War II, see Kersten, "African Americans and World War II."

66. White certainly knew of Aptheker's scholarship and had a professional relationship with him by the early 1950s if not earlier. Aptheker published extensively on African American history in leftist publications such as *New Masses* and *Masses and Mainstream*, and his articles were often accompanied by White's illustrations. Later essays included "Negro History: Arsenal for Liberation," *New Masses* 62, no. 7 (Feb. 11, 1947): 8–12; "Frederick Douglass: Titan of Our History," *Masses and Mainstream* 5, no. 2 (Feb. 1952): 15–22; and "Negro History: Lesson in Loyalty," *Masses and Mainstream* 7, no. 2 (Feb. 1954): 7–11. White became a contributing editor to *Masses and Mainstream* in 1951, and his prints occasionally appeared as illustrations for Aptheker's work. Aptheker also wrote the foreword to *Negro USA: A Graphic History of the Negro People in America* (New York: Workshop of Graphic Art, 1949), which featured two illustrations by White.

67. Aptheker reviewed the reprint edition of *The Kidnapped and the Ransomed* (1856) and described the Negro Publication Society; see Herbert Aptheker, "Rediscovered Treasure," *New Masses* 42, no. 6 (Feb. 10, 1942): 26.

68. Robertson, "Pan-Americanism, Patriotism, and Race Pride in Charles White's Hampton Mural," 67. Morgan suggests that this figure is a self-portrait of White, but there is no indication that White included his own image; Morgan, *Rethinking Social Realism*, 69.

69. Schomburg, "The Negro Digs Up His Past," 670.

70. White, "Path of a Negro Artist," 42.

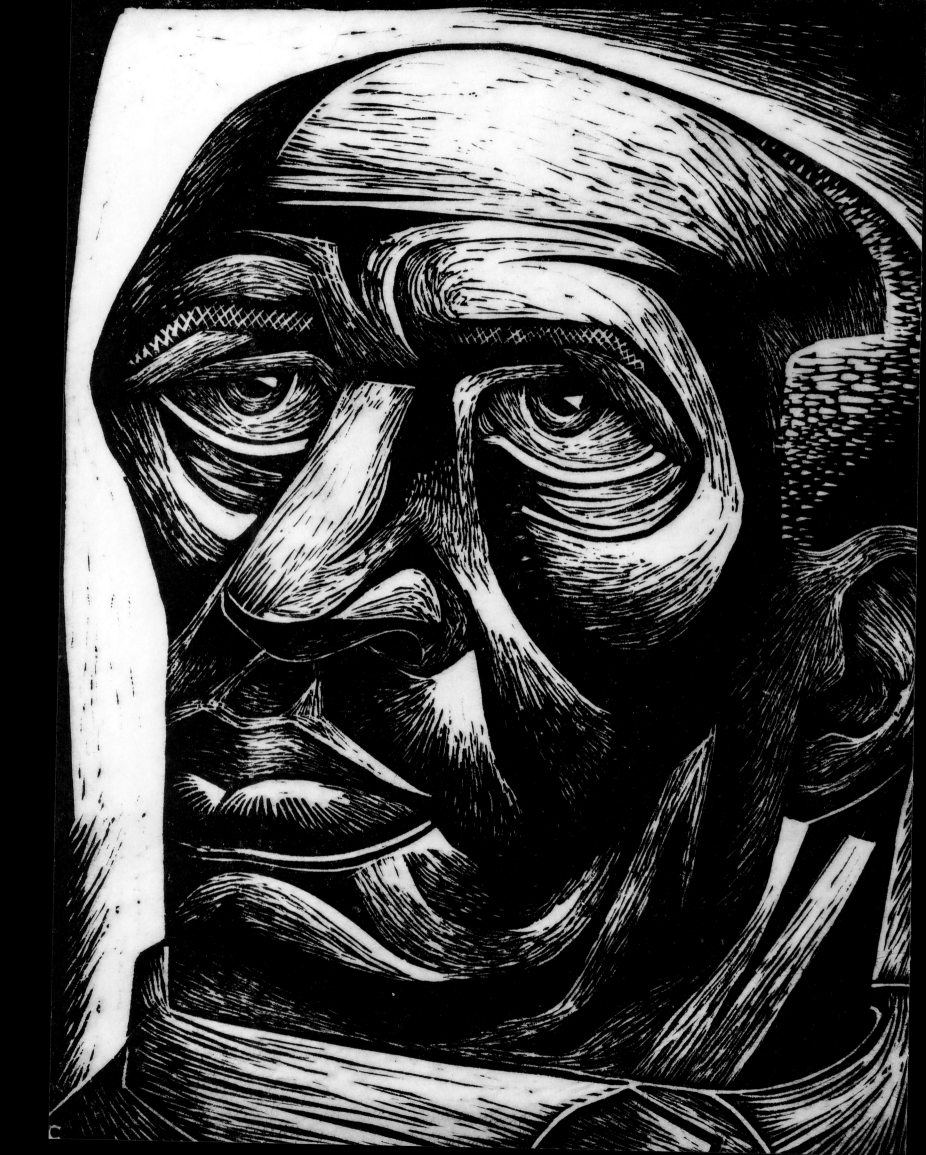

"GRAPHIC INTERPRETER OF THE BLACK PEOPLE": CHARLES WHITE AS DRAFTSMAN AND PRINTMAKER

MARK PASCALE

But drawing is [a] particularly exciting medium for me. I just like the feel of it. My whole body is into it when I draw and I think black and white is as effective a medium [as any]. I don't know about this preciousness—that oil painting has been looked upon as a very precious medium, and therefore it's the final kind of test. . . . The great German artist Kathe Kollwitz proved a point. If Daumier had never painted a picture in his life, he still would have been remembered as a great, great artist. Or Goya. His etchings alone would put him up in the class of greatness.

—Charles White[1]

In a publicity poster for a 1971 lecture (fig. 1), Charles White was billed as a "graphic interpreter of the black people," a phrase that adroitly summarizes one crucial component of his artistic practice.[2] Although he set out to become a painter, his work as a draftsman and printmaker figures among his most accessible and enduring achievements. White was a focused student from an early age. His drawn self-portrait of 1935 (pl. 1), created when he was about seventeen years old, already demonstrates prodigious graphic skill. With drawing (as with writing), the place where most people sketch their first thoughts, there is no need for special equipment or expensive supplies—it's a democratic endeavor. For the young White, determined in his striving for education and excellence, drawing provided the foundation for all his art and his communication in general.[3] In this essay, I will discuss links between White's drawings, prints, and in particular, an early sketchbook of drawings owned by the Art Institute of Chicago that tell us about his creative method.

Process played an important role in White's graphic work. He was an attentive student, frequently writing historical notes and technical descriptions in his sketchbooks.[4] The Art Institute acquired such a sketchbook in 2006 (pl. 2); it is one of at least two surviving bound volumes that he used while attending the School of the Art Institute

FIG. 1
Promotional poster for lecture given by Charles White, "White Is Beautiful: Charles White, Graphic Interpreter of the Black People," April 14, 1971. Charles White Archives, CA.

of Chicago (SAIC). The Art Institute book contains approximately fifty drawings in a variety of media and approaches—enough that one can closely predict or summarize White's graphic approach until the 1960s, when he embarked on his *Wanted Poster Series* and introduced an oil-wash drawing technique that had no sustained precedent in his work up to that point. Among the sketchbook drawings are works in watercolor, pen and ink, graphite, various charcoals, combinations of prepared grounds with colored dry media, and pen and ink or dry brush over ink or watercolor wash. In addition, White added generic titles (e.g., "sketch for block print," "study for composition") and, for studies of African sculpture, notations about cultural origins.[5]

During an interview with art critic and former Otis Art Institute dean Peter Clothier recorded late in White's life, the artist described at length his many and varied educational experiences, both formal and informal. White's art instruction began long before he enrolled at the SAIC. He studied books in the library, participated in workshops offered by local artist George Neal, and spent time with established Chicago artists such as Morris Topchevsky and Todros Geller. He met them "in the neighborhood" (he refers to Topchevsky "living in a black neighborhood") and saw their works exhibited at the Chicago Century of Progress International Exposition when he was a teenager.[6] Geller, in particular, was generous, offering White the chance to take one of his workshops. There, the young artist had his first exposure to drawing directly from a live model. Geller also implored White not to copy and then offer the work as his own but to draw from life, composing his own pictures. All of these lessons accelerated White's understanding of techniques and furthered his accomplishments at an early age.[7]

A second extant sketchbook dating from the late 1930s (private collection) also contains notes about techniques, particularly lithography, the duplicating medium with which White made most of his prints. When White was a student at the SAIC, Francis Chapin was the primary instructor of lithography, but during the year that White was enrolled, Chapin was on leave, and Briggs Dyer had taken his place.[8] White must have come into contact with Chapin, because in this second sketchbook, he made a note that "Mr. Shapen [*sic*] has several pgs from sketchbook in his possession."[9] Additionally,

there was a separate, loose sheet with hand-writing titled "Lithography Notes" slipped between the pages of this book. These notes became the basis for an article about White that appeared in print in 1940, in which he demon-strated that he was already highly educated about the process.[10] Although documentation about White's engagement with lithography at the SAIC survives, less is known about his study of lithography outside of the SAIC, including with Carl Hoeckner.[11] Hoeckner was decidedly prolabor, as illustrated in his print *Steeltown Twilight* (fig. 2), which documents the massacre of striking Republic Steel workers by private security in Chicago in May 1937. In September 1938 White began working as a painter in the Illinois Art Project (IAP) of the Works Progress Administration (WPA); this time commitment, together with his lack of access to a printmaking studio after leaving the SAIC, explains why there are few surviving examples of his work in lithography from the time.

FIG. 2
CARL HOECKNER
(AMERICAN, 1883–1972)

Steeltown Twilight, 1937. Lithograph on cream wove paper; image: 26.5 × 29.8 cm (10 7/16 × 11 3/4 in.); sheet: 29.4 × 41.2 cm (11 9/16 × 16 1/4 in.). The Art Institute of Chicago, gift of Carl Hoeckner, Jr., 1998.470.

FIG. 3
CHARLES WHITE
(AMERICAN, 1918–1979)

Sketch of a laborer. From White, Sketchbook, 1937–42, p. 40. Graphite with smudging on ivory wove paper. The Art Institute of Chicago, 2006.259. Cat. 2.

Lithography can emulate any drawing technique or style, but most typically, artists use it to create a broad range of tones, from the deepest black to the most silvery gray, usually employing specially formulated pencils and crayons, both sharp and blunt. The primary black pigment in lithography ink is carbon black, which produces a deep, pen-etrating result. Prophetically, in high school, White discovered a drawing tool—Wolff's carbon pencil, or "Wolff crayon"—that he used extensively in his drawings.[12] Although not as greasy as a lithographic pencil or crayon, it shares many of the same properties. Artists who become familiar with blacks produced in lithography seek to replicate the effect in their drawings, with great success in White's case.

There is only one recorded White lithograph from his Chicago period, *Laborer* (c. 1939–40; location unknown).[13] White's murals at this time included figures at work, an indication of his high esteem of labor. And, like many of his WPA peers, he joined and exhibited with the Chicago chapter of the Artists Union. He participated in the union's protest against Increase Robinson, the head of the IAP, who was accused of discriminat-ing against qualified African Americans.[14] It is fas-cinating to consider that a sketch in the Art Institute's book (fig. 3) may have served as the basis for that lithograph. White produced the related laborer sketch with graphite, building tone upon tone with hatching and also using the tip of a sharpened pencil for contours. The aes-thetic properties of this drawing could easily be transferred to lithography. In the picture, a man grasps a horizontally oriented bar, possibly made of steel, which is cropped at one side of the com-position and thereby disengaged from a source. It could be the kind of bar given to figure-drawing models for balance, but those are often used to stabilize a vertical pose. Here the man, clothed

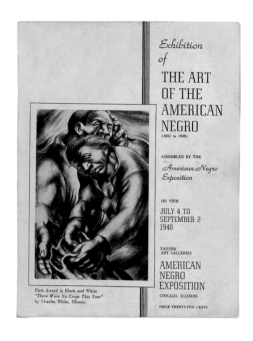

FIG. 4
Charles White's *There Were No Crops This Year*, reproduced on cover of American Negro Exposition, *Exhibition of the Art of the American Negro (1851 to 1940)*, exh. cat. (Chicago: n.p., 1940).

FIG. 5
CHARLES WHITE
(AMERICAN, 1918–1979)

Sketch of gestures. From Sketchbook, 1937–42, p. 42. Graphite with smudging on ivory wove paper. The Art Institute of Chicago, 2006.259. Cat. 2.

and looking down on his grasping hands with an expression of grim determination and inner strength, appears to be working. This is the only composed image in the sketchbook that resembles a worker.

When making early prints, an artist will often refer back to an existing composition rather than compose directly on the printing matrix (stone, plate, or block). This is especially true in lithography, which requires a labor-intensive process to prepare the surface of the limestone to receive the drawing. Furthermore, if the artist makes a mistake, the stone usually has to be regrained, so careful preparation of an image is essential to the process. Given this, White's first lithographic image likely evolved from earlier sketches, including perhaps the Art Institute drawing or another similar example.

From his student years until 1943, White spent most of his time painting murals. Printmaking took a back seat to simpler, more direct methods such as drawing. White's profoundly powerful 1940 drawing *There Were No Crops This Year* (pl. 9) was a career-making work of art. The drawing appeared on the cover of *Exhibition of the Art of the American Negro (1851 to 1940)* (fig. 4), for which he won First Award in Black and White. The closely cropped image depicts a desperate farm couple—one holds a feedbag, agonizingly empty—that neatly summarizes the catastrophic effects of the Great Depression and the dust bowl on subsistence farmers. It is iconic and deeply moving, typifying the graphic sophistication that developed over the course of years of constant practice.

A drawing in the Art Institute's sketchbook (fig. 5) reveals not only White's observational skills but also his growing understanding of gesture and scale, and it likely predates the prizewinning drawing. Here the artist appears to have drawn the man from life, because the structure of the head and face, as well as of the hands, is more naturalistic. In the prizewinning drawing, White drew in the stylized manner that typified his murals, inspired in part by Winold Reiss, whose similarly stylized portraits of celebrated African Americans were reproduced in Alain Locke's *The New Negro: An Interpretation,* a book that profoundly affected White when he read it as a fourteen-year-old.[15] At this early point in his career, White adapted Reiss's style in both preparatory drawings and the murals he executed for the IAP. His sketchbook drawings demonstrate his skill at life drawing, and in these incunabular studies we can see foreshadowing of his mature style that evolved around 1950.

White and his wife at the time, artist Elizabeth Catlett, traveled to Mexico in April 1946. There, they were invited to work on prints at the Taller de Gráfica Popular (TGP), a graphic arts collective in Mexico City. With ready access to equipment, White enjoyed his first sustained period of printing lithographs (see fig. 6).[16] He also noticed that carved

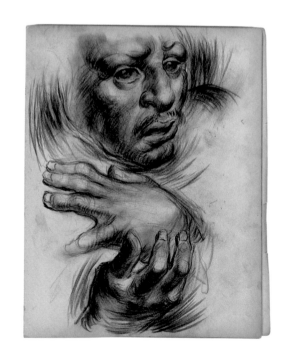

linoleum blocks were used for the vast majority of prints created at the TGP. This method became more important to White later in his career, although before he and Catlett left New York for Mexico, he had made a curious but powerful linocut of a man's head known either as *Worker* or *John Henry* (pl. 19).[17] Among the few extant impressions of this print, some show the man facing to the left and others, to the right; in the absence of written or recorded evidence, there is no way to determine which is correct. White's friend and fellow artist Norman Lewis owned a left-facing impression. The figure is distorted in both orientations, although the man looks slightly more natural and proportional in the left-facing orientation.[18] White printed the image on a transparent sheet similar to Japanese paper, so thin that the ink fully penetrated both sides. He may have consciously exploited this aspect of the sheet, realizing that he could present the printed image in the same orientation as it appeared in the cut block and thus eliminate the

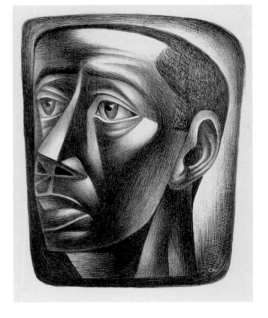

FIG. 6
CHARLES WHITE
(AMERICAN, 1918–1979)

Cabeza (or *Youth*), 1946. Lithograph in black on cream wove paper; image: 34 × 27.5 cm (13 3/8 × 10 13/16 in.); sheet: 65.1 × 50.2 cm (25 5/8 × 19 3/4 in.). The Art Institute of Chicago, gift of Denise and Gary Gardner, 2015.717.

problem of image reversal that is a natural aspect of hand printing. The artist's initials appear at the bottom corners of the Lewis impression; in the strike-through image on the other side of the sheet, with the figure facing to the right, the letters would be reversed. This fact, combined with the likelihood that Lewis obtained his print close to the time White made it, suggests that his left-facing impression has the intended orientation. The artist also may have liked it both ways and used the strike-through of the printing ink to enable a flexible orientation, underscoring his playful, experimental approach to the medium.

After White returned to the United States from Mexico, he again took up residence in New York, where he taught to subsidize his income from art sales and commissions. He became reacquainted with Robert Blackburn, an artist of his generation who had become a printer with his own workshop in New York.[19] Founded in 1948, it offered access to printmaking facilities for many African American artists. There, building upon the momentum he established at the TGP, White produced three lithographs, including *Gideon* (pl. 39), his most noble image among the early prints.

FIG. 7
Charles White line drawing, reproduced on the cover of Howard Fast, *Spartacus* (n.p.: Howard Fast, 1951).

Gideon depicts a man seen from below and cropped along the neckline. Lit frontally, the figure's features are powerful. He gazes beyond the picture frame with strong eyes and set jaw. White visualized the Old Testament prophet as a contemporary young black man, with close-cropped hair. In spirit and intention, this Gideon seems like an archetype for a present-day leader. He is unadorned and therefore could be anyone, just as the biblical Gideon was a valiant everyman who, through his faith, led his people out of subservience to another tribe. White's subject also may be related to Gideon Jackson, the main character of Howard Fast's 1944 novel *Freedom Road*. White and Fast were friendly, and the same year he created *Gideon*, White illustrated the cover of another of Fast's books (fig. 7).[20]

In *Gideon*, White foreshadowed the 1953 drawing *Harvest Talk* (pl. 43)—one of his most poetic

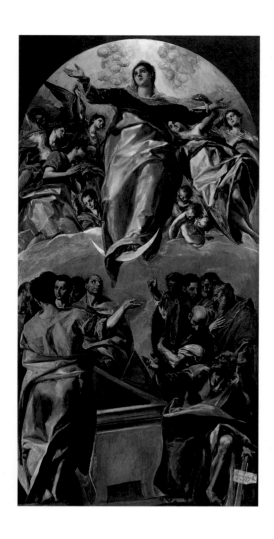

FIG. 8
EL GRECO (DOMENIKOS THEOTOKOPOULOS) (GREEK, ACTIVE IN SPAIN, 1541–1614)

The Assumption of the Virgin, 1577/79. Oil on canvas; 403.2 × 211.8 cm (158¾ × 83¾ in.). The Art Institute of Chicago, gift of Nancy Atwood Sprague in memory of Albert Arnold Sprague, 1906.99.

masterpieces—through his rendering of the figure's mien and posture as well as the striking use of media. The deep space and tonal variation apparent in the drawing largely result from the artist's use of Wolff's carbon pencils, which are noteworthy for their fine grain and capacity for producing rich, matte blacks in line or in blending, as seen throughout *Harvest Talk*. Two muscular farmers, shown from the waist up, are positioned at the front of the composition, heads cropped by the top edge of the frame. Their powerful arms and hands are those of field workers, and one sharpens a scythe. The farmers seem to be enveloped and exalted by their drawn environment; behind them a softly undulating landscape of wheat recedes toward a horizon that bisects the figures, and dramatically lit high clouds proudly frame their heads. The men wear serene expressions, and the gestures of their powerfully muscled hands are gentle. If White's Gideon had a body, he might have looked like these men. They, too, are presented as confident, self-aware individuals. Their agrarian context lets us know that they are producers of essential grains and possibly other produce, and they are to be celebrated for their pride and honest labor—just as they would have been valorized in Soviet Socialist Realist depictions had they lived in a Communist country. White's telling inclusion of the scythe, which resembles a long-handled sickle, is a subtle reference to one-half of the Soviet revolutionary symbol of the hammer and sickle.[21]

Before White made *Harvest Talk*, he and his second wife, Frances Barrett White, traveled to the Soviet Union and Communist countries in Eastern Europe, where he was greeted warmly.[22] As his work had been published in socialist-leaning journals such as the *New Masses* and *Masses and Mainstream*, his artistic and philosophical reputation preceded him. During his residency in Mexico, White worked in an angular style, which he had described as typical of left-leaning artists in both Mexico and the United States; there were numerous artists in Chicago working in this manner. Upon his return home, he participated in salons where the discussion often turned to problems of style and how best to represent one's core philosophical values aesthetically. White already showed proclivities for a more massive, naturalistic approach—he often spoke about his careful study of the Art Institute's El Greco painting *The Assumption of the Virgin* (fig. 8), for example. His exposure to art in the Soviet Union and other Communist countries likely helped to cement his decision to work more naturalistically, focusing first and foremost on mass as opposed to line. The eight drawings that he exhibited at New York's American Contemporary Art (ACA) Gallery in 1953, including *Harvest Talk*, exemplified this stylistic change, and henceforth White rarely returned to his pre-1950s mannerisms.[23]

In discussing his choice of techniques, the artist was very specific. He used pen and ink when he focused more on a linear approach, as in the work he made in Mexico and just after he returned to the United States. Drawings such as *Trenton Six* (pl. 29) and *Frederick Douglass Lives Again (The Ghost of Frederick Douglass)* (pl. 30), both from 1949, exemplify his expressive handling of hatching and cross-hatching, which is the only way to create value with this medium. Despite using pen and ink throughout the 1950s, White later preferred charcoal, Conté crayon, and Wolff's carbon pencil to

render volume more gradually (see pls. 42–43, 47).[24] Conversely, in his choice of print-making techniques, throughout the 1950s White preferred linoleum-block prints, which rely more on the aesthetic of pen and ink and wash, so he did not completely forsake the medium or its inherent properties.

Relief impressions printed from wood or linoleum blocks require no special equipment, and White made prints such as *Solid as a Rock (My God is Rock)* (pl. 76) at home. Using primarily a gouge to articulate the lights and darks on the block, he was clearly still engaged with pen and ink, a technique similar to relief block carving that was still evident in his drawings of the 1950s. About relief prints, White cautioned long-time friend artist Margaret Burroughs that it was "a very deceitful medium in that the appealing freshness of the printed black and white cut can give the illusion of strength."[25] Despite the real chance that the technique could disguise bad drawing or emphasize the decorative potential of the inherent marks left by cutting, White called out the examples of Catlett, Alberto Beltrán García, Leopoldo Méndez, Alfredo Zalce and others who "brilliantly achieve a simplification of form" in their linoleum-block prints.[26] Compared to his earlier efforts with relief printmaking such as *Worker*, *Solid as a Rock* exemplifies the careful reduction of planar and textural development that White aspired to, underscoring the importance of his Mexican experience to his development. Here White did leave a large amount of visible hatching, which he artfully juxtaposed, tight on the figure and more open in the negative spaces of the ground, with select areas of solid black masses of shadow. The effect is similar to actual stone carving, and as such, an intriguing material support for the meaning of the title, which also poetically evokes a traditional hymn and Bible verse.[27]

After White was established in Los Angeles, exhibiting commercially at Heritage Gallery, he found his way back to printmaking workshops. He continued to produce linoleum-block prints noted for their skill and ambitious size (such as *Micah* [pl. 77]), paralleling his contemporaneous large-scale drawings. The bulk of his print work during the 1960s and into the 1970s was made in lithography. There were more opportunities to work with lithographic printers in Los Angeles, where Tamarind Lithography Workshop, founded in 1960, operated a printer-training program. Before White's engagement with various lithography printers in Los Angeles, his output as a printmaker was primarily in black and white. Younger printers helped him experiment and extend the range of his printed output, and so we see evidence of an increased use of color after 1970 (see pls. 101–4). Beyond the simple ability to create more complex images in color, White also needed a parallel lithographic process to emulate a new drawing medium—oil wash—which he began to explore in earnest for his *Wanted Poster Series* in the late 1960s. He used oil wash monochromatically, applying thin washes of a warm-brown paint. As they accreted in multiple overlays, this single color separated into the undertones of pigments, such as oranges, that were components of the wash.

To achieve parallel effects in lithography, White had to extend his drawing tools beyond the greasy crayons and pencils he typically used on the stone. He had recently discovered a liquid medium called tusche, which he diluted and applied to the stone in alternating layers with crayons and pencils; with this combination of media he was able to approximate the tonal and liquid qualities he was producing with oil wash. When he used a single mixed color other than black, such as brown, the various tonal effects on the stone translated more deeply or complexly with a single printing. White experimented with printing the key drawing twice in works such as *Wanted Poster Series #12a* (fig. 9). He also used a tricky procedure known as image reversal or transposition for the prints *Wanted Poster Series #11* (pl. 91) and *#11a* (pl. 92), a chemical process that causes the image to resemble a photographic negative. In *#11a*, it makes the subject appear more vulnerable.

Tradition—artistic and otherwise—was important to White throughout his life. Not unexpectedly, he made his last prints in etching, a printmaking medium with a history dating back to the fifteenth century. *Missouri C* (pl. 97) and *Cat's Cradle* (pl. 98), both from 1972, were printed in the nearby Altadena studio of Joseph Mugnaini, who excelled at the process. White had limited experience with etching, a medium he had avoided because the fumes of the acid needed to "bite" the image into copperplates irritated his weakened lungs. Both etchings, like his best work in any medium, are models of restraint. Each focuses on a single figure, forcefully drawn in a shallow space, and incorporates the dimensional lines yielded by a deeply and cleanly etched plate.[28] These two prints demonstrate White's mastery of line and tonal effects, whether by the distinct methods of contour drawing or by hatching. After an extended engagement with oil wash in his *Wanted Poster Series*, it seems that White wished to return to a more direct approach to mark making. Etching allowed him to do so, but the medium also provided a new problem to solve, the resistance of the plate to his pressure. Ultimately, this allowed him to make powerful marks, which found their analog in such definitive drawings as *Mississippi* (pl. 95), in which a bloody handprint hovers over the lone figure's hooded head. Among White's most provocative and direct works of art created in the last decade of his career, *Mississippi* is also quite traditional in its conception and execution. It demonstrates that, for White, clarity was foremost, and in his traditional approach to image making and media, he always made his intentions clear.

1. In White, *Charles White: Let the Light Enter*, 7. In the Art Institute's Charles White sketchbook, he referred to a lecture about the artist Käthe Kollwitz he apparently intended to attend, illuminating how sincere he was in his statement about the gravitas of drawing and the graphic arts in general.

2. "White Is Beautiful: Charles White, Graphic Interpreter of the Black People," Apr. 14, 1971.

3. White famously declared that his primary form of expression was making pictures—specifically painting—rather than speaking, writing, or another discursive method. But his drawing exceeded his painting output, so making images autographically became his primary mode of expressing all of his cultural, historical, and aesthetic ideas.

4. White, interview by Clothier, Sept. 14, 1979.

5. According to his official SAIC transcript, White took art history with the renowned educator Helen Gardner, whose seminal textbook, *Art through the Ages*, had been revised in 1936 with an expanded chapter on African art. White's sketchbook demonstrates his early interest in African art (see pl. 2), as he was surely inspired by the ideals of the New Negro Movement to explore African history and heritage—a subject he would return to later in life in drawings such as *J'Accuse #7* (pl. 82). The Art Institute's sketchbook contains drawings of African sculpture that appeared as plates in the 1937 edition of the book, which links White to one of Chicago's most significant cultural treasures—Gardner's book, which was researched and written in the Art Institute's Ryerson and Burnham Libraries, where a desk with her nameplate is still in use in the reading room.

6. White, interview by Clothier, Sept. 14, 1979.

7. Ibid. For more on Topchevksy and Geller, see Oehler, *They Seek a City*.

8. Primarily a painter, Dyer caught the printmaking bug as a student at the SAIC and was probably Chapin's trusted assistant; assistants often took the place of instructors when they went on leave. Dyer was important to White. Despite having a scholarship and a job, White could not afford to buy supplies. When Dyer learned of this, he made his own store account available to White, which White never forgot. At the time of Dyer's death years later in 1971, White wrote a note of condolence to the SAIC, describing Dyer's extraordinary generosity to him. He offered a "small contribution to the memorial fund." Along the top of the original note, someone has written, "This is *the* Charles White." Located in Briggs Dyer folder, Institutional Archives, Ryerson and Burnham Libraries, Art Institute of Chicago.

9. This was noted by the author during examination of the "Art Inst" sketchbook on February 16, 2016.

10. Robert A. David, "The Art Notebook," *Chicago Sunday Bee*, Oct. 6, 1940, n.p. Clipping, Charles W. White Papers, Archives of American Art, Smithsonian Institution, Washington, DC (hereafter CWP, AAA).

11. White's study with Hoeckner probably occurred at Hull-House Settlement, as this is where Hoeckner did his lithography, even though he was on the design faculty at SAIC. Hoeckner also designed a poster printed from a wood block at Hull-House. See note 14 below.

12. White, interview by Clothier, Sept. 14, 1979, transcript, 32. Wolff's carbon pencil was frequently referred to by White and others at the time as "Wolff crayon."

13. Gedeon, "Introduction," 348. The print is numbered by Gedeon as "Ea1," and lithographs were given the designation of "Ea."

14. In the same sketchbook referred to in note 9, on the first page, White also made this enlightening remark: "Millman Thursday 7 to 10 / Fresco Painting" and / "Wed. Lithography / Hoeckner." It is well known that White studied mural painting with Edward Millman. White had direct contact with many artists who taught private classes and at Hull-House. For example, when discussing the WPA era, he mentions Morris Topchevsky and Todros Geller, two of many Chicago artists who were employed by the WPA, who also made powerful prints.

15. White, interview by Clothier, Sept. 14, 1979, transcript, 28–29.

16. *Cabeza* was included in the TGP commemorative volume: Hannes Meyer, ed., *TGP, Mexico: El Taller de gráfica popular; Doce años de obra artística colectiva / The Workshop for Popular Graphic Art; A Record of Twelve Years of Collective Work* ([Mexico]: Estampa Mexicana, 1949), 143.

17. Gedeon recorded this relief print as "Eb3, Worker, c. 1949–50." Subsequently, an earlier date of 1944 has been offered and published; Swann Galleries, *African-American Fine Art*, sale cat. (New York: Swann Galleries, Apr. 6, 2017), n.p., lot 22.

18. Curator Esther Adler and paper conservator Erika Mosier, both of the Museum of Modern Art, New York, together with this author, carefully examined two impressions of this linoleum-block print on March 27, 2017.

19. Blackburn established his eponymous workshop in 1948 in the Chelsea neighborhood of Manhattan. It moved several times and has survived his death in 2003 as the Printmaking Workshop. White's Chicago friend and SAIC classmate Eldzier Cortor would only make his prints at Blackburn's Printmaking Workshop.

20. The novel is set in Virginia during the late nineteenth century and concerns Gideon Jackson, a former slave who is elected to the US Senate and fights for land rights on behalf of former slaves and white sharecroppers. White and Fast were friendly, and Fast wrote a short introduction about White's work, printed along with the checklist for his 1950 exhibition at the ACA Gallery in New York. Fast was credited with loaning White's drawing *Blues Singer* to the show.

21. See Brandon K. Ruud, "*This, My Brother*; *Harvest Talk*," in Barter, *American Modernism at the Art Institute of Chicago*, 281–84, cats. 137–38.

22. White discussed his travel to Communist countries and his ties to socialist publications, and the House Un-American Activities Committee, which twice called on him to testify about his activities, but then cancelled his appearances; see White, interview by Clothier, Sept. 14, 1979.

23. In 1953, owing to the power and popularity of White's exhibition, *Masses and Mainstream* published a portfolio of six offset reproductions of his drawings (cat. 109), issued in a paper folder and sold through the magazine. White had first authorized two offset reproductions of his drawings in 1947 for the series *Negro U.S.A.*, and printed by another avowed American Communist, Charles Keller. These early experiences issuing more mainstream, as opposed to rarified, hand-printed prints allowed White to distribute his work to the very people he was addressing—working-class individuals whose lives were enriched by the stories White was telling but who could not afford a unique work of art. Subsequently, in the 1960s and 1970s, White again issued folios of his drawings, reproduced by offset lithography, and presented so that they could be enjoyed as a broadside or framed.

24. White described his method: "I begin lightly in halftones which I fix very strongly. I then work from that and fix another layer as I keep building up the composition. In this way, when I work with conté or charcoal, I can get very strong blacks . . . get a far more extensive range of values than I would ordinarily." Quoted in Young, *Three Graphic Artists*, 5.

25. "Memo on a Folio: The Seven Arts Workshop," May 1956, reel 3190, CWP, AAA.

26. Ibid.

27. "The LORD is my rock" (Psalm 18:2). In response to an inquiry about the title of this print, White explained that it came from the old spiritual, "Got a House in Dat Rock"; White, lettergram to Ruth Hopkins, Nov. 7, 1963, reel 3193, CWP, AAA. In the same year White made this print, Robeson released *Solid Rock: Favorite Hymns of My People*, an LP that included the popular hymn "Solid Rock." The chorus of this hymn is "On Christ the solid rock I stand / All other ground is sinking sand." See *Gospel Pearls* (Nashville, TN: Sunday School Publishing board National Baptist Convention, 1921), no. 10. See also the chronology in Jeffrey Stewart, *Paul Robeson: Artist and Citizen* (New Brunswick, NJ: Rutgers University Press, 1998), xxxiv. Esther Adler suggests that *Solid Rock* more accurately reflects White's meaning; Adler, *Charles White: Black Pope*, 56n62.

28. Unlike lithography and relief printing, which are essentially planographic processes (prints are made from the top plane of the stone or block), etching depends upon the incisions or pitting driven into the plate by mordant effects of acid on metal or by direct engraving or drypoint, which White loved for the powerful, crisp effect it produced.

CHICAGO AND THE WAR YEARS

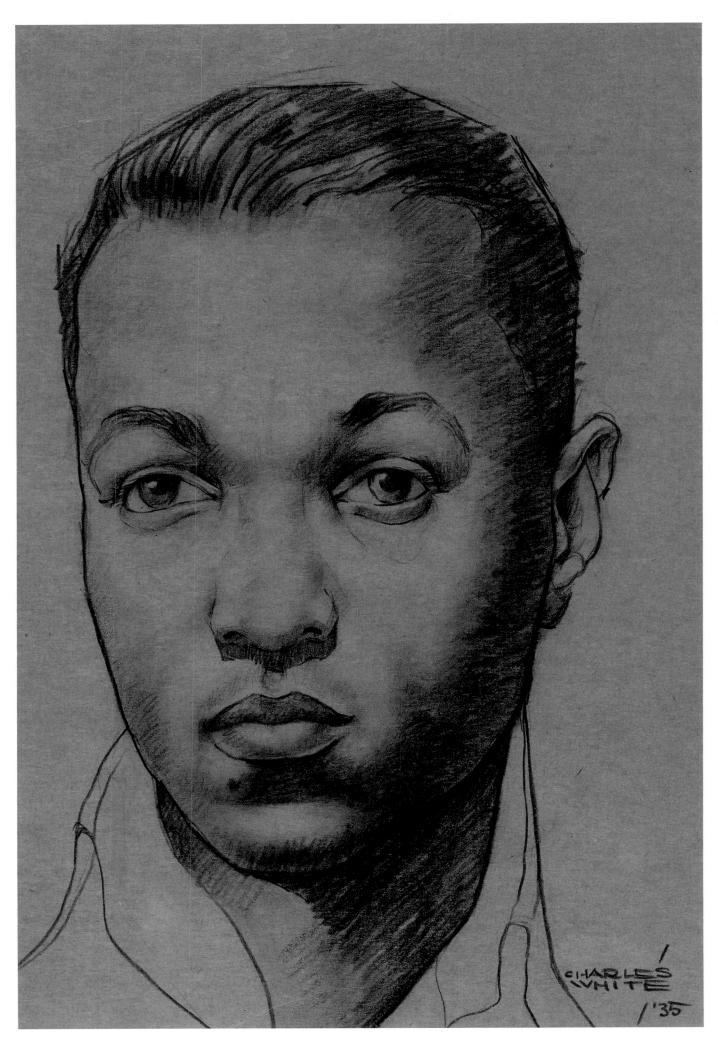

1. *Self-Portrait*, 1935
Black crayon on cardboard
Cat. 1

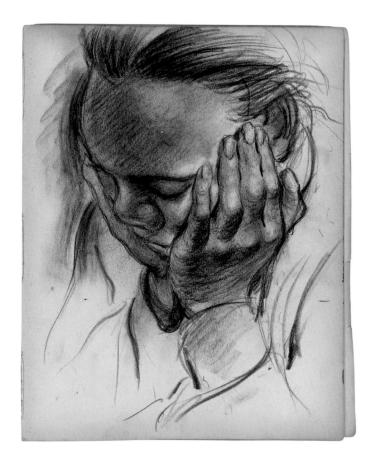

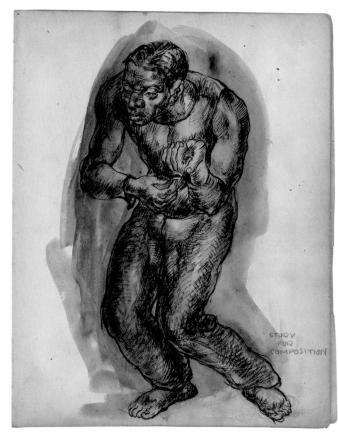

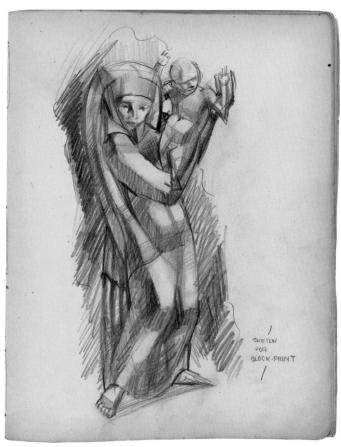

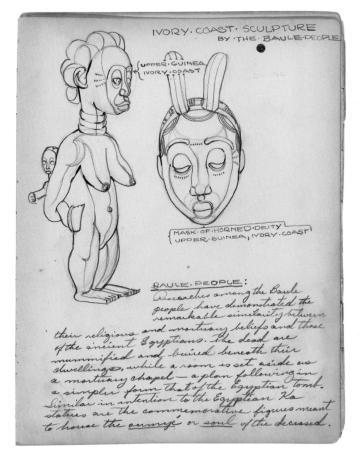

2. Pages from a Sketchbook, 1937–42
Top left, woman with face in hands (p. 41): charcoal with smudging; top right, hunched-over man
(p. 12): pen and ink and watercolor over graphite; bottom left, sketch for a block print (p. 4): graphite
with smudging; bottom right, Ivory Coast sculpture (p. 75): graphite; all on ivory wove paper
Cat. 2

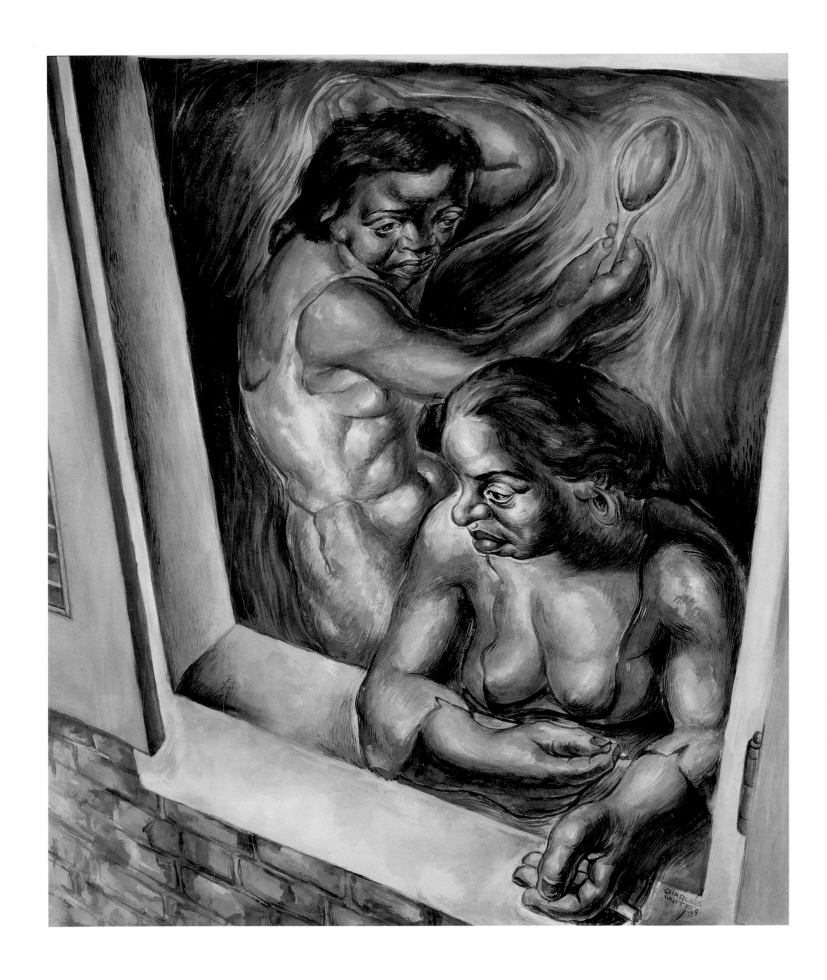

3. *Kitchenette Debutantes*, 1939
Watercolor on paper
Cat. 7

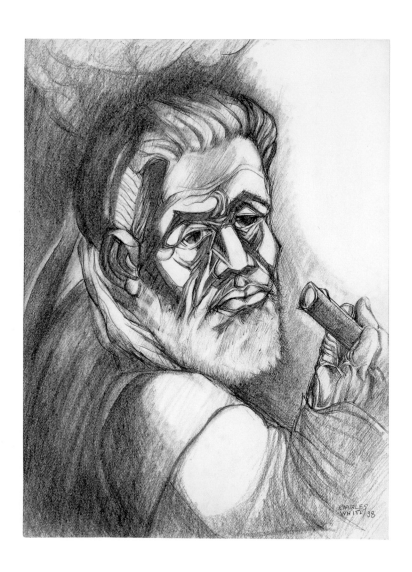

4. *John Brown*, 1938
Charcoal on paper
Cat. 3

5. *Card Players*, 1939
Oil on canvas
Cat. 5

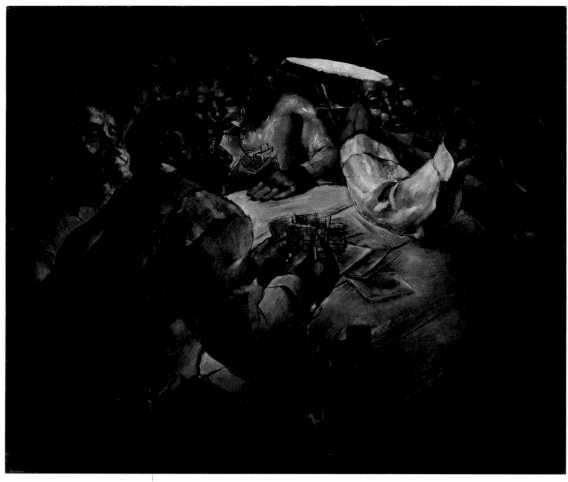

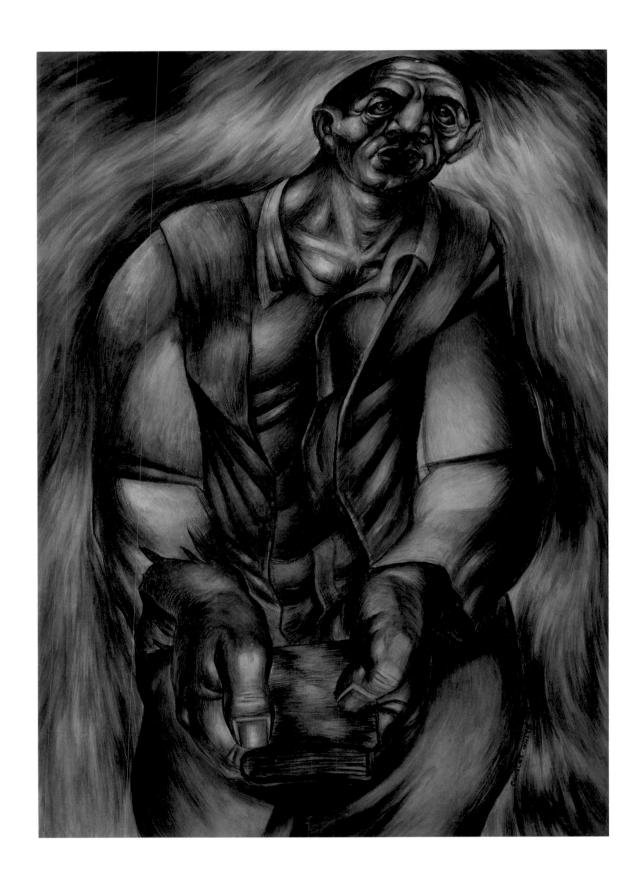

6. *Preacher*, 1940
Tempera on board
Cat. 8

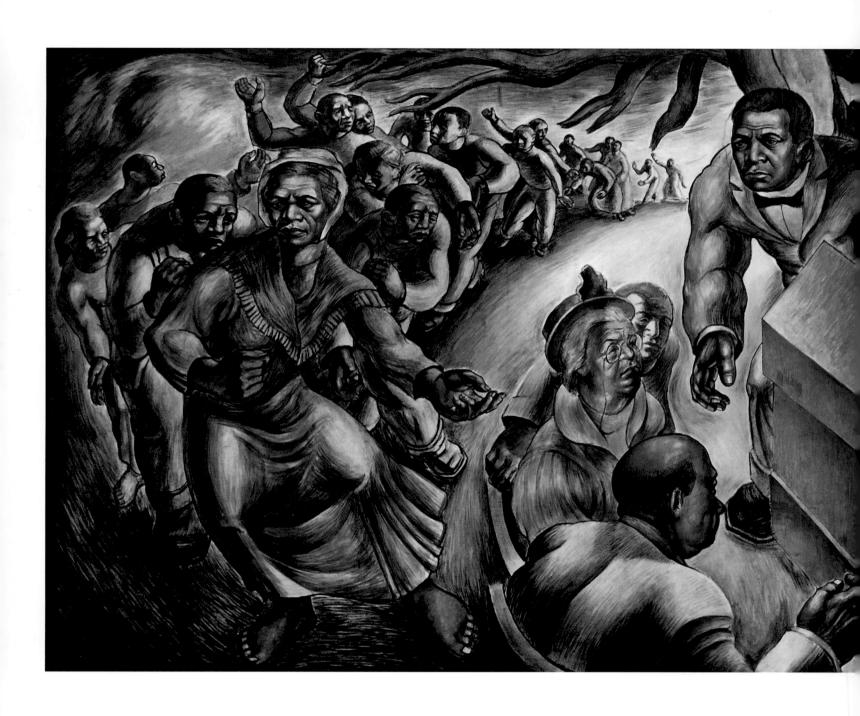

7. Five Great American Negroes, 1939
Oil on canvas
Cat. 6

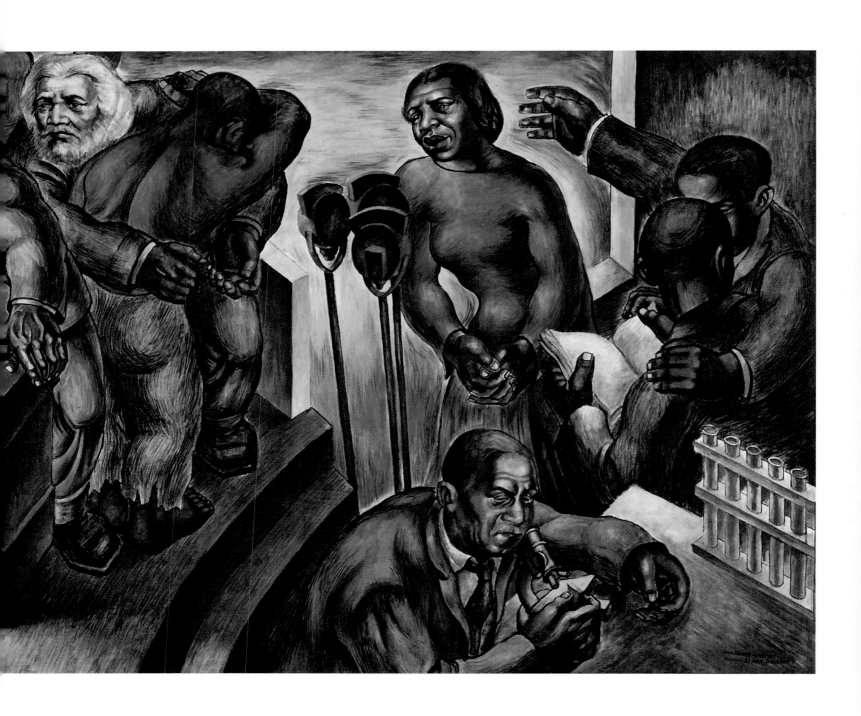

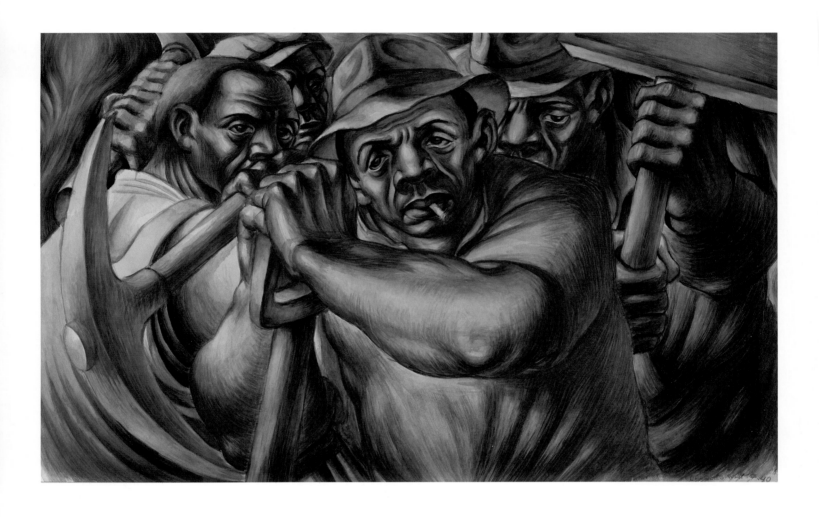

8. *Untitled (Four Workers)*, 1940
Tempera on paperboard
Cat. 11

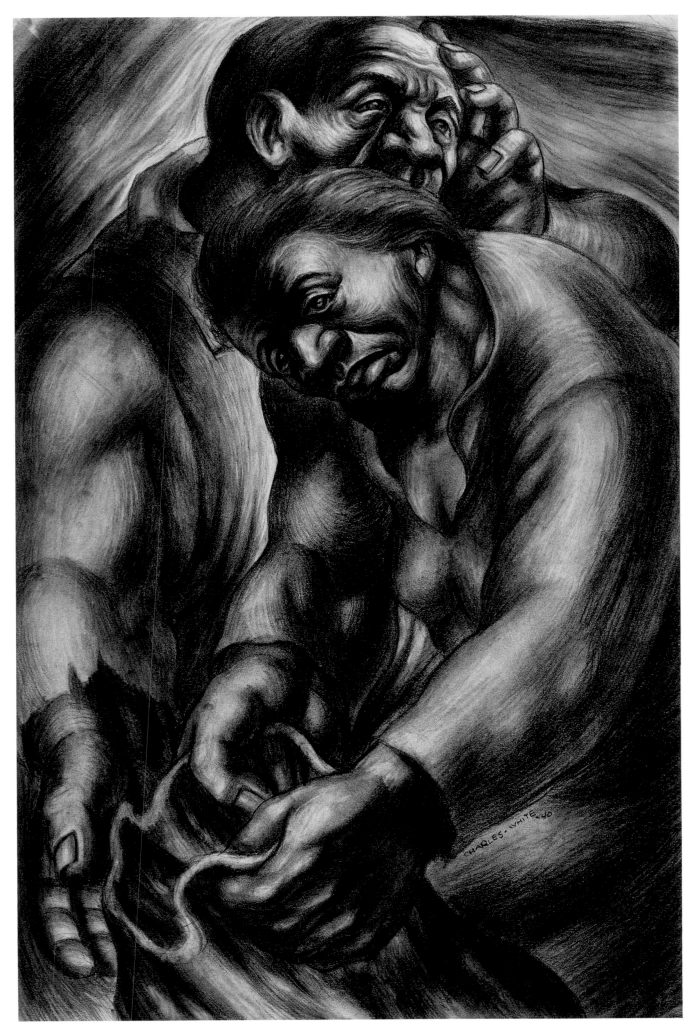

9. *There Were No Crops This Year*, 1940
Graphite on paper
Cat. 10

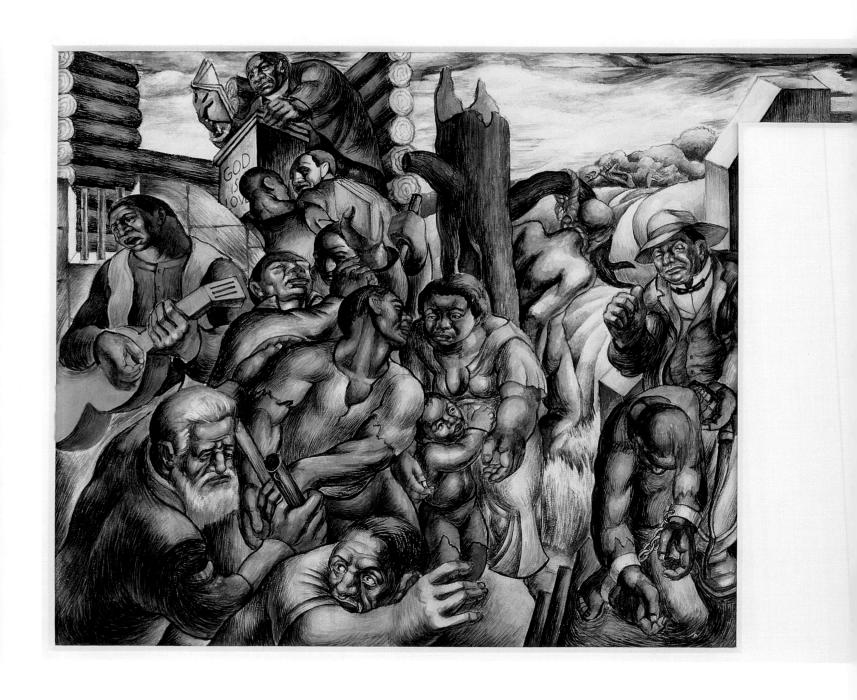

10. Study for *Struggle for Liberation*
(Chaotic Stage of the Negro, Past and Present), 1940
Tempera on illustration board
Cat. 9

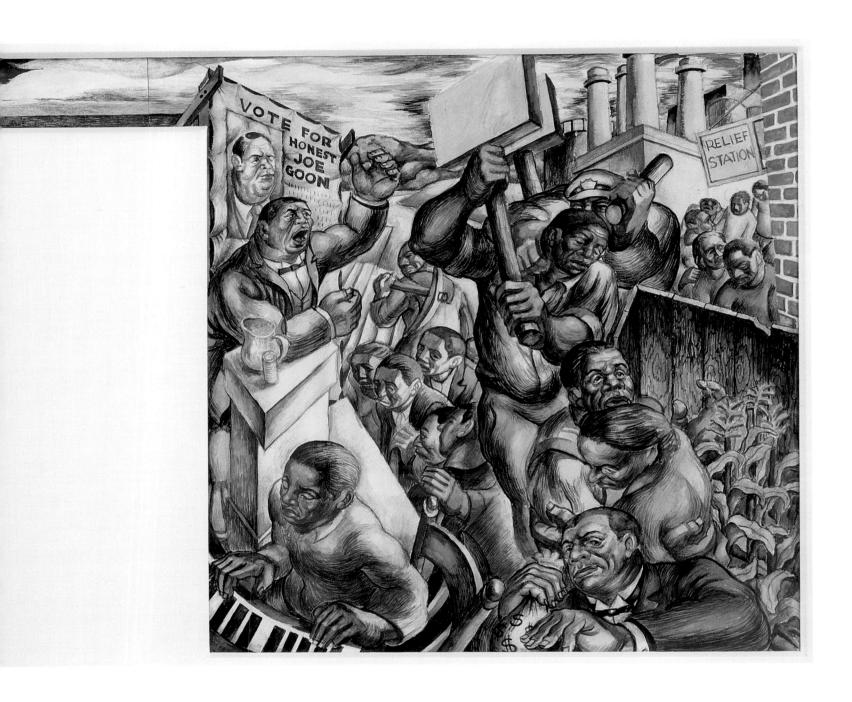

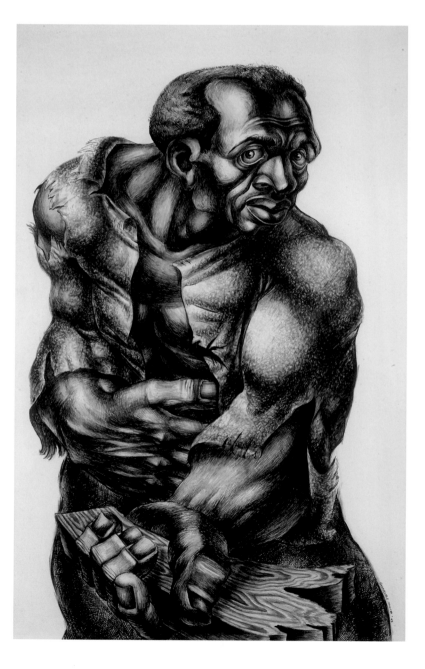

11. *Spiritual*, 1941
Oil on canvas
Cat. 12

12. *Native Son No. 2*, 1942
Ink on paper
Cat. 14

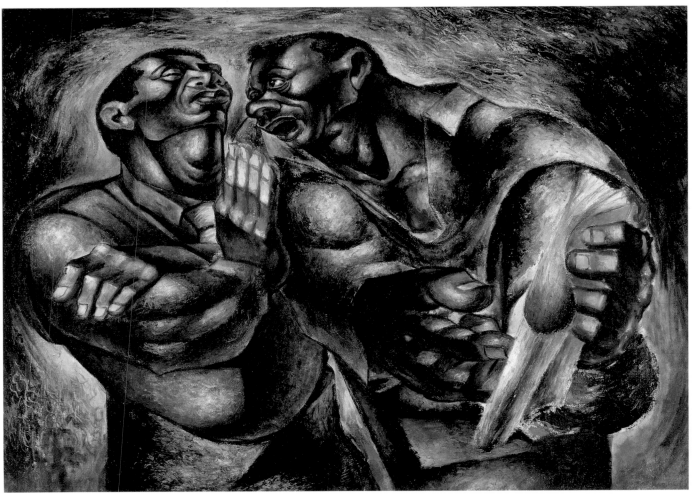

13. *This, My Brother*, 1942
Oil on canvas
Cat. 15

14. *Hear This*, 1942
Oil on canvas
Cat. 13

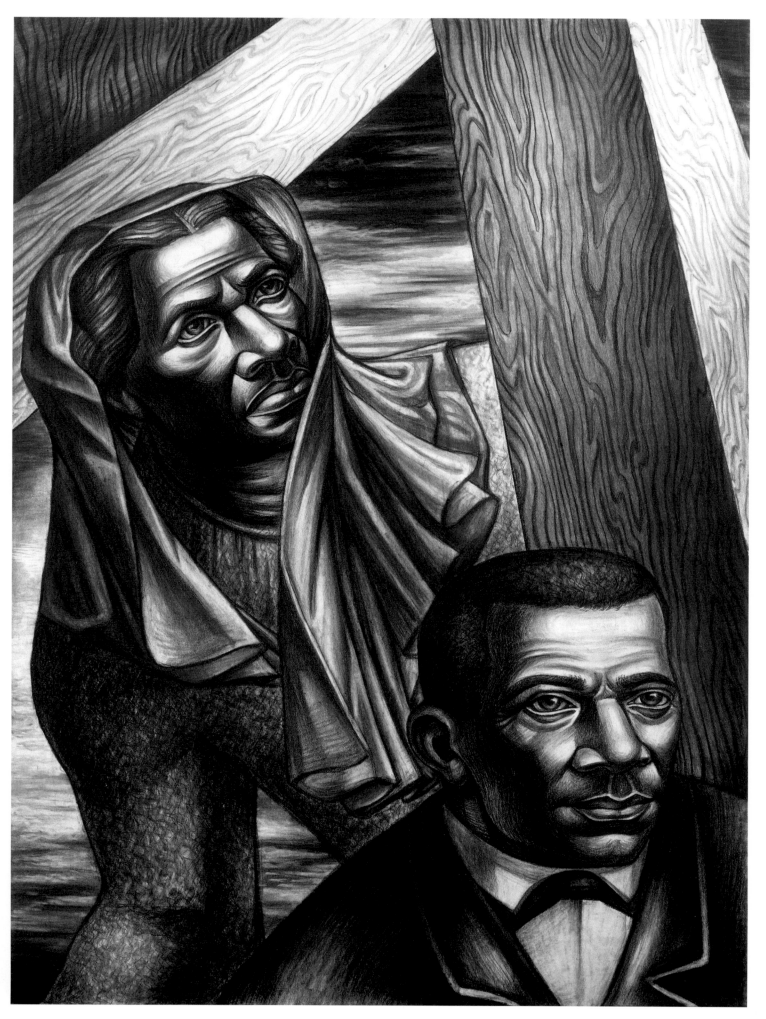

15. *Sojourner Truth and Booker T. Washington* (Study for
Contribution of the Negro to Democracy in America), 1943
Pencil on illustration board
Cat. 18

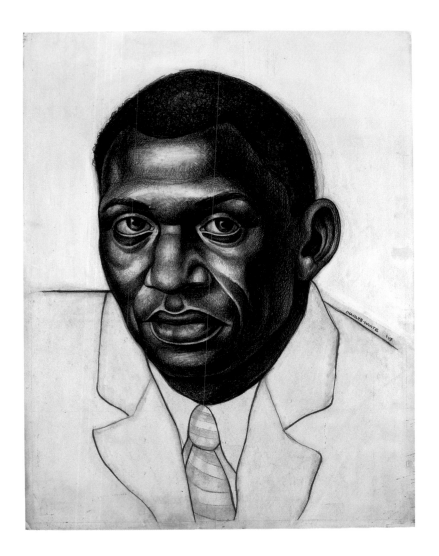

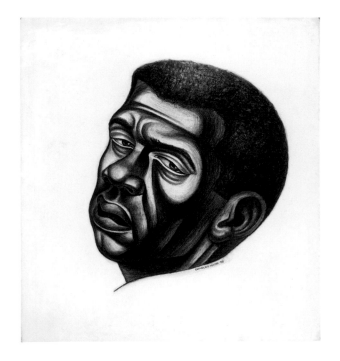

16. *Paul Robeson* (Study for *Contribution of the Negro
to Democracy in America*), 1942–43
Carbon pencil over charcoal, with additions and corrections in white
gouache, and border in carbon pencil, on cream drawing board
Cat. 16

17. *Denmark Vesey* (Study for *Contribution of the
Negro to Democracy in America*), 1943
Charcoal and white gouache on illustration board
Cat. 17

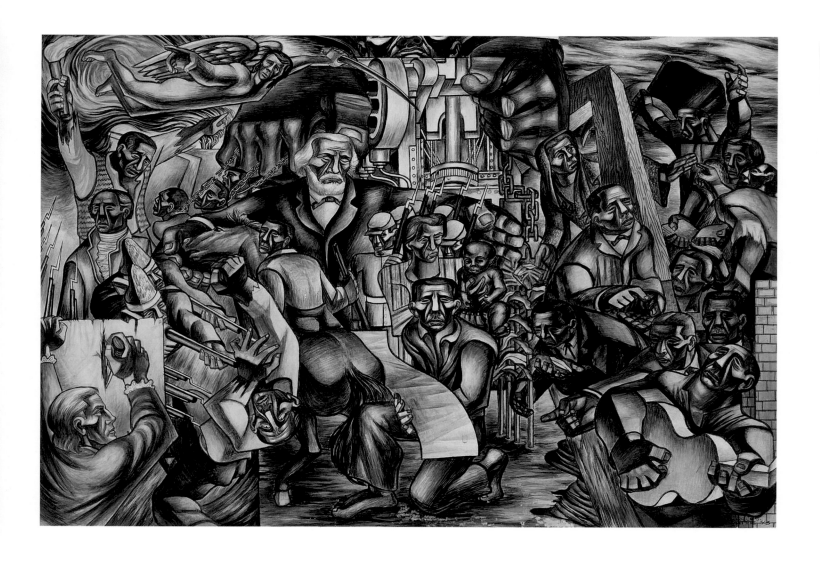

18. Study for *Contribution of the Negro to
Democracy in America*, 1943
Tempera on board
Cat. 19

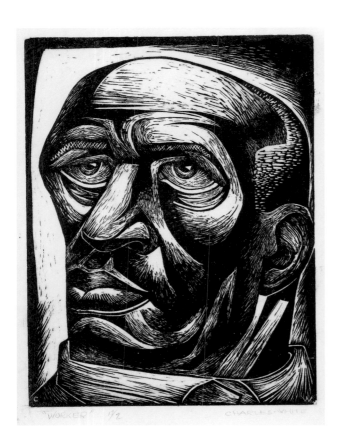

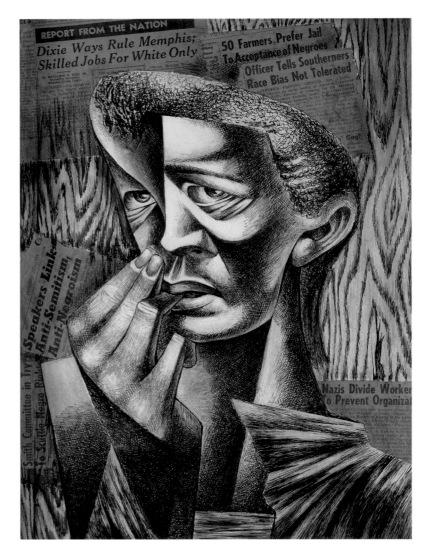

19. *Worker*, 1944
Linocut on paper
Cat. 22

20. *Headlines*, 1944
Ink, gouache, and newspaper on board
Cat. 20

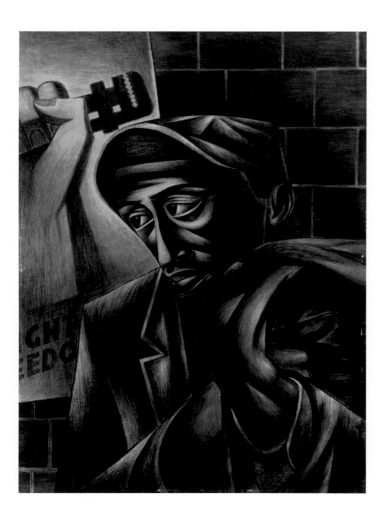

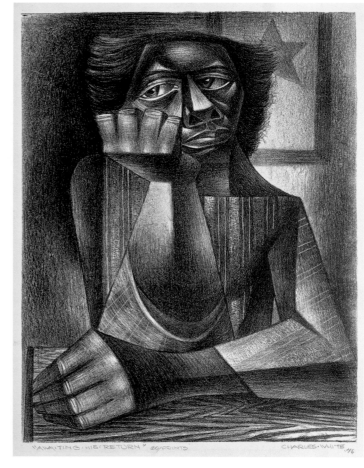

21. *War Worker*, 1945
Tempera on board
Cat. 25

22. *Mother (Awaiting His Return)*, 1945
Lithograph on paper
Cat. 24

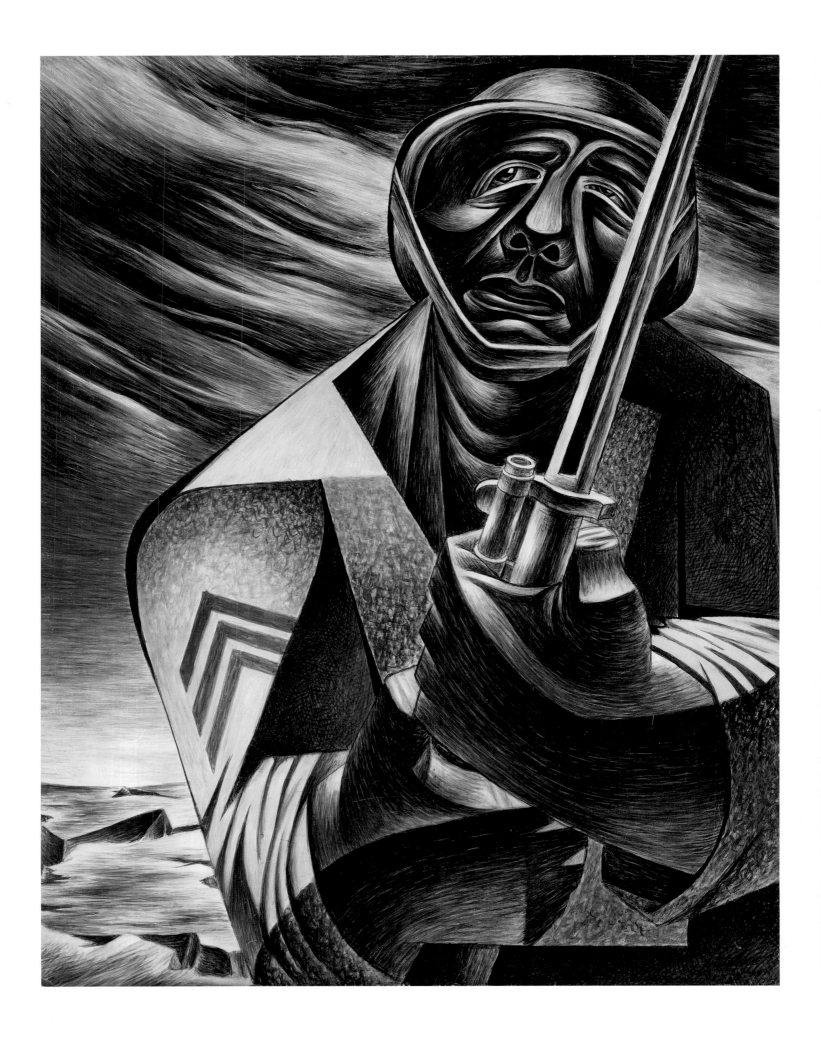

23. *Soldier*, 1944
Tempera on Masonite
Cat. 21

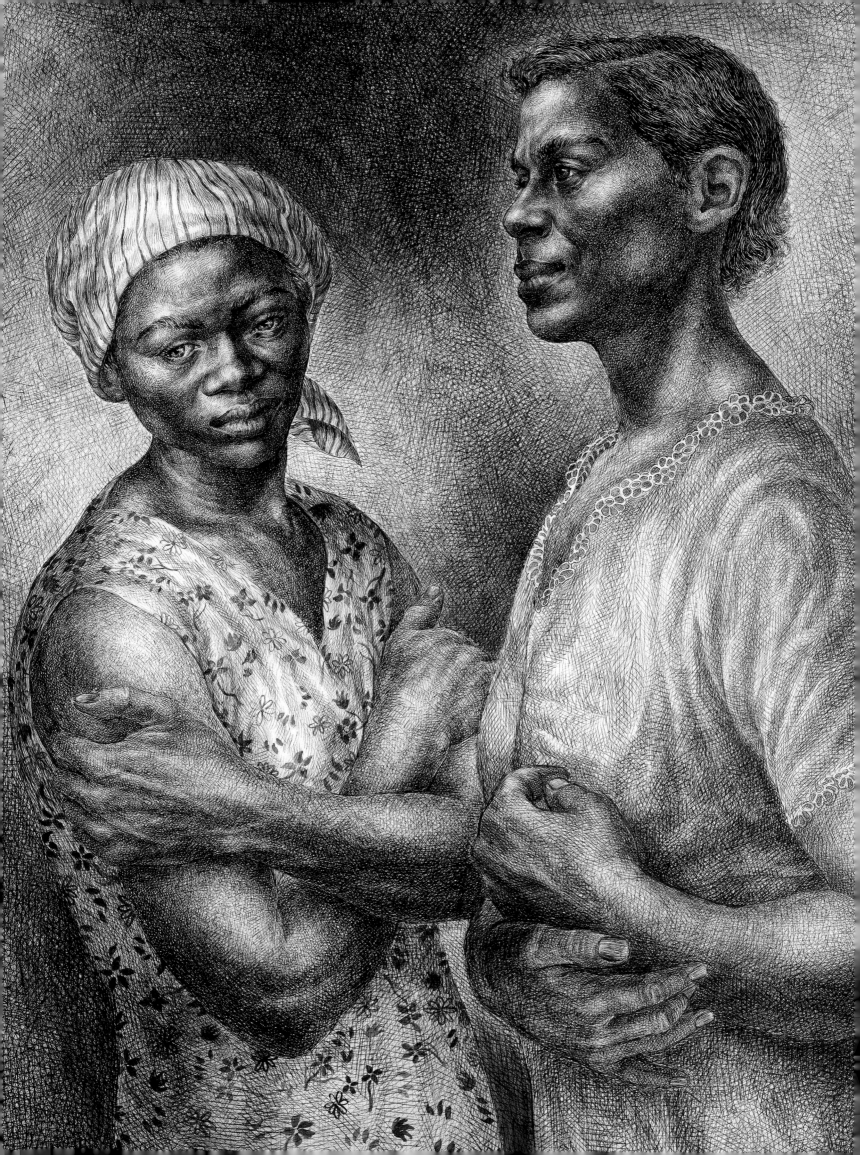

CHARLES WHITE, FEMINIST AT MIDCENTURY

KELLIE JONES

Living a feminist life does not mean adopting a set of ideals or norms of conduct, although it might mean asking ethical questions about how to live better in an unjust and unequal world . . . how to create relationships with others that are more equal; how to support those who are not supported or are less supported by social systems.
—Sara Ahmed

In her book *Living a Feminist Life*, Sara Ahmed asks what it means to hold on to "the promise" of the word *feminism*. For Ahmed there are many feminisms and many feminist movements; they are not always visible or public. She asks readers to find and tell feminist stories. This is one, a story about Charles White—and other African American artists and activists of his generation—whose work in the middle of the twentieth century advocated for an end to "sexism, sexual exploitation and sexual oppression."[1] In the 1950s black feminism brought together art, activism, writing, politics, journalism, and history. White was both deeply implicated in and inspired by this movement. This essay will first seek to immerse the reader in some of White's work from the end of the decade, to examine these images on their own terms, and then turn to the beginning of the decade to look at the movements and influences that shaped them.

White's paintings and drawings of the 1950s were filled with women, and his 1958 exhibition at New York's American Contemporary Art (ACA) Gallery was no exception. Monumental drawings ruled; they were, as one critic noted, "more like paintings made with pencil."[2] *I've Been 'Buked and I've Been Scorned* from 1956 (pl. 50) is a delicate and textured charcoal. An elderly woman stands in an open doorway. Every detail is accounted for: the soft folds of her housedress, the grain of her wooden home, tender wrinkles gracing her face, her hair a gray halo. From the same year, *Oh, Mary, Don't You Weep* (pl. 51), although graphite and pen and ink on paper, retains the softness of

charcoal. If the protagonist of *I've Been 'Buked* looks out at us, her right hand extended into our world, the companions of *Oh, Mary* nestle together, engrossed in their own private universe. Another large drawing is *Mahalia* (pl. 49), a portrait of the gospel singer Mahalia Jackson. Her figure is centered in the picture, and she sways and smiles to her own music, satisfied. These pictures highlight animated hands, as critic Dore Ashton has noted, as well as expressive gestures registered on faces and in bodies. Gestures, scholar José Muñoz reminds us, are schematic turns toward the future, a horizon.[3]

In 1958 White, comfortable in his Los Angeles world, was beginning to move to the beat of Hollywood, and so it is not surprising that the brochure for his 1958 show included a text by his friend Harry Belafonte.[4] The popular entertainer notes that White's "art is a testimony to the vitality of American culture" and is "tremendously American." Such ideas of Americanness are expressed through what Belafonte identifies as "Negro Americana . . . the poetic beauty of Negro idiom."[5] He reminds us that black life and culture are American life and culture, and suggests ties between White's work and his own creative projects that built on folk or traditional American form. White's art, like Belafonte's, was activist, and White used music in many ways during this time to signal the championing of working-class life and culture. For White, such ideas would also be primarily expressed through images of women.[6]

Another oversize work on paper, *Eartha Kitt* (from *Anna Lucasta*) (pl. 75), dates from the same year as the ACA show but was apparently not included in it. The mood of this piece is markedly different from the ones in the exhibition. Created in Wolff crayon (a carbon pencil), it combines the properties of graphite (sharpness) and charcoal (sumptuous black line). There is a playful and sensual atmosphere heightened by the inky charcoal and felt in the dynamic diagonals and the subject's flirty posture and hands. The drawing is part of a triptych of intertitles created for *Anna Lucasta*. Featuring Kitt, Sammy Davis Jr., and an all-black cast, the film was a remake of a 1949 version based on the stage play of the same name by Philip Yordan. Kitt's title character, a good girl gone bad struggling to redeem herself, offered a take on womanhood that was potentially more complex than the pious, spiritual figures of White's 1958 New York show.[7]

C'est l'amour (fig. 1), another monumental drawing, also gestures toward women's erotic lives. It, too, centralizes a single figure with smiling full lips, bare shoulders, and a gesturing hand, who appears, nymph-like, under a delicately sketched branch. In *C'est l'amour* the artist does not use the genre of the nude to suggest eroticism; instead, he renders, in exquisite detail, a figure exuding love. We might think about a few other competing frameworks in the 1950s for the image of woman. In *The Nude: A Study in Ideal Form* (1956), art historian Kenneth Clark sets up a dichotomy between the body that is naked—"huddled and defenseless," a figure of embarrassment and deprivation—and the nude, a "balanced, prosperous, and confident body."[8] The naked body, something average and mundane, is the starting point, the pretext, for the nude, which is an illusion. The nude is an idea; it is "ideal beauty" with roots in Classical Greek form and almost exclusively female by the nineteenth century. Yet, I would also argue that White is

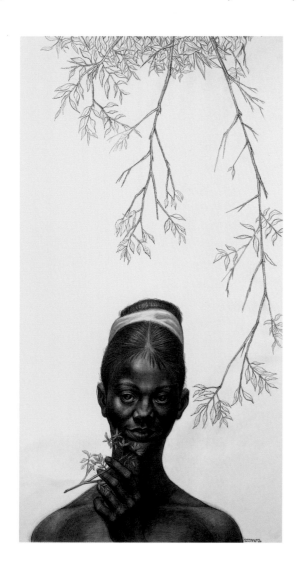

himself creating ideal form. While he does favor the unblemished and muscular body for images of women in the 1950s, his paradigm is shaped by something else.

Indeed, the nude was rarely used by African American artists in the first half of the twentieth century because of its relationship to centuries of real enslaved bodies: beaten, raped, worked until death. Such historical exigencies were continued by racial terror in the present. When White does show nude bodies, they are usually naked in Clark's schema, "huddled and defenseless," deprived. They are the bodies at auction in his *Wanted Posters Series*, commodities of the flesh, as literary critic Hortense Spillers reminds us.[9] Or as seen in *Kitchenette Debutantes* (pl. 3), in which exposed breasts signal availability, while flashy earrings and a mirror call our attention to the figures' performance of beauty and desirability, which is enacted before an open window. Sex work was viable labor for black women recently arrived in northern cities, particularly migrants with few skills outside of sharecropping and domestic labor.

FIG. 2
WILLEM DE KOONING
(AMERICAN, BORN
NETHERLANDS, 1904–1997)

Woman I, 1950–52. Oil on canvas;
192.7 × 147.3 cm (75 ⅞ × 58 in.).
The Museum of Modern Art, New York,
478.1953.

Working primarily with images of women from midcentury on, White reminds us of another New York artist, Abstract Expressionist Willem de Kooning, who saw woman as a compulsion, something he was perhaps perpetually trying to get ahold of. De Kooning's "nice, juicy, greasy surfaces," which he continually scraped down and layered, created a substantive picture, a nude fleshiness (see, for example, fig. 2); such framing resonates quite differently when read through Spillers's notion of the political economy of race, reminding us instead of bodies as commodities.[10] Turning increasingly away from oil-based media for health reasons, White created a surface that nonetheless thinks in layers through cross-hatching and delicate transparent deposits in water-based media, as well as thinner and drier applications of oil. White instead focused on an embracing and absorbing color, an openness exhilarating to the eye, as Clement Greenberg would later argue about color-field painting.[11] White also perfected the conversation of competing textures developed in a comprehensive print practice. Perhaps he, too, was trying to get ahold of woman, yet in a very different way and for different reasons. For White, black woman was also a political sign.

In her masterful study of de Kooning, art historian Rosalind Krauss sees the artist's paintings of women as a "compositional solution" to what he "wanted to say about the status of painting as representation."[12] If for de Kooning such commentary required a surface aligned along three compositional positions plotted onto the painting—painter/model/representation—White's strategy was different, as he sought to invent an African American figure that is neither ridiculed nor degraded, indeed an ideal body. In Western art, black women are, most often, the always-already sign of white debasement and carnality (as in the maid in Manet's *Olympia* [1863; Musée d'Orsay, Paris]), and so White chose not to lean on profligate nudity. The smiles on his subjects' faces are neither de Kooning's "oral rictus" nor signs of feminine complacency.[13] Their countenances are instead important signs of radical black joy, black happiness. Indeed, for White and others, figuration still had stories to tell. To remove image, "just to PAINT," in critic Harold Rosenberg's thinking, was not enough.[14]

Although overshadowed by the success of American abstraction in the 1950s, figuration continued apace in works by Jack Levine, Alice Neel, and numerous others. Their works offered another approach to existentialism, evincing struggles against

annihilation in the Cold War years.[15] At midcentury, White's "tremendously American" art used women to tell this tale. He placed working-class black women at the center of key works, engaging social struggle in ways that brought together issues of race, class, gender, and ultimately transnational discourse.

African American creative artists across fields continued to find variant forms of social realism the best means to highlight black inequity in a country that remained bifurcated by Jim Crow law and custom.[16] Indeed, White's woman possesses an ideal beauty or an ideal black body, in many ways quite unlike what most people had seen before. The clothed body, the working body, the happy body, the woman engaged in her life's work, was the ideal beauty. It is Clark's "balanced, prosperous, and confident" figure, the same one agitating for equal rights, increasingly loud and clear.

An earlier ACA show in 1951 entitled *Negro Woman*, Charles White's third solo there, has gone down in history as a storied first in which images of women are a central focus. All fifteen works—a mix of paintings, prints, and drawings—centered on the female form. They are shown in groups, comforting children, as partners with men, and also very much involved in their own thoughts, dreams, and creative acts, something quite unique for black women in Western art.

White's interest in music is seen here too. In the lush painting *Bessie Smith* (pl. 35), we note the warmth of the palette and the room of floating wallpaper details. White shows the blues queen not singing but perhaps humming; she is lost in thought, imagining. *Gospel Singers* (pl. 38) is another tempera painting whose surface vibrates with color. The work depicts a guitar-playing duo, but in a telling compositional move, the woman, who dominates the picture, is seen from the back, draped in a red dress that falls lovingly over her body, her beautiful, strong arm grasping her instrument. The woman's turned back signals that she is wrapped in her thoughts, composed and intent, focused on her sound. Her male companion faces us from the depths of the canvas, eyes closed, mouth open. The singers perform against a fascinating backdrop that appears to be a modernist painting. Indeed, White's shift to a more naturalistic rendering of figures in space, in which he focused on organic, rounded forms that reject Cubist-inspired geometries, occurred at this moment. This shift is perhaps signaled by the abstract piece relegated to the background.

The works seen in *Negro Woman* are a measure of White's artistic development during the 1940s, which included his travels to the US South documenting farmers and laborers, as well as his sojourn in Mexico and creative conversations with the Mexican muralists.[17] His move to more lifelike renderings, like theirs, was thoughtful and intentional. It privileged audience, valued "communicability," and was arrayed "against caricature and abject violence," as he would later write.[18] One piece from the show is perhaps most emblematic of such ideas. *Our Land* (pl. 37) is another tempera painting flush with color. Here, too, we find a principal female figure; this time, however, she regards us directly, head at a jaunty and confident angle. One hand rests sassily on her hip; with the other she holds a proper pitchfork. The browns of her body are enhanced by an orange dress, their warm tones accented by shadows and cross-hatching. The folds of her garment add to the painting's dynamic line, while the patch of blue over her right shoulder provides a perfect contrast, pushing the body further toward the viewer. Her face is lovingly lit, confident, beatific, crowning her sensuality and strength. If the ideal body is average, habitual in Clark's eyes, that of the black woman worker fits the bill, though it has rarely been considered with such care and love.

White's work is a shining example of social—or Socialist—realism in many ways. And so it is no surprise that some of the most poignant and insightful con-

siderations of his praxis appear in newspapers supporting leftist causes. The *Daily Worker,* the organ of the Communist Party in the United States, and the Marxist *Masses and Mainstream* provided some of the most useful and consistent coverage of White, whose reviews in the general US art press (including *Arts*, *ArtNews*, and the *New York Times*), though steady, were slim, his content seen as problematic in the age of Abstract Expressionism, his formal invention falling short.

Indeed, John Pittman's *Daily Worker* review of White's 1951 show is a wonderful example of the stellar regard the artist enjoyed in progressive circles, starting with its title, "Charles White's Exciting 'Negro Woman' Show at A.C.A. Gallery." The writer relates that this exhibition, across fifteen works in varied media, insists that "the Negro woman merits the most inspired artistic treatment." He continues, "Is there now, or has there ever been, any other artist who has consistently striven to portray the Negro woman as child, adolescent, woman, mother, worker, leader, artist? I don't think so."

The complexity of woman stands, along with her beauty, beyond "Anglo-Saxon standards." For Pittman (and I think for White as well) such allure in the image signaled profoundness, character, and depth. In an amazing passage Pittman's radical position as a black Communist journalist allowed him to see not only the loveliness of black women but also an inner creative life that other critics writing at that moment or even ten years later mischaracterized as sadness and loneliness, a performance of abjection. Instead, Pittman's nuanced reading of these figures' interior lives exposed the profundity of White's practice.

> There is great beauty in the expressions of these women. Undoubtedly such women in reality have moods of defeatism, grow impatient, know fear, and sometimes dislike themselves; living under the conditions of the present, they would not be people at all if they did not reflect such reactions to their environment. But White, the artist, does not select these kinds of reactions to represent; he selects what seem to him the more abiding and constant, hence more truthful reactions—the pride and confidence and honest directness of the worker realizing the fruits of her labor.[19]

From its image to its title, *Our Land* can also be placed within the tradition of American Regionalism, whose pastoral nationalism was a counterpoint to social realism; but the picture's celebration of the black woman worker also provides a critique of this style. White's pitchfork-wielding and self-assured beauty is in conversation with the dour couple of Grant Wood's *American Gothic* (fig. 3). Wood's painting was acquired by the Art Institute of Chicago and would certainly have been known by White, a Chicagoan who attended the School of the Art Institute in the late 1930s. In Wood's piece, stasis is modeled in strict geometries: the upright couple is hemmed in by their boxy house and the farm building in the distance. In White's work, the woman is an active agent, her tool held firmly in hand at an angle that energizes the panel. She is framed by the entryway of her home, whose open door leads us further back into space. White's subject, buoyantly controlling her labor and destiny, offers a marked contrast to Wood's somber matriarch framed by her apron.

Our Land also exists in dialogue with the work of White's friend Gordon Parks, who reframed *American Gothic* as a photograph in 1942 (fig. 4). The two midwesterners met through Chicago-based Works Progress Administration (WPA) networks, including the South Side Community Art Center, which housed some of Parks's first exhibitions. The friends' early vision as creators came from visiting South Side neighborhoods, experiencing poverty, and seeing that, through the modes of social realism and related documentary photography, they could offer important perspectives on

FIG. 3
GRANT WOOD
(AMERICAN, 1891–1942)

American Gothic, 1930. Oil on
Beaver Board; 78 × 65.3 cm
(30¾ × 25¾ in.). The Art Institute
of Chicago, Friends of American
Art Collection, 1930.934.

FIG. 4
GORDON PARKS
(AMERICAN, 1912–2006)

American Gothic, 1942.
Gordon Parks Foundation.

"the lives of ordinary people in a politically engaged manner."[20] Parks immortalized their shared Chicago beginnings in a series of photographs of White in front of one of his early, now lost, murals (see fig. 8, p. 30; and fig. 1, p. 87).

Parks's *American Gothic* springs from his first series for the Washington, DC, Office of War Information, which was among the last of the WPA programs. It shows Ella Watson, one of the countless "charwomen" who kept the capital's halls of government spotless. While this image of Watson with a broom and mop and framed by the American flag has become iconic, it was part of a much larger photographic consideration of her at home and in church, outside of her role on the lowest rung of labor's ladder. In depicting his subject beyond her job as a cleaning woman, Parks employed increasingly inventive approaches, including the powerful use of mirrors, reflections, and double exposure, especially in the religious setting. Important, too, is the interplay between the images and captions, which name Watson and give her visibility and a full identity. As scholar Nicholas Natanson has observed, the "full-length, extreme-foreground human figures draw us into Parks's scenes," creating a heroic body that would characterize the photographer's oeuvre in the years that followed.[21]

Both Parks and White reveal black women as workers, those who make the country run. Watson's mop and broom are as much tools as the woman's pitchfork in *Our Land*, things usually unseen and unacknowledged in art. As black male artists, White and Parks recognized the tripartite oppression of black women that is imbricated not only in race and class but also in gendered forms of domination. Their works effectively "put gender oppression on the agenda of black liberation."[22] As Ahmed reminds us, feminism is built from many such moments and built continually.[23]

At the time of White's 1951 show, he and Parks were both working in New York.[24] Their artistic conversation throughout the decade centered on color and female charm. The saturated chroma of White's tempera, as seen in such works as *Our Land*, is matched in Parks's imaginative series *A Segregation Story*, which appeared in *Life* magazine in 1956 (see fig. 5). Here, Mobile, Alabama, is brought to us not in the solemn, black-and-white photographic images that have become emblematic of the civil

rights era, but with a kind of opulence. The color brings to life not only the signs and spaces of segregation but also magnificence, particularly that of women. The angles, profiles, and settings with which Parks constructs his glamorous images share much with his fashion photos for publications like *Vogue*, which he worked on contemporaneously.

In the paintings, drawings, and massive linocut prints on view in White's 1951 show, critics saw monumentality and a social message, both qualities that he had been developing from his mural work onward. The figures radiate a sense of the colossal, the undaunted, with large, strong hands signaling epic labor but also a boundless creativity.[25] The hands also point, gesturing out of their frames or showing the way forward. Mainstream and progressive critics alike were struck by one print whose enormity reinforces this action of pointing the way. *Exodus I: Black Moses (Harriet Tubman)* (pl. 40) is a linocut in which a young Harriet Tubman fills the foreground, standing at left and gesturing toward our right. A seemingly unending line of people follows behind her, curving through a mountainous landscape; one raises his hands in a sign of triumph. White's intricate shading and manipulation of line is striking, carefully delineating Tubman's followers and creating varying textures for skin, hair, and lips. The freedom fighter's countenance is self-assured, broadcasting excitement about the future, indicated by a bright and mountainous horizon. As with so many of the women White depicted in this era, Tubman possesses a gaze that, while looking outward, also signals thought, a certain self-possession.

In the 1960s and 1970s White would reimagine Tubman anew. She appears again in *General Moses (Harriet Tubman)* (pl. 79), a commission for the fortieth anniversary of the Golden State Mutual Life Insurance Company of Los Angeles, and in *Harriet* (pl. 96), both large-scale works, on paper and board, respectively. Here the figure once more addresses us through the worked surface. Older and solitary, she is representative of the many yet stands for her own work and ingenuity. Only the bloody mark above her head in the latter piece reminds us of the violence that she and others endured.[26]

As if mounting a show of fifteen works dedicated to their image was not enough to make the point of celebrating black women, White also framed this idea in the pamphlet accompanying the 1951 exhibition. Simple brochures accompanied most of the artist's seven solo shows at ACA Gallery in this era. The folded sheet included the title and dates of the exhibition and a checklist of works. The brochures almost always contained a text of some kind. For White's 1951 show it took the form of a poem.

This splendid homage, "To My Negro Sisters" (p. 76), was penned by poet and prolific Jewish writer Eve Merriam, a contemporary of White's and possibly his West Village neighbor.[27] From the very first stanza, the shared imagery is remarkable. Merriam begins her poem with the "North Star" calling "Moses," a reference to Harriet Tubman. The sinuous line of followers behind her in *Exodus I* mirrors the repetition of the word *marching* throughout the poem. "As Sojourner, your Truth abides," of course, alludes to the great abolitionist and women's advocate Sojourner Truth, who is best known for her speech referred to as "Ain't I a Woman" at the Ohio Women's Rights Convention of 1851.[28] Toward the end of the work, the lines "We come to claim our hands full laboring due" and "Full measure in heavenly earthwright" both beautifully capture the sensibility of the figure in *Our Land*.

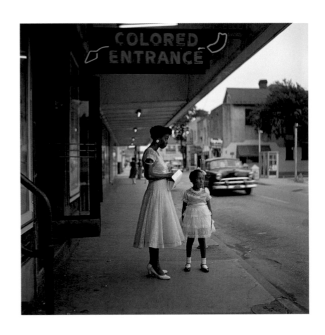

FIG. 5
GORDON PARKS
(AMERICAN, 1912–2006)

Department Store, Mobile, Alabama, 1956, from the series *A Segregation Story*. Gordon Parks Foundation.

TO MY NEGRO SISTERS

North Star calling clear
As Moses still guides her people,
As Sojourner, your Truth abides
In younger daughters grown
Great among us here.
 Marching marching
From lives denied
From lives jimcrowed
From lives that were jailed
From lynchtree road
 Marching marching far
 I take my honored place:
 I walk by your side.
 Far far to go
 Marching free and far to go
Together our fingers grow firmer,
Take twining forceful root;
Together our footsteps resound
On peaceful planted ground.
 Marching free and far
 Marching
MORANDA SMITH
 So fresh in your new-laid grave
 Only the bosses, dry as tobacco leaves,
 Do not mourn your loss
BESSIE MITCHELL
 Stamping the land for freedom for your
 brother,
 For all brothers
AMY MALLARD
 Widow wed to justice
ROSALIE McGEE
 Tears turning to mighty wrath
 Higher than Mississippi
ROSA LEE INGRAM
 Defending the body and soul
 Of
 Everywoman

All the millioned motherless mothers
 Orphaned over slops
 Stooping to other women's floors
 Nursing every baby but their own
 Climbing the narrow ghetto stairs
 To stretch one cold midnight hour
 Into the broad bright length of day
 Washing cleaning scouring scrubbing
 And trampled on as dirt
 Out of your denial
 Out of our demand
 From all the bitter parings
 From the separating walls
 Of the master's house
 We march
 Meet in the bittersweet mass
 And lift every voice
 To make from the sorrow songs
 A future music:
Out of the narrow leavings
Out of the making do
Out of the meagre handful flung our way
Out of the patch and the scrap
 We come to claim our hands full laboring due
 To stir and knead
 To bake the bread of sisterhood
 Rising,
 Nourishing,
 Enough for all,
The golden brown crust dipped in the wine of milk;
Hungry no more,
Human at long last
Woman
Full measure in heavenly earthwright

—Eve Merriam

Having begun her poem heralding the heroes of the past, Merriam then presents a new generation of crusaders. Moranda Smith, Amy Mallard, Rosalie McGee, Bessie Mitchell, and Rosa Lee Ingram led the way in challenging racial violence and discrimination in the postwar United States. Smith, a tobacco worker in North Carolina, helped form the Food, Tobacco, Agricultural, and Allied Workers Union in the early 1940s in a sector where 40 percent of workers were black women. In Georgia, Mallard's husband was shot dead in front of her by the Ku Klux Klan. She went on to be a tireless advocate against racial violence. McGee fought against the conviction and execution of her husband, Willie, on rape charges in Mississippi. Mitchell, a garment worker (and member of the International Ladies' Garment Workers' Union), labored to free the Trenton Six, black men framed for the murder of a white business owner in 1948 in Trenton, New Jersey. Her brother Collis English was one of the accused. This incident showed racism as it existed in the North. Trenton was one of many destinations of the Great Migration.[29] There was an unease with rising black populations, and, similar to the South, state violence was used to keep African American citizens in check. McGee and Mitchell were exemplary of the commitment women relatives demonstrated on behalf of black men in these situations. White would have certainly known of these incidents due to their sheer national and international visibility. His focus in the 1951 ACA exhibition on several images of the singer Bessie Smith might also have been a subtle reminder of other black women with that name in the news, activists Bessie Mitchell and Bessie McGee, mother of Willie McGee, who was also involved in a public defense of her son.

Though equally the site of international activism and outrage, the case of Rosa Lee Ingram was somewhat different in that it revolved around sexual violence against a black woman. Ingram was a Georgia widow, sharecropper, and mother of fourteen. After continual harassment, both physical and sexual, by a neighboring white sharecropper, she was accused of killing the man in self-defense in November 1947, aided by two of her sons. They were sentenced to death in a one-day trial the following year, and after vigorous protest, the sentences were commuted to life imprisonment. The National Association for the Advancement of Colored People and the Civil Rights Congress collaborated on Ingram's legal defense. However, the widespread activism on the Ingrams' behalf in the following years was fueled by women and by three organizations in particular: the National Committee to Free the Ingram Family; its successor, the Women's Committee for Equal Justice; and Sojourners for Truth and Justice.[30] These groups brought together a wide array of women across the political spectrum, from Mary Church Terrell, a renowned reformer and veteran of the women's club movement, to contemporary luminaries of black struggle such as Shirley Graham Du Bois and Eslanda Goode Robeson, communists Claudia Jones and Louise Thompson Patterson, publisher Charlotta Bass, and creative artists Alice Childress and Beah Richards.[31] As historian Erik S. McDuffie has remarked, "For Ingram's supporters, her case represented the interlocking systems of oppression suffered by black women: the rape of black women, the lack of protection for black motherhood, the economic exploitation of black women . . . [and] the disenfranchisement of black women in the Jim Crow South."[32] After more than a decade of campaigning, Ingram and her sons were released in 1959.

White counted many of the activist women mentioned above as creative colleagues and friends. In New York, he and Childress were both involved in the Committee for the Negro in the Arts (CNA; see fig. 6), which was dedicated to diversifying the arts both in content and with an eye toward the impact that jobs in industries such as film, television, and theater could have on African American communities.[33] Letters found in White's archive reveal how Thompson Patterson treasured the importance of visual

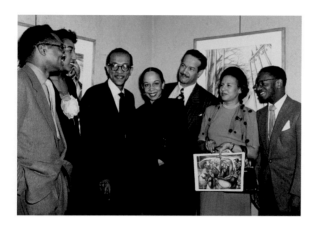

FIG. 6
Committee for the Negro in the Arts reception at the ACA Gallery, 1950. Left to right: Walter Christmas, Ruth Jett, Charles White, Janet Collins, Frank Silvera, Viola Scott-Thomas, and Ernest Crichlow. Charles White Archives, CA.

imagery in radical struggle and turned to him for images to support feminist and other social causes.[34] Bass helped White secure some of his first shows after he moved to the West Coast. While they undoubtedly met in New York, White and Richards would work together in Los Angeles on the film *Guess Who's Coming to Dinner* (1967). Richards played lead actor Sidney Poitier's mother, while White also "appeared" when his drawing *Folksinger (Voice of Jericho: Portrait of Harry Belafonte)* (pl. 72) silently asserted itself in the study of newspaperman Matt Drayton (Spencer Tracy). We are reminded here that Parks, Poitier, Richards, and White—and the wider network of left-leaning artists of the 1940s and 1950s, which included members of groups such as the CNA—became important players in black Hollywood of the 1960s.

In a solo show held at ACA in 1950, the year before *Negro Woman*, White celebrated several of the high-profile cases in which black women's protest turned the tide. The exhibition brought together portraits of historical figures (*Frederick Douglass Lives Again [The Ghost of Frederick Douglass]* [pl. 30], *Gabriel Prosser, Harriet Tubman,* and *John Brown*) and works related to current struggles. The large drawing *Trenton Six* (pl. 29) represents a group of young men who stand behind a barbed wire fence. At front, a woman is draped in a robe both classically and biblically inspired. She is the *mater dolorosa* whose hands flutter, birdlike and free; she is also, in Mary Helen Washington's reading, Bessie Mitchell, who worked tirelessly for the innocent men's release.[35] Certainly the picture is suffused with melancholy, but in the shadings of black ink and graphite on paperboard, the shadows run and move, infusing light into the surface.

A drawing by White called *The Ingram Case* (fig. 7) graced the cover of the brochure for the 1950 ACA show. Here, too, flowing garb encases the figures' rounded bodies, which seem to float behind sharp, vertical prison bars. The gazes of the two boys rest on their mother, the only figure engaging the viewer. A flurry of hands moves behind the rigid, icy bars. But Rosa Lee Ingram's right fist emerges and holds us, as do her eyes.

Howard Fast, a novelist, television writer, and contributing editor of *Masses and Mainstream*, contributed a text for the brochure. He called particular attention to *The Ingram Case*:

> [T]he hands of Mrs. Ingram and her two sons overwhelm the iron bars which they clutch. In each case, they seem to say, "Look at my hands and fear them, the strength of my hands is immeasurable." . . . Whether he pictures today or the past, he is equally conscious of the heroic quality of Negro resistance, and the truth of his concepts is always an inner historical truth which transcends the role of the individual without lessening it.[36]

Fast shows here how White's subjects, as emblems of both the historical struggle and the vanguard of resistance, signal the vitality of black people; this is nowhere more true than in his representations of black women.

Merriam's poem "To My Negro Sisters" opens up many trajectories into White's work—not only his approach to depicting women but, more important, his conversations with them. It was, however, Richards's poem "A Black Woman Speaks of White

Womanhood, of White Supremacy, of Peace" that made the most powerful and lasting impact on the Cold War cultural landscape. Inspired by the McGee case, it refracts the events through female eyes. Long, exquisite, caustic, and hard-hitting, the work explodes the notion of a singular conception of womanhood, peeling away the layers of "woman" from those of "whiteness" and articulating the space of black/woman/ radical. Richards's text also moves between contemporary events and the historical past, interrogating the fallacies of "American womanhood" and the structural inequities that make any claim to universal representation impossible.[37]

The poem was a smash in leftist circles during the summer of 1951. Published by American Women for Peace, it energized black communist women, leading them to create Sojourners for Truth and Justice. Richards, along with Thompson Patterson, would craft the originating document, "A Call to Negro Women."[38] McDuffie contends that the Sojourners "marked something new in the history of diasporic feminism, black radicalism, U.S. women's movements, and American Communism because it provided black women radicals a unique opportunity to lead their own organization."[39] Inspired by the Ingram case, the Sojourners opposed war, violence, and Jim Crow laws with direct action, using the guiding examples of Tubman and Truth. The group combined a variety of leftist principles, from the rhetoric of communism to the "prophetic black Christian" tradition, to bring together a wide array of black participants. McDuffie also remarks on a strategy he calls "familialism," which relied on more staid notions of family than many of these radical women had heretofore embraced.[40] For scholar Tina Campt this would be a performance of family, which mobilized the sign of "maternal touch."[41] Familialism fit perfectly with rhetorics of domesticity in a postwar period that pushed middle-class women back into the home and burgeoning suburbs after years in the wartime workforce.

The Sojourners' initiating committee included Amy Mallard, Rosalie McGee, and Bessie Mitchell, all known for speaking out in militant denunciation of the violence and inequity directed at black people. They are all names, too, that figure in Merriam's poem. The organization held its inaugural convention in Washington, DC, in 1951. A 1952 event in New York included a unity luncheon with the Emma Lazarus Federation of Jewish Women's Clubs; as a lifelong activist herself, Merriam may have been in attendance. What is certain is that White's *Exodus I* graced the invitation to the Sojourners' 1952 conference.

In 1954 a letter-writing campaign took place on behalf of the effort to free Rosa Lee Ingram. Timed near Mother's Day, cards were sent both to Ingram, assuring her of the continued fight on her behalf, and to Georgia governor Eugene Talmadge, demanding the release of the Ingram family. The Women's Committee for Equal Justice produced two postcard mailers: one to the governor with a photograph of Ingram and her sons, the other addressed to Ingram in Reidsville Prison (fig. 8) featuring White's drawing *Ye Shall Inherit the Earth* (pl. 48). The title of this monumental charcoal on paper casts its sharecropper and her child as biblical figures, and the reference is reinforced by the garment wrapping the infant. Here, the artist himself seems to take up the biblical vocabulary that was part of these broad-based coalitions of women.

That same year, White was the featured artist for the Philadelphia Pyramid Club's annual exhibition. An organization of black professionals and society folks, it had been hosting art shows since its inception in 1940 with the assistance of area

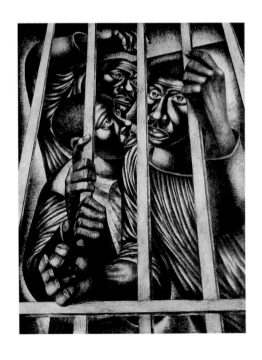

FIG. 7
CHARLES WHITE
(AMERICAN, 1918–1979)

The Ingram Case, 1949. Pen and ink; 71.1 × 91.4 cm (28 × 36 in.). From Sidney Finkelstein, *Charles White: Ein Künstler Amerikas* (Dresden: Veb Verlag der Kunst), pl. 15.

artists Samuel J. Brown, Paul Keene, and Dox Thrash. The program's signal image was White's charcoal drawing *General Moses and Sojourner (Harriet Tubman and Sojourner Truth)* (fig. 9). Although the artist had been creating individual images of these nineteenth-century radicals for years, he paired them here in a dual portrait. Together, they reverberate in the current moment, referencing the inspirations of the recently defunct Sojourners for Truth and Justice. It serves both as an homage to that group in particular and to black women's organizing over the centuries.

The continuity of radical black women's activism at midcentury with activist movements that came before would also account for Merriam's poem and its opening odes to Tubman and Truth. While, like White's *General Moses and Sojourner*, it seems to make specific reference to Sojourners for Truth and Justice, in fact Merriam's words were published in the spring of 1951, months before Richards's own poem inspired the birth of the Sojourners in the summer or fall of that year. Of course, the examples of Tubman and Truth were invoked throughout this time in connection with contemporary radical activism. However, one event in 1950 may have also influenced White's thinking. In April members of the National Committee to Free the Ingram Family staged a protest at the United Nations. In an exercise in political theater (or performance art), they descended on the organization's headquarters dressed as Tubman and Truth.[42]

As we now see, White's overwhelming turn toward images of women from midcentury on was not random. In fact, his work was not just about women but rather was clearly made in dialogue with black feminists and the discourse of black left feminism that developed from the 1920s into the 1950s.[43] Nurtured in part among activists including those in Communist Party and Popular Front circles, black left feminism supported working-class black women in both national and international struggles, recognizing their oppression in the structures of race, class, and gender.

One major feminist influence in White's life in the 1940s was his first wife, artist Elizabeth Catlett.[44] They spent the early part of the forties together, meeting in Chicago, living in New Orleans; Hampton, Virginia; and New York; and traveling to Mexico, where they would part ways. As art historian Lowery Stokes Sims points out, White and Catlett shared a stylistic trajectory with a number of their peers, such as Romare Bearden and John Wilson, in which "simplified planes and forms . . . conveyed a heroic and dignified image of African Americans."[45] However, it is also the case that Catlett created a practice dedicated almost exclusively to imaging women over a career that spanned more than seven decades.

White and Catlett shared a radical approach to printmaking inspired by Mexico City's renowned Taller de Gráfica Popular, where they worked in 1946. Like Mexico's better-known mural movement, from its founding in the 1930s the workshop aimed to make art available to the country's citizens, creating things that made people's lives better, such as posters supporting literacy and flyers for workers.

Although Catlett completed her important *Negro Woman* series (see fig. 10) in Mexico between 1946 and 1947, she began it in New York. The work is epic in its historical breadth but accomplished in fifteen linocuts of modest size and in a serial format reminiscent of that used by Jacob Lawrence for his sixty-panel *Migration of the Negro* (1940–41). Catlett's images of black female labor developed in tandem with those of White and other black feminists who were a part of New York's radical communities in the 1940s.

In addition to Catlett, White was also in conversation with Marvel Cooke. A neighbor at 409 Edgecombe Avenue when White and Catlett lived in Harlem in the early 1940s, Cooke was a journalist who covered cultural topics (including visual art)

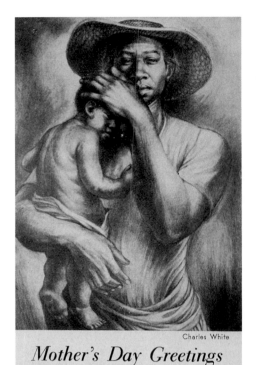

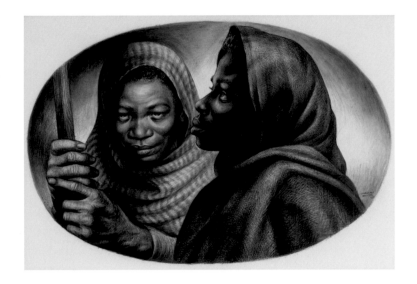

for the *New York Amsterdam News.* She is probably best known for her exposés on the so-called Bronx Slave Market. On the blocks of 170th Street and Jerome and Walton Avenues in the Bronx (and other locales such as Coney Island in Brooklyn), women—predominantly southern black migrants—waited on street corners to be picked up for day labor. In a crisis exacerbated by the Depression, they were compensated with minimal wages and sometimes barely paid at all. Cooke wrote what might be her earliest article on this topic for the NAACP's *Crisis* magazine in 1935 with coauthor Ella Baker, who became renowned for her civil rights activism in the 1950s and 1960s.[46] Cooke reprised such serial coverage for the *Daily Compass* when the Bronx Slave Market reasserted itself in the early 1950s. Unlike her work in the 1930s, these articles were written in the first person and accompanied by pictures of Cooke, presumably undercover, performing household tasks. They were followed by extended articles on prostitution and teen narcotics abuse. For Cooke, all these stories led back to the structural racism and inequity embedded in American capitalism.

Along with White and Parks, the photographer Robert H. McNeil was another male artist whose work participated in the feminist cause at midcentury. After opening the McNeil News Photo Service in late 1930s Washington, DC, he provided images to papers including the *Washington Afro-American*, the *Philadelphia Tribune*, the *New York Amsterdam News*, the *Pittsburgh Courier*, and the *Chicago Defender*. The African American press began hiring photographers with greater frequency in the 1920s as a way to combat black invisibility in white periodicals. However, while the reporting in these papers exposed injustice, the visuals tended to be upbeat.[47] McNeil would challenge that formula.

While still a student at the New York Institute of Photography in 1937, the twenty-year-old photographer received a commission from *Fortune* magazine for a piece on domestic workers at the Bronx Slave Market. For the story, McNeil followed one woman, Bessie Windstown, "from the long wait on the corner of 170th St. and Walton Ave. in the Bronx to an employer's kitchen."[48] In his first major series for a periodical of any kind, McNeil takes us inside Bessie's world, waiting on the sidewalk with countless

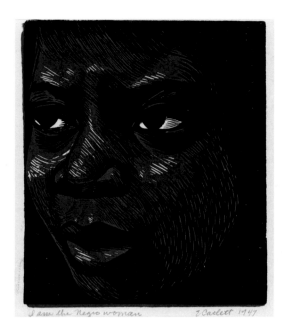

FIG. 10
ELIZABETH CATLETT
(AMERICAN, ACTIVE IN
MEXICO, 1915–2012)

I am the Negro Woman, 1947, from
the series *Negro Woman*. Linocut on
paper; 13.97 × 12.7 cm (5 ½ × 5 in.).
Pennsylvania Academy of Fine Arts,
Art by Women Collection, gift of
Linda Lee Alter, 2011.1.172.

others, sitting and standing, grasping the brown paper bag holding work clothes that was a sign of her status and availability as a laborer, negotiating with a potential employer, scrubbing floors, and watching pots. His compositions, with their ironic and charged juxtapositions, created formidable narratives.

In the end, *Fortune* rejected the photographs, running the story in March 1938 under the title "The Servant Problem" and highlighting only the employers' perspectives. In fact, McNeil's pictures did appear in print a month prior to the *Fortune* article in a February 1938 issue of *Flash!*, an African American periodical based in Washington, DC, that billed itself as a "Newspicture Magazine."[49] For his first large serial photo story, then, McNeil focused on black women's lives and their battles to thrive in an androcentric world. This is another feminist story—one whose goal is, as Ahmed would describe it, to "dismantle the world that is built to accommodate only some" bodies and their viewpoints.[50] And it is another point at which to locate a black male perspective allied with feminism, a tradition going back to the nineteenth century in figures like Frederick Douglass, and in McNeil's own era, W. E. B. Du Bois.[51]

These various stories of black feminism at midcentury come to us as both "loud acts" of rebellion and quiet refusals. They come to us in myriad ways, fought "for women and as women."[52] Another friend and lifelong correspondent of White's was Esther Cooper Jackson. Beginning with her work as an organizer with the Southern Negro Youth Congress in the 1940s and her membership in the Communist Party, she was important in black leftist circles into the 1980s as the managing editor of the journal *Freedomways*. Indeed, White's work appeared in the journal throughout its twenty-five years of existence; a special issue (edited by Cooper Jackson) was even dedicated to the artist after his death. Like Thompson Patterson, Cooper Jackson understood the powerful role of art in radical struggle and turned to White for images.[53] In her 1940 master's thesis in sociology from Fisk University, she initially presented her thoughts on black working women as a vanguard whose position in the larger society was a true gauge of democracy. This project focused on the efforts of these workers to organize, allowing her to examine the pitiable working conditions for black women in the United States, including the atrocities of the Bronx Slave Market.[54]

In Cooper Jackson's ideas, White would have recognized his mother's story. As a teen, Ethelene Gary Marsh made her way alone from Vicksburg, Mississippi, to the streets of Chicago and a life of domestic service. He would have also recognized other relatives: natives of Mississippi, subject to gendered violence and exploitation, yet hardly complacent, and persisting against all odds. For White and others, women were the ultimate figures whose bodies signified the complexities of the makings of the modern. He dedicated his work to their travails but most of all celebrated their beauty.

For African American artists at midcentury, the conceptualization and manipulation of meaning was paramount. These were the rewards of struggle against being defined and debased, rendered inadequate and ignorant, ugly and worthless, through acts as well as images. These artists grasped the power to have and control methods of signification firmly and fiercely. For these creators the representational and figurative was still necessary and needed, because it still had so much to offer black people. For White in the 1950s, it offered a way to celebrate black women, political power, and the possibilities of a feminist future.

For Mildred Dweck, an original Sojourner.
With special thanks to Deborah Willis and the
Women and Migrations working group;
the Charles White Archives; and to Madeline
Weisburg for research assistance.

1. Ahmed, *Living a Feminist Life*, 5.

2. Sawin, "Charles White," 62.

3. Muñoz, *Cruising Utopia*.

4. See Ilene Susan Fort's essay in this
volume.

5. Belafonte in *Charles White*, exh. cat.
(New York: ACA Gallery, 1958), n.p.

6. Morgan, *Rethinking Social Realism*, 180.
After closing in New York, White's 1958
exhibition at the ACA landed for one week
at the University of Southern California in
Los Angeles, sponsored by the State
Association of Colored Women's Clubs and
the Southwest Symphony Association,
a collective of black classical musicians.
The linocut *Solid as a Rock (My God is Rock)*
(pl. 76), which was included in the show,
would end up at the Long Beach Museum.
A. M., "Excellent Exhibit Marks Landau
Gallery's Birthday," *Los Angeles Times*,
Apr. 27, 1958, E12.

7. *Anna Lucasta* was also the most
commercially successful production of the
American Negro Theater, another important
community for White in New York. A site of
progressive African American cultural
activity during that era, the American Negro
Theater was the training ground for actors
Harry Belafonte, Sidney Poitier, Ruby Dee,
and Ossie Davis and playwright Alice
Childress. Poitier, Childress, Dee, and Davis
were part of the national tour of *Anna
Lucasta*. Childress was passed over for a part
in the film (though she had been nominated
for a Tony Award for her stage work)
because of her leftist profile. Washington,
The Other Blacklist, 133–35; see also Griffin,
Harlem Nocturne, 101–3; and Bogle, *Toms,
Coons, Mulattoes, Mammies, and Bucks*, 160.

8. Clark, *The Nude*, 23.

9. Spillers, "Mama's Baby Papa's Maybe."

10. For "nice, juicy, greasy surfaces," see
Thomas B. Hess, "De Kooning Paints a
Picture," *Artnews* 52, no. 1 (Mar. 1953):
30–33, cited in Hills, *Modern Art in the USA*,
155.

11. Greenberg, *Art and Culture*; see also
Krauss, *Willem de Kooning Nonstop*.

12. Krauss, *Willem de Kooning Nonstop*, 23.

13. Ibid., 26; see also Hess (n. 10 above),
cited in Hills, *Modern Art in the USA*, 156.

14. Harold Rosenberg, "The American Action
Painters," *Artnews* 51, no. 8 (Dec. 1952),
cited in Hills, *Modern Art in the USA*, 153. For
painter Norman Lewis, painting abstractly
was an intellectual and emotional activity
that added to the knowledge and pleasure of
viewer and artist; it was discovery, breaking
away from tradition or being pigeonholed as
working in a "Negro idiom." See Norman
Lewis, "Thesis" (1946), in Hills, *Modern Art in
the USA*, 163–64.

15. Hills, *Modern Art in the USA*, 176–97.

16. Morgan, *Rethinking Social Realism*, chap.
1; see also Washington, *The Other Blacklist*,
introduction; and Griffin, *Harlem Nocturne*.

17. For more on the influence of Mexican
muralism on White's work, see Sarah Kelly
Oehler's essay in this volume.

18. Charles White, "Address to Second
Annual Conference of Negro Artists," reel
2041, Charles W. White Papers, Archives of
American Art, Smithsonian Institution,
Washington, DC (hereafter CWP, AAA).

19. John Pittman, "Charles White's Exciting
'Negro Woman' Show at A.C.A. Gallery," *Daily
Worker*, Feb. 26, 1951, 11. See also Charles
Corwin, "White's Exhibit Is Valuable Object
Lesson to Progressive Artists, Public, Says
Corwin," *Daily Worker*, Feb. 26, 1951, 11.
Both clippings; courtesy Charles White
Archives, CA. Similarly to Andrew
Hemingway, Washington argues that White's
move toward greater naturalism in his art
was a response to pressure from US
Communist Party institutions. However,
many leftist artists interviewed by Hills state
that there was more interest in having
bodies on picket lines than controlling
imagination. See Hemingway, *Artists on the
Left*, chap. 10; Washington, *The Other
Blacklist*, chap. 2; and Hills, *Modern Art in the
USA*, chap. 3.

20. Morgan, *Rethinking Social Realism*, 54.
For more on this period, see White, *Images
of Dignity*, 15; Washington, *The Other Blacklist*,
78; and Parks, *A Choice of Weapons*.

21. Natanson, *The Black Image in the New
Deal*, 183.

22. Lemons, "A New Response to 'Angry
Black (Anti) Feminists,'" 282.

23. Ahmed, *Living a Feminist Life*, 6–7.

24. White and Parks continued to travel in
the same Los Angeles circles when, in 1969,
Parks became one the first black directors in
Hollywood with his film *The Learning Tree*.

25. Mary Cole, "Charles White," *Art Digest*
25, no. 15 (Feb. 1951): 22; Betty Holliday,
"Charles White," *Artnews* 49, no. 10 (Feb.
1951): 53; and Howard Devree, "In a Wide
Range," *New York Times*, Feb. 18, 1951, 88.

26. For more on these later works, see
K. Jones, *South of Pico*, chap. 1.

27. Born Eva Moskoswitz, she changed her
name to Merriam (after *Merriam-Webster's
Dictionary*) to improve her chances of being
published. Recognized for her poetry and
later for her plays, she is perhaps best
known for her writing and poetry for children.
The themes of social justice and feminism in
her early work for adults and children are
less recognized, though her book *The Inner
City Mother Goose* (New York: Simon and
Schuster, 1969) stirred controversy for its
critique of the inequities of black urban
existence.

28. While it is unknown whether an image of
Truth was in White's 1951 show, she does
figure in his Hampton Institute mural, *The
Contribution of the Negro to Democracy in
America* (fig. 10, p. 33) and in a charcoal
study for it the same year of Sojourner Truth
and Booker T. Washington (pl. 15).

29. The "up South" character of New Jersey
springs in part from it being one the last
Northern states to abolish slavery. During
the antebellum period, Princeton University
provided housing for the slaves of
Southerners. See Knepper, *Jersey Justice*,
4–5.

30. Horne, *A Communist Front?*, 207; and
McDuffie, *Sojourning for Freedom*, chap. 5.
These black feminist organizations came into
being between 1949 and 1951. Most were
short-lived.

31. Until the 1960s Richards was also known
by her maiden name, Beulah Richardson.

32. McDuffie, *Sojourning for Freedom*, 166.

33. Founded by Paul Robeson, the CNA
(1947–54) included many New York artists,
White's creative cohort among them, such as
Belafonte, Childress, Davis, Dee, Poitier,
Ernest Crichlow, Lorraine Hansberry,
Langston Hughes, and Fredi Washington. The
numerous activities of this impressive group
were reviewed in *Freedom* and the *Daily
Worker*. F. B. White, *Reaches of the Heart*, 76,
77, 55–57; Washington, *The Other Blacklist*,
89–93; Morgan, *Rethinking Social Realism*,
23; and Newkirk, "Fredi Washington's
Forgotten War on Hollywood."

34. See Louise Thompson Patterson to
Charles and Frances B. White, Jan. 25, 1961,
reel 3189, CWP, AAA. White's correspon-
dence with the circle of leftist writers,
including John Oliver Killens, is voluminous.

35. Washington, *The Other Blacklist*, 88.

36. Fast's text is excerpted from a larger
review penned simultaneously in the press,
"A Note on the Graphic Art of Charles White,"
Daily Worker, Feb. 9, 1950, 11. See also
Charles Corwin, "Charles White's Exhibit an
Important Event in Art World," *Daily Worker*,
Feb. 9, 1950, 11.

37. Other poets responding to these and
other feminist issues included Gwendolyn
Brooks, Lorraine Hansberry, and Langston
Hughes.

38. McDuffie, *Sojourning for Freedom*, 173;
and Richardson, *A Black Woman Speaks*.

39. McDuffie, *Sojourning for Freedom*, 173.

40. Ibid., 173 and chap. 5. Many radicals
went by their maiden names (Thompson and
Cooper among them) until Cold War
surveillance and strategies of familialism
made them adopt their married names.

41. Campt, *Image Matters*, 53.

42. Horne, *A Communist Front?*, 208.

43. On black left feminism, see Washington,
"Alice Childress, Lorraine Hansberry, and
Claudia Jones," 185, 193–94; McDuffie, "'No
small amount of change could do'"; and
Griffin, *Harlem Nocturne*.

44. White and Catlett divorced in 1947, and
he married Frances Barrett in 1950.

45. Sims, "Elizabeth Catlett," 15.

46. Ella Baker and Marvel Cooke, "The Bronx
Slave Market," *Crisis* 42, no. 11 (Nov. 1935):
330–31, 340.

47. Lusaka, "Seeking Cultural Equity," 63.

48. Natanson, "Robert H. McNeill," 101.

49. "The Servant Problem," *Fortune* 17, no. 3
(Mar. 1938): 81–120; and "Bronx Slave
Market," *Flash!* 1, no. 50 (Feb. 14, 1938):
8–10. *Flash!* ran from 1937 to 1939.

50. Ahmed, *Living a Feminist Life*, 14.

51. Byrd and Guy-Sheftall, *TRAPS*.

52. Ahmed, *Living a Feminist Life*, 1, 15.

53. *Freedomways* 20, no. 3 (1980); and
Esther Jackson to White, Jan. 3, 1968, reel
3189, CWP, AAA.

54. Cooper, "The Negro Domestic Worker."

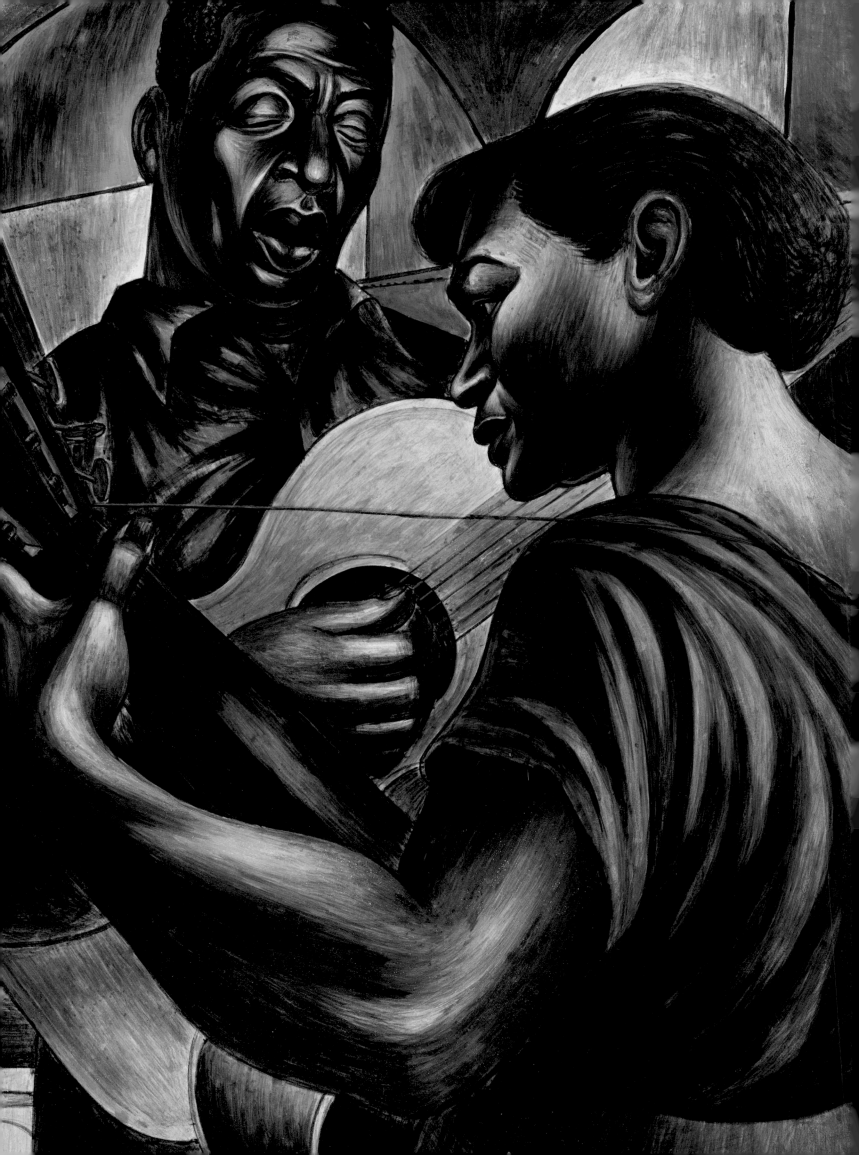

IN SEARCH OF BEAUTY: CHARLES WHITE'S EXPOSURES

DEBORAH WILLIS

I try to deal with beauty, and beauty again as I see it in my personal interpretation of it, the beauty in man, the beauty in life, the beauty, the most precious possession that man has is life itself.
—Charles White, 1965[1]

Charles White is known for his carefully composed paintings, drawings, and prints of African American men, women, and children. His bold portrayals of historical figures such as John Brown, Frederick Douglass, Sojourner Truth, and Harriet Tubman and twentieth-century artists and activists such as Harry Belafonte are striking in part because they are so realistic. White achieved this by consulting public archives of portrait photography. He also used his own photographs as source material. The artist's personal photographs, approximately three hundred in number and dating roughly from the 1950s, are preserved in a private collection and have been made available for the first time for this exhibition and catalogue.[2] The 3 × 4 ½–inch machine-processed prints reproduced here have been selected to represent the collection as a whole. Some read like snapshots, with a familiar unposed style, while others were studies for future works. Together they give insight into the intellectual commitment White brought to picture taking.

Born and raised in Chicago, White was active there as well as in New York and Los Angeles. From his early studies in painting as a member of the Art Crafts Guild and at the School of the Art Institute of Chicago, he explored composition—fore-, mid-, and background—and scale to create images that emphasized his subjects' humanity, with gender and identity playing significant roles in his visualization. As historian David Driskell argues, "White was committed to producing positive change through portrayals that were both poetic and creatively descriptive. The poetic vision that White shared with the world is composed of powerful images of stunning people of African ancestry during a time when such images were not in vogue—indeed, were

rarely seen. . . . Yet White's preoccupation with African American themes does not relegate his art to the black race alone." White's particular subject matter opened onto universal themes: "His images often looked beyond race and class, offering an informed and enlightened view of all people with dignity and uncompromising human values in the global village."[3]

White's photographic output brings together portraiture and documentary images. His photographs include intimate portraits and city scenes, all containing "an implied narrative that can be expanded and expounded upon," as writer Geoff Dyer describes Roy DeCarava's photographic work.[4] White narrated the streets and parks of New York: busy street corners and children at play, men contemplating chess moves, worn billboards, and the fashions of the day. Driskell elaborates on the positivity and hope in White's world view: "Always harboring genuine love for art that depicted the human condition within the social order, White made visual narrations that centered principally on people in search of the good life."[5] And, I argue, this assessment of his work extends to his photographs as well.

Making photographs throughout his career, White was an avid student of urban life. His never-before-published images offer another window onto the way social issues informed his work, which was produced during a turbulent time in the United States. His keen eye recorded events large and small: parades protesting racial oppression as well as lighthearted moments in his everyday life. His interests dovetailed with the activities of the Photo League.[6] Based in New York, the Photo League was a collective of amateur and professional photographers active in the period 1936–51 united by a desire for social change.[7] The league was composed of many first-generation Americans, particularly leftist Jewish immigrants from Eastern Europe; members told stories with their cameras of Harlem and other neighborhoods. The organization embodied the spirit of Franklin Delano Roosevelt's New Deal, which employed artists in the 1930s to document migrant workers and other laborers through the Works Progress Administration (WPA) and the Farm Security Administration (FSA).

Among White's inner circle was Gordon Parks, an important emerging photographer of the era. White's own photographs paralleled and influenced his styles and concerns as they began to document the harsh realities of life in New York and Chicago, the joy of family, and the dignity of the individual. In the late 1930s, Parks worked as a railway porter and often visited local museums when in Chicago. His trips to the Art Institute of Chicago inspired his interest in painting and photography. Parks also frequented the South Side Community Art Center; a 1941 exhibition there of his photographs opened doors to the art world, and before long he was the only black photographer doing work for the FSA.

The South Side Community Art Center was where Parks met White. Parks recalled hours spent talking about art with his friend:

> He was mild-appearing, bespectacled, and blessed with humor, but his powerful, black figures pointed at the kind of photography that I knew I should be doing. . . . It was good to laugh and talk with him; and it was good to watch him strengthen an arm with a delicate brush stroke or give anguish to a face with mixtures of coloring. . . . We had great hopes, Charlie and I, and we spent hours talking about them.[8]

In Parks's powerful and decisive 1941 portrait of White (fig. 1), he focused on the painter's hands holding brushes as he stands in his studio in front of the mural *Struggle for Liberation* (1940–41). Through gesture and pose, Parks represents White at his profession—an artist in control of his medium.

White was also closely acquainted with DeCarava (see pl. 56). Trained as a printmaker and painter, DeCarava began making photographs in the 1940s and in 1952 became the first black photographer to receive a prestigious Guggenheim Fellowship. He opened A Photographer's Gallery in 1955, which became one of the first in the United States devoted to the exhibition and sale of photography as a fine art. In 1955 four of DeCarava's photographs from his book with the poet Langston Hughes, *The Sweet Flypaper of Life* (see fig. 2, p. 212), were included in the landmark show *The Family of Man* at the Museum of Modern Art in New York. Both DeCarava and White were activists who worked closely as leaders of the Committee for the Negro in the Arts, an organization founded in 1947 to advocate for greater African American participation and representation across cultural media.[9] DeCarava recalled being "deeply affected by White's warmth of fellow feeling, his identification with 'the mass of people who are disenfranchised and miserable.'"[10] Art historian Peter Galassi describes White's influence on his young friend: "[DeCarava's] deepest early attachment was to White. . . . White preferred black-and-white drawing to painting, and his solitary, emblematic figures—a mother, a soldier, a worker, a musician—have an evident parallel in DeCarava's photography."[11]

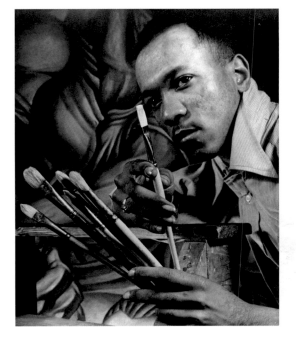

FIG. 1
**GORDON PARKS
(AMERICAN, 1912–2006)**

Portrait of Charles White. Photograph. Gordon Parks Foundation.

As a social realist artist, White was concerned above all with the human condition. His photographs, like the rest of his creative output, expressed his progressive convictions.[12] The artist chronicled the theater of the street, and as we look at his scenes of everyday life and snapshots of friends and students, we experience how he understood city life. White lived in New York City for almost fifteen years, studying art and teaching graphic design while painting and making pictures. He spent a considerable amount of time walking in neighborhoods and districts such as Greenwich Village, the Lower East Side, Midtown, and Harlem, taking in the people, architecture, and bustling streets. In one photograph, White captures a man carrying a 35 mm camera who has stopped to photograph children playing in front of a brownstone. White snapped this scene from across the street; he also took a closer image with one of the boys looking directly at him (pl. 64) and boys in a group of three (fig. 2). White composed

FIG. 2
**CHARLES WHITE
(AMERICAN, 1918–1979)**

Three boys posing, 1950s. Black-and-white photograph; 7.9 × 11.4 cm (3 ⅛ × 4 ½ in.). Private collection.

the shot to frame them off-center, accentuating the empty space to the left. White photographed both black and white children of all ages and during all seasons. They play outdoors with sticks and carry books, create art on the sidewalks, walk with their mothers and friends, and look into his camera playfully or appear oblivious to his presence. White created scenes that were both vibrant and sedate. City dwellers protest, play, skate, sell, and shop—not confined to their small apartments in the cold of winter or heat of summer. He photographed and painted social life—street vendors selling meals off their carts, an umbrella salesman creating an artistic display, pedestrians window shopping outside Fifth Avenue department stores and along 125th Street in Harlem. In a tongue-in-cheek photograph (fig. 3), a man in a suit sleeps soundly on a step stenciled "No Parking."

Although White's photographs suggest casual snapshots or ordinary scenes of daily life, he composed each one purposefully. The medium offered him another means to explore social issues and human relationships. This attention to individuals, as well as to details such as a garment or a gesture signaling fatigue, reveals significance and beauty in seemingly ordinary details. One example of this is a photograph of a woman with her back to the camera, holding two bags (fig. 4). Their weight is evident from the sway of her back and shoulders. She is the only woman near this Harlem subway kiosk, which displays an assortment of magazines and stacks of newspapers as two men sit, likely waiting for shoeshine customers. These men wear hats, as do others milling in the vicinity, and the busy street corner invites us to imagine that this might be the way home after a long workday. The newsstand offers a variety of choices for Harlem residents: local papers for those interested in politics, classified ads for people searching for work, and picture magazines to keep up-to-date on cultural events. The 1950s-style dress distinctly framed gender—men in wide hats and overcoats, women with scarves and sweaters. Unlike many of White's paintings and prints, his photographs are crowded and busy, celebrating subjects who manifest the heroic in everyday life.

White photographed artist friends in doorways and within window frames, or bathed in natural light on streets and beaches—in effect framing the future of African American art. He captured social realist painter Ernest Crichlow smiling for the camera

FIG. 4
CHARLES WHITE
(AMERICAN, 1918–1979)

Woman near newsstand, 1950s.
Black-and-white photograph;
7.9 × 11.6 cm (3 ⅛ × 4 ⁹⁄₁₆ in.).
Private collection.

and wearing round glasses, a herringbone overcoat, and a large hat fashionably tilted to the side, with a camera strap on one shoulder. On another day, White photographed Crichlow, now hatless, standing in a crowd of onlookers at a parade, his back to the camera, the strap still visible, as he looks in the opposite direction than the crowd does (fig. 5). White appears to have photographed the printmaker Robert Blackburn from below as building tops and a cloudless sky dominate the upper half of the composition. Blackburn is unposed, wearing a beret as he raises his left hand to his face.

White's photographs include pictures of friends and family. With each one, he sought to illuminate his subject's life story. His sensitive portraits of his wife and mother brought out their beauty and humanity. In two photographs of his mother, Ethelene Gary Marsh, taken around 1950, she wears a white blouse and jewelry. White's pictures celebrate her grace and express his respect for the hard-working woman who supported his early artistic interests. In one frame, she smiles at her son as he snaps the shot. In a three-quarter view (pl. 53), she turns to the left in a thoughtful pose. There are several portraits of his wife Frances, probably taken at about the same time. In one (pl. 52) she wears a dark cotton blouse with a round collar; the soft lighting highlights her beauty and her warm smile hints at their close bond.

Many of the subjects in these photographs were friends and fellow artists involved with the Committee for the Negro in the Arts. These are close-cropped portraits shot indoors, which allowed White to play with the lighting, as in two images of DeCarava. In one picture, DeCarava looks directly at the camera (pl. 56); a dramatic shadow obscures the right side of his face. On another day, he poses with eyes aimed straight ahead and shadow falling softly on the wall behind his shoulder. A pensive Jacob Lawrence (pl. 55), wearing a suit and dark tie with a colored shirt, is framed near a window in White's apartment. He faces the camera but looks sharply to his right. White photographed him again looking outside with his head turned in the other direction. Two posed photographs of artist Margaret Burroughs (see pl. 54) express White's tenderness for his high school classmate and colleague in the Art Crafts Guild in Chicago. White and Burroughs also worked together at the Workers Children's Camp in New Jersey, one of the first interracial and coeducational camps.[13] The intimacy of these portraits indicates the warm bond of lifelong friends.

White also took many photographs of street protests of the era. In a unique position as a part of the crowd, he participated in and recorded the rallies and parades without difficulty. The imposing actor Frank Silvera confidently looks upward as he stands casually behind Crichlow (partly cropped out at the right edge) as the latter takes in the proceedings (fig. 6). This particular event was in protest of the arrest and conviction of a wrongfully accused Mississippi man, Willie McGee. The case became a cause célèbre worldwide, sparking reaction from acclaimed artists and writers Richard Wright, Tennessee Williams, and William Faulkner. In one photograph, a protest poster rises above the crowd (pl. 69).[14] White's photographs of parades and marches included all kinds of participants, from a marcher in full Ku Klux Klan robe and hood holding a Klan sign (pl. 67) to protesters carrying signs that read "Outlaw Anti-Semitism" (pl. 68). He was drawn to diverse gatherings and onlookers—people carrying babies and hand-bags, wearing uniforms and Stetson hats, leaning over parade barricades—whose attention was on the events on the streets and who were unaware of his camera.

White also recorded moments of personal connection experienced by the strangers he encountered on the street. He composed some scenes with such intimacy that they suggest relationships and moments of pure joy. In a crowd of teenage boys, a young black girl wearing a baseball jacket and skirt stands shoulder to shoulder

FIG. 5
CHARLES WHITE
(AMERICAN, 1918–1979)

Ernest Crichlow, 1950s. Black-and-white photograph; 7.9 × 11.4 cm (3 ⅛ × 4 ½ in.). Private collection.

FIG. 6
CHARLES WHITE
(AMERICAN, 1918–1979)

Frank Silvera (left) and Ernest Crichlow (at right, cropped), 1950s. Black-and-white photograph; 7.9 × 11.4 cm (3 ⅛ × 4 ½ in.). Private collection.

with a black man in a hat and a pinstripe suit. The white barrette in her hair sparkles amid the motion of boys in white shirts to her right. White portrayed a connection both curious and tender as the young girl looks down and over the shoulder of the adult, possibly her father. The afternoon sun shining through a fence in front of them casts a shadow on their smiling faces. Across the street in the background, a white dog on the sidewalk approaches congregating men. This is the quiet humanity that he found crucial to document.

FIG. 7
**CHARLES WHITE
(AMERICAN, 1918–1979)**

Musician in Washington Square Park. Black-and-white photograph; 8.3 × 11.8 cm (3 ¼ × 4 ⅝ in.). Private collection.

White also took sequences of shots at specific locations. Washington Square Park was one place that drew him and his camera. He explored the park's attraction to a wide array of people: musicians and music lovers, chess players, dog walkers, and families. In one picture, a male guitarist performs in a wheelchair in the midst of a large crowd. White also took a series of close-up portraits of a young female guitarist in a white floral-printed dress. She is accompanied by male admirers who appear to appreciate her music (see fig. 7 and pl. 62). With a flower pinned to her right shoulder as the strap of the guitar crosses her chest, she projects a marked female presence. White recorded her and others in various frames as she plucks the strings. The scene inspired his 1951 painting *Gospel Singers* (pl. 38). One photograph in particular (pl. 62) was clearly used as a study: the musician's bobbed haircut, cropped sleeves, loose-fitting dress, and bend of the head are the same. "It is not that I have ever tried to translate the music directly into pictorial art," White reflected. "But the music affected me so perfectly, in a way that touched the heart more directly than any other art, the dignity, the outpouring of tenderness, the social and comradely feelings, and humanity of the people," he said regarding the influence of music in his work. "It is this that has helped in my efforts, in paintings and drawings, to present a feeling of universal humanity within a particular image, so that all people of good will, looking at a particular image would feel that something of themselves was contained there."[15] The photographic studies of the Washington Square guitarist and her friend can be understood as part of White's process of expressing his beliefs visually.

Another powerful example is a series of photographs of a blind woman (figs. 8–10). She has situated herself at a bustling street corner in Harlem and would have been seen by all approaching the intersection. It is wintertime, and people are bundled up in heavy overcoats; she has a cup pinned to hers. On her lap is a weighty book; in one photograph the placement of her hands suggests that she is reading braille. She sits directly under a mailbox with "Letters" marked boldly in white (the delivery zone, noted on the mailbox, locates the scene in Harlem). White took two photographs documenting an encounter between this particular woman and a man in an overcoat and hat. In one shot, the gentleman, with his hands casually tucked in his pockets, engages her in conversation (fig. 8). White stepped to the side to document the man bending down with his hand reaching toward her, while she raises her hand to her chest (fig. 9).

In a third photograph in this sequence, White observed another man also photographing the blind woman (fig. 10); it is not clear whether she is aware of the presence of either photographer. White composed the scene in such a way that a sign hanging to her left is visible at the top left corner, ironically announcing "Money Back on Request." The prominence of the blind subject—and her inability to see the busy scene around her—makes this a remarkable encounter. Dyer describes a similar theme in relation to photographer Paul Strand's iconic 1916 *Blind Beggar*:

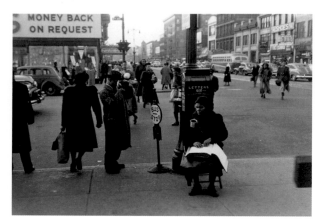

FIGS. 8–10
CHARLES WHITE
(AMERICAN, 1918–1979)

Blind woman at a Harlem street
corner, 1950s. Each: 7.9 × 11.6 cm
(3 ⅛ × 4 ⁹⁄₁₆ in.). All private collection.

The photographer sees his subject as she is unable to see herself. An unconscious embodiment or representative of the process whereby the photographer becomes unheeded, invisible, she is in turn a projection of his ultimate ambition: to become her—and the world's—eyes. . . . The blind subject is the objective corollary of the photographer's longed-for invisibility. It comes as no surprise therefore—the logic of the medium seems almost to demand it—that so many photographers have made pictures of the blind.[16]

White's photograph, however, adds nuance to Strand's sense of invisibility. Although the blind woman does not register his presence, the appearance of the second camera operator draws attention to the photographic action. It reinscribes White's presence, evoking his choices as artist and documentarian.

The scale and form in which White depicted the varied experiences of black Americans shifted over time and across media but were framed in his reflective imagination. A photograph of White working on a large canvas with the boldness and realistic portrayal of a history painting illustrates the scope of his influence in creating work that shaped movements from social realism to the Black Arts Movement of the 1960s. Activist and actor Belafonte (see pl. 58) aptly lauded White's lifetime commitment to represent his subjects despite the ever-changing tastes and styles of the art world: "In a period when many artists have deserted reality for the various schools of non-objectivity and abstractionism, Mr. White has continued to work for broader horizons of human expression and to explore deeper dimensions of truth and reality."[17]

White's lifelong interest in recording and interpreting the people and places around him, which began in painting and graphic design and led to his work as a master printmaker, also informed his important, personal explorations as a photographer. All his artistic endeavors—paintings, drawings, prints, and photographs—reveal much about the lives and hopes of black Americans and reflect a view of the world that is both lyrical and truthful. His photographs document the power and the beauty of African American life and offer an inclusive, positive view of society and humanity, of people "in search of the good life." This unstudied collection of photographs quite literally shows how White looked at the world, and it invites fresh examination of his oeuvre and practice.

1. White, oral history interview by Hoag.

2. This collection of personal photographs taken by Charles White was never exhibited or sold.

3. Driskell, foreword to Barnwell, *Charles White*, v.

4. Dyer, "The Intimacy behind Jazz's Seminal Image."

5. Driskell, foreword to Barnwell, *Charles White*, ix.

6. Tucker, *This Was the Photo League*, 9–19.

7. Tucker, "The Photo League."

8. Parks, *Voices in the Mirror*, 171.

9. Galassi, *Roy DeCarava*, 32.

10. Ibid., 15.

11. Ibid.

12. Social realists envisioned themselves as workers and laborers, similar to those who toiled in the fields and factories. Often taking side jobs to earn supplemental income that would support their cultural work, these artists identified with the working class, rather than as elites living on the margins and working for the upper crust. White, for example, worked as a cook and newspaper carrier. As Stacy Morgan notes, these artists felt they were critical members of society, "often constructing themselves as "cultural workers.'" Morgan, *Rethinking Social Realism*, 5. Melanie Anne Herzog writes that the "social realist art scene at that time was a movement unique in the history of art in the United States for its class consciousness and racial integration"; see Herzog, *Elizabeth Catlett*, 43.

13. White worked as an arts coordinator with Burroughs, Crichlow, Elizabeth Catlett (White's first wife), Rockwell Kent, and Robert Nemeroff as well as Frances Barrett, whom he married in 1950. Barnwell, *Charles White*, 39.

14. "Willie McGee," Mississippi Civil Rights Project, mscivilrightsproject.org/jones /person-jones/willie-mcgee/. In March 1951, Faulkner (the 1950 Nobel Prize laureate) spoke to a group of northern and southern McGee supporters, arguing that McGee had been framed and was innocent of the charges against him. Wright raised $18,000 for McGee's widow and children. Williams even included a reference to the McGee case in his play *Orpheus Descending* through the character of Carol Cutrere.

15. White, "Path of a Negro Artist," 40.

16. Dyer, *The Ongoing Moment*, 13.

17. Belafonte, foreword to *Images of Dignity*, quoted in "Images of Dignity: A Portfolio of Drawings by Charles White," *Negro Digest*, June 1967, cited in Victoria L. Valentine, "*Negro Digest* Publishes Charles White's 'Images of Dignity,'" www.culturetype .com/2013/10/25/negro-digest-publishes -charles-whites-images-of-dignity.

NEW YORK

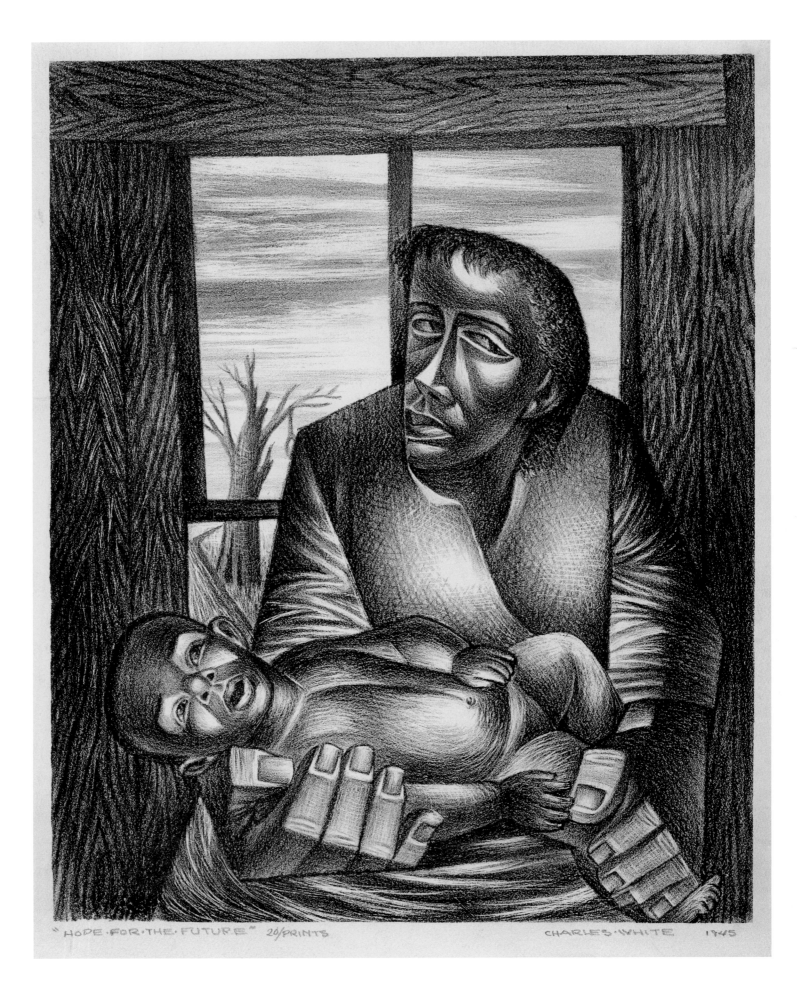

"HOPE·FOR·THE·FUTURE" 20/PRINTS CHARLES·WHITE 1945

24. *Hope for the Future*, 1945
Lithograph on paper
Cat. 23

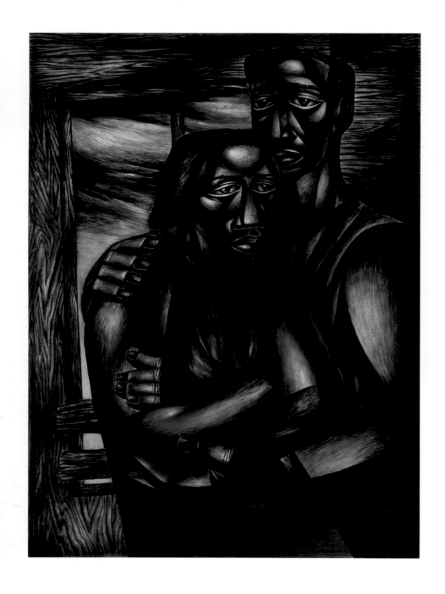

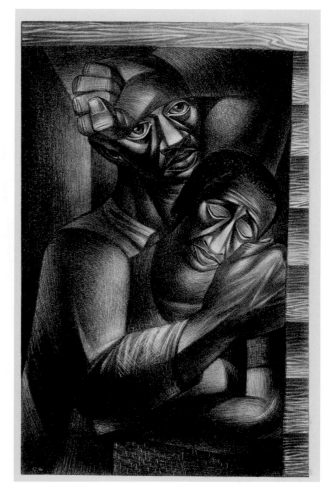

25. *Two Alone*, 1946
Oil on board
Cat. 29

26. *Black Sorrow (Dolor Negro)*, 1946
Lithograph on paper
Cat. 26

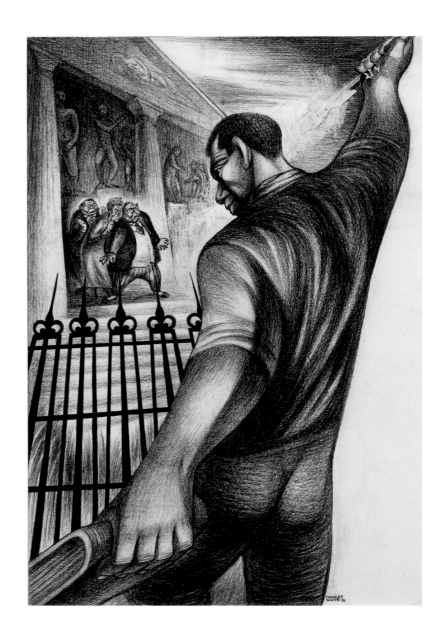

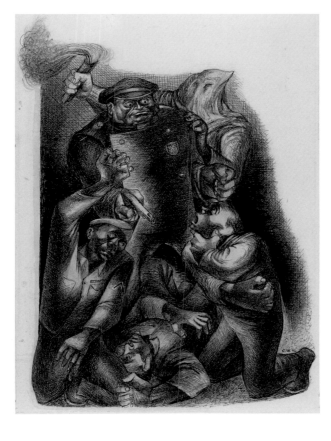

27. *The Return of the Soldier*
(Dixie Comes to New York), 1946
Ink with white additions on board
Cat. 28

28. *Can a Negro Study Law in Texas*, 1946
Charcoal and ink, with white heightening, on paper
Cat. 27

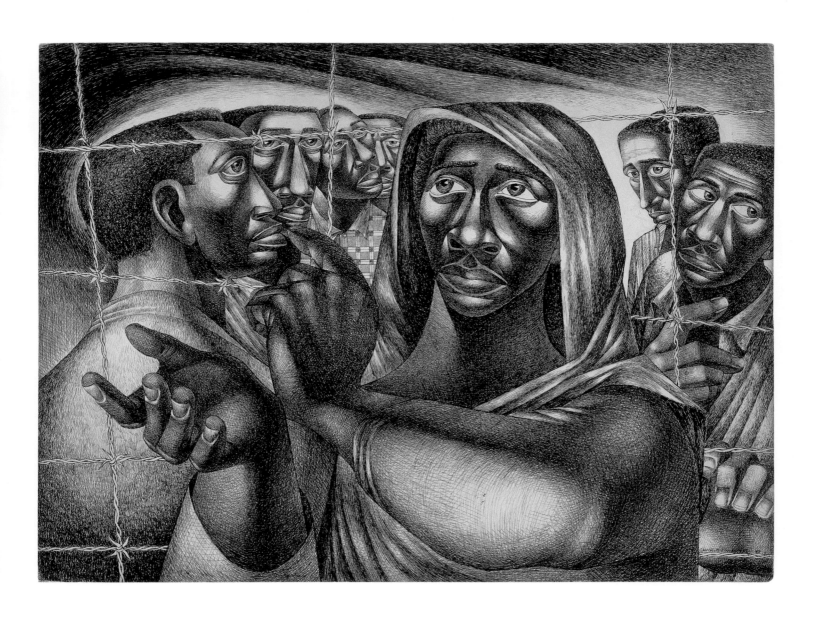

29. *Trenton Six*, 1949
Ink over graphite underdrawing on paperboard
Cat. 34

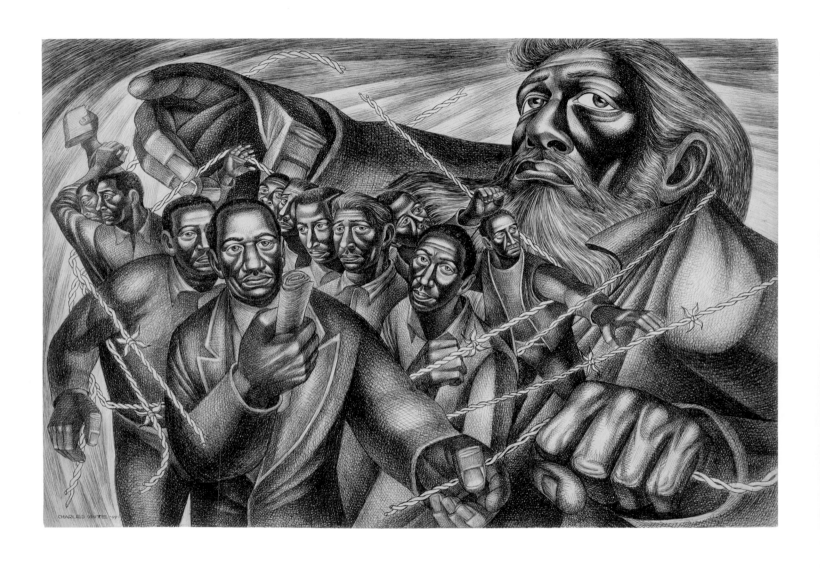

30. *Frederick Douglass Lives Again*
(The Ghost of Frederick Douglass), 1949
Pen and ink over pencil on illustration board

Cat. 32

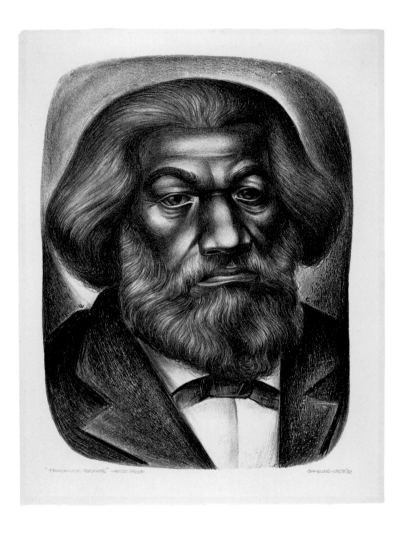

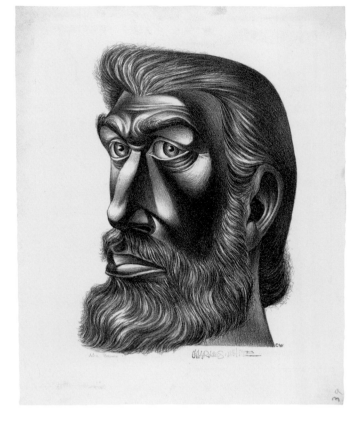

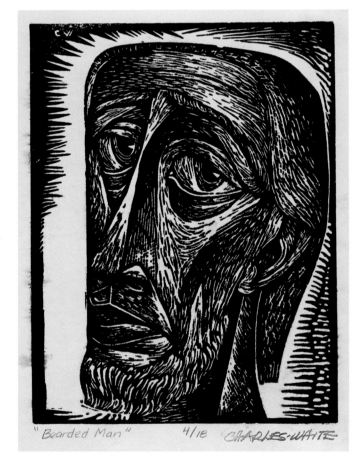

31. *Frederick Douglass*, 1950
Lithograph on paper
Cat. 36

32. *John Brown*, 1949
Lithograph on paper
Cat. 33

33. *Untitled (Bearded Man)*, c. 1949
Linocut in black on cream wove paper
Cat. 31

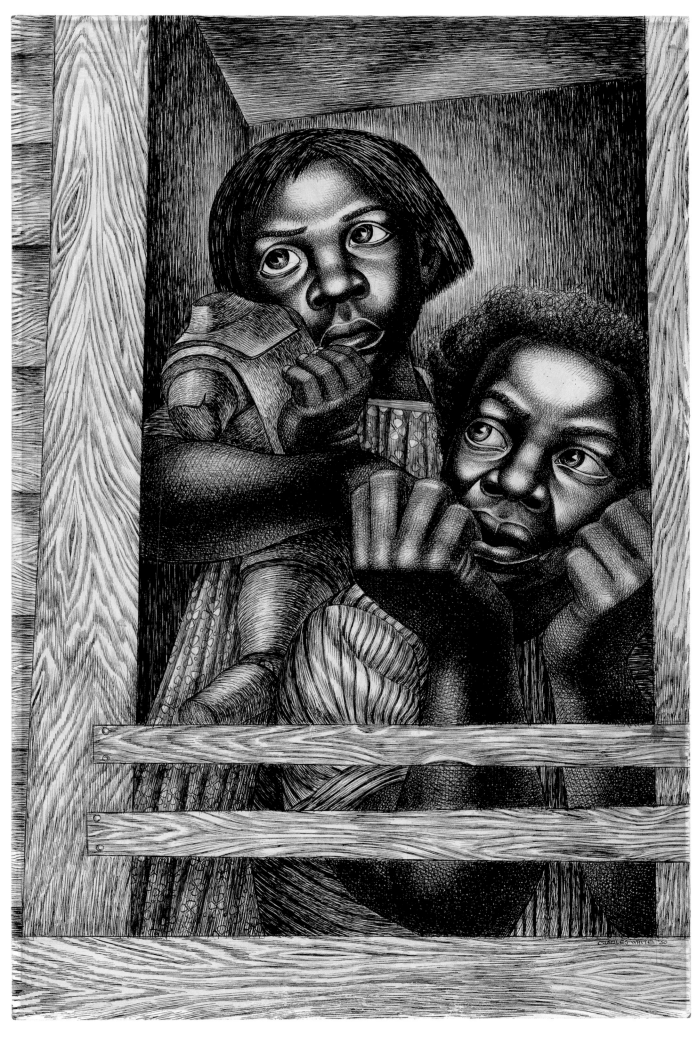

34. *The Children*, 1950
Ink and graphite on paper
Cat. 37

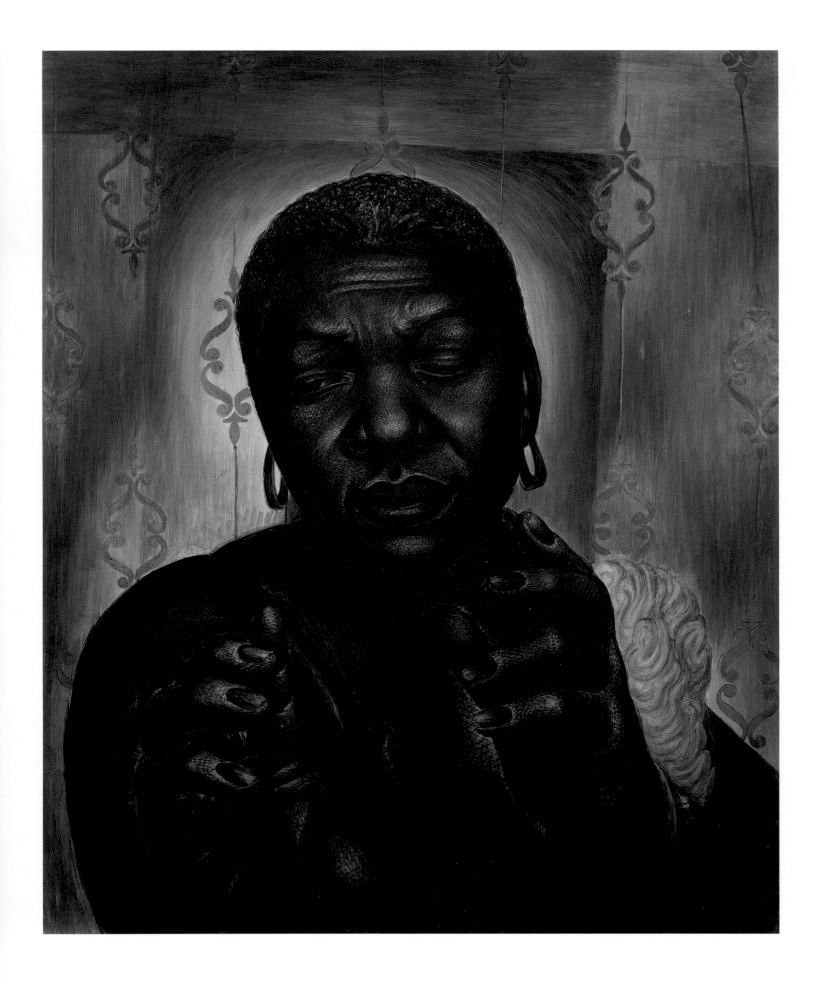

35. *Bessie Smith*, 1950
Tempera on panel
Cat. 35

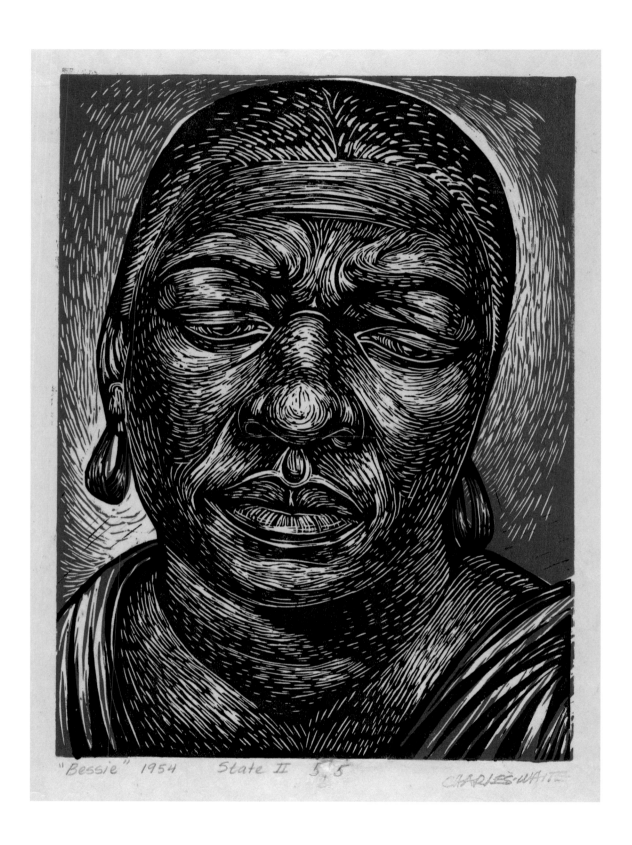

"Bessie" 1954 State II 5/5 CHARLES·WHITE

36. *Bessie Smith*, 1954
Linocut printed in green and black on
cream Japanese paper
Cat. 50

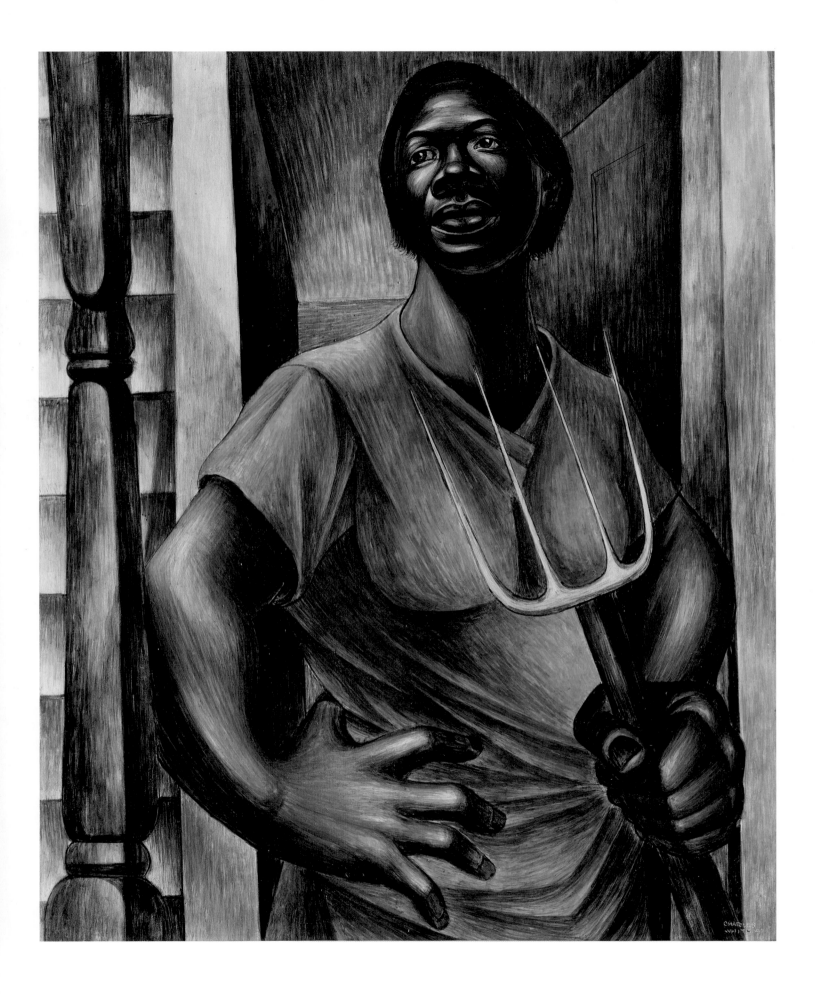

37. *Our Land*, 1951
Tempera on panel
Cat. 41

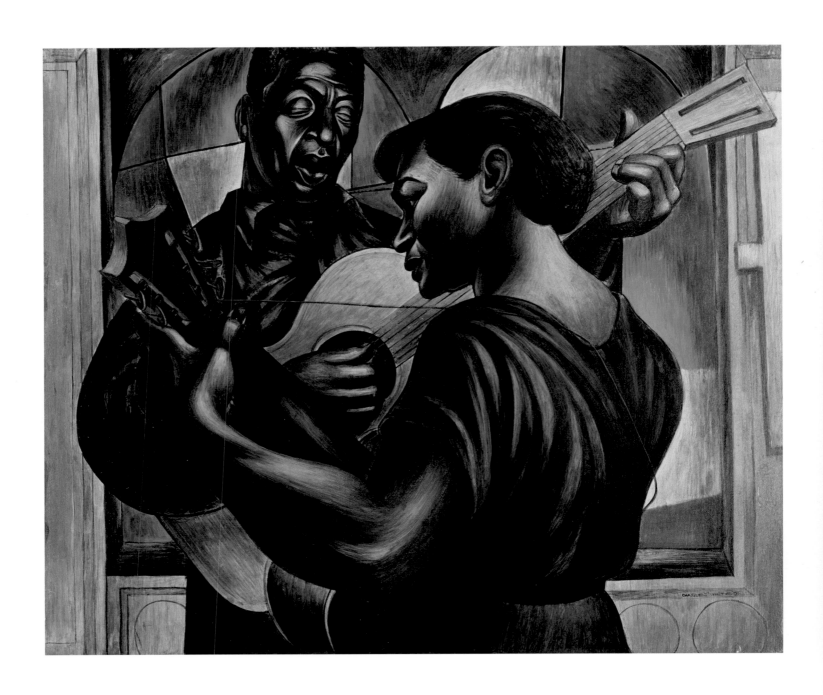

38. *Gospel Singers*, 1951
Tempera on board
Cat. 40

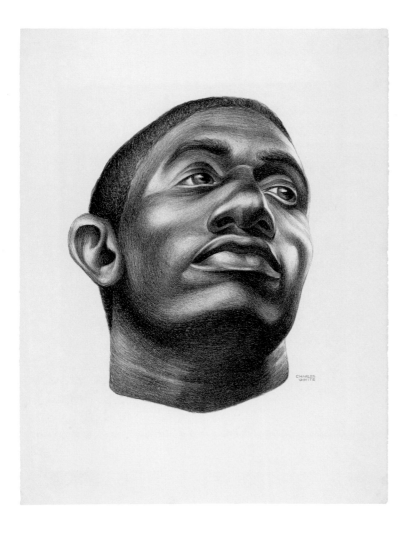

39. *Gideon*, 1951
Lithograph in black on ivory wove paper
Cat. 39

40. *Exodus I: Black Moses (Harriet Tubman)*, 1951
Linocut on paper
Cat. 38

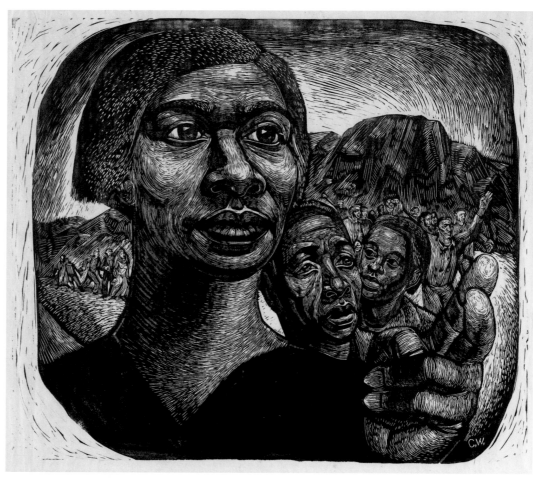

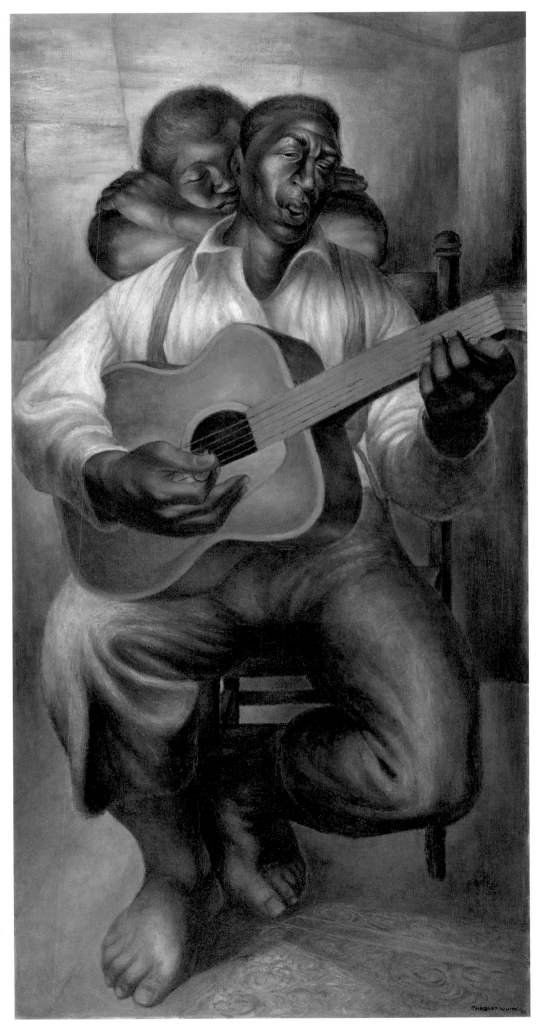

41. *Goodnight Irene*, 1952
Oil on canvas
Cat. 43

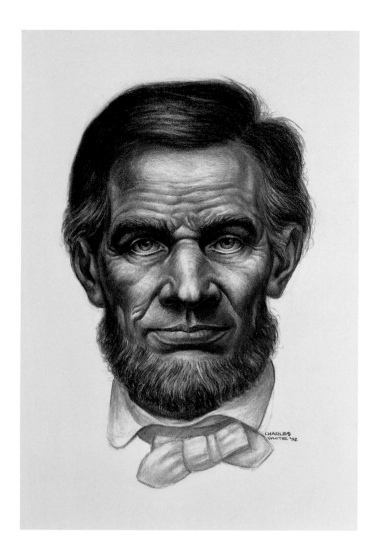

42. *Abraham Lincoln*, 1952
Wolff crayon and charcoal on paperboard
Cat. 42

43. *Harvest Talk*, 1953
Charcoal, Wolff crayon, and graphite, with stumping
and erasing, on ivory wood-pulp laminate board
Cat. 45

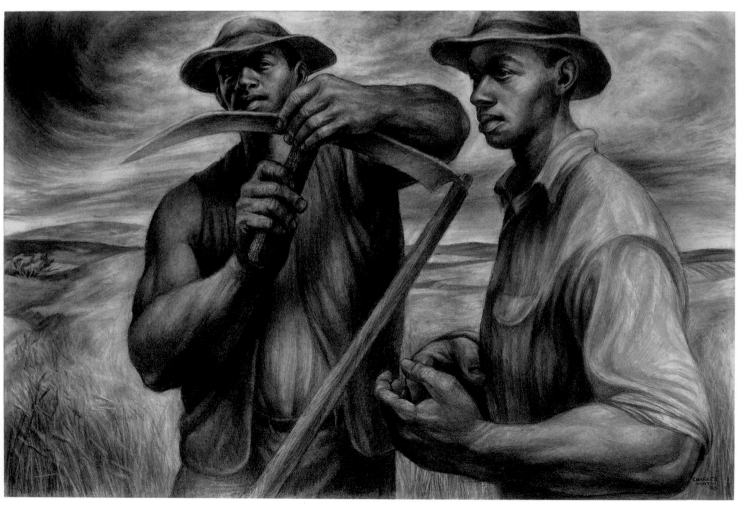

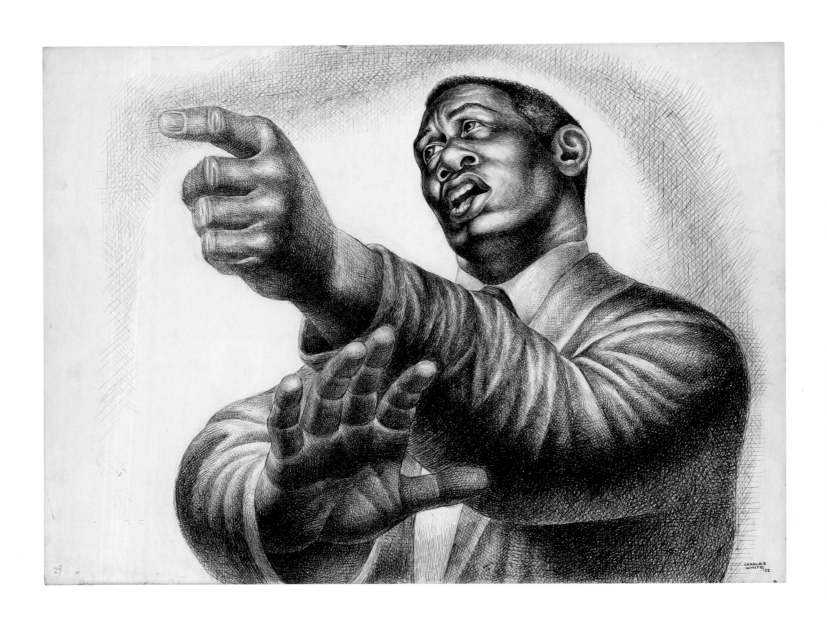

44. *Preacher*, 1952
Pen and ink and graphite pencil on board
Cat. 44

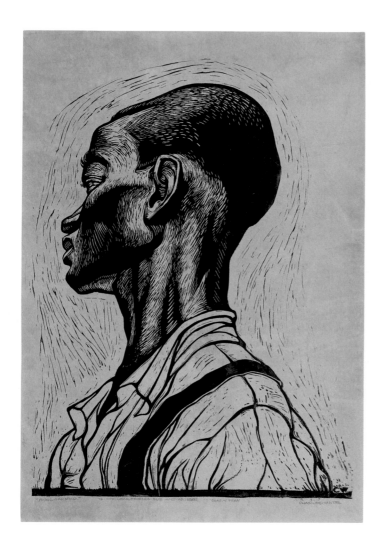

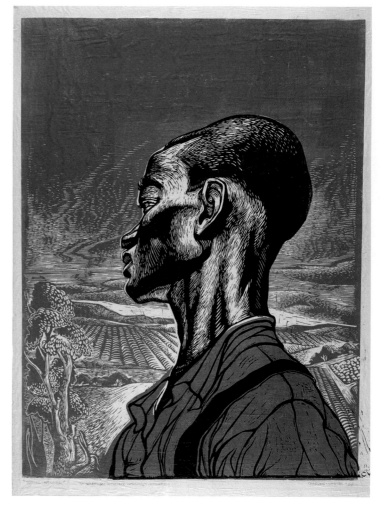

45. *Young Farmer*, 1953
Linocut on paper
Cat. 48

46. *Young Farmer*, 1953
Linocut on paper laid on board
Cat. 49

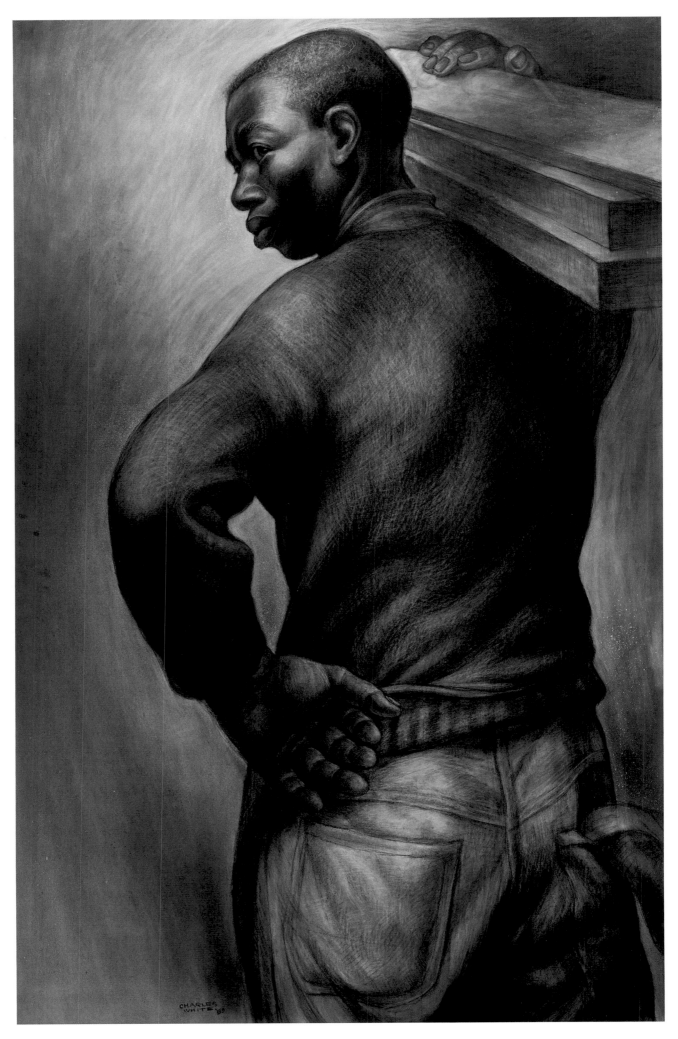

47. *Work (Young Worker)*, 1953
Wolff crayon and charcoal on illustration board
Cat. 46

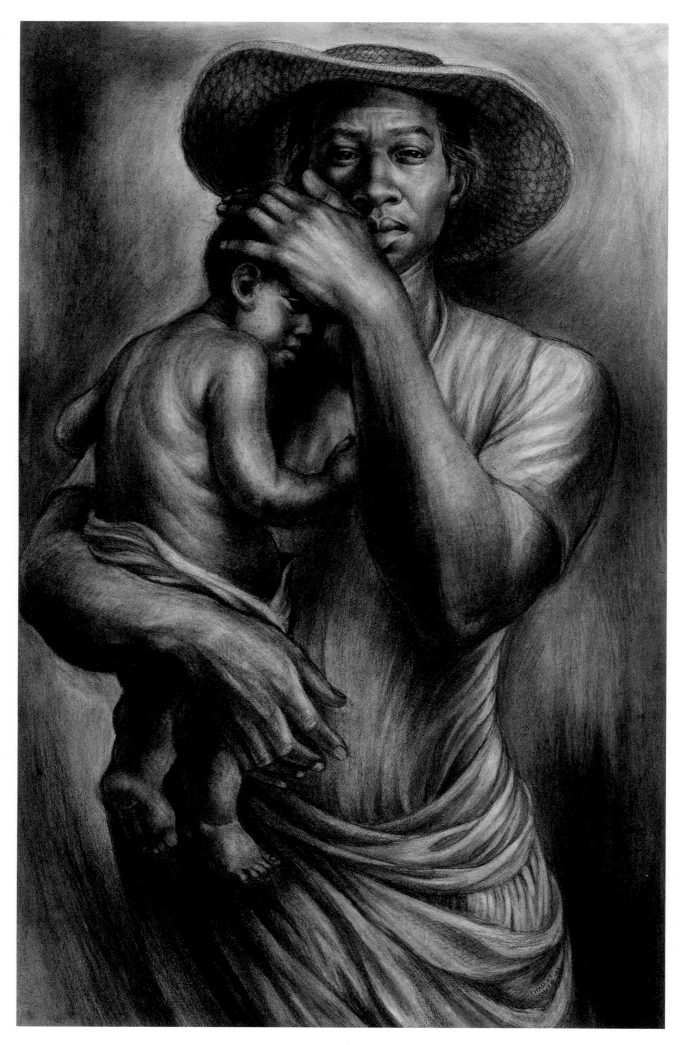

48. *Ye Shall Inherit the Earth*, 1953
Charcoal on paper
Cat. 47

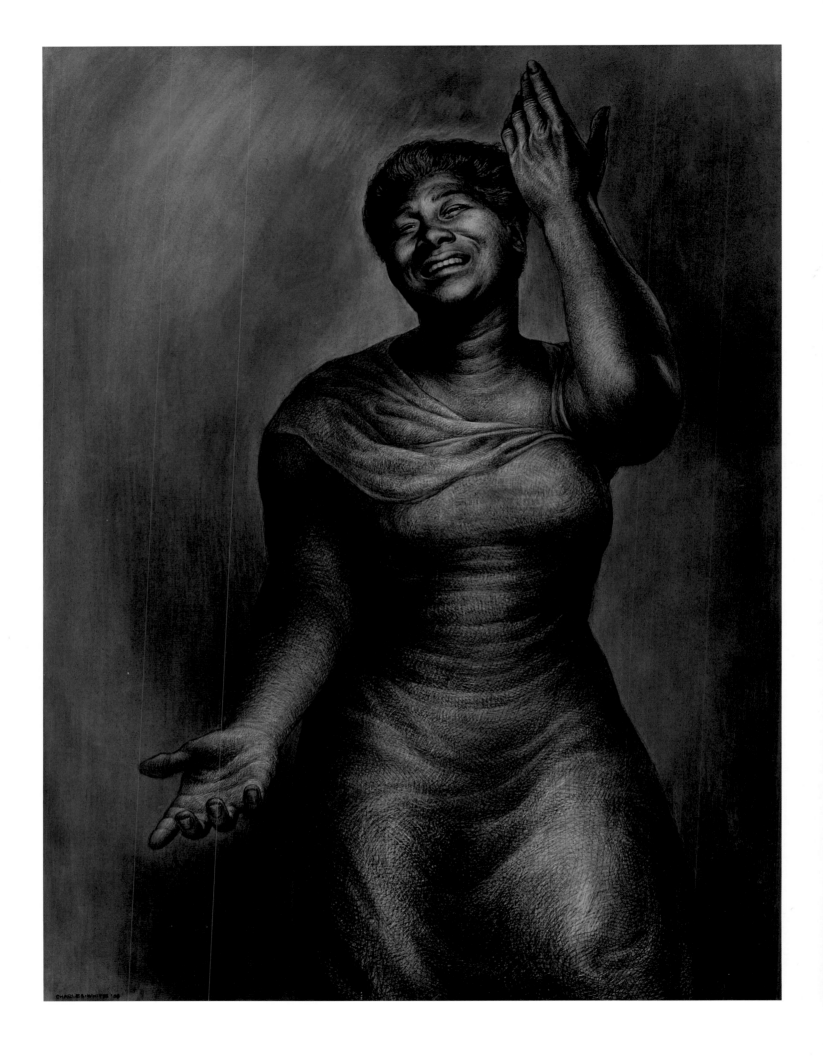

49. *Mahalia*, 1955
Charcoal and Conté crayon on board
Cat. 51

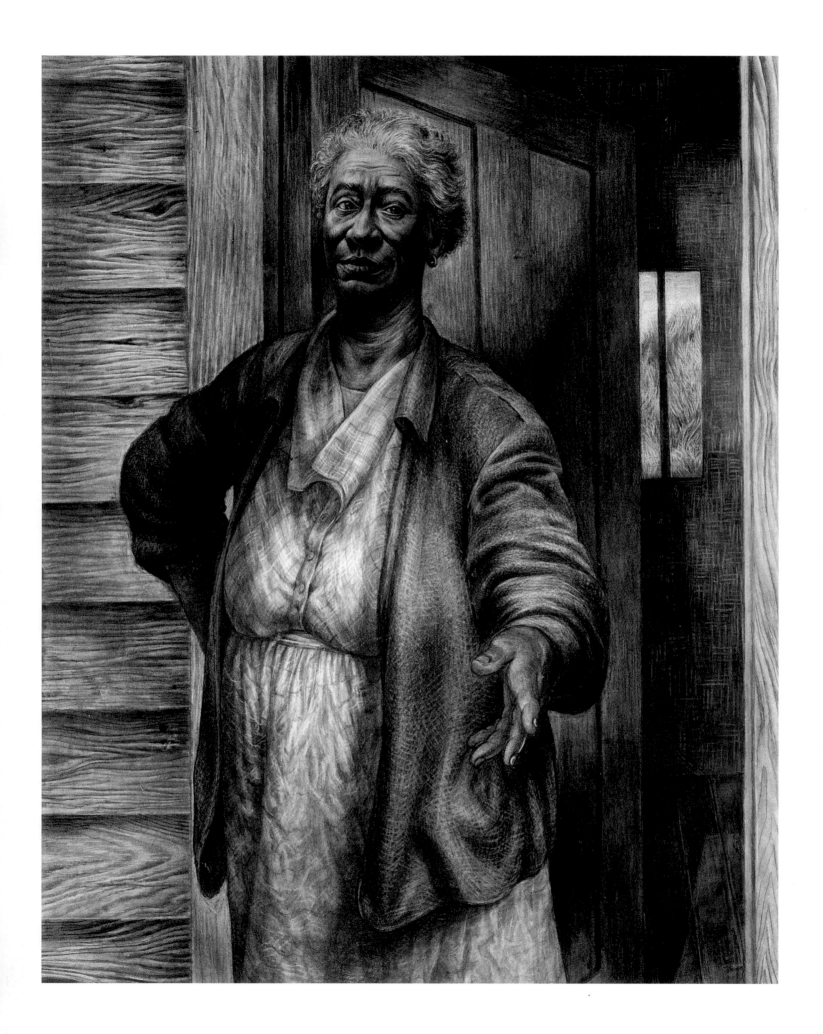

50. *I've Been 'Buked and I've Been Scorned*, 1956
Compressed and vine charcoal with carbon pencil and charcoal
wash splatter over traces of graphite pencil on illustration board
Cat. 52

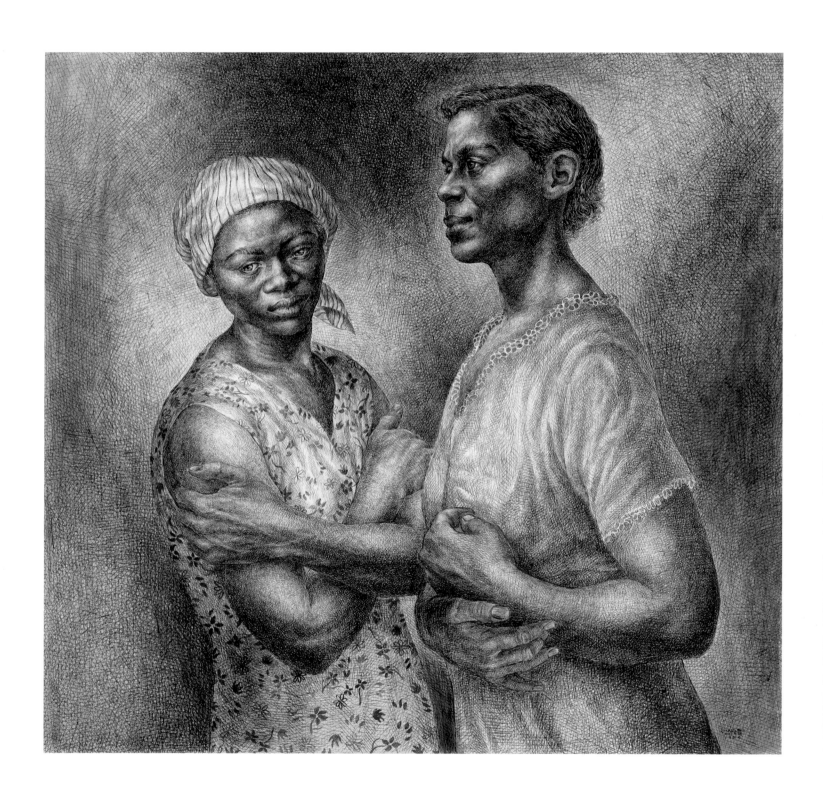

51. *Oh, Mary, Don't You Weep*, 1956
Graphite and pen and ink on board
Cat. 53

52. Frances Barrett White, 1950
Black-and-white photograph
Cat. 92

53. Ethelene Gary Marsh, 1950
Black-and-white photograph
Cat. 91

54. Margaret Burroughs, 1950s
Black-and-white photograph
Cat. 100

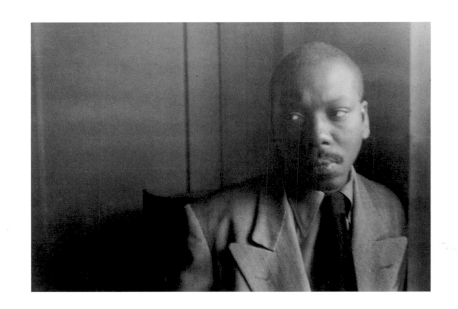

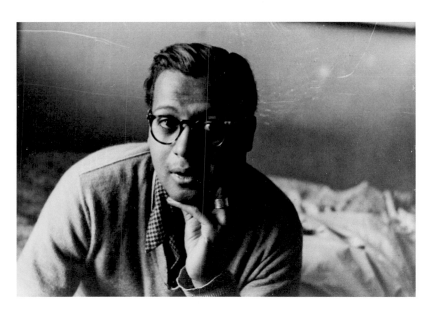

55. Jacob Lawrence, 1950
Black-and-white photograph
Cat. 93

56. Roy DeCarava, 1950s
Black-and-white photograph
Cat. 105

57. Miriam Makeba, 1950s
Black-and-white photograph
Cat. 101

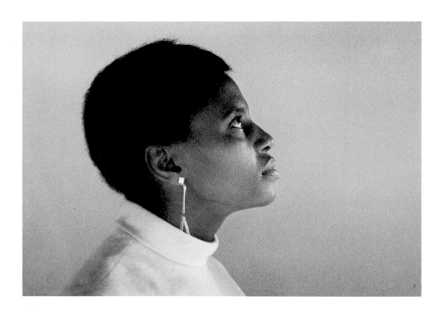

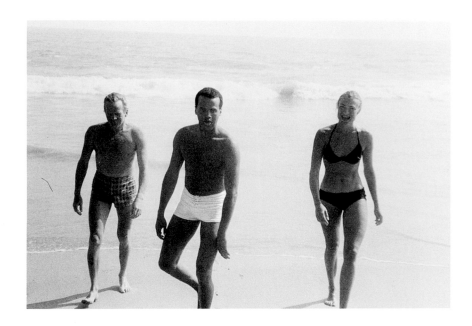

58. Harry Belafonte and
Mr. and Mrs. David Stone Martin, 1957
Black-and-white photograph
Cat. 108

59. Woman reading *Jet* magazine, 1950s
Black-and-white photograph
Cat. 107

60. Drawing class, 1950s
Black-and-white photograph
Cat. 96

61. Street artist, 1950s
Black-and-white photograph
Cat. 106

62. Musician in Washington Square Park, 1950s
Black-and-white photograph
Cat. 102

63. Boy playing on street, 1950s
Black-and-white photograph
Cat. 94

64. Boys on the street with photographer behind, 1950s
Black-and-white photograph
Cat. 95

65. Newsstand and pedestrians, 1950s
Black-and-white photograph
Cat. 103

66. Protest onlookers, 1950s
Black-and-white photograph
Cat. 104

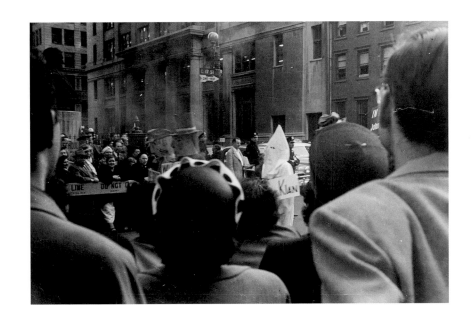

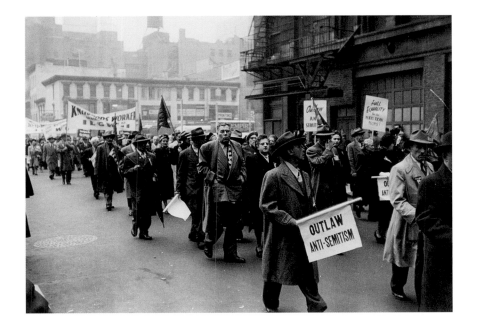

67. March in New York, 1950s
Black-and-white photograph
Cat. 97

68. March to outlaw anti-Semitism, 1950s
Black-and-white photograph
Cat. 99

69. March in New York, 1950s
Black-and-white photograph
Cat. 98

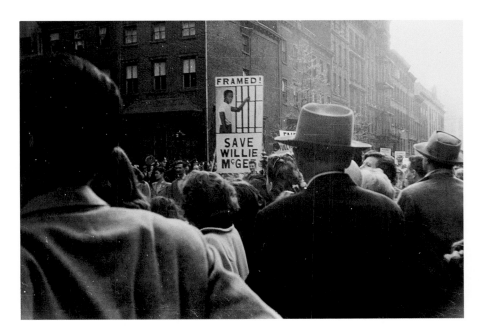

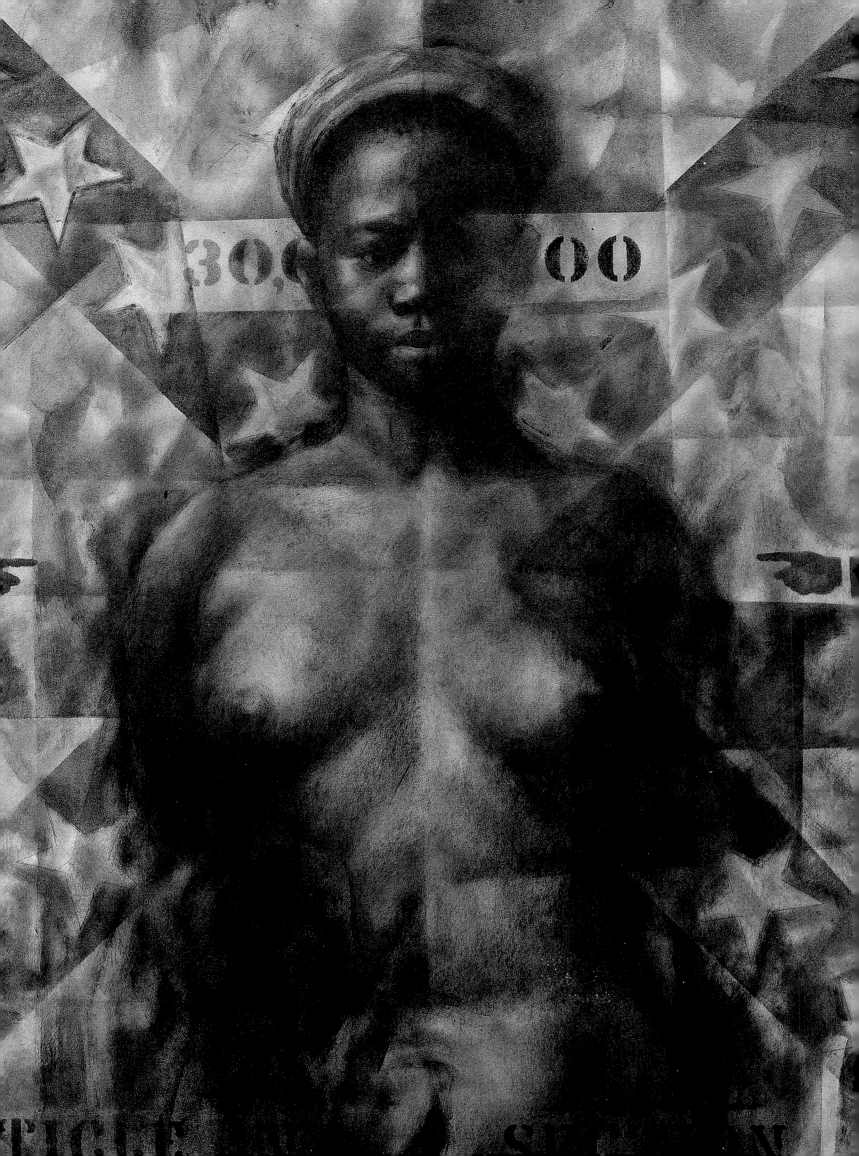

CHARLES WHITE'S ART AND ACTIVISM IN SOUTHERN CALIFORNIA

ILENE SUSAN FORT

Charles White found in Los Angeles a "big sprawling country town" drastically different from the intense, integrated, leftist milieu of New York where he and his wife Frances lived until September 1956.[1] At the time, it lacked the sophistication of cities like New York and Chicago, and the art scene lagged decades behind.[2] But while White may have removed himself from the center of the US art world in search of relief from the effects of tuberculosis, his departure in no way curtailed his art making and commitment to social causes.[3] From his arrival in Southern California until his death in 1979, he continued to quietly and calmly promote his humanistic ideals and encourage the advancement of racial equality. His art spoke to and about black experiences while demonstrating, promoting, and honoring African Americans' dignity and history.

White's commitment to leftist causes was long-standing. Beginning in the mid-1940s, he contributed illustrations to socialist and Marxist publications (see Esther Adler's essay in this volume). In 1951 he traveled to the Soviet Union, where he admired what he saw as advances in economic and social justice. But in 1956, Soviet leader Nikita Khrushchev denounced the recently deceased leader Joseph Stalin, detailing a list of crimes that included purges, deportations, and labor camps. The text of the speech was soon smuggled abroad and published in Western newspapers. By the time the Whites arrived in California later that same year, the couple had to find not only a new home but also a different progressive social action group with which to align themselves.

The mid-1950s witnessed the beginning of the civil rights movement. The Whites became involved in both local and national organizations to support the passive resistance espoused by Martin Luther King Jr. Their tight financial situation prohibited cash contributions, but White allowed his name to be included in membership and pledge campaigns, and he donated his art to fundraising efforts. In 1960 he joined the Committee to Defend Martin Luther King, Jr., and the Struggle for Freedom in the South, a group formed in Harry Belafonte's New York apartment shortly after the minister was arrested for tax fraud. White was a signatory to a *New York Times*

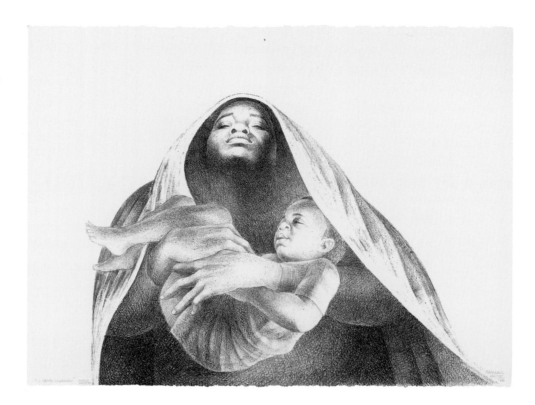

advertisement condemning Alabama for its harassment of King, which led to a warrant for White's arrest there.[4] Both White and his wife aided the committee in identifying prominent Southern California black leaders who could financially support King's defense.[5] After the civil rights leader's assassination in 1968, White participated in an exhibition and auction in his memory at the Museum of Modern Art in New York to benefit the Southern Christian Leadership Foundation, offering his major drawing *Birmingham Totem* (pl. 70). He also donated artworks for memorials held in Los Angeles and New York commemorating the first anniversary of King's death. The artist created several prints honoring King's "I Have a Dream" speech (see fig. 1), unique works in 1965 and 1976, and a series in 1969.[6]

Despite White's alignment with King, his approach resonated even with militaristic black artists such as Black Panther illustrator Emory Douglas (see fig. 2). Douglas appreciated White's art even though it did not incite the viewer, as he said, to "go out and kill pigs."[7] Longtime Los Angeles County Museum of Art (LACMA) staff member and black activist Cecil Fergerson knew White personally and admired his broad-minded perspective. Fergerson concluded that White's less overt type of protest had a great influence within the Los Angeles cultural community.

> He [White] never did talk much about social communism to us. But he was still political. He was good for us because, as his artwork is, it's political, but it's not guns and hand grenades. It's about people, right? So he could quiet us down when we were thinking of doing something stupid, you know. He could show us the power of art without the guns.[8]

LOS ANGELES'S BLACK AND WHITE COMMUNITIES

White was among the tens of thousands of African Americans who migrated to Southern California in the decades after World War II—in less than fifteen years, the black population there more than doubled.[9] Encouraged by the belief that middle-class life would be more attainable there, black people flooded the region, seeking jobs and homes in the new, modern housing developments. According to art historian Kellie

Jones, such a transplantation of home for black people at this time enabled many to change their social and economic circumstances, even to the extent of reinvention.[10] However, although the federal government had banned Los Angeles's restrictive housing covenants in 1948, African Americans were subjected to severe segregation; massive suburbanization in effect signified white flight. On top of this, mixed marriages had only just been decriminalized in 1948, so the Whites, as an interracial couple, faced additional challenges—for example, finding a real estate agent amenable to assisting an interracial couple. Through the assistance of many new friends, as well as some of their old colleagues, they were able to establish a comfortable life in their new home.

When he first arrived in California, White realized he would have to familiarize himself with the various factions of the city, including the black and Mexican populations, before he could determine his place and role.[11] By the 1960s, he was the leading force of the black art community. At the time of his arrival, the small number of African American artists in Los Angeles and the surrounding cities that constitute Los Angeles County fell into one of two general groups. Herman "Kofi" Bailey, Yvonne Cole Meo, Samella Lewis (see fig. 3), and William Pajaud favored traditional figuration to communicate black narratives and black pride, while Melvin Edwards, Senga Nengudi, John Outterbridge, Noah Purifoy, and Betye Saar preferred to innovate and explore new techniques, such as assemblage, to express the drama of the African American experience emotively rather than naturalistically. Newly established near the wealthy city of Beverly Hills, LACMA aimed to compete with venerable cultural institutions like the Metropolitan Museum of Art, New York, and the Art Institute of Chicago by focusing on the old masters and contemporary European artists rather than on local figures. Only at the end of the 1960s, at the encouragement of White and Lewis, did LACMA recalibrate its exhibition policy. Until then, black artists had few opportunities to exhibit outside their neighborhoods and were limited to showing mainly at churches, women's organizations, schools, and art centers located in the lower-income South-Central neighborhood and in the middle-class cities of Pasadena and Altadena north of downtown.

White's art remained figurative, focused on black subject matter and idealistic in orientation. By the time White left New York, social realism was out of fashion there, although former colleagues such as Jacob Lawrence and Robert Gwathmey were striving to reinvent social commentary in their art through formal and conceptual means. But Los Angeles in the mid-1950s—in spite of its growing size and importance as a port of entry and distribution center—was basically still a conservative town, and for this reason, the local art scene differed substantially from that of other urban centers. The community was also more geographically dispersed. On the East Coast, the

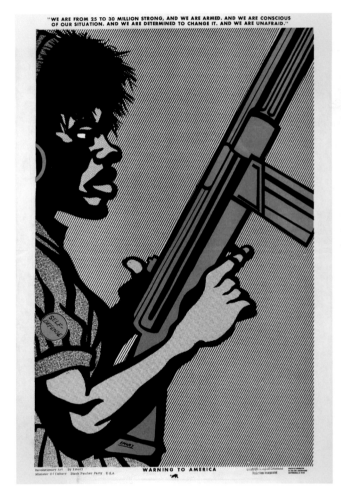

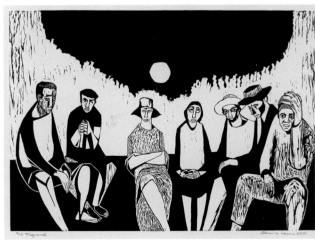

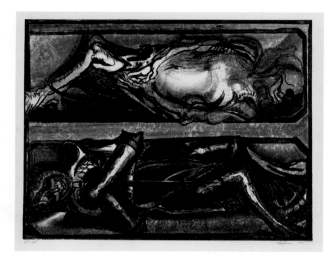

avant-garde promoted Abstract Expressionism in the 1950s and Pop Art and Minimalism the following decade.[12] Impressionism had reigned supreme in Southern California during the first three decades of the twentieth century; figuration, expressed through a variety of styles, spanned an even longer period. Artists and teachers Rico Lebrun (see fig. 4) and Howard Warshaw were already active by the time of White's arrival. They were also superb draftsmen who focused on the body as an expressive device. Artists diverse in terms of gender, race, and ethnicity included Wallace Berman, Judy Chicago, and Outterbridge, as well as little-known artists such as Jirayr Zorthian and Marjorie Cameron Parsons Kimmel (known as Cameron). Although their art varied in style, humanism was its philosophical foundation. According to writer Michael Duncan, the Los Angeles figurative tradition at midcentury reflected the introspection and angst of the postwar era—what he characterized as "abject expressionism."[13]

White's outlook set him apart from other local figurative artists. At first his belief in the righteousness of humankind and his hope for a better future endured. By the late 1960s, however, in the midst of rising violence, a sense of frustration and anger began to infiltrate his art. A comparison of two of his mother-and-child compositions suggests his despair: the 1953 drawing *Ye Shall Inherit the Earth* (pl. 48) is a tender depiction of a mother's love, demonstrated by her protective embrace. In *Wanted Poster Series #6* (pl. 88), completed sixteen years later, the woman can no longer protect the boy; both figures are naked, shorn of even the dignity clothing would provide. Moreover, the child, separated from the adult, crouches in fear with the realization that no one protects him. Although the *Wanted Poster Series* image draws most directly on the historical past, White could easily have been referring to the many children who were being murdered and maimed during the 1960s civil rights struggle.

White was frequently moved by contemporary events, and he responded to them through his art, although not always in a literal way. One example is *Birmingham Totem* (pl. 70), which he created in reaction to the Ku Klux Klan bombing of the Sixteenth Street Baptist Church in Birmingham, Alabama, which killed four young girls. The Klan had attacked in response to King's first nonviolent campaign, held in that city. White explained his response:

> I'm not a reporter. Instead of trying to re-create an event, I put a reaction on paper. Several years ago [1963] four young black girls were killed in a bombing of a church in Birmingham. I drew a picture of a crouched male figure holding a plumb line over the rubble [*Birmingham Totem*]. The symbol and the statement were intended to suggest that perhaps destiny has chosen blacks to be the catalyst for change in our society. The crouched figure was symbolic of the architect who would help to do the planning in creating a new society.[14]

Rather than dwell on violence or contemplate retribution, White preferred to confront this devastation with positive action. He proffered the explicitly symbolic imagery of the splintered lumber of the destroyed church as the building blocks for a future sanctuary. The rendering of the mass of wood, so detailed in its physicality, culminates in a crouched figure protected by what appears to be an African textile.

THE WHITES' CIRCLE

One of White's earliest artist-friends in California was the painter and activist Edward Biberman (see fig. 5).[15] White already knew of him: in 1954 he wrote a positive review of Biberman's work, which he described as exhibiting "a clever and deeper vision of the Negro people than is ordinarily found in American art."[16] The two shared a realist aesthetic in both the artistic style and the subject matter of their art. White's trip to the Soviet Union and interactions with cultural producers there led him to adopt a more representational style in the spirit of Soviet Socialist Realism, as opposed to what was viewed as the formalism and antihumanism of bourgeois art.[17] Biberman and White presented their African American subjects as large and stoic as in Soviet patriotic treatments, but mainly in portraits and single-figure compositions. Both artists featured personalities associated with Hollywood and leftist politics, including actor Paul Robeson (see pl. 16) and black female singers.[18]

Biberman was also an early supporter of White's. He secured White his first teaching position in Los Angeles, at the Westside Jewish Community Center. He arranged to have White appear in a segment of his television series, *Dialogues in Art*, which was broadcast in 1967–68 on the local NBC affiliate. It was partly through Biberman that White made initial connections with the progressive art scene and civil rights groups in the city. And most important, Biberman found White a local dealer, Benjamin Horowitz, who owned the Heritage Gallery.[19] A New Yorker and Jewish leftist, Horowitz had moved west at the encouragement of New York social realists William Gropper, Ben Shahn, and Raphael and Moses Soyer, who tasked him to create a market in California for their political works. Horowitz opened his gallery in 1961, and for forty years he promoted the social realists as well as contemporary African Americans and Latin Americans. White would become the most successful artist he represented. The two also became good friends, often traveling together.[20]

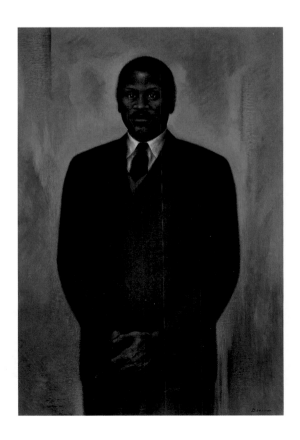

FIG. 5
EDWARD BIBERMAN
(AMERICAN, 1904–1986)

Paul Robeson, 1947. Oil on canvas; 127 × 86.4 cm (50 × 34 in.). Estate of the artist, courtesy of Gallery Z, Los Angeles.

Leftist politics factored substantially in the Whites' new circle. Frances and Charles loved entertaining, and their home brimmed with local guests as well as out-of-town visitors. Their artist-acquaintances reflected the multiracial character of Los Angeles. For example, White associated with a small group of Asian artists, including Frank Sata, a Pasadena-based architect, and Mike Kanemitsu, a New York and Los Angeles–based painter and printmaker. The couple also had many friends in the entertainment field—actors, musicians, and writers. Their real estate agent introduced them to Carlton Moss, an early African American filmmaker in Hollywood.[21] Through Biberman, the Whites met his brother and sister-in-law, Herbert Biberman and actress Gale Sondergaard. A theater and film director, Herbert was one of the Hollywood Ten—the screenwriters, directors, and producers imprisoned for suspected Communist sympathies during the McCarthy era. The threat of blacklisting lingered well after the Whites' arrival in California. Edward Biberman and White were under government surveillance for years, as attested by the size of the FBI files gathered on them. In an era in which people would cut relations with someone suspected of Communist sympathies, the Whites continued to associate with these friends, dining at the homes of both Bibermans and becoming close with Dalton Trumbo, another of the Hollywood Ten, and his wife, Cleo.

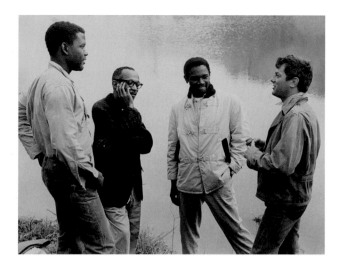

FIG. 6
The set of the film *The Defiant Ones* in Los Angeles, March 1958. Left to right, actor Sidney Poitier, Charles White, stuntman Ivan Dixon, and actor Tony Curtis.

The Whites had ties to entertainment and literary circles even before their arrival. In New York they had associated with Robeson, Ossie Davis, and Ruby Dee and writers Alice Childress and Langston Hughes, among others, through their participation in the Committee for the Negro in the Arts. The couple enjoyed enduring friendships with Belafonte and actor Sidney Poitier, both of whom became major collectors of White's art and helped him obtain contract work in Hollywood (see fig. 6). They featured his art in their film, television, and music projects as well.[22] In his correspondence, White often wrote about how exciting it was to make art that appeared in movies and how it afforded him opportunities to expand his audience. He also contributed art for album covers, and in 1965 his design for an RCA Victor cover of the Chicago Symphony Orchestra playing Morton Gould's *Spirituals for Orchestra* and Aaron Copland's *Dance Symphony* was nominated for a Grammy Award.

From the late 1950s on, with the exception of some *J'Accuse* images, White typically focused on single figures. He also eschewed positioning figures in interiors or naturalistic landscapes, as he had done earlier in the drawing *Harvest Talk* (pl. 43). Devoid of most references to specific settings, his compositions usually focused on one or two figures, with White conveying situations through pose, gesture, and facial expression. At this time, such a refocus may have been encouraged in part by commercial experiences. In 1962 White was commissioned to provide illustrations to accompany Belafonte's planned anthology of folk songs, with his drawings to serve as both an album cover and a libretto cover. Although the project was ultimately abandoned for several decades, White did submit some initial drawings. "We [the staff and Belafonte] all felt it was not necessary to have so many figures," the project director wrote. "In other words what is needed is something simpler, something perhaps more symbolic . . . representing both the immense heritage of the past and also the great aspirations for the future."[23]

THE PIVOTAL YEAR, 1965

The year 1965 was crucial for the black community in Los Angeles as well as for White personally. It marked the centennial of the Thirteenth Amendment, which abolished slavery, and was the year of the passage of a Voting Rights Act, but this advancement was not enough to quell the mounting frustration and anger on the part of Los Angeles's African American citizens. Violence erupted in August 1965 in the city's segregated Watts neighborhood. In the aftermath of the Watts Rebellion, white Los Angeles was forced to acknowledge that black people, who numbered 13.5 percent of the city's population, deserved fair housing, equal employment opportunities, and inclusion in its political and cultural arenas. The civil rights movement encouraged West Coast activism and increased White's visibility in both local white and black art circles. One immediate result was that the Otis Art Institute invited White to join its faculty. Six thousand demonstrators paraded in solidarity to Los Angeles city hall, prompted by both the assassination of activist Malcolm X in February 1965 and the King-led voting rights march the following month from Selma to Montgomery, Alabama, which White commemorated in nine small circular charcoal drawings, *Rights Marchers* (fig. 7). Student protestors, including black militants at Otis, also organized throughout the region. Otis may have hired White in part to pacify the students, as he was the first black artist to join the all-white faculty.[24]

FIG. 7
CHARLES WHITE
(AMERICAN, 1918–1979)

Rights Marchers, 1965. Charcoal; average diam. of each image: 8.5 cm (3 ⅜ in.). Private collection.

In addition, in 1965 the black-owned Golden State Mutual Life Insurance Company asked White to become a member of the selection committee for the company's Negro art collection.[25] William Pajaud, Golden State art director and later director of public relations, likely calculated that White's national reputation would confer credibility on the collection. White knew most of the major black artists throughout the country and could successfully solicit works from artists of Lawrence's caliber.

Pajaud was charged to ensure that the artworks in the Golden State collection displayed "elements of vigor, social protest and group consciousness" and that they contributed to the "understanding of the life and thought of the American Negro people."[26] White's large ink drawing *General Moses (Harriet Tubman)* (pl. 79) from 1965 was acquired for the collection. Tubman, dubbed the African American Moses for leading her people out of slavery to freedom, appealed to White. He depicted the heroine several times, here as a single figure immersed in her own thoughts. She sits on a stony outcropping that echoes her sturdy, monolithic frame. Despite White's careful delineation of the fractured and crystalline character of the stone, the overall size of the boulders underscores General Moses's position as the bulwark of her people.

WHITE AND THE BLACK ARTS MOVEMENT

Golden State's art mandate reflected the growing influence of the national Black Arts Movement. Its goal was to educate and encourage the black community about its inherent creativity and to demonstrate to the white public black ability for cultural self-identification and determination. The Black Panther Party organized initiatives in the visual and performing arts, knowing that they were integral to African American life. A 1967 article about black revolutionaries ranked White as the foremost artist of the Black Arts Movement. As Robert C. Maynard, a staff writer for the *Washington Post*,

explained, the movement encouraged writers and artists to "invest the arts with a special mission, to evoke images of beauty that are black and images of blackness that are beautiful."[27] The illustration accompanying the article was White's drawing *Uhuru* (1964; private collection), the title of which means "freedom" in Swahili. Then on view in a solo exhibition at Howard University, *Uhuru* depicts a black man whose raised arms echo the pose of the crucifixion. For Maynard—who one day would become the first African American owner of a major daily newspaper—White thereby became a revolutionary in subject matter despite his traditional technique and nonviolent stance.

The Black Arts Movement in Southern California was a grassroots effort. Organizations, festivals, and commercial galleries were established: the brothers Dale Brockman Davis and Alonzo Davis began the Brockman Gallery, and Suzanne Jackson, a former student of White's, opened Gallery 32. These modest enterprises became cultural centers of activism. White visited many of these spaces and spoke often throughout the region. His deep, soft voice, echoing his kind personality, was mesmerizing. Outterbridge explained the powerful impact of his lectures and informal chats: "[White's] emotionalism could be flung in such a way that it gave you enough courage and foresight and vision for the next three months when you heard him one time."[28]

The mainstream cultural establishment now acknowledged White's presence on the scene. He and people like him were needed to organize and mediate in Southern California between the black and white communities as well as between older and younger artists. By the time of White's death, he was one of the city's foremost cultural activists. LACMA, the largest art museum in the region, was compelled to become more broadly relevant, engaging nonwhite groups as well as its long-standing Anglo supporters, and around 1968 various departments of the museum began asking White repeatedly to address staff and collectors and appear in public lectures.[29] The support staff became more active in part due to his engagement. Fergerson and Claude Booker, another LACMA employee, asked the museum to hold educational events and exhibitions for the black community. The two men had recently cofounded the Black Arts Council (BAC), consisting of black staff, local artists, and citizens. Late in 1969 the BAC held its first conference of black speakers, including Lewis and White. In his talk "Soul and Art," White expressed his dream that someday there would be a museum of African American culture.[30]

J'ACCUSE AND THE WANTED POSTER SERIES

In the mid-1960s White began two thematic series that posed a sustained and unified message to the viewer. In 1966 he produced *J'Accuse*, twelve charcoal and ink-wash drawings, using a fluid yet representational technique that became a signature style.[31] The transitional nature of the series is demonstrated by the variety of motifs, both familiar ones and new favorites. *J'Accuse #5* (Michael Rosenfeld Gallery LLC, New York) and *#7* (pl. 82) were initially created for Belafonte's musical anthology, although they were not ultimately used.[32] *J'Accuse #11* (private collection) consisted of two circular images of single black heads; this was a transformation of the keyhole format that was popular in the nineteenth century, used in particular for portraits of American dignitaries. White had employed the format the year before in *Rights Marchers* (fig. 7) to underscore the subjects' importance. Although the artist insisted he did not work from models, the individualism of the figures suggests that he likely consulted source photography.[33] He repurposed the circular format and similar likenesses in the *J'Accuse* series and frequently thereafter, which enabled him to equate the black protestors with eighteenth-century American revolutionaries.

The major themes and moods of *J'Accuse* range from poverty and homelessness to despair and determination. The man in *J'Accuse #5* wears several layers of oversized,

ill-fitting garments, possibly given to him in charity. *J'Accuse #1* (pl. 80) is a monumental, seated figure protected from the cold by a large, heavy blanket. She stares straight ahead, confronting the viewer as if in judgment. The wrapped, massive, triangular form became a favorite of White's, used later in his drawings, paintings, and murals (see pl. 77 and fig. 11 below), often to exemplify the endurance of the oppressed. Other drawings in the series allude to the history of agricultural labor shared by many African Americans and emphasize the dignity of their labor. The woman in *J'Accuse #8* (private collection), for example, carries a huge basket of food on her back; with such imagery White connected the series to past works such as the lithograph *Harvest* (1964).

White manipulated his backgrounds to reinforce his message. In *J'Accuse #1*, striated charcoal lines suggest rain. Most of the figures seem engulfed in murky shadows, as the heads of a crowd of people in *J'Accuse #2* (1965–66; private collection) and *J'Accuse #10 (Negro Woman)* (pl. 83) emerge from darkness.[34] In other works in the series, the atmosphere seems more agitated: the young man in *J'Accuse #6* (pl. 81) appears caught in motion as he lifts his head toward the light emanating from around him, while another man in *J'Accuse #9* lifts his arms in a pose of control as if he were a conductor.

Together, these drawings constitute a thematic indictment of the systemic, ongoing disenfranchisement of African Americans. White's title refers to the notorious Dreyfus Affair: in 1894 a Jewish officer in the French army, Alfred Dreyfus, was falsely accused of spying for Germany and was imprisoned for twelve years in what has come to be recognized as a grave miscarriage of justice that revealed broad societal and institutional anti-Semitism. After the actual spy was acquitted, the author Émile Zola wrote an open letter, "J'accuse," to the French president accusing the military and judiciary of a cover-up; Dreyfus's name and Zola's title continue to be catchwords for political injustice. Ben Shahn, one of White's New York colleagues who shared his commitment to social justice, also referenced the notorious French incident in his art, twice. In 1930 Shahn devoted an early watercolor series to the scandal, illustrating all the protagonists, both heroes and villains. In his 1932–33 series about labor leader Tom Mooney, who, beginning in the late 1920s, was referred to as the "American Dreyfus," Shahn again exposed government corruption and unjust imprisonment. White's series was about an analogous cause that also had international implications—the government's repeated practice of depriving African Americans of their rights.

White may not have originally planned the drawings as a cohesive group. The works are not consistent in size, composition, paper orientation, or framing device. The drawings and one lithograph, *Exodus II* (1966), went on view at the Heritage Gallery in November 1966. Just before the opening, the artist changed the titles of all but the lithograph to the single moniker *J'Accuse*. According to art historian Erica Moiah James, this deliberate act of renaming marked "a notable break in the . . . artist's otherwise unmitigated faith in universal humanism."[35] The repeated use of the title *J'Accuse* for all the drawings, paralleling Zola's repetition of the term, echoed the federal government's recurring inability to recognize black humanity. White's appropriation of the French title also links the Jewish and African American experiences; by not changing the title of *Exodus II*, he reinforced the association.[36] "J'accuse" becomes a solemn chant, its spirituality echoing the repetition of the Hebrew phrase "Al chet" ("We have sinned") sung by worshippers during the service of Yom Kippur, the day of atonement, as they pound their fists against their chests in remorse. Torn from their native lands, Jews and African Americans lived a diasporic existence. They were both minorities who suffered increasing discrimination in the early decades of the twentieth century and became allies in their crusade for equality. During this period, some African Americans received assistance from Jewish philanthropic foundations that encouraged education; in 1942, White

won a Julius Rosenwald Fellowship that advanced his career. Throughout the civil rights movement of the 1960s, Jews and African Americans would march side by side.[37]

White's most famous series, the *Wanted Poster Series*, consists of fourteen unique oil-wash drawings and seven lithographs issued in editions of twenty for a total of twenty-one distinct images.[38] The artist's change of medium midway through the production of the series can be explained in part by his continued interest in printmaking.[39] Lithography particularly satisfied his needs: by drawing on a lithographic stone, he easily conveyed his actual touch and came closest to the manual process and overall effect of his charcoal, oil, and watercolor drawings (for more on White's process, see Mark Pascale's essay in this volume). Lithography offered the added benefit of multiplicity, thereby enabling his art to be financially accessible to the general public, not limited to collectors. White's arrival in California coincided with the emergence of Los Angeles as a major center of lithography, and the availability of printers probably encouraged his return to the process.[40] In 1964 he worked with the printer Joe Zirken to produce *Harvest* and the following year collaborated with Joe Funk for *I Had a Dream* and *Juba.* Thereafter, he worked primarily with the larger firms Gemini, Cirrus, and Tamarind, the last of which printed the *Wanted Poster Series* lithographs. The capacities of the large print shops may have encouraged White's use of big, often poster-size, sheets and experiments with color.

White began the series in the summer of 1969 after thinking about Black Panther Eldridge Cleaver and others who had fled the country during the recent strife. His response was, "[W]e are all fugitives."[41] A group of old newspapers given to him by his friend Edmund Gordon determined the subject matter and new treatment.[42] Newspaper advertisements of slave auctions and wanted posters broadcasting runaway slaves, which were widely posted in the antebellum South, are part of the material culture of slavery in the United States. Appropriating these historical documents, White reinforced the layering of time and place by situating them in his own lifetime, thereby suggesting that injustices suffered in the past still occur in the present.

Faint texts appear throughout the *Wanted Poster Series* prints. The stenciled letters, numbers, and images of pointed hands are often barely discernible. An X and fragments of words, phrases, and numbers may refer to a slave's name, date of escape, monetary value, or legal standing. In *Wanted Poster Series #4* (fig. 8), one of the simplest compositions of the series and the example closest to actual nineteenth-century posters, hands point the viewer toward the centered image of young Sarah, who, according to the inscription, was worth thirty-six dollars. The texts at times seem to disappear and reappear, their fugitive character suggesting a palimpsest. It is as if White is proposing that contemporary African Americans experience similar conditions, their historical enslavement resurfacing in slightly different forms throughout the twentieth century. Sometimes the surrounding bits of imagery and text are difficult to read in a coherent, logical manner. In the charcoal drawing *I Have Seen Black Hands* (fig. 9), executed the year before he started the *Wanted Poster Series*, White faintly drew a right hand holding an illustration of a black face torn in four.[43] Art historian Teresa Carbone has

FIG. 8
CHARLES WHITE
(AMERICAN, 1918–1979)

Wanted Poster Series #4, 1969. Oil on paper mounted on composition board; image: 61 × 61 cm (24 × 24 in.); overall: 74.6 × 74.3 cm (29 ⅜ × 29 ¼ in.). Whitney Museum of American Art, New York; Purchase, with funds from The Hament Corporation, 70.41.

explained that many African American artists of the counter-culture rejected a straightforward representation for collage, considering this modern technique more appropriate as an expression of the disharmony and dislocation of contemporary black lives.[44] In *I Have Seen Black Hands*, White explored the visual effect of collage with a similar intent. By presenting the image of an African American torn to pieces in the right palm of an anonymous person, he was surely expressing their continued control and manipulation.

The age of the source material also encouraged formal transformations, especially the treatment of the backgrounds. The old, crumpled posters became a fractured arrangement of crystalline planes. Occasionally, the poster appears more like a creased sheet pinned to a wall. In *Wanted Poster Series #6* (pl. 88), one of the most complex images of the series, White presented two

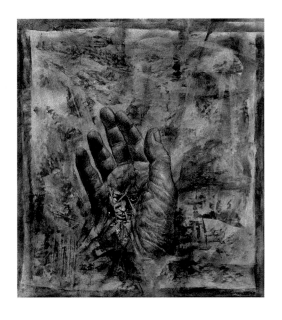

FIG. 9
CHARLES WHITE
(AMERICAN, 1918–1979)

I Have Seen Black Hands, 1968. Charcoal on paper; 40.6 × 35.6 cm (16 × 14 in.). Schomburg Center for Research in Black Culture, New York Public Library.

figures in an upright format with the hanging cloths transformed into flags. At top a waist-length female nude stands before the Confederate flag; hands point directly at her, evoking old printer's broadsides. A boy huddles below, seeming to float before the Union Stars and Stripes. White separated the woman and child, referencing the practice of slaveholders who broke up families by selling individual members to different masters. The word "valuable" placed below the figure may refer to the child's sale value — or to the humanistic belief that all people have value. The text floating in front of the woman but behind the boy, thereby uniting them, is from article 4, section 2 of the US Constitution, which refers to fleeing criminal justice.[45] *Wanted Poster Series #17* (pl. 90) is another woman-and-child image featuring an equally complex faceted background, texts, and a flag. Here, the two figures stand facing the viewer with eyes lowered, the woman resting her hands on the boy's shoulders. The word "sold" floats above them despite the presence of a large white eagle, representing the United States, supposedly the land of the free.

The *Wanted Poster Series* is more consistent and cohesive than *J'Accuse* and consequently constitutes White's first mature series. The mottled texture appears in every image, either as an old-fashioned framing device that surrounds the figurative component (#4, #11, #14) or as a backdrop with the figures appearing before it (#6, #10, #17 [pls. 88–90]). White began with head shots of single figures, usually depicting them in a circular format similar to the two heads in *J'Accuse #11* (private collection) but now with the addition of a crumbled backdrop. The artist eventually complicated the imagery by doubling and tripling the number of heads and by presenting the persecuted figures in three-quarter view rather than just showing their faces. Some of the fugitives have a downcast expression, others appear more determined. Perhaps the most curious of the series is *Wanted Poster Series #12* (pl. 93), in which two figures that may be reverse images of a child are tucked tightly in a fetus-like pose. The bony skeleton is perhaps a comment on the effects of poverty. The pellet-shaped body also appears in *Wanted Poster Series #10* (pl. 89) above a swaddled infant in what might be an Indian papoose; White occasionally depicted Native Americans, another oppresssed population.[46]

The artist's experiments with colored pigments and negative/positive images attest to his growing sophistication with the lithographic process. He had some of the prints, such as *Wanted Poster Series #14*, issued in different-colored inks, usually brown or golden sepia; *Wanted Poster Series #12a* (fig. 9, p. 46) was printed with a khaki-green overlay. White intended the two prints of *Wanted Poster Series #11* (pls. 91–92)

to be positive and negative impressions of a single unit; he achieved subtle gradations by combining the techniques of tusche, rubbing, and scraping water, ink, and crayon.

The *Wanted Poster Series* was White's most potent attack on the status quo. He admitted the hunted figures were different: "Some of my recent work has anger. I feel that at this point I have to make an emphatic statement about how I view the expression, the condition of this world and of my people. . . . I guess it's sort of finding the way, my own kind of way, of making an indictment."[47] The artist's increasing dissatisfaction with the slowness of change coincided with his support of the more militant civil rights activist and UCLA professor Angela Davis. In 1970 he became a founding member, along with actors William Marshall and Beah Richards and painter Arnold Mesches, of the Committee of the Arts to Free Angela Davis.[48] In 1972 White participated in a Southern California conference for her in Los Angeles. He also donated a work of art to an exhibition and sale sponsored by the International Artists for the Defense of Angela Davis in New York City. The artist gave permission for his print *Love Letter I* (pl. 101) to illustrate the open letter sent to Governor Ronald Reagan as part of the National United Committee to Free Angela Davis and All Political Prisoners.

In 1970 Concerned Citizens for Black Art (a cross-section of the constituents of Art West, BAC, the Black Artists Association, Brockman Gallery, and other local groups) met with Dr. Franklin Murphy, chairman of LACMA's board of trustees, and five other members to present a position paper demanding far greater African American involvement at all levels of the museum.[49] Street picketing led LACMA to quickly organize *Three Graphic Artists*, featuring forty-one works by White, David Hammons, and Timothy Washington. It opened on January 26, 1971, and later traveled to the Santa Barbara Museum of Art; a different version appeared later at the Monterey Peninsula Museum of Art.[50] White showed eighteen works in various media, dating from 1964 to 1971, including examples from *J'Accuse* and the *Wanted Poster Series*. He was the esteemed elder with an international reputation, while Hammons and Washington were much younger, representing the next generation of black artists. Hammons had been one of White's students at Otis and was a close friend of Washington's. Washington knew White's art and occasionally met him at meetings of the Black Art Association and at exhibition openings.[51] All three were political, but the expressions of their concerns varied.

The museum bought one work by each of the artists. Of White's works in the show, *Seed of Love* (pl. 84) was selected for its permanent collection. In the large ink drawing, a solitary, pregnant woman fills almost the entire composition. She stands upright, looking toward the future. *Seed of Love* was his first drawing to enter the LACMA collection, although the institution had already demonstrated interest in him and recognized his significance by purchasing in 1970 seven lithographs from the *Wanted Poster Series*, part of its first large acquisition of Tamarind prints.[52]

A number of artists and organizations considered the exhibition to be tokenism. They criticized the absence of the word "black" in the title and deplored the pairing of a nationally respected senior figure of the art world with two local artists. The protesters wanted the museum administration to acknowledge the significance of White's reputation by organizing a solo show.[53] Lewis, who was then on the educational staff, concurred and suggested, unsuccessfully, that LACMA organize an exhibition on nationally prominent African Americans, for example, Lawrence, White, and Romare Bearden.[54] She telephoned White to explain the problem and was exasperated at White's response, which was that he did not mind showing with emerging artists as "he wanted to help the young brothers."[55] Such a reply illustrates White's modesty and his long-standing efforts on behalf of black artists.

Meanwhile, White continued creating art. In 1972 he made two monumental drawings, *Mississippi* (pl. 95) and *Harriet* (pl. 96), both of which recall the earlier

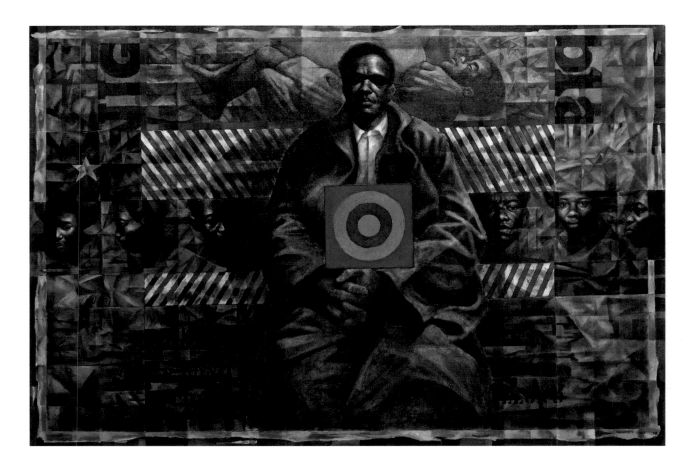

J'Accuse #1. Both show monumental figures swathed in heavy cloth, with evocative splatters of red paint—and in *Mississippi*, a bloody handprint—centered ominously above them. He may have been initially inspired by his young colleagues, both white and black. The conceptual artist Douglas Huebler had incorporated a wanted poster with fingerprints in *Duration Piece #15 (Global)* (1969; private collection).[56] Washington added his own handprint to his antiwar works, and Hammons visualized himself through body prints—but White's use of this motif further expressed his own disillusionment with the failure of the legal system to uphold the rights of African Americans. The police often fingerprinted and jailed protestors, treating them as criminals. In *Mississippi*, from 1972, White placed a bloody handprint above the figure. In *Harriet*, a large splash of paint suggests a cross emerging from the splatter. In the context of these visceral scenes, the handprints evoke stigmata.

White continued to use his innovative background treatment of the *Wanted Poster Series* in later prints and even transferred it to some of his late oil paintings. As with the recent prints, the paintings are large and focus on one person. The artist usually placed the single figure facing out toward the viewer and standing before a visually dense backdrop. The overall mood of these images is one of quiet grandeur and hearkens back to old master paintings, with their rich coloration, mellow lighting, and three-dimensionally delineated bodies—a strong contrast to the crumpled paper or quilt backdrops. *Homage to Sterling Brown* (fig. 10) was a tribute to a significant black literary figure and teacher. Brown also served as faculty advisor to the Non-Violent Action Group, the Student Nonviolent Coordinating Committee affiliate at Howard University. White presented him seated before a quilt-like background with colorful rectangles of red-and-white stripes, perhaps alluding to the Black Panthers; texts and partial images of African Americans are scattered all over, suggestive of the quilted artwork that Faith Ringgold would begin creating in the 1970s. A small multicolored square, similar to the

FIG. 10
CHARLES WHITE
(AMERICAN, 1918–1979)

Homage to Sterling Brown, 1972. Oil on canvas; sight: 101.6 × 152.4 cm (40 × 60 in.). Blanton Museum of Art, University of Texas at Austin, Gift of Susan G. and Edmund W. Gordon to the units of Black Studies and the Blanton Museum of Art at the University of Texas at Austin, 2014.91.

ones Jasper Johns made famous in his 1950s *Target* paintings, floats in front of the figure, perhaps implying that even a prominent African American could be an object of attack. The metallic-hued background of *Mother Courage II* (1974; National Academy Museum, New York) suggests the gilding in old religious paintings, with the greenish areas alluding to the patina that develops on metal over time. In this respect, the artist presented *Mother Courage II*, an icon of African American lore, as a medieval madonna.

WHITE'S LAST YEARS

White's last years were brimming with art making, exhibiting, speaking engagements, and honors. He not only showed in the landmark 1976 exhibition *Two Centuries of Black American Art* organized by LACMA, but also participated in its planning and programming. His local activities thereby culminated in a national touring show that significantly advanced the recognition of African American cultural history. Early in 1974 White, along with Outterbridge, joined the museum's Community Advisory Committee for the exhibition, and it was he who advised Rexford Stead, deputy director at LACMA, to hire David Driskell, a highly respected scholar in the field, to curate.[57] Of the more than two hundred works representing sixty-two artists, White showed eight drawings and prints, including *Sojourner Truth and Booker T. Washington* (Study for *Contribution of the Negro to Democracy in America*) (pl. 15), *Seed of Love* (pl. 84), and *The Brother* (1968; private collection). His color lithograph *The Prophet No. 1* (1975–76) was one of only six images featured in the exhibition promotion in magazines and newspapers across the country. LACMA's Graphic Arts Council commissioned White to create a print to coincide with the *Two Centuries* exhibition. Cirrus issued the lithograph *I Have a Dream* (fig. 1) in 1976 for the museum in an edition of 125, and it quickly sold out. The organizers were so pleased that they chose it to be an exhibition poster.[58] White gave tours of the exhibition and appeared on the local station KNXT-TV for the program *It Takes All Kinds*.[59] The artist's first traveling retrospective, *The Work of Charles White: An American Experience*, organized by the High Museum, opened the same month.[60]

Late in the decade, he became chair of the drawing department at Otis and received his last mural commission. The mural was for the Dr. Mary McLeod Bethune Regional Library located in Exposition Park and dedicated to the renowned black educator Mary McLeod Bethune (fig. 11). White, who had not worked on a mural since

FIG. 11
CHARLES WHITE
(AMERICAN, 1918–1979)

Mary McLeod Bethune, 1976–78. Oil on canvas on panel; 305 × 43 cm (120 1/16 × 16 15/16 in.). Dr. Mary McLeod Bethune Regional Library, Exposition Park, Los Angeles Public Library.

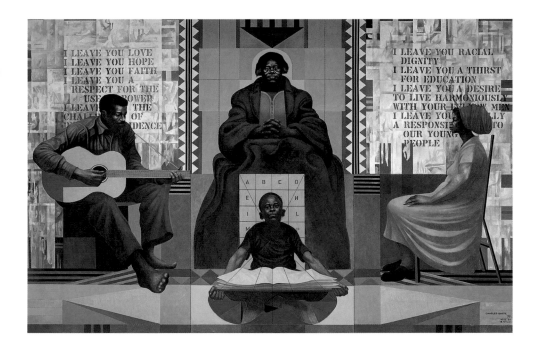

1943, was delighted to honor a black teacher who shared his belief in the importance of uplifting people through learning. In the single panel, a monumental black woman at center oversees a child with an open book. They are flanked by a guitar player at left and a young woman at right. He combined previous motifs into a tightly structured composition, presenting the text of Bethune's famous *Last Will and Testament* as if it had been carved on the marble back wall.

In the last decade of his life, the artist assisted in the early development of several African American cultural institutions. In 1970 the National Center of Afro-American Artists in Boston elected him to its board of directors and the Studio Museum in Harlem asked him to join its curatorial committee. White took these commitments seriously, traveling cross-country to attend meetings. He also participated in similar projects back home. African American art remained critical to Los Angeles black politics, especially after the 1973 election of Tom Bradley as the city's first black mayor. White created a print portrait of Bradley at Cirrus to celebrate his victory (fig. 12). He also shared his expertise with Bradley, who, during his second term, began

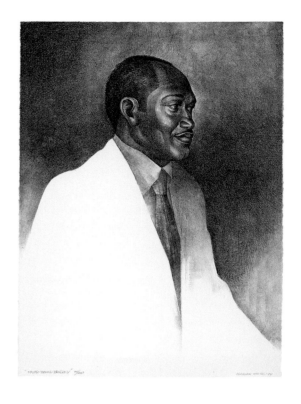

FIG. 12
**CHARLES WHITE
(AMERICAN, 1918–1979)**

Portrait of Tom Bradley, 1974. Lithograph on Arches paper, edition 75/200; 76.2 × 56.52 cm (30 × 22 ¼ in.). Los Angeles County Museum of Art, gift of Mayor Tom Bradley, AC1992.283.1.

a major initiative to organize and encourage the political mobilization of African Americans through the arts. White served as a member of the Mayor's Advisory Committee on Culture, and the following year, Governor Edmund G. Brown Jr. appointed him to the advisory board of the new California Museum of Afro-American History and Culture (now the California African American Museum) in Los Angeles. This was a dream come true for the artist, who had long hoped such an institution would become a reality.

During his California years, White produced a body of work that was both beautiful and political, explicitly supporting civil rights. He also became a significant cultural voice in the transformation of Los Angeles into a notable place for art making. Soon after his move to the area, White asserted, "[T]he Negro people are moving ahead with tremendous force. And culture is playing such a vital role in the movement."[61] Two decades later, he had become one of these crucial forces, embodying the importance of the African American artist and encouraging the establishment of a vibrant black arts community.

1. White to Margaret Burroughs, Apr. 9, 1957, Charles White Archives, CA.

2. Art critic Peter Plagens attributed this to the lack of "numbers, concentration, and intensity [of artists, critics, and galleries]." Plagens, *Sunshine Muse*, 59.

3. Mary Helen Washington locates White's leftist associations and Communist leanings to his Chicago and New York periods, devoting only a few pages to his California years and summarizing his late leftist interactions as primarily private ones, involving an intimate circle of friends; Washington, *The Other Blacklist*, 115–22. In his study of artists on the political left, Andrew Hemingway went so far as to demote White's California period to "a distinguished teaching career." Hemingway, *Artists on the Left*, 263.

4. Committee to Defend Martin Luther King, Jr., and the Struggle for Freedom in the South, "Heed Their Rising Voices" [advertisement], *New York Times*, Mar. 29, 1960, 25; see also Charles White to Margaret Burroughs, n.d., Charles White Archives.

5. Frances Barrett White, "Committee to Defend Martin Luther King, Jr.," typed note, n.d.; and A. Philip Randolph to Mr. and Mrs. Charles White, June 9, 1960, Martin Luther King file, reel 3192, Charles W. White Papers, Archives of American Art, Smithsonian Institution, Washington, DC (hereafter CWP, AAA).

6. In 1968 the Oakland Museum of California acquired White's drawing *Silent Song* (1968), which became part of his *I Have a Dream* series. White's 1965 and 1976 prints, which have almost identical titles, were completely different compositions.

7. Quoted by Widener, *Black Arts West*, 212. The block of text across the top of Emory's *Warning to America* (fig. 2) makes the "warning" explicit: "We are from 25 to 30 million strong, and we are armed. And we are conscious of our situation. And we are determined to change it. And we are unafraid."

8. Cecil Fergerson, interview by Karen Anne Mason, 1990–94, transcript, 175–76, African American Artists of Los Angeles Project, Oral History Collection, Department of Special Collections, UCLA, www.oac.cdlib.org/view?docId=hb7h4nb803&brand=oac4&doc.view=entire_text. In 1948 Fergerson began working at the Los Angeles Museum of History, Science and Art, and from 1961 at LACMA, when it became a separate institution. He worked there until 1985.

9. Widener, *Black Arts West*, 32, 57.

10. Kellie Jones's newest study, *South of Pico*, is an investigation of the black migration narrative in the West and how "the dislocations and cultural reinventions of migration, its materials of loss and possibility, and sense of reinscription" plays into it, using White as the pioneering figure of the post–World War II phenomenon; K. Jones, *South of Pico*.

11. Charles White to Margaret Burroughs (n. 1 above).

12. Plagens, *Sunshine Muse*, 59.

13. Duncan, *L.A. Raw*, 11–12, 21.

14. Marshall Berges, "Home: Questions and Answers; Frances and Charles White," *Los Angeles Times*, Oct. 13, 1974, Home Magazine, 74.

15. On their meeting in Los Angeles, see F. B. White, *Reaches of the Heart*, 99.

16. Edward Biberman to Charles White, May 18, 1954, Biberman file, reel 3190, CWP, AAA. See Charles White review of Edward Biberman, *The Best Untold: A Book of Paintings* ([New York]: Blue Heron Press), *Masses and Mainstream* 7, no. 5 (May 1954): 60.

17. Hemingway, *Artists on the Left*, 263.

18. Biberman, *Lena Horne* (1947; National Portrait Gallery, Smithsonian Institution, Washington, DC), and White, *Eartha Kitt* (pl. 75).

19. F. B. White, *Reaches of the Heart*, 99–100. An audiotape of the television broadcast is available; CWP, AAA.

20. Horowitz wrote an extensive essay for the first English-language monograph on the artist, *Images of Dignity*.

21. F. B. White, *Reaches of the Heart*, 101.

22. In *South of Pico*, Jones discusses these associations in more detail.

23. Bob Bollard (director of music projects, Belafonte Enterprises, Inc.) to White, May 21, 1962, CWP, AAA. R. M. Jones, art director, RCA, to White, Aug. 27, 1965, CWP, AAA. Belafonte's anthology was ultimately realized in 2001 as *The Long Road to Freedom: An Anthology of Black Music*. White's painting *Goodnight Irene* (pl. 41) was reproduced on the cover.

24. White remained the only teacher of color for some time—his friend Kanemitsu would not be hired until six years later. Frances Barrett White believed that Horowitz and Biberman pressured Otis to hire him as the school's first black instructor; F. B. White, *Reaches of the Heart*, 116.

25. William E. Pajaud to Charles White, Oct. 11, 1965, Golden State Mutual Insurance Co. file, reel 3191, CWP, AAA.

26. *Golden State Mutual Negro Art Collection* (Los Angeles: Golden State Mutual Life Insurance Co., n.d.), n.p., reel 3191, CWP, AAA.

27. Robert C. Maynard, "The Black Revolutionaries VI: Black Nationalist Movement Spawns Cultural Revival," *Washington Post, Times Herald*, Sept. 30, 1967, A4.

28. John Outterbridge, interview by Allen Bassing, Jan. 3, 1973, 273, transcript, AAA, quoted in Carolyn Peter and Damon Willick, "Gallery 32 and Los Angeles's African American Arts Community," *Journal of Contemporary African American Art* 30 (Spring 2012): 25n4.

29. For example, Helen Spencer to Charles White, Feb. 25, 1969, about speaking to the museum's security guards, reel 3192, CWP, AAA. Unfortunately, most of LACMA's early files, including photographs, have been inadvertently lost or destroyed. Consequently, the author has relied heavily on several recent and excellent studies: Cooks, *Exhibiting Blackness*, chap. 3; and K. Jones, *South of Pico*, 162–72.

30. White, "Soul and Art," in Black Artists: Art and Social Commentary, Arts Council lecture, LACMA, Oct. 27, 1969, archive.org /details/clcmar_000039.

31. The counts presented in this essay are based on the author's survey of the listings in Gedeon, "Introduction," 176–79. White often skipped numbers when he incorporated consecutive numbering into his titles. The *J'Accuse* series is numbered 1–11 and 18.

32. Stickers on the back of both works with notes written in the hand of the artist suggest that their original intended purpose was the anthology. I thank Esther Adler for making the connection to the Belafonte project.

33. For example, the central figure was drawn from a book on the Congo; see John Latouche and Andre Cauvin, *Congo* (New York: Willow, White, 1945). Email discussion with Sarah Kelly Oehler, Sept. 29, 2017.

34. *Ebony* magazine used a detail of *#10* as the cover of its August 1966 special issue, "The Negro Woman."

35. James, "Charles White's *J'Accuse* and the Limits of Universal Blackness," 5, 17–21.

36. Ibid., 17–21.

37. Lewis, "Parallels and Divergences," 17–19, 31.

38. Statistics culled from analyzing each work listed in Gedeon, "Introduction," 185–89, 437. There are omissions and variants listed in the consecutive numbering. Although twenty examples of each image allowed a wider circulation than a unique drawing, White desired an even more democratic distribution. For that reason, Heritage Gallery published a portfolio of six reproductions later in 1970 for sale at the modest price of fifteen dollars.

39. See M. P., "Artist of the Area," *Graphic Arts Council Newsletter* (*Los Angeles County Museum of Art*) 5, no. 5 (Jan.–Feb. 1970): 6. Earlier in his career White created linocuts, but from around 1969 he turned to intaglio processes (etching and drypoint). Until 1973, Joseph and Hugo Mugnaini produced all his etchings, beginning with *Elijah* (1969).

40. Background material on printing firms culled from *Selections from Cirrus Editions Ltd.*, text by Joseph E. Young, exh. cat. (Los Angeles: Los Angeles County Museum of Art, 1974); *Tamarind: From Los Angeles to Albuquerque,* exh. cat. (UCLA, Grunwald Center for the Graphic Arts, 1984), published as *Grunwald Center Studies V,* text by Lucinda H. Gedeon, Gordon L. Fuglie, and James Smalls; and Bruce Davis, "Print Workshops at Mid-Century," in Fine, *Gemini G.E.L. Art and Collaboration*, 9–14.

41. White, "Soul and Art" (n. 30 above).

42. Ian White to the author, Feb. 28, 2017.

43. The title of this work is from a Richard Wright poem from 1934. The print was part of the *I Have a Dream* series and was reproduced in the 1969 portfolio of that name. Other prints included *The Wall*; *Brother II*; *Nat Turner, Yesterday, Today, Tomorrow* (pl. 85); *Vision*; and *Seed of Heritage*.

44. Carbone, "Exhibit A," 88.

45. Article 4, Section 2 of the US Constitution reads, "a Person charged in any State with Treason, Felony, or other Crime,

who shall flee from Justice, and be found in another State, shall on Demand of the executive Authority of the State from which he fled, be delivered up, to be removed to the State having Jurisdiction of the Crime."

46. The artist's heritage was partly Native American, and this surely encouraged his understanding and sympathy for injustices they faced.

47. Charles White, quoted in *Graphic Arts Council Newsletter* 5, no. 5 (Jan.–Feb. 1970): 6.

48. Typed letter to Dear Friends, signed William Marshall, Arnold Mesches, Beah Richards and Charles White, [1970], in Angela Davis file, CWP, AAA. The Davis file in White's archive is quite substantial.

49. These included adding black board members and professional staff, organizing a major exhibition on black art, and in general, creating a more sympathetic climate for black artists and supporters. Unattributed author and untitled, [c. 1970], in CWP, AAA.

50. *Three Graphic Artists*, foreword by Ebria Feinblatt, text by Joseph Young, exh. cat. (Los Angeles: LACMA, 1971); and *Three Black American Artists*, exh. brochure (Monterey: Monterey Peninsula Museum of Art, 1971). A month after the close of the tour, on May 19, 1971, the Graphic Arts Council sponsored a public lecture by White, "Black Artists in America," archive/org/details/clcmar _000085.

51. Timothy Washington, interview by Ilene Susan Fort and Devi Noor, Mar. 2, 2017, Los Angeles.

52. In 1968 David Ginsburg donated the color lithograph *Exodus II* (1966) to LACMA, making it the first work by the artist to enter the museum. White's first oil painting, *The Embrace* (1942), was donated to the museum as a bequest of Fannie and Alan Leslie in 2006. LACMA currently owns nineteen works by the artist.

53. Unknown authorship, no title [about the cultural vacuum of representation of black artists in Los Angeles County], Jan. 22, 1971, typed, pp. 3–5, in CWP, AAA (possibly from the White files of the Heritage Gallery, Los Angeles). The title was changed when the exhibition traveled to Monterey; unattributed author and untitled, [c. 1970], CWP, AAA.

54. In her account, Lewis was very blunt about the racist attitudes of the museum's curators. Samella Lewis, interview by Peter Clothier, Feb. 1981, transcript, 2, Charles White Archives, CA.

55. Ibid.

56. Conwell and Phillips, "*Duration Piece*," 189.

57. Rexford Stead to David Driskell, Apr. 3, 1974, in David C. Driskell Archives, Hyattsville, MD, cited in Cooks, *Exhibiting Blackness*, 98–99, 184n25. After closing in Los Angeles, the exhibition traveled in 1977 to the High Museum of Art in Atlanta, the Dallas Museum of Fine Arts, and the Brooklyn Museum.

58. White insisted the print be sold for only one dollar and be distributed free in Los Angeles public schools. Albert S. Cahn (chairman, commissioned prints, GAC) to Charles White (contractual letter); Rexford Stead to Charles White, Aug. 3, 1976; and GAC, LACMA, newsletter, "Charles White Lithograph," *Newsletter* (Oct. 1976 supplement): 2, CWP, AAA.

59. Browne Goodwin (education chairman, GAC) to Charles White, Oct. 7, 1976; and LACMA, "Memo: Television Interview," Sept. 27, 1976, CWP, AAA.

60. This large retrospective traveled to several venues; see the exhibition history in this volume.

61. Charles White to Margaret Burroughs (n. 1 above).

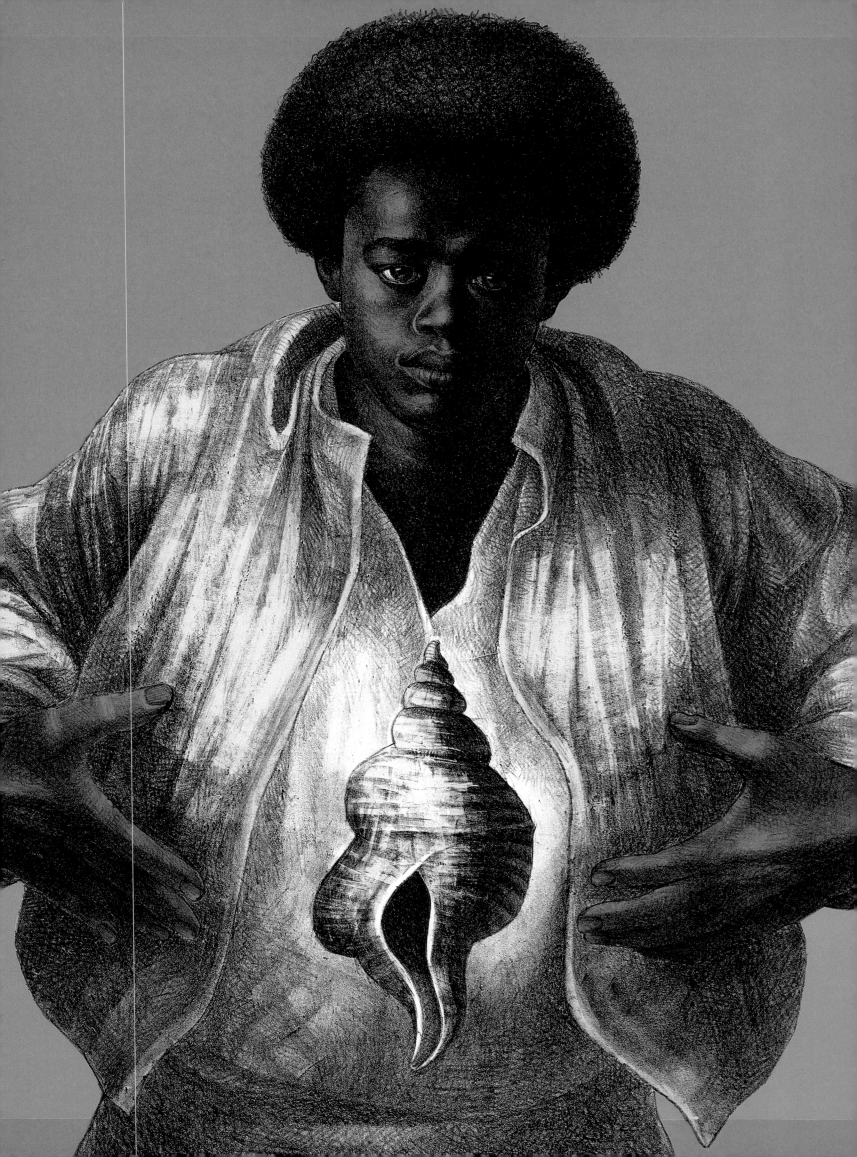

CHARLES WHITE, ARTIST AND TEACHER

ESTHER ADLER

If you don't know, learn. If you know, teach.
—Liberation Bookstore motto

Charles White was a devoted teacher his entire life. Throughout his career, he seamlessly wove his dedication to education into his artistic practice. White embodied the motto of the activist Una Mulzac's Liberation Bookstore in Harlem through his belief in self-reliance and the responsibility to learn, paired with the duty to teach.[1] For him, personal discovery was not enough. Hard-earned knowledge had to be shared.

Even as a student in Chicago, White had already begun to teach others about history and culture as well as fine-art techniques. He would assume the role of teacher formally, at art schools and universities, and as needed, engaging with community groups. His commitment to creating meaningful, accessible images of African Americans and making them available to a broad range of viewers was central to his teaching mission. To this end, he embraced popular and commercial media as well as conventional fine-art venues for works that depicted underappreciated historical figures, celebrated cultural heroes, and archetypes of the oppressed and unseen. His paintings, drawings, and prints were perfectly suited for democratic distribution as book and album covers but equally as inexpensive reproductions. This latter use in particular allowed them to function both as independent artworks and as teaching surrogates for the artist himself, bringing his imagery and the knowledge and values it embodied to much wider audiences than he could reach through his exhibitions or classes. White was an advocate for the people he depicted in his artwork as well as for the generations of students he taught and mentored, many of whom continue to work as professional artists today. His influence, as attested by the stylistic and conceptual connections between their practices and by their own acknowledgment, reflects his continuing legacy.

"IF YOU DON'T KNOW, LEARN"

White's reverence for learning and dedication to teaching can be traced to his child-hood in Chicago. He attended a predominantly white high school, where the teachers actively discouraged his interest in African American history.[2] But he was already edu-cating himself, mainly on his own initiative, on US history and the role played by black Americans. As a young child, he had benefited from the guidance and generosity of librarians at the main branch of the Chicago Public Library, who supervised him while his mother was at work. White was encouraged and supported at the library in a way he was not in school, and what he learned there and through later study became his subject matter. This is especially apparent in the early monumental works he executed while working for the mural division of the Illinois Art Project of the Works Progress Administration (WPA) (see pls. 7, 10, 18) and in 1943 for Hampton Institute (now University) (see fig. 10, p. 33; see also Sarah Kelly Oehler's essay in this volume).

White began formal art instruction at the School of the Art Institute of Chicago (SAIC) in middle school. Simultaneously, he studied on his own and discovered resources like the Art Crafts Guild, an organization founded by local like-minded African American artists.[3] Members would pool funds to send selected artists to classes at the SAIC (as one of the youngest, White was never chosen).[4] In return, those artists were expected to share this instruction with the larger group. This way of learning, driven by hard work and generosity, would be a touchstone for White throughout his career.

In fact, he began teaching even as he actively pursued his own studies at the SAIC, where he enrolled after graduating high school in 1937. He gained part-time employment as an art instructor at Saint Elizabeth Catholic High School and led classes in life drawing at the South Side Community Art Center (SSCAC), which he helped found with other members of the Art Crafts Guild. This activity paralleled his own art practice and his experimentation with media and techniques, including monotype (see fig. 1). After his marriage to sculptor and printmaker Elizabeth Catlett in 1941, he relo-cated to New Orleans, where she was chair of the art department at Dillard University. He worked there for one semester as a drawing teacher, introducing his students to the practice of working with a live model.[5]

White's artistic ambition and belief in the transformative power of education are further evident in his continual study and efforts to improve his own skills. Even after executing successful mural projects and numerous other critically acclaimed artworks in Chicago, he continued to push himself to broaden his capabilities and take advantage of every opportunity. In April 1942 he received a Julius Rosenwald Fellowship, which allowed him to enroll at the Art Students League in New York. A destination for his genera-tion, the league was run by and for artists. Its focus on stu-dio experience and creative freedom was similar in some ways to that of the SSCAC.[6] White studied with artist Harry Sternberg, who had made murals for the WPA, including *Chicago: Epoch of a Great City* for the post office in the Lakeview neighborhood in 1937–38.[7] In a report on his Rosenwald experiences, White recalled that "under the guid-ance of Harry Sternberg, by far the most stimulating and understanding instructor I have ever worked with, I experi-mented with the various tempera techniques as applied to both mural and easel painting. Five months of study at the League gave me a clearer understanding of the techniques of egg tempera and the function of mural painting."[8] In

FIG. 1
CHARLES WHITE
(AMERICAN, 1918–1979)

Untitled (Seated Woman), c. 1939. Monotype in oil on paper; 35.6 × 26.7 cm (14 × 10 ½ in.). Merrill C. Berman Collection. Cat. 4.

addition to continuing to learn new techniques, White also maintained his commitment to independent learning: in the same report, he discussed his own study of "the history of the American Negro, with particular emphasis on his role in helping to build a democratic America"; he conducted his research at the Schomburg Collection of Negro Literature, History and Prints located at the 135th Street Branch Library, as well as at the Library of Congress in Washington, DC, and at the library at Hampton Institute.[9]

The Contribution of the Negro to Democracy in America (fig. 10, p. 33) was the culmination of White's scholarly investigations and study of tempera. This was the first mural he executed on a wall and not a freestanding canvas. The artist felt able to engage with students at the historically black college, and for this reason he considered Hampton the "ideal" location for his work: "I feel that in advancing my ideas in the art field, I will have to spend much of my time teaching and encouraging young Negro art students. We have the opportunity to make a great contribution to American culture, but it will have to be a group effort rather than an individual contribution."[10] White taught by example as much as through technical art instruction, and the mural, which was unveiled on June 25, 1943, exposed students both to the contributions made by African Americans in the United States and to the role of art in educating viewers. His painting challenged what White referred to as "a plague of distortions, stereotyped and superficial caricatures of 'uncles,' 'mammies,' and 'pickaninnies'" in popular culture and replaced them with uplifting depictions of black leadership and humanity.[11] He considered his time at Hampton ultimately a success and believed that his presence on campus had a lasting effect: "I feel that I have been quite instrumental in interesting the entire Hampton community in the function of art in advancing the cause of the Negro people and that I have helped to stimulate the art students to express themselves more freely and with greater understanding of their role as Negro artists."[12]

White's influence was fostered in large part by Viktor Lowenfeld, an Austrian émigré who started at the school in 1939 and founded its art department. A known figure in pedagogical circles prior to his arrival in the United States, Lowenfeld would ultimately become one of the most influential figures in the field of American art education.[13] While at Hampton, he encouraged his students to embrace personal expression above all else: "Art consists in depicting the relations of the artist to the world of his experiences—that is, depicting his *experience* with objects, not the *objects themselves*," he wrote in 1945. "If we would like to learn to understand Negro art we have to try to analyse the forces which determine his experiences with the world which surrounds him."[14] These forces included, of course, intense prejudice and inequality, especially in the American South. Lowenfeld believed that these social factors adversely affected black artists, encouraging them to emulate their white counterparts rather than follow their own creative impulses.[15] As a successful professional with a history of completed projects and exhibitions, White proved that a black artist could overcome limitations to great ends.[16] His commitment to changing the narrative surrounding African Americans and their accomplishments further supported Lowenfeld's goal of challenging young artists to find their own voices and draw on their personal experiences.

The dialogue and friendship between the two men had a profound effect on their students. The recollections of muralist John Biggers, who studied at Hampton in 1943, give a sense of the exhilarating atmosphere:

> Learning from Charles White, Betty Catlett and Viktor Lowenfeld was such a wonderful opportunity. Listening to them criticize each other's work—it really got me motivated. Viktor and Charlie would argue. Viktor would say, "Well, Charlie, I don't think that's so very good," and then tell him why. Charles

would get so mad. . . . Then we'd see them at supper; all laughing and smiling and hugging each other. . . . I know that many students were overwhelmed, but that experience made me really want to become an artist.[17]

Biggers also learned by watching White work: "I produced little Charles Whites for a while. I watched his every step, became his helper, made myself as useful as I could to him."[18] He was keenly attuned to the details of the older artist's process: "Charlie blocked out his drawing, then worked it out in geometric forms and planes. He started from spontaneous little scribbles, then tightened it up in the black-and-white studies, and then loosened it up again in the color study. He blew up every figure to full size before he put it on the wall" (see pls. 15–18). Biggers found it difficult, however, to incorporate this extensive preparatory stage into his own practice: "Because he'd 'overdrawn' the preliminary work, the painting lost its freshness. I learned from that, not to make such highly detailed sketches that I can't change them on the wall. In my latest murals, I made a conscious effort to concentrate my energy in the painting rather than the drawing."[19] Biggers was likely referring to his murals *House of the Turtle* and *Tree House* (fig. 2), which were commissioned for the William R. and Norma B. Harvey Library at Hampton. Biggers's formative experiences with White influenced his own art and teaching career, which addressed African American history and heritage.

"PEOPLE'S INSTITUTE"

Following their time at Hampton, White and Catlett returned to New York. Over the course of the next few years, they were both exposed to leftist organizations and

practices that shaped their own art and pedagogical approaches. For White, this engagement with politics surrounding labor and race began in Chicago but continued in New York and is evident in the subject matter and choice of medium in his work.[20]

When the George Washington Carver School opened at 57 West 125th Street in Harlem in October 1943, White and Catlett were on staff. According to press reports, it was incorporated as "a non-partisan people's institute for adults . . . to develop thinking citizens who can take their rightful place in the modern world . . . to develop interracial understanding, harmony and unity . . . an educational and social center with the object of developing mature leadership and intelligent citizenry among the Negro people."[21] The school's director was Gwendolyn Bennett, the poet, artist, and former director of the WPA-sponsored Harlem Community Art Center, with powerful black politicians and cultural figures on its board like New York City Council member Benjamin Davis Jr., the Reverend A. Clayton Powell Jr., and the performer Paul Robeson.[22] The school offered classes in African American history, contemporary literature, music appreciation, and fine arts as well as life skills classes like sewing and personal finance. "This school," Bennett explained, "is owned and operated . . . by people who believe that the man in the street is a creative force that must be developed."[23] White taught drawing, as did fellow artist and friend Ernest Crichlow (see fig. 5, p. 90); artist Norman Lewis taught painting, and Catlett taught sculpture. Enrollment grew steadily—by 1946, just over two years after the school was founded, it had more than seven hundred students.[24]

Carver's official mandate may have been "non-partisan," but political awareness and education were part of the curriculum in practice. Years later, in a 1991 interview, Catlett referred to it as "theoretically a Marxist institution" that encouraged class consciousness even in seemingly apolitical courses.[25] Among the staff and supporters were many with leftist leanings, including Bennett herself, who had been dismissed from the WPA for her "un-American" views, and Davis, who was elected to the New York City Council on the Communist Party ticket. Some accused the school of being a Communist front: labor leader and organizer Frank Crosswaith derided it in the press as an attempt to "exploit the Negro and try again to hitch him to the tail of the Communists' kite."[26]

White's affiliation with Carver, and even earlier with Workers Children's Camp (Wo-Chi-Ca), the interracial camp where he and Catlett taught from the summer of 1942, reflected his belief that black Americans fighting for racial equality could find common cause with those fighting for workers' rights.[27] This position was also evident in his work with the leftist press. He wrote articles and drew illustrations for the Communist Party newspaper *Daily Worker* and the Marxist periodical *New Masses* (after 1948, *Masses and Mainstream*), the latter of which published a lithographic portfolio of six of his drawings in 1953.[28] White's independent art making also engaged with contemporary social and political issues. Whether fine art or commercial illustration, his output aligned with his approach as an educator, embracing an accessible style aimed at teaching his viewer. In a 1978 interview White argued that "art must be an integral part of the struggle. It can't simply mirror what's taking place. It must adapt itself to human needs. It must ally itself with the forces of liberation. The fact is, artists have always been propagandists. I have no use for artists who try to divorce themselves from the struggle."[29]

White's insistence on art being "part of the struggle" informed his work of the 1940s. His 1945 painting *War Worker* (pl. 21) depicts an anonymous laborer whom White considered as critical as the eminent historical figures of his murals. The man's oversized, powerful hands figure prominently, twisted and grasping a satchel swung over his shoulder, echoing the raised fist in the poster behind him that champions

workers' fight for freedom. White exposed the clear disconnect between this strong and capable but weary African American man and the poster's message of hope for his country. The worker participates in the fight for freedom but, as a black man in America, will not share in the victory.

Made not for a gallery but for the cover of a *Daily Worker* pamphlet, the 1946 drawing *The Return of the Soldier (Dixie Comes to New York)* (pl. 27) is more explicit in its message. The illustration accompanied an article by Harry Raymond about the murder of active-duty soldier Charles Ferguson and his brother Alphonso, a veteran, by a Long Island policeman (a third brother was also shot and a fourth imprisoned for disorderly conduct).[30] The bloated officer, backed by a hooded Klan member, towers over dead and pleading black men, the pyramidal composition reflecting the unbalanced power dynamic among them. White's dramatic visual telling of contemporary events, even in an image specifically made to accompany a text that would do the same, is evidence of his focus on effective communication in his art. And his willingness to make works that would function as accompanying illustrations further shows a lack of concern about the typical hierarchies between high and low art forms. If White's ultimate goal was to make powerful, accessible images that would be seen by and teach a broad range of viewers, then the cover of a mass-produced pamphlet was as desirable an exhibition space as a gallery or museum wall.

In 1946 White and Catlett traveled to Mexico, using funding from a Julius Rosenwald Fellowship she had received the previous year. Although this was the first trip abroad for either artist, they were already aware of and impressed by the revolutionary content and compelling representational style of contemporary Mexican artists, particularly the famed muralists Diego Rivera, José Clemente Orozco, and David Alfaro Siqueiros. But printmakers like Leopoldo Méndez, Pablo O'Higgins, Francisco Mora, and others working at the Taller de Gráfica Popular (TGP), a graphic arts collective in Mexico City, also had a significant influence on White. With diminished opportunities and funding for mural projects, and precarious health caused by tuberculosis, he began to focus more attention on drawings, prints, and easel paintings. He was already firmly committed to reflecting in a meaningful way on contemporary events in his art by the time he visited Mexico, but his observations and experiences from his time at the TGP further convinced him of the success of such an approach:

> The Graphic Workshop is a collective of artists whose work is primarily for the consumption of the Mexican working people . . . they deal with the issues that spring from the problems of the people in their fight to overcome the oppression of the Mexican working people, in their struggle to achieve freedom for the working class. It is a people's art that they are producing. . . . I saw for the first time artists dealing with subjects that were related to the history and contemporary life of the people. Saw these artists go to the people, get their material, I saw them come out of the studio . . . their studio was in the streets, their studios were in the homes of the people, their studio was where life was taking place.[31]

White's affiliation with the Carver School, where he taught students for whom fine art could open doors and expand world views, and the highly accessible, message-driven art he produced both independently and for left-leaning publications, had already aligned his work as a visual artist and teacher with his political beliefs. His experience in Mexico decisively confirmed the validity of his approach and the possibilities it held for measurable social impact.

THE WORKSHOP SCHOOL AND ART FOR HIRE

In June 1950 White was once again teaching in New York, but this time for a decidedly different type of institution: the Workshop School of Advertising and Editorial Art.[32] Directed by the designers A. F. Arnold and Milton Wynne, the Workshop School curriculum aimed to serve people already working in the advertising world and those looking to break into it.[33] One of two black instructors on staff, White likely taught life drawing, given his previous experience in that area.[34] The school promoted ethical accountability, professional development, and technical instruction: "[T]he artist must assume responsibility as to what use is made of his art, to what purpose he lends his art, what his art sells, decorates, stands for. If his sole function is to choose and arrange, draw and prepare art for reproduction or use, without moral obligation as to content, he is something less than an artist. . . . The process of art . . . is not a way of making a living, but a way of life."[35] Thus, the school aimed to broaden the scope of the artist working in the commercial world, both in a professional and a moral sense.

These goals paralleled those of the Committee for the Negro in the Arts (CNA), a group that also occupied much of White's attention during the 1950s. Organized in 1947 with support from a broad interracial coalition of major figures that included poet Langston Hughes, writer Dorothy Parker, and entertainers Harry Belafonte and Paul Robeson, among many others, the CNA was "dedicated to the integration of Negro artists into all forms of American culture on a dignified basis of merit and equality."[36] The organization aimed to "help erase the persisting racial stereotype and to create employment for Negroes in the various art fields."[37] The CNA was more than an advocacy group; it provided education and training for black artists and professionals looking to pursue careers in radio, television, and other areas of popular culture. Once employed in the arts and media, they would be able to counter the widely distributed, generally negative, images of African Americans.[38]

White was a member and a financial supporter of the CNA. He donated the proceeds from the sale of a painting from his 1949 American Contemporary Art (ACA) Gallery exhibition to help establish scholarships for young black artists. He also donated money from the sale of prints of his drawing *Trenton Six* to the CNA.[39] His personal artistic goals aligned with those of the CNA: he challenged stereotypes of black Americans with his powerful images of heroes and ordinary people who summon great strength in the face of oppression. Although little is known about White's curriculum at the Workshop School, his commitment to presenting accurate, and at times idealized, imagery in his own work likely influenced his role. His position there, as at Hampton years earlier, gave him the opportunity to push the CNA's agenda of changing how black people were represented in American culture. Furthermore, his unique stature as a black man who was also an accomplished artist and respected teacher would have had an important effect on his students.

The artist created a significant body of commercial work over the course of his career. Moreover, he allowed his noncommercial output to be reproduced on a broad scale. In this way, his for-hire output—positive representations of African American empowerment that reached a range of viewers—served his intertwined artistic and pedagogical philosophies. White illustrated books, both for children, like *Four Took Freedom: The Lives of Harriet Tubman, Frederick Douglass, Robert Smalls, and Blanche K. Bruce* (fig. 3), and for adults, such as his oil-wash drawings commissioned for *The Shaping of Black America* (1975), written by the senior editor at *Ebony* magazine, Lerone Bennett Jr.[40] From 1968 to 1971 White allowed his works to be reproduced in the complimentary calendars distributed by the black-owned Golden State Mutual Life Insurance Company in Los Angeles (for more on this, see Ilene Susan Fort's essay in this volume). These included his drawing *General Moses (Harriet Tubman)* (pl. 79), which Golden State

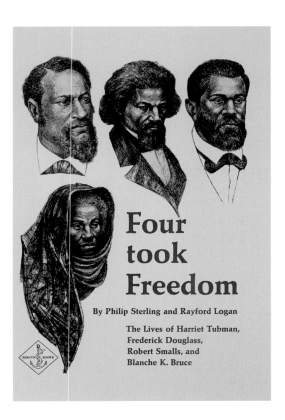

FIG. 3
Charles White drawings (clockwise from top left) of Blanche K. Bruce, Frederick Douglass, Robert Smalls, and Harriet Tubman, reproduced on the cover of Philip Sterling and Rayford Logan, *Four Took Freedom* (New York: Zenith Books, 1967).

FIG. 4
Charles White's *General Moses (Harriet Tubman)*, reproduced in Golden State Mutual Life Insurance Company's calendar for 1969. Cat. 113.

commissioned; it appeared in the 1969 calendar (see fig. 4). These projects had clear educational aims: even the calendars were made by a company with a vested interest in supporting black artists and sharing their work with the community.[41] The powerful image of Tubman, resting solidly on a boulder and staring directly at the viewer with enormous self-possession, merged a lesson about this important historical figure with a message of self-empowerment.

White's commercial opportunities included a variety of popular entertainment projects. In 1954–55 he made numerous drawings for Vanguard Records's *Jazz Showcase;* they appeared on album covers, including recordings of trumpet player Joe Newman and pianist Sir Charles Thompson.[42] White was nominated for a Grammy Award for Best Album Cover—Graphic Arts in 1965 for his drawing *Spirituals,* which was reproduced on an RCA Victor recording of the Chicago Symphony Orchestra playing Morton Gould's *Spirituals for Orchestra* and Aaron Copland's *Dance Symphony* (fig. 5).[43] He also made work for film and television. A triptych depicting the main characters of the 1958 film *Anna Lucasta* (pls. 73–75), including Eartha Kitt and Sammy Davis Jr., appeared just prior to the closing credits. A reviewer commented that this ending "would send audiences away certain that they had seen a masterwork in the fine arts."[44] Drawings including *Folksinger (Voice of Jericho: Portrait of Harry Belafonte)* (pl. 72), *Chain Gang* (1959; private collection), and *Children Playing* (1959; private collection) introduced the different acts in Belafonte's Emmy Award–winning television special *Tonight with Belafonte,* which the entertainer envisioned as a way to "demand equality by offering a proud black history that could challenge mainstream white erasure, show defiant survival against the odds, and soothe the difficult memory of 'the pain of that life.'"[45] When reproduced on record covers, in print, and on television and film screens, White's images reached audiences far larger than those who visited exhibitions. Moreover, he understood that his fully realized depictions of African Americans had to be seen by viewers of all races in order to affect popular perceptions: "I'm no longer concerned with whether I win another big prize here or a grant there," he said in a 1967 interview in *Ebony* magazine. "The recognition which I seek is getting my work before more and more masses of people, and improving my work. I'm not out to overwhelm the art world to prove I'm an artist. There are other barometers I can use."[46]

"IF YOU KNOW, TEACH"

White had been teaching for three decades by the time he moved to Los Angeles, but it was as a drawing instructor at the Otis Art Institute (now the Otis College of Art and Design) that he solidified his legacy as an

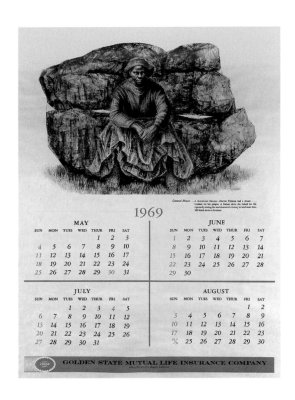

educator. He joined the faculty in 1965 and remained until his death in 1979—his longest institutional affiliation. At Otis, White trained a generation of artists that would, in many ways, carry on his own socially committed practice.

White continued to focus on his own art making, and this influenced his lesson plans at Otis. In the syllabus for his second-year drawing class in 1967–68, in addition to sessions on life drawing with an "emphasis on anatomical structure," White assigned exercises in "vignette drawing," directing students to "create [a] figure within an oval or circular shape or a combination with [a] rectangular shape."[47] He regularly used this tondo format in his own work, especially in his recently completed *J'Accuse* series of drawings, including *J'Accuse #6* (pl. 81) and *J'Accuse #10 (Negro Woman)* (pl. 83), in which monumental images of black men and women are situated in

LSC-2850 STEREO

CONTEMPORARY
AMERICAN MASTERPIECES
Gould: Spirituals for Orchestra
Copland: Dance Symphony
Chicago Symphony Orchestra
Morton Gould conducting

RCA VICTOR
RED SEAL
DYNAGROOVE
RECORDING

FIG. 5
Charles White drawing reproduced on the cover of *Contemporary American Masterpieces: Gould: Spirituals for Orchestra; Copland: Dance Symphony* (RCA Records, 1965).

a format historically used for portraits of nobility and wealthy sitters. As his student Kerry James Marshall noted, "He taught us to do the things he was doing. . . . His lectures would be about things like how the *J'Accuse* group of works came to be, what that means, how you try to do work that's symbolic and emblematic."[48]

Another class assignment was the following: "From a representational study of the figure, create an abstract study"; this was listed in the syllabus under the heading "Representational plus Abstract."[49] Although White worked in a figurative, representational style for his entire career (in a 1967 interview he said, "Basically, I'm a realistic painter and I can't apologize for being a realistic painter"[50]), in later decades he began setting his figures within increasingly abstract grounds. Stripes and planes of tone created through layering umber oil wash, a signature medium for the artist in his last decade, complicate the space from which the men, women, and children of the *Wanted Poster Series* (see pls. 88–93) emerge and contribute to the multivalence of later drawings like *Black Pope (Sandwich Board Man)* (pl. 99). White's engagement with abstraction and his requirement of an abstract study from his students reflect a personal negotiation with nonrepresentational art and, more broadly, an openness to diverse styles and perspectives.[51]

In fact, the work White made leading up to and during his time at Otis is some of his most experimental. The crouching nude figure in *Birmingham Totem* (pl. 70), a drawing made in 1964 in response to the 1963 Alabama church bombing that killed four young girls, squats atop a pile of building rubble. That pile is a tour de force of abstract mark making, with grids and planes thrusting up and toward the viewer. Similar passages of graphic experimentation can be seen in the rocks and grass in *General Moses (Harriet Tubman)* (pl. 79) and in the area surrounding the head at the top of *Nat Turner, Yesterday, Today, Tomorrow* (pl. 85). In *Dream Deferred II* (pl. 86), the variously shaped detritus seemingly attached to the side of a dilapidated house are also layers of geometric abstraction weighing down on the figure who peers out from beneath them. White used unorthodox techniques to apply ink to illustration board, and he encouraged his students to experiment as well, specifying on his syllabus that "[a]side from the conventional drawing tools, students will search for and discover the unconventional such as: balsa wood, Kleenex, rags, branches, wax, cue sticks, leaves, etc., etc."[52] He found his Otis students a receptive and inspiring audience: "Oh, it's such a beautiful, reciprocal kind of relationship, one in which both teacher and student grow as a result of the mutual contact. I'm not too happy about my own peer group.

FIG. 6
CHARLES WHITE
(AMERICAN, 1918–1979)

Ceramic sculptures, 1968.
Left, ceramic and paint; 40 × 24.8 ×
10.2 cm (15 ¾ × 9 ¾ × 4 in.).
Right, ceramic, paint, and twigs;
36.8 × 31.8 × 31.8 cm (14 ½ × 12 ½ ×
12 ½ in.). Both private collection.
Cats. 68–69.

They're too self-satisfied. They're not willing to take risks. They're not questioning. Youth has a tendency to do those things. There are no sacred cows to them. I like the fact that they're willing to challenge the accepted idols."[53] White, too, was willing to challenge expectations, even about his own work. Moving beyond the boundaries of his graphic and painting practice, he took advantage of the ceramic facilities at Otis established by artist Peter Voulkos and created sculptures that referenced the patterning of African art but had little obvious connection to his drawings. Nevertheless, he included them (fig. 6) in an exhibition at Heritage Gallery in 1973.[54]

While White embraced the new and, to a limited extent, the abstract late in his career, he still served as a touchstone for young artists interested in more classical technical instruction, especially those committed to working in a figurative style. Judithe Hernández, a former student of White's who continues to live and work as an artist in Los Angeles, explains, "We looked at Otis as an opportunity to be trained. The best possible training one could get in those days was either there or Chouinard [Art Institute] in a classical sense."[55] Born in East Los Angeles into a Mexican American family, Hernández enrolled at Otis in 1969, taking the undergraduate courses offered at the time and earning an MFA in 1974.[56] Concurrent with her studies, she was heavily involved in the Chicano movement's fight for civil rights for Mexican Americans, and this political activism influenced her artistic endeavors. It also mirrored White's own commitment to support his social and political values through his art. Hernández provided illustrations for the early issues of *Aztlán: Chicano Journal of the Social Sciences and the Arts* and artwork to accompany the poetry of Chicano writer and activist Alurista in his first book, *Floricanto en Aztlán* (1971).[57] She was also affiliated with the Chicano artist group Los Four, which included artists Carlos Almaraz, Roberto "Beto" de la Rocha, Gilbert "Magu" Sánchez Luján, and Frank Romero, as well as a number of other collective endeavors in Los Angeles during the 1960s and 1970s. This political engagement shaped her proposal for her Otis MFA thesis project (see fig. 7): "One of the things I wanted to do was to have a practicing artist, in an academic setting, in a scholarly way, talk about Chicano iconography and then produce a suite of work that was based on that iconography using the tools of that urban expression. So it's actually

graffiti art—my whole thesis was aerosol spray paintings and drawings. And [White] thought that was great." According to Hernández, White talked to his students about his own positive experiences in Mexico.[58]

White was especially supportive of the relatively few students of color at Otis, many of whom sought him out. His professional success established him as a role model, proof that a career as an artist was possible for them. "Charles White was the pivotal figure that everyone in California rallied around," according to Kerry James Marshall, who enrolled at Otis specifically to study with White, earning his BFA in 1978 (see Marshall's preface to this volume). "I don't think there's another figure like him who seemed to embody all the possibilities of being a professional artist . . . [His work] was popular. His work was in the world in a way that people who were in the arts and people who weren't in the arts knew about it. . . . I don't know another person who was in California at the time that I would have heard about who had the same kind of profile."[59] Marshall's own practice as a painter, draftsman, and printmaker has been close to White's since he began studying with him as a teenager. He mimicked his mentor's oil-wash palette in an early work painted on a window shade (fig. 2, p. 17)—a reference to a much-repeated story of White's own childhood misappropriation of his living room curtain as a canvas. Marshall grew up in Los Angeles, then lived in New York before settling in Chicago, and his adopted city has informed his work. His 1994 painting *Many Mansions* (fig. 8), set in the Chicago Housing Authority's Stateway Gardens complex, depicts three well-dressed black men tending colorful flower beds in front of high-rises that had become notorious as sites for violence and crime. Their lush surroundings, which include a surreal collection of cheerfully colored Easter baskets and twittering bluebirds carrying a banner with the message "Bless Our Happy Home," stand in startling contrast to the bleak reality faced by residents (in 1996 Chicago began to demolish Stateway Gardens). *Many Mansions* and the four other paintings that make up Marshall's *Garden Project* series all tackle the issues of inequity and poverty facing African American communities. He cites White as an influence on this commitment to social consciousness in his work:

FIG. 7
JUDITHE HERNÁNDEZ (AMERICAN, BORN 1948)

Viva la Revolución!, 1974. Spray paint, gesso, and pastel on paper; 182.8 × 243.8 cm (72 × 96 in.). Courtesy of the artist.

FIG. 8
**KERRY JAMES MARSHALL
(AMERICAN, BORN 1955)**

Many Mansions, 1994. Acrylic on
paper mounted on canvas; 289.6 ×
342.9 cm (114 × 135 in.). The Art
Institute of Chicago, Max V.
Kohnstamm Fund, 1995.147.

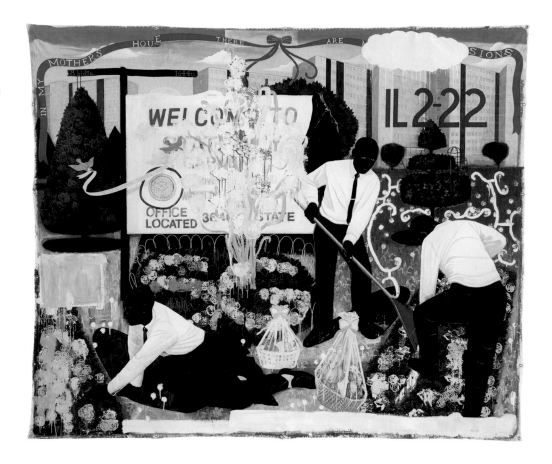

I think he felt that there was a responsibility for artists to address social
inequity, and if you're not doing it directly, certainly to always make sure that
was present in people's consciousness, that they understood something
about history. If you think about the way he talked about his career and what
you should be thinking about as a student, that was the charge—that you
should always be engaged with history, that you should be engaged with the
politics of your time, and that your work should be in the service of helping to
dignify people.[60]

Like Marshall, artist David Hammons knew of Charles White prior to studying
with him at Otis, seeing his work in reproductions as well as in exhibitions, as he
recalled in 1970:

I never knew there were "black" painters, or artists, or anything until I found
out about him—which was maybe three years ago. There's no way I could
have got the information in my art history classes. . . . He's the only artist that
I really related to because he is black and I am black, plus physically seeing
him and knowing him. Like, he's the first and only artist that I've ever really
met who had any real stature. And just being in the same room with someone
like that you'd have to be directly influenced.[61]

Hammons had moved to Los Angeles in 1963. He took classes at a number of schools,
including Los Angeles City College, Los Angeles Trade-Technical College, and Chouinard
Art Institute in addition to studying at Otis. The focus on the black figure in the "body
prints" he began making in the late 1960s, as well as the underlying social and political
messaging in many of these works, reveal White's influence. After coating himself and
his clothing with margarine, Hammons would "print" an image on board by pressing

his body against it, later applying powdered pigment to reveal the impression. The positioning of the figure, together with the addition of silkscreened elements and found objects, often extended the political commentary of these works—another connection with White's legacy of socially engaged art. *Injustice Case* (fig. 9), for example, shows a man bound to a chair and gagged; the work's frame is wrapped in an American flag. Visceral and highly charged, this body print was a response to the actual treatment of Bobby Seale, the cofounder of the Black Panther Party for Self-Defense, who was physically restrained in this way during his trial in Chicago on charges of inciting a riot at the 1968 Democratic National Convention.[62] *Injustice Case* was included in the Los Angeles County Museum of Art 1971 exhibition *Three Graphic Artists: Charles White, David Hammons, Timothy Washington* alongside a number of White's works, including *J'Accuse #1* (pl. 80), *Seed of Love* (pl. 84), and *Wanted Poster Series #17* (pl. 90). White agreed to participate in this exhibition, despite the protests of the local Black Arts Council, which believed he deserved a solo show there. This was a clear statement of his support for his students and young black artists, which was a fundamental aspect of his pedagogy.[63]

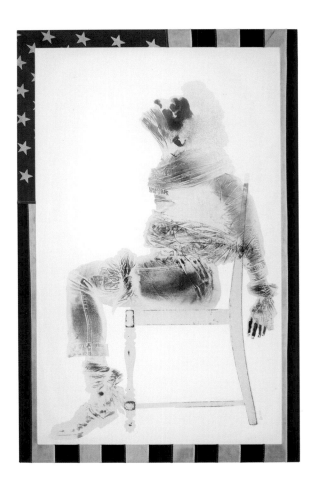

FIG. 9
**DAVID HAMMONS
(AMERICAN, BORN 1943)**

Injustice Case, 1970. Body print (margarine and powdered pigments) and American flag; framed: 175.26 × 120.02 × 5.72 cm (69 × 47 ¼ × 2 ¼ in.). The Los Angeles County Museum of Art. Museum Acquisition Fund (M.71.7).

In addition to his role at Otis, White participated in a number of local programs for middle-school and high-school students (see fig. 10). William Pajaud, art director of Golden State Mutual Life Insurance Company, and artist Bill Tara lobbied for White to teach Saturday morning classes for the Tutor/Art Program, which served underprivileged communities.[64] It was through the Tutor/Art Program that the artist Richard Wyatt Jr. met White.[65] Even as one of the youngest participants, at twelve years old, Wyatt was immeasurably influenced by White: "He would show me things, and encourage me to find my own voice, which I did later on. During my UCLA years, around 1976, I was bothered by the fact that a lot of the stuff that I was doing wouldn't necessarily be seen by people in the areas where I grew up. So I started doing work in the street, and that became my canvas. . . . And that's how I found my voice, kind of utilizing the things I learned from him."[66] Like White, Wyatt was drawn to murals as a way of making his art widely available, and he has been commissioned to create public artworks situated throughout Los Angeles: the 1991 mural *Hollywood Jazz: 1945 to 1972* is located at the Capitol Records Tower in Hollywood, and *City of Dreams/River of History* (fig. 11) is installed in Union Station.[67] Following his mentor's practice, Wyatt's work includes both well-known figures, like singers Nat King Cole and Ella Fitzgerald, in *Hollywood Jazz*, and anonymous settlers who helped found the

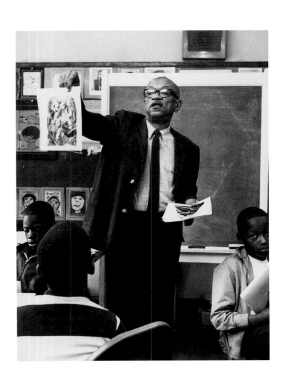

FIG. 10
Charles White visiting a Los Angeles school classroom, mid- to late 1960s.

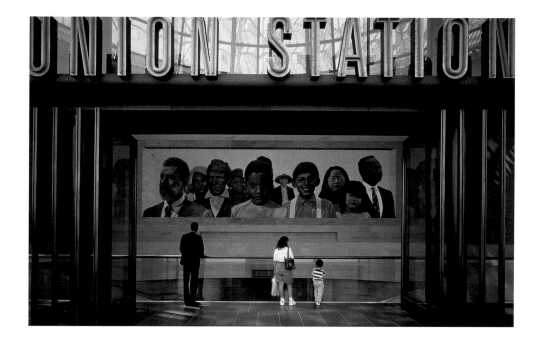

metropolis in *City of Dreams*. He has similarly welcomed commercial opportunities for his art, and his drawings appeared in the 1980 Golden State Mutual Life Insurance Company calendar.

Many of White's Los Angeles students have explored the mural format.[68] Hernández made numerous public murals with the group Los Four. Kent Twitchell is perhaps White's student most associated with a Los Angeles mural practice. Although Twitchell was not initially familiar with the older artist's work, Hernández suggested that Twitchell meet White, and he ultimately enrolled in graduate school at Otis specifically to study with White: "I wasn't interested in anybody else. He was the one who kept me sane there—everybody else was talking about 'painting is dead.' . . . I didn't feel very welcome there, but Charles White kept me sane."[69] White was a touchstone for students interested in pursuing figurative, representational painting at a time when conceptual art and new media were increasingly popular.[70] Twitchell had served in the Air Force and received degrees from East Los Angeles College and California State University, Los Angeles, by the time he enrolled in the graduate program at Otis. He had also already begun making public murals—he was working on *The Freeway Lady*, visible at the time to drivers on the 101 Freeway, in 1973, when he and Hernández had their initial discussion about White.[71] Despite this, he still found White to be a significant influence and mentor: "It was invaluable what we learned from him, way beyond just being able to draw. . . . For the most part, he respected who each of us was at that point, where we were going, and didn't try to turn us into him. . . . I started taking drawing very seriously, much more seriously than painting, because he did."[72] Twitchell considered White an "American cultural hero," and the elder artist became the subject of one of his monumental drawings, *Portrait of Charles White* (fig. 12).[73] Twitchell ultimately executed a mural at Otis, *Holy Trinity with Virgin* (1978), a religious painting disguised as a portrait of the television actors Billy Gray, Jan Clayton, and Clayton Moore. Although Otis relocated in 1997, *Holy Trinity with Virgin* remains at the site, which is now the Charles White Elementary School of the Los Angeles Unified School District.[74]

During his time in Los Angeles and at Otis, White taught and mentored students who dedicated themselves to creating work that has social and political impact. As he noted in 1942, "We have the opportunity to make a great contribution to American culture, but it will have to be a group effort rather than an individual contribution."[75]

"THE ARTIST AS TEACHER"

In September 1977 *The Work of Charles White: An American Experience* opened in the main gallery of the Los Angeles Municipal Art Gallery in Barnsdall Park.[76] In addition to works from the 1960s and 1970s, the Barnsdall Park installation of this major traveling exhibition included some significant additions, in particular, the monumental working drawings for White's final mural, *Mary McLeod Bethune* (fig. 11, p. 136), commissioned for the Dr. Mary McLeod Bethune Regional Library in Exposition Park. Bethune, the daughter of former slaves, rose to prominence not only as an activist and influential political figure but also as an educator, and White's altarpiece-like mural pays homage to her legacy of teaching. In the painting a young child, a book open on his lap, sits at Bethune's feet, the gridded alphabet behind him symbolizing her fight for educational opportunities for African Americans. It is especially fitting that this work was represented in the artist's Barnsdall Park exhibition, for White's importance as an educator was also evident in a parallel exhibition installed there, *The Artist as Teacher*, which presented works by his students including Hammons, Twitchell, and Wyatt. According to Adrienne Rosenthal, writing in *Artweek*, "Their debt to White in theme or execution within the variety of their expression is an enriching example of the valuable legacy that White's talent gives to all people."[77]

This juxtaposition of White's work with that of his students in one of his final major exhibitions prior to his death in 1979 affirmed his legacy as a teacher and artist. It also reflected the inseparable ties between his art making and pedagogy. Shaped by his own struggles, his drive and ambition to learn led him to create powerful visual images that would, in turn, teach others. His engagement with a variety of schools and institutions over the course of his career is evidence of his talent for and commitment to teaching. His willingness to engage in both a fine-art practice and a more commercially oriented one that placed his work in books, on record covers, and in films speaks to his ultimate goal of communicating with the largest possible audience. That his art, and the art of many of his students, continues to challenge and educate viewers today is a testament to his success.

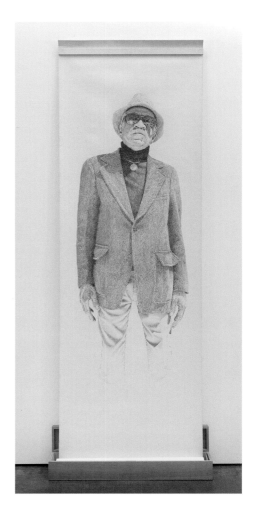

FIG. 12
KENT TWITCHELL (AMERICAN, BORN 1942)

Portrait of Charles White, 1977. Pencil on paper; 335.28 × 121.92 cm (132 × 48 in.). Los Angeles County Museum of Art, gift of Benjamin Horowitz.

1. The Liberation Bookstore (1967–2007) sold literature on black life, culture, and power. For more information on Una Mulzac and the Liberation Bookstore, see Douglas Martin, "Una Mulzac, Bookseller with Passion for Black Politics, Dies at 88," *New York Times*, Feb. 4, 2012, www.nytimes.com/2012/02/05/nyregion/una-mulzac-harlem-bookseller-with-a-passion-for-black-politics-dies-at-88.html; and Fisher, *Black Literate Lives*, 77.

2. See Sarah Kelly Oehler's essay in this volume.

3. For more on the Art Crafts Guild and the history of the SSCAC, see Oehler, *They Seek a City*, 40–42; and Tyler, "Planting and Maintaining a 'Perennial Garden.'"

4. On the pooling of funds to pay for SAIC classes, see Gellman, "Chicago's Native Son," 149.

5. Barnwell, *Charles White*, 27; and Samella Lewis, interview by Peter Clothier, transcript, 3, Charles White Archives, CA.

6. White had initially intended to study at the Escuela Nacional de Pintura y Escultura (National Academy of Painting and Sculpture) "La Esmeralda" in Mexico City, but the US draft board would not grant him permission to leave the country. In his application for a Rosenwald Fellowship, White specified that "[m]y choice of this particular institution is dependent on the workshop basis of the school." This further explains why he would have found the Art Students League, with its own "workshop basis," an appropriate substitute.

7. Warner, *The Prints of Harry Sternberg*, 108. Like White, Sternberg also exhibited at the ACA Gallery beginning in the 1940s, and their social and professional circles likely overlapped during White's time in New York.

8. White, "Report of a Year's Progress and Plan of Work," 1, Charles W. White fellowship file, Julius Rosenwald Fund Archives, box 456, file 6, John Hope and Aurelia E. Franklin Library, Special Collections and Archives, Fisk University, Nashville.

9. White, "Report of a Year's Progress and Plan of Work," 1–2.

10. Ibid., 2; and in the same folder, White, "Statement of Plan of Work."

11. White, "Statement of Plan of Work."

12. White, "Report of a Year's Progress and Plan of Work," 2.

13. P. Smith, "Lowenfeld Teaching Art," 30–33; and Ritter, *Five Decades*, 8–9. Lowenfeld's reputation, as well as connections to MoMA head of education Victor D'Amico, enabled him to arrange an exhibition at MoMA in 1943 of Hampton student artwork. He had already organized one exhibition there, *Visual and Non-Visual Art Expression*, which was held in the museum's Young People's Gallery from March 7 to May 1, 1940. It contrasted artworks made by blind children and those with unimpaired vision as a way of highlighting different modes of experience and creative communication. For the press release for that exhibition, see www.moma.org/documents/moma_press-release_325164.pdf. *Young Negro Art*, featuring the work of Lowenfeld's Hampton students, was held in the same gallery October 26–November 28, 1943. For the corresponding press release, see www.moma.org/documents/moma_press-release_325414.pdf. A work from *Young Negro Art* was purchased for the museum's collection: Junius Redwood, *Night Scene* (1941).

14. Viktor Lowenfeld, "Negro Art Expression in America," *Madison Quarterly* 5, no. 11 (Jan. 1945): 27.

15. Lowenfeld, press release for *Young Negro Art* (n. 13 above).

16. Catlett's presence at Hampton, where she taught sculpture while White worked on his mural, was influential as well, especially on the artist and scholar Samella Lewis: Lewis had studied with Catlett at Dillard and transferred to Hampton to continue her studies with her. See Muchnic, "Samella Lewis," 16-17; and Herzog, *Elizabeth Catlett*, 34–36.

17. Olive Jensen Theisen, *The Murals of John Thomas Biggers* (Hampton, VA: Hampton University Museum, 1996), 3. Another student at Hampton, Joseph Gilliard, suggests that White also learned about fresco and other painting techniques from Lowenfeld; see Ritter, *Five Decades*, 17.

18. Theisen, *Murals of John Thomas Biggers*, 3.

19. Ibid.

20. See the chronology in this volume.

21. "Harlem to Open Center Named for George Washington Carver," *New York Herald Tribune*, Oct. 24, 1943, 5.

22. Ramona Lowe, "Harlem's Carver School Draws Capacity Classrooms," *Chicago Defender*, Feb. 5, 1944, 18.

23. Bennett quoted in Ann Rivington, "The George Washington Carver School," *Daily Worker*, Oct. 26, 1943, 7.

24. Earl Conrad, "A Lady Laughs at Fate," *Chicago Defender*, Jan. 5, 1946, 9. White left Carver in 1944 when he was drafted into the US Army. According to a flyer titled "This Is the Carver School," dated Feb. 3, 1946, he had returned as an instructor by then. Professional and Literary Activities, George Washington Carver School, box 2, folder 2, reel 1, Gwendolyn Bennett Papers, Schomburg Center for Research in Black Culture, New York Public Library.

25. Herzog, *Elizabeth Catlett*, 37, quoting from a 1991 interview with the artist.

26. Frederick Woltman, "Carver School Name Called Red Negro Ruse," *New York World Telegram*, Nov. 16, 1943, 14.

27. White and Catlett ran the art program at Wo-Chi-Ca that summer and thereafter continued to offer advice and support. There White met Frances Barrett, who was a Wo-Chi-Ca counselor in 1942. They would reconnect and marry in 1950. For more on the connections between the camp and members of White's artistic communities in Chicago and Harlem, see Levine and Gordon, *Tales of Wo-Chi-Ca*, 9–28.

28. White, *Charles White: Six Drawings*. For more on White's involvement with the leftist press, see Washington, *The Other Blacklist*, 73; for an extensive discussion of his political affiliations and their effects on his work, 69–122.

29. White, quoted in Jeffrey Elliot, "Charles White: Portrait of an Artist," *Negro History Bulletin* 41, no. 3 (May–June 1978): 828.

30. Harry Raymond, *Dixie Comes to New York: Story of the Freeport GI Slayings* (New York: Daily Worker, 1946). See also Morgan, *Rethinking Social Realism*, 148–49.

31. Transcript of undated interview with Charles White, located in Lucinda H. Gedeon, research material on Charles W. White (c. 1977–97), Archives of American Art, Smithsonian Institution, Washington, DC (hereafter AAA). For more on the history and influence of Mexican art and artists on White, Catlett, and other American artists, see Herzog, *Elizabeth Catlett*, 49–56.

32. Frances Barrett White writes that, after their marriage on May 31, 1950, "Charles returned to New York later that afternoon to start his new job at the New York School of Advertising Art"; F. B. White, *Reaches of the Heart*, 24. The school seems to have been known by several names—in 1949 alone, posters advertised it as both "Workshop School of Advertising Art" and "Workshop School of Advertising and Editorial Art"; see *Annual of Advertising and Editorial Art* 29 (1950): n.p., entry 198–99. Little information is available about how long the school was in operation. A letter from administrative director Matthew Cooper to White dated August 20, 1952, suggests that it may have closed at some point in 1951 or 1952, and that White was not asked to teach there during a planned reopening in October 1952. See reel 3194, Charles W. White Papers (CWP), AAA. On a curriculum vitae likely dating to the mid-1960s, White listed his time at the Workshop School as 1950–53. He also describes himself in the header as "Charles W. White, Painter, Graphic artist, teacher, designer," unmicrofilmed material, CWP, AAA.

33. "Up to now, there has been no really professional school for artists in New York or elsewhere where an art director, layout artist, free-lance designer, art teacher could continue life drawing, improve on his design facility, increase his store of production data, and generally keep abreast of current trends, and help create future ones on a clinical, experimental and adult basis. It is on this basis that the school serves a real and unique purpose." From A. F. Arnold, "Prospectus of Workshop School of Advertising Art," unpublished, 1949, Columbia University Libraries, New York, 707 Ar65.

34. "Charles White One-Man Show—ACA Gallery," press release, Feb. 1950. This announcement listed him as "one of the two Negroes on the faculty of the Workshop School of Editorial and Advertising Art." A copy of this release can be found at the Amon Carter Museum of American Art, Fort Worth, Texas, in the object file for White's drawing *Trenton Six*. I thank Shirley Reece-Hughes, curator of paintings and sculpture there, for sharing this and other materials with me.

35. Arnold, "Prospectus," 6, 8 (n. 33 above).

36. Circular letter from CNA, June 17, 1949, W. E. B. Du Bois Papers, MS 12, Special Collections and University Archives, University of Massachusetts Amherst Libraries, credo.library.umass.edu/view

/pageturn/mums312-b128-i052/#page/1/mode/1up.

37. Undated document, CNA, Printed Ephemera Collection on Organizations, PE.036, box 29, Tamiment Library/Robert F. Wagner Labor Archives, Elmer Holmes Bobst Library, New York University Libraries.

38. "Call to a Conference on Radio, Television, and the Negro People," 1949, CNA, Printed Ephemera Collection on Organizations (n. 37 above).

39. "Charles White One-Man Show—ACA Gallery," and "One Man Show of Charles White, Leading Young Negro Artist Opens at ACA Feb. 12," *Daily Worker*, Feb. 7, 1950, 11.

40. Sterling and Logan, *Four Took Freedom*; and Bennett, *Shaping of Black America*. The drawings for *Four Took Freedom* are listed as D189–D208 in Gedeon, "Introduction." It is likely that correspondence between White and Diana Klemin of Doubleday regarding illustrations for a publication referred to as "Freedom Soldiers" is about *Four Took Freedom*. See reel 3191, CWP, AAA. Gedeon lists the drawings for Bennett's book D287-98; "Introduction." They are now in the collection of Arthur Primas; see *Heroes*, 81–104.

41. K. Jones, *South of Pico*, 37, 143–44. Calendars are in the Golden State Mutual Life Insurance Company Records (collection 1434), UCLA Library Special Collections, Charles E. Young Research Library, Los Angeles.

42. Gedeon lists thirteen drawings made for Vanguard for album covers. See Gedeon, "Introduction," D87–D99.

43. 1965 Grammy Award nomination card and program, reel 3191, CWP, AAA.

44. "Artist for Anna," *Hue* 6, no. 4 (Feb. 1959): 51. For more on White's involvement with *Anna Lucasta*, and film and television generally, see K. Jones, *South of Pico*, 24–27.

45. J. Smith, *Becoming Belafonte*, 203.

46. Louie Robinson, "Charles White: Portrayer of Black Dignity," *Ebony* 22, no. 9 (July 1967): 36.

47. "Second Year Drawing 1967–68, Charles White, Instructor, Introduction: Outline of Program," reel 3194, CWP, AAA.

48. Kerry James Marshall, conversation with the author, June 2016.

49. "Second Year Drawing 1967–68" (n. 47 above).

50. Robinson, "Charles White," 30.

51. For more on abstraction as it functions in the *Wanted Poster Series* and later works, see K. Jones, *South of Pico*; and Adler, *Charles White*.

52. "Second Year Drawing 1967–68" (n. 47 above).

53. Elliot, "Charles White," 826.

54. William Wilson, "Art Walk: A Critical Guide to the Galleries," *Los Angeles Times*, May 11, 1973, IV, 14.

55. Hernández, oral history interview, transcript, Mar. 28, 1998, AAA. The Chouinard Art Institute, founded in 1921 by Nelbert Chouinard, merged with the Los Angeles Conservatory of Music in 1961 to form the California Institute of Arts, a move orchestrated by Walt and Roy Disney. However, it remained a distinct entity at its

existing location in the Westlake area of Los Angeles, walking distance from the Otis Art Institute, until 1970 and the opening of the current CalArts campus in Valencia. Chouinard, more so than Otis, was also known as a center for unorthodox and avant-garde thinking. For more information, see Karlstrom, "Art School Sketches," 97–99; and Perine, *Chouinard*.

56. During White's tenure at Otis, students were required to complete two years of undergraduate education prior to enrollment; they could then complete their junior and senior years at Otis. Judithe Hernández and Kerry James Marshall, discussions with the author; and Otis Art Institute of Los Angeles County Catalogue 1978–79, 13–14, collections.otis.edu/cdm/compoundobject/collection/arp/id/1359/rec/16.

57. Noriega and Rivas, "Chicano Art in the City of Dreams," 76; see also Alurista, *Floricanto en Aztlán*. For more on Hernández and her work, see her website, www.judithehernandez.com/.

58. Hernández in discussion with the author, Sept. 2016; and Hernández, oral history interview (n. 55 above). Richard Wyatt Jr., another former student of White's, also remembers him talking about his experiences in Mexico. Wyatt, conversation with the author, Sept. 2016.

59. Marshall, conversation with the author, June 2016.

60. Ibid.

61. Hammons, conversation with Joseph E. Young, 1970, quoted in Young, *Three Graphic Artists*, 7.

62. Young, *Three Graphic Artists*, 7; and K. Jones, *South of Pico*, 224–30.

63. F. B. White, *Reaches of the Heart*, 174–76. See also notes, most likely written by Frances Barrett White, reel 3192, CWP, AAA; and Lewis, interview by Clothier (n. 5 above). For more on the Black Arts Council, see K. Jones, *South of Pico*, 162–72. For more on White's agreement to participate in this show, see the essay by Ilene Susan Fort in this volume.

64. "Golden State Mutual Life Insurance Company Scholarship Class and Tutor/Art—a Report," reel 3194, CWP, AAA; and K. Jones, *South of Pico*, 35–38, 142–44. White's role as a teacher in this program recalls his own experiences as a student attending Saturday classes at the Art Institute of Chicago; see Sarah Kelly Oehler's essay in this volume.

65. Wyatt, conversation with the author, Sept. 2016; and Wyatt, "His Special Gift for Teaching . . . ," *Freedomways* 20, no. 3 (1980): 177–78. Wyatt's mother, Ruby Wyatt, also sought White out, determined that her son have an opportunity to meet and study with him.

66. Wyatt, conversation with the author, Sept. 2016. Wyatt graduated from UCLA in 1978 with a BFA in painting.

67. "That specific site has layers and layers of history, so we wanted to deal with that. . . . I included early settlers of Los Angeles, known as los pobladores, along with references to the old Chinatown. I also put a couple of family members in there." Wyatt, quoted in Hugh Hart, "Stationed in Los Angeles," *UCLA Magazine* 26, no. 1

(Oct. 2014): 27. Wyatt restored *Hollywood Jazz* in 2013; Randy Lewis, "'Hollywood Jazz' mural lives on more brightly," *Los Angeles Times*, Feb. 18, 2013, articles.latimes.com/2013/feb/18/entertainment/la-et-cm-hollywood-jazz-mural-20130219.

68. White generally ceased mural painting after the dissolution of the WPA, when opportunities and funding, previously provided for this kind of public artwork by the US government, disappeared. An exception is White's last mural, *Mary McLeod Bethune* (fig. 11, p. 136), commissioned for the Bethune Branch Library in Exposition Park.

69. Twitchell, conversation with the author, Sept. 2016.

70. White discusses this in "Rap Session CW/RS 70," typescript, Charles White Archives, CA. There is also a copy in Lucinda H. Gedeon, research material on Charles W. White (c. 1977-97), box 2, folder 2, AAA. The interviewer is not identified by name but is referred to only as "student."

71. Twitchell, conversation with the author, Sept. 2016. For more information on *The Freeway Lady*, which was destroyed twice and repainted at Los Angeles Valley College in 2016, see Dana Bartholomew, "LA's Freeway Lady mural to be retired in San Fernando Valley," *Los Angeles Daily News*, Apr. 13, 2016, www.dailynews.com/arts-and-entertainment/20160413/las-freeway-lady-mural-to-be-retired-in-san-fernando-valley.

72. Twitchell, conversation with the author, Sept. 2016.

73. Ibid.

74. Ibid. LACMA has worked with the Charles White Elementary School to bring exhibitions and programming to the school's gallery since 2007. When *Charles White: A Retrospective* is presented at LACMA in 2019, the elementary school will host an exhibition of the work of White's students, some of whom continue to live and work in Los Angeles.

75. White, "Statement of Plan of Work" (n. 10 above).

76. Exhibition announcement, reel 3190, CWP, AAA. The exhibition was organized in 1976 by the High Museum of Art, Atlanta, and traveled to several institutions in the South prior to being presented in Los Angeles; see the selected exhibition history in this volume.

77. Adrienne Rosenthal, "Charles White Paints Hope and Anger," *Artweek* 6, no. 32 (Oct. 1, 1977): 4.

LOS ANGELES

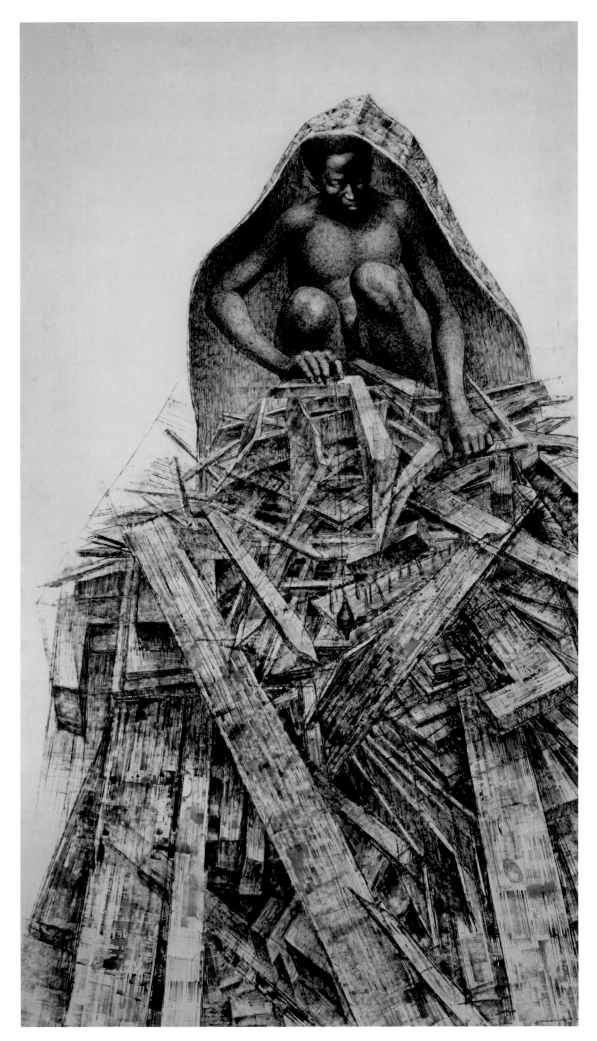

70. *Birmingham Totem*, 1964
Ink and charcoal on paper
Cat. 61

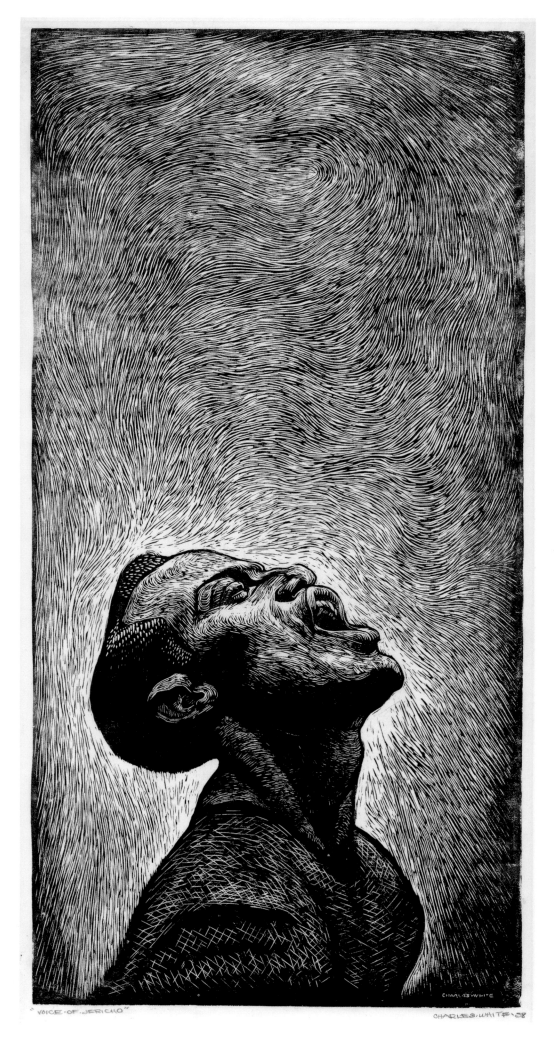

71. *Voice of Jericho (Folksinger)*, 1958
Linocut on paper
Cat. 59

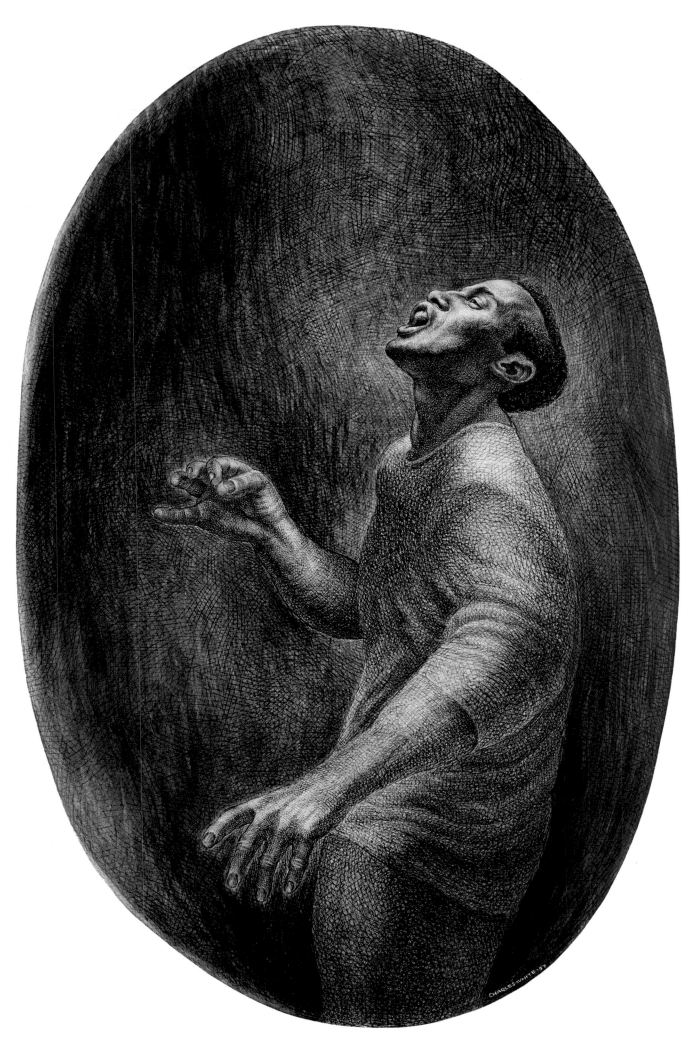

72. *Folksinger (Voice of Jericho: Portrait of Harry Belafonte)*, 1957
Ink and colored ink with white additions on board
Cat. 54

73. *Sammy Davis Jr.* (from *Anna Lucasta*), 1958
Charcoal on board
Cat. 57

74. *Rex Ingram, Fred O'Neal, and Georgia Burke*
(from *Anna Lucasta*), 1958
Wolff crayon on paper
Cat. 56

75. *Eartha Kitt* (from *Anna Lucasta*), 1958
Wolff crayon over traces of brown pencil on illustration board
Cat. 55

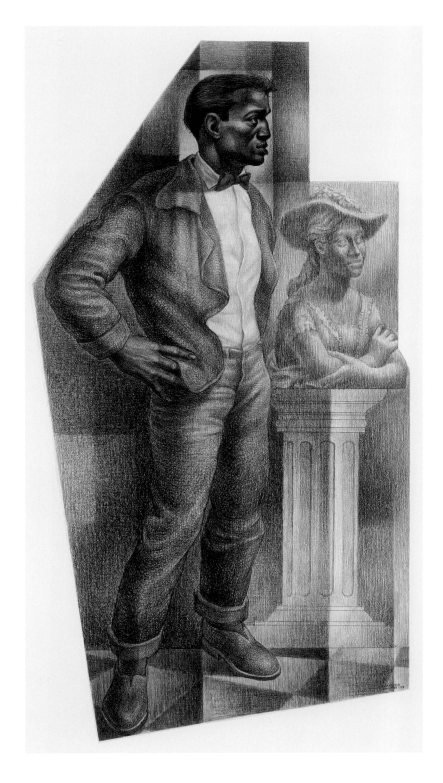

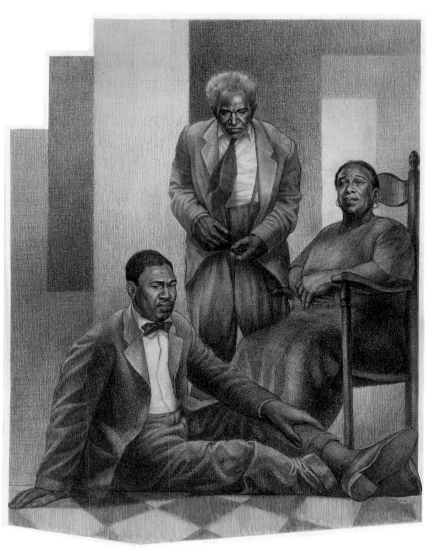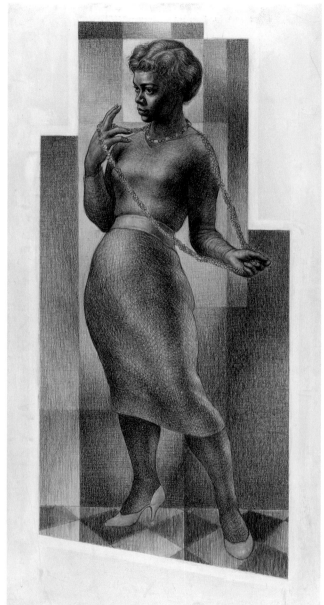

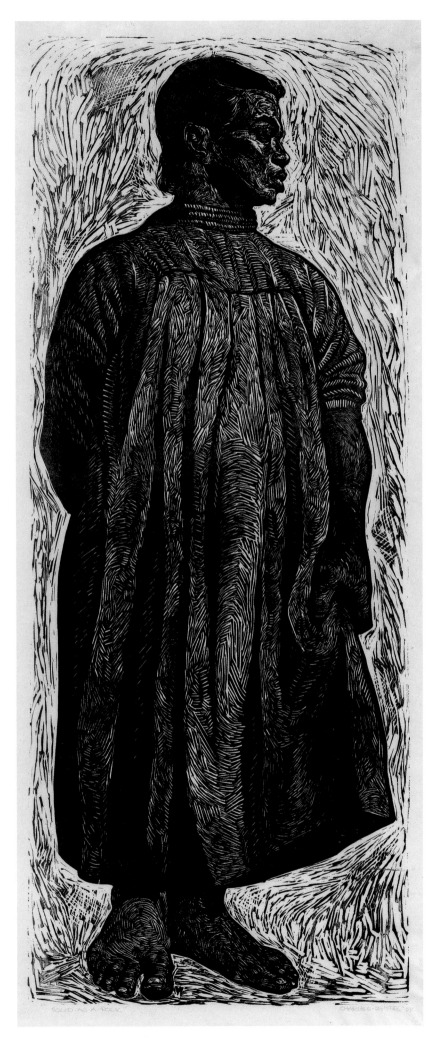

76. *Solid as a Rock (My God is Rock)*, 1958, printed 1959
Linocut in black ink on cream laid Japanese paper
Cat. 58

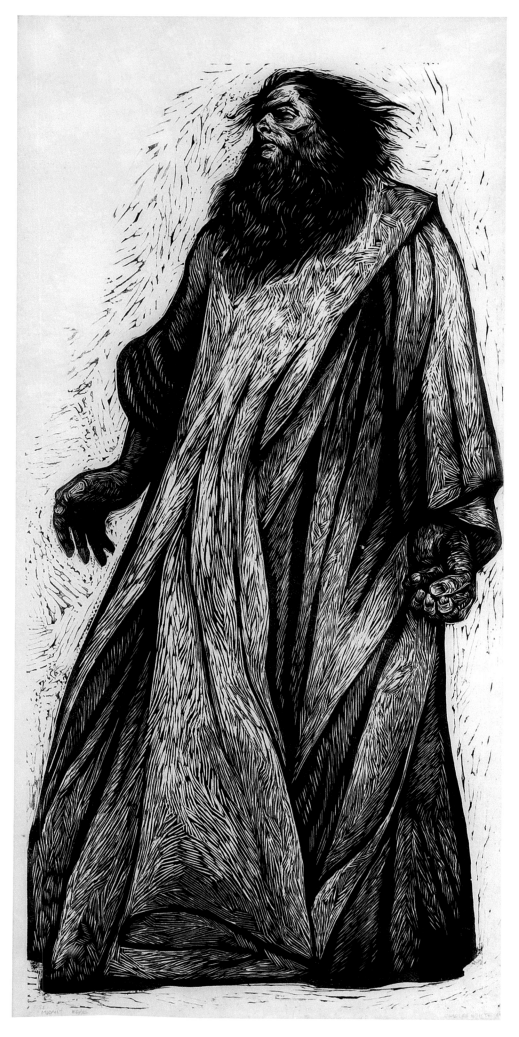

77. Micah, 1964
Linocut on paper
Cat. 62

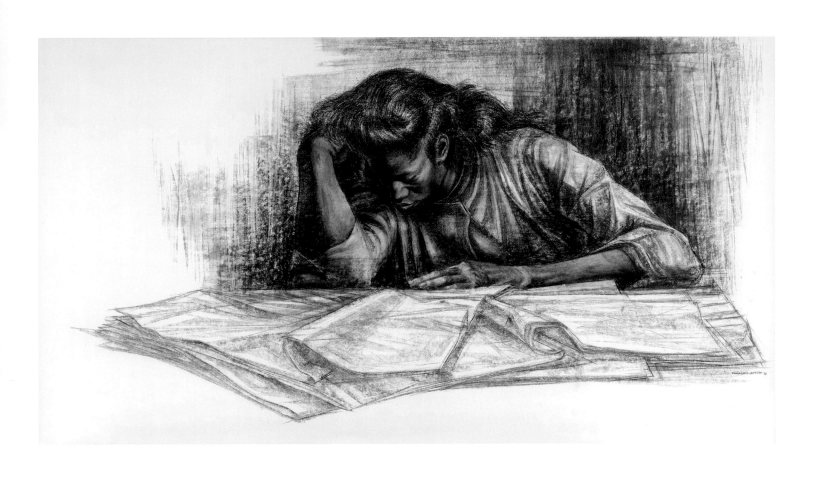

78. *Awaken from the Unknowing*, 1961
Compressed and brown and gray vine charcoal with scratching
out, blending, and erasing on cold-pressed illustration board
Cat. 60

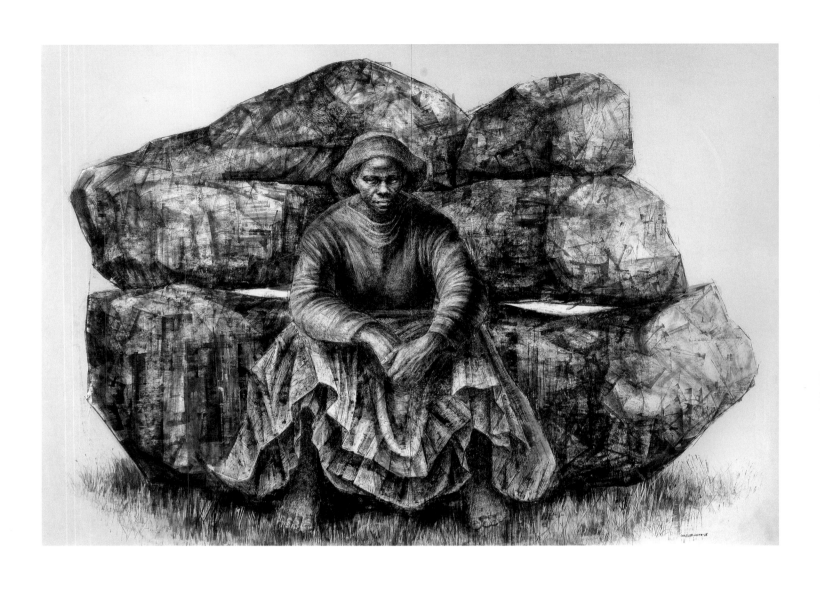

79. *General Moses (Harriet Tubman)*, 1965
Ink on paper
Cat. 63

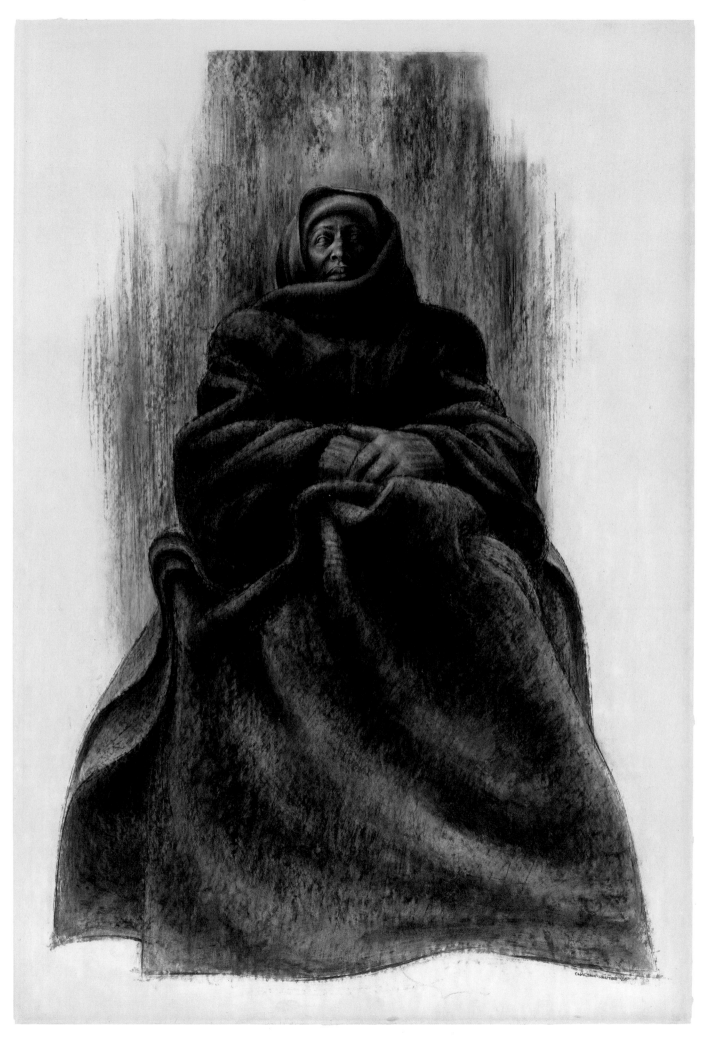

80. *J'Accuse #1*, 1965
Charcoal and Wolff crayon on illustration board
Cat. 64

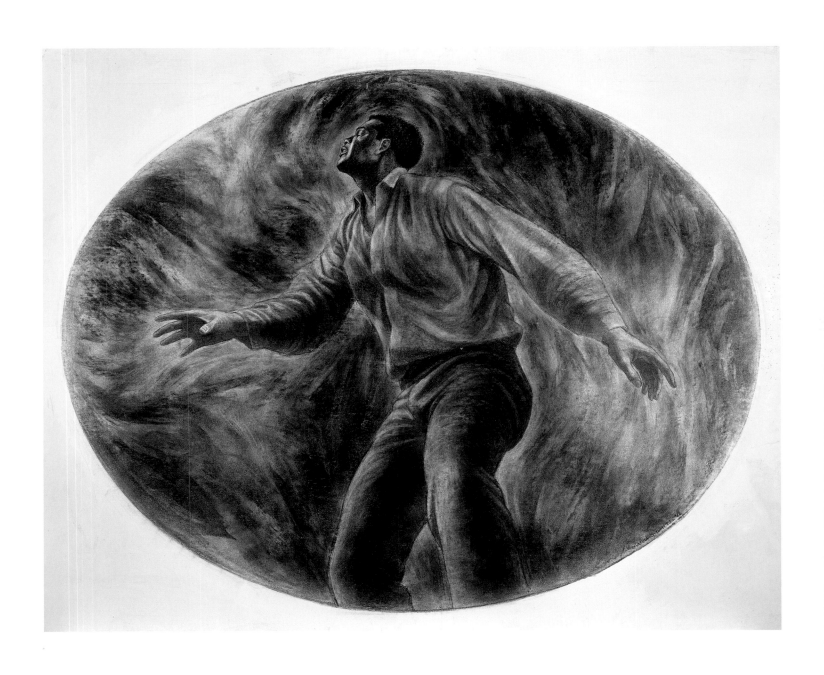

81. *J'Accuse #6*, 1966
Charcoal on paper
Cat. 65

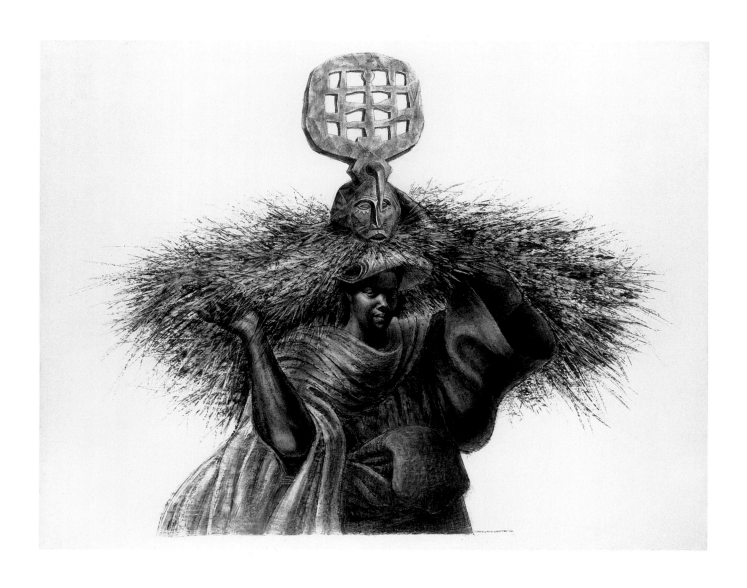

82. *J'Accuse #7*, 1966
Charcoal on paper
Cat. 66

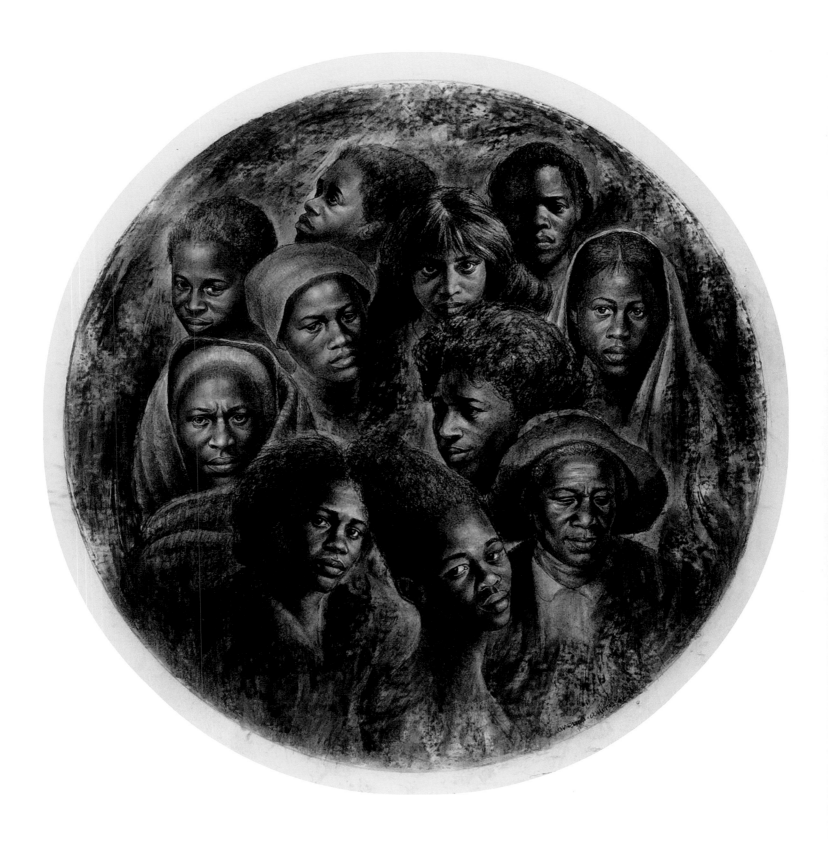

83. *J'Accuse #10 (Negro Woman)*, 1966
Charcoal on paper
Cat. 67

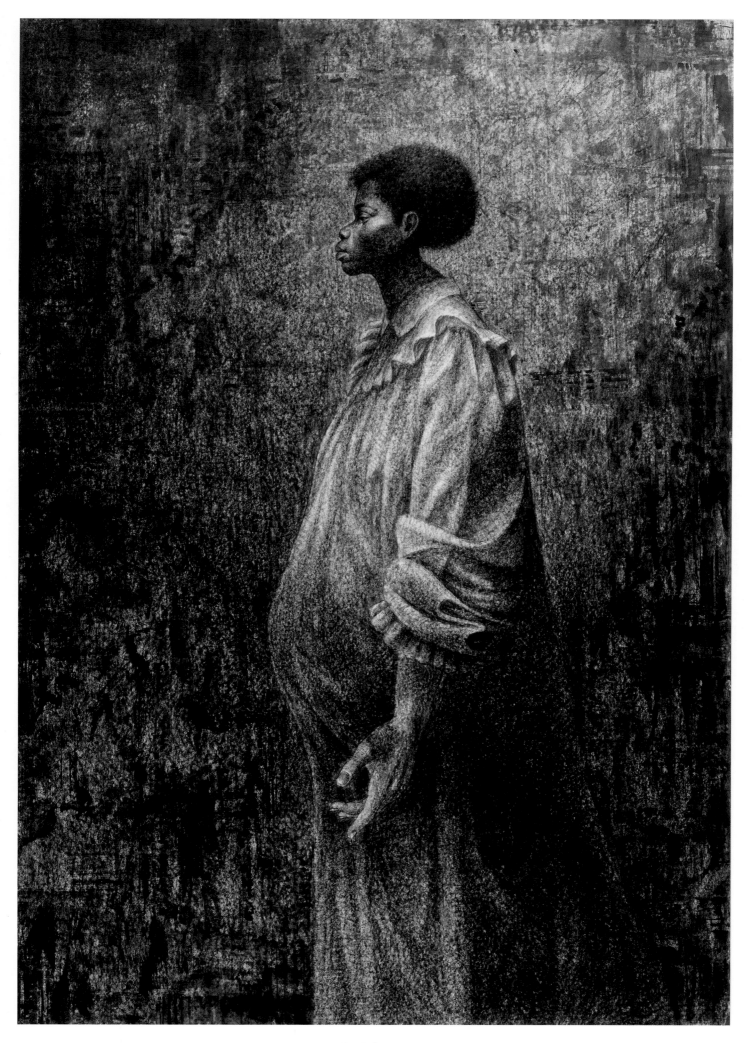

84. *Seed of Love*, 1969
Ink on paper
Cat. 73

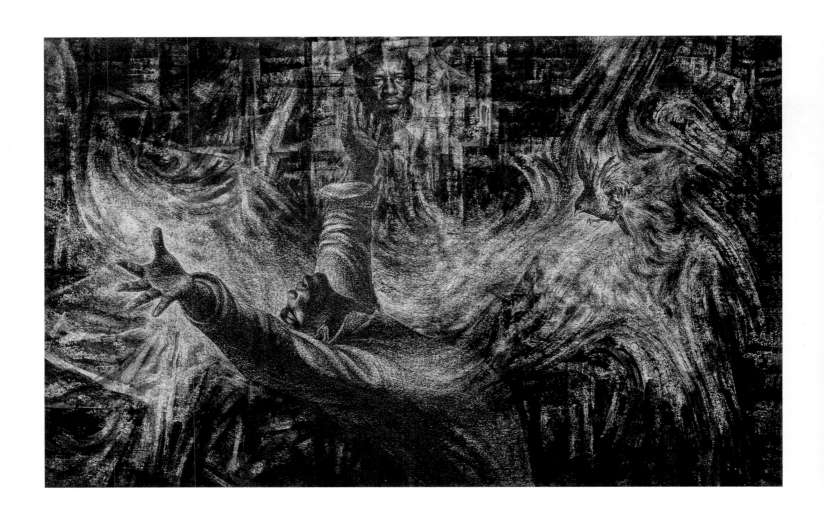

85. *Nat Turner, Yesterday, Today, Tomorrow,* 1968
Drybrush and ink on board
Cat. 70

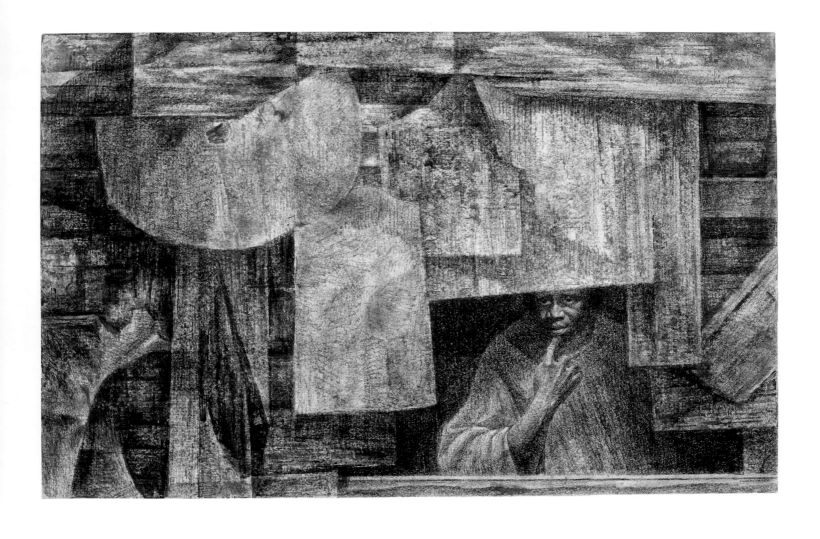

86. *Dream Deferred II*, 1969
Oil wash, ink, and Wolff crayon on paper
Cat. 71

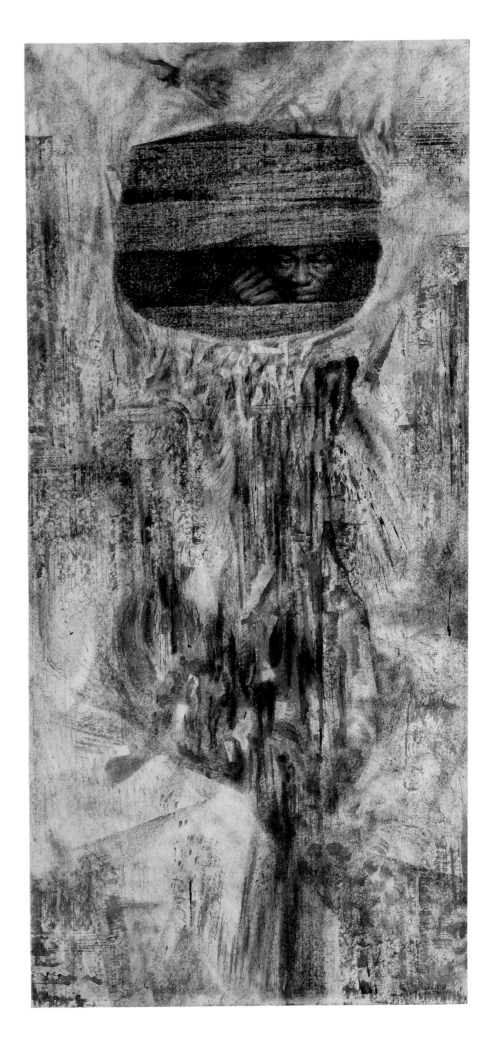

87. *Elmina Castle*, 1969
Ink on board
Cat. 72

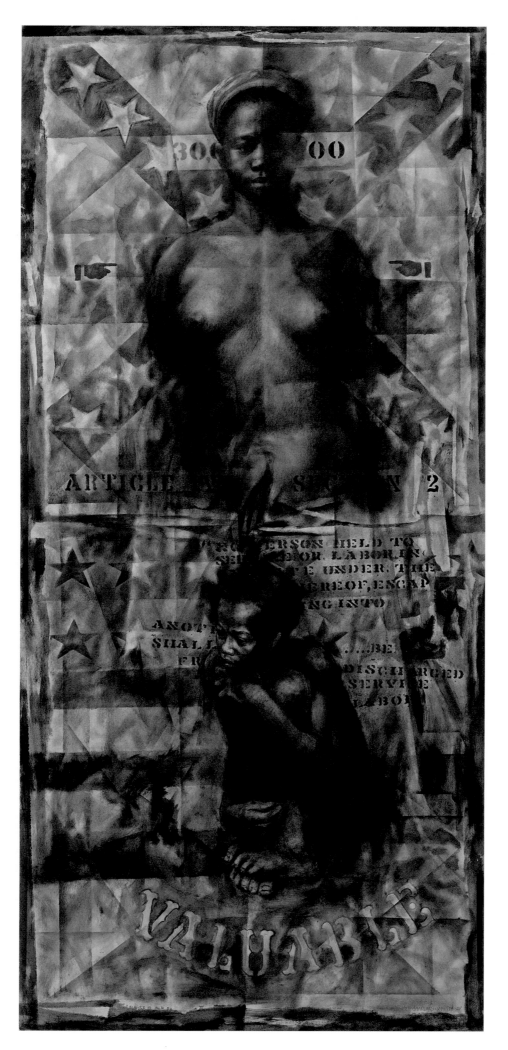

88. *Wanted Poster Series #6*, 1969
Oil wash brushed and stenciled with masking out over traces of
graphite pencil on commercial laminated board
Cat. 74

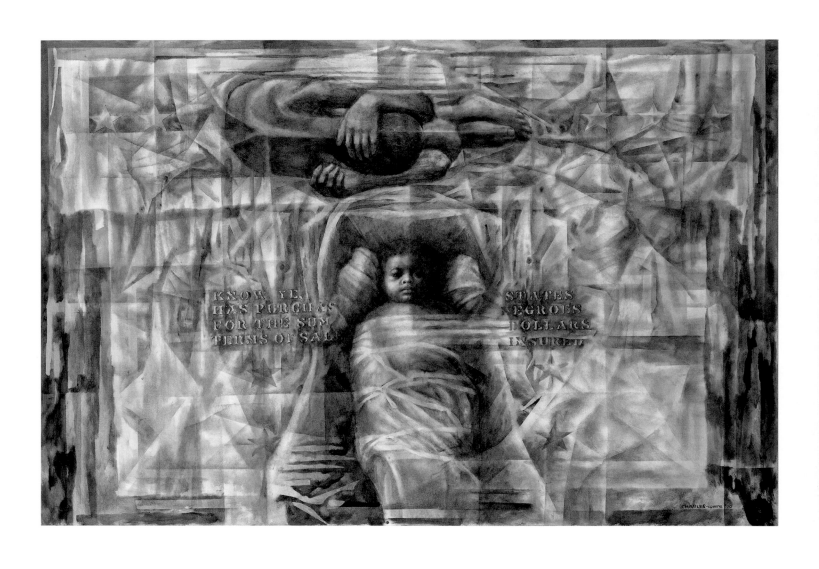

89. *Wanted Poster Series #10*, 1970
Oil wash brushed and stenciled with masking out over traces of
graphite pencil on commercial laminated board
Cat. 76

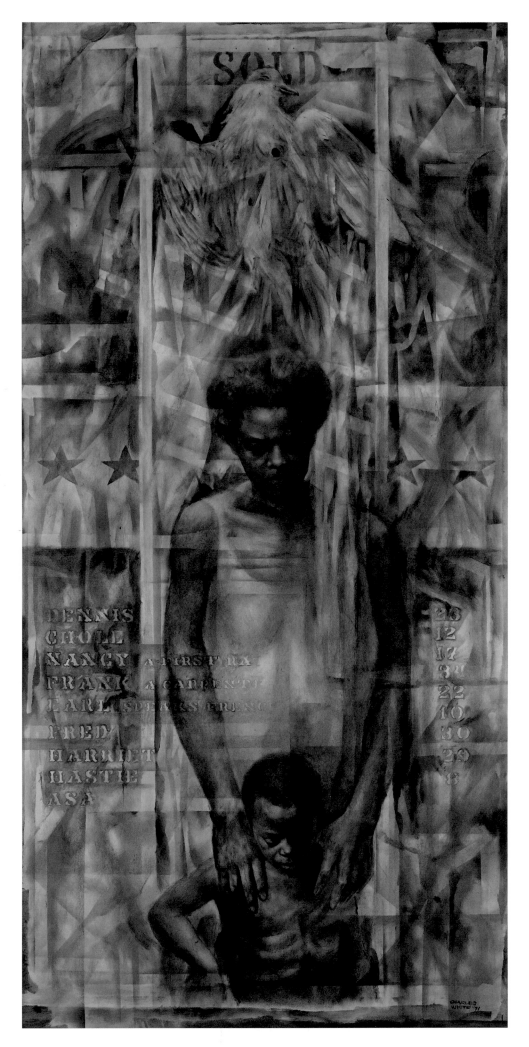

90. *Wanted Poster Series #17*, 1971
Oil and pencil on poster board
Cat. 81

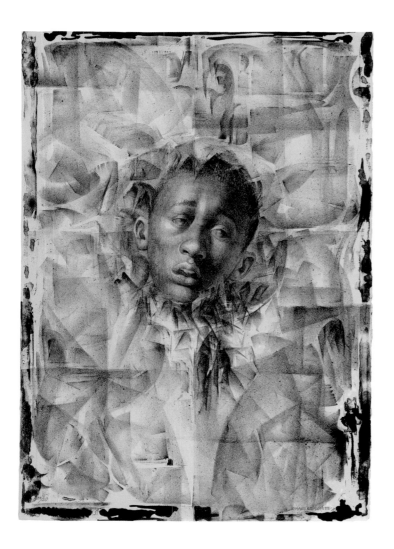

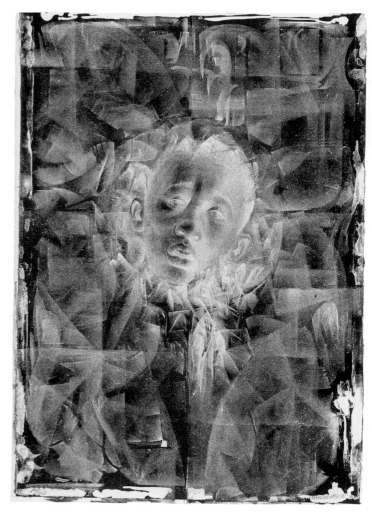

91. *Wanted Poster Series #11*, 1970
Lithograph in brown on buff wove paper
Cat. 77

92. *Wanted Poster Series #11a*, 1970
Lithograph in brown on buff wove paper
Cat. 78

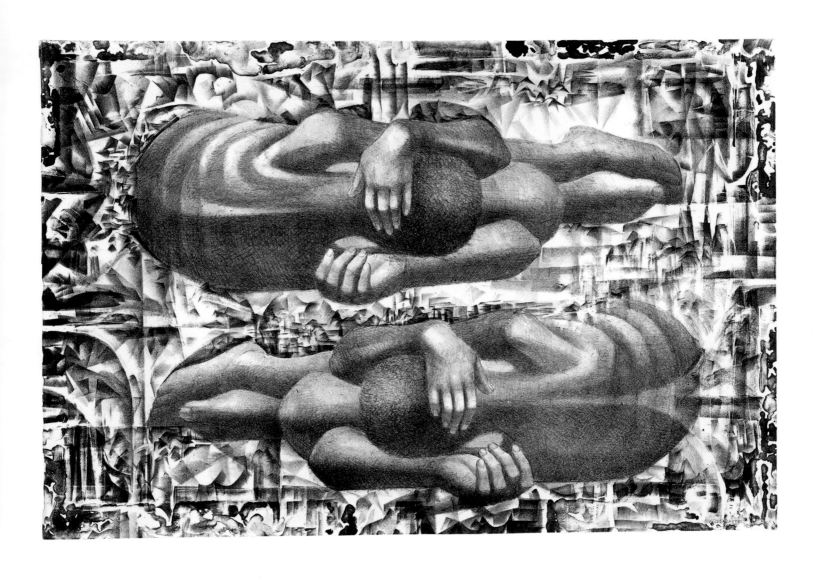

93. *Wanted Poster Series #12*, 1970
Lithograph in brown on white wove paper
Cat. 79

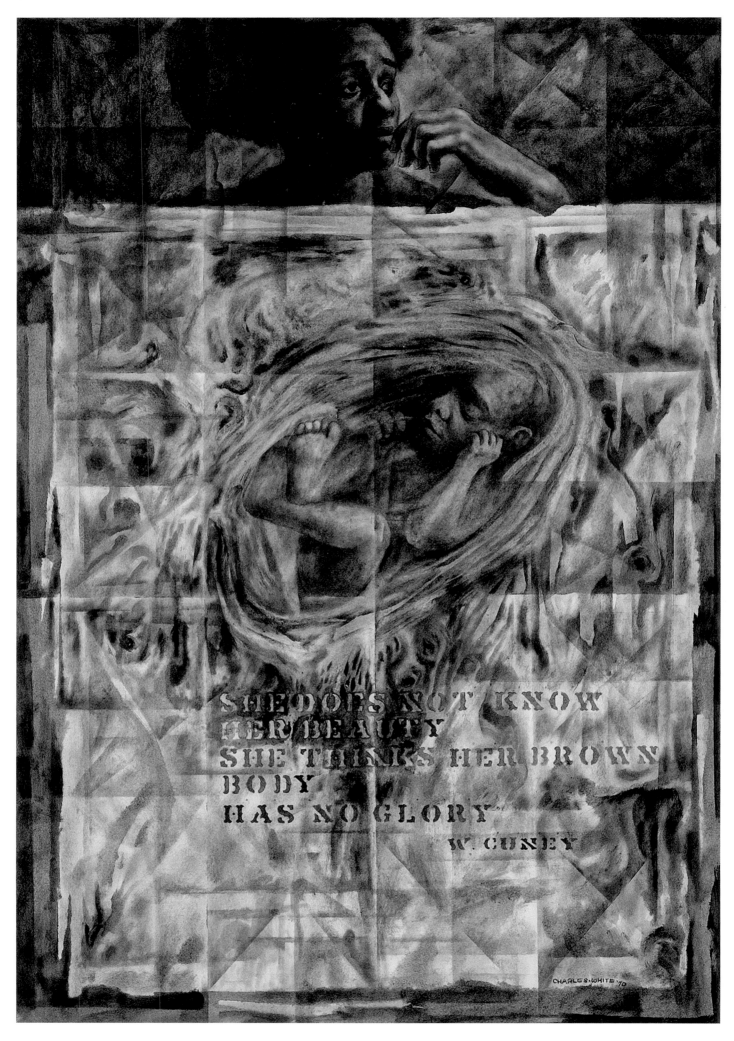

94. *She Does Not Know Her Beauty*, 1970
Oil on board
Cat. 75

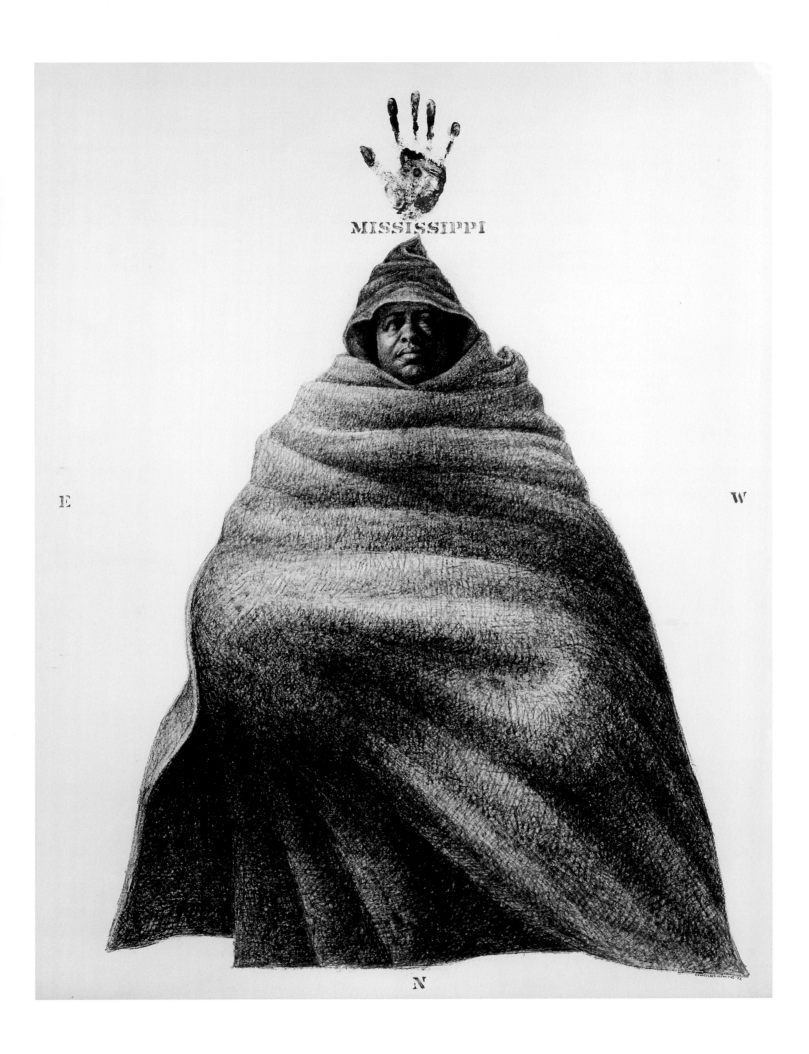

95. *Mississippi*, 1972
Oil wash on board
Cat. 84

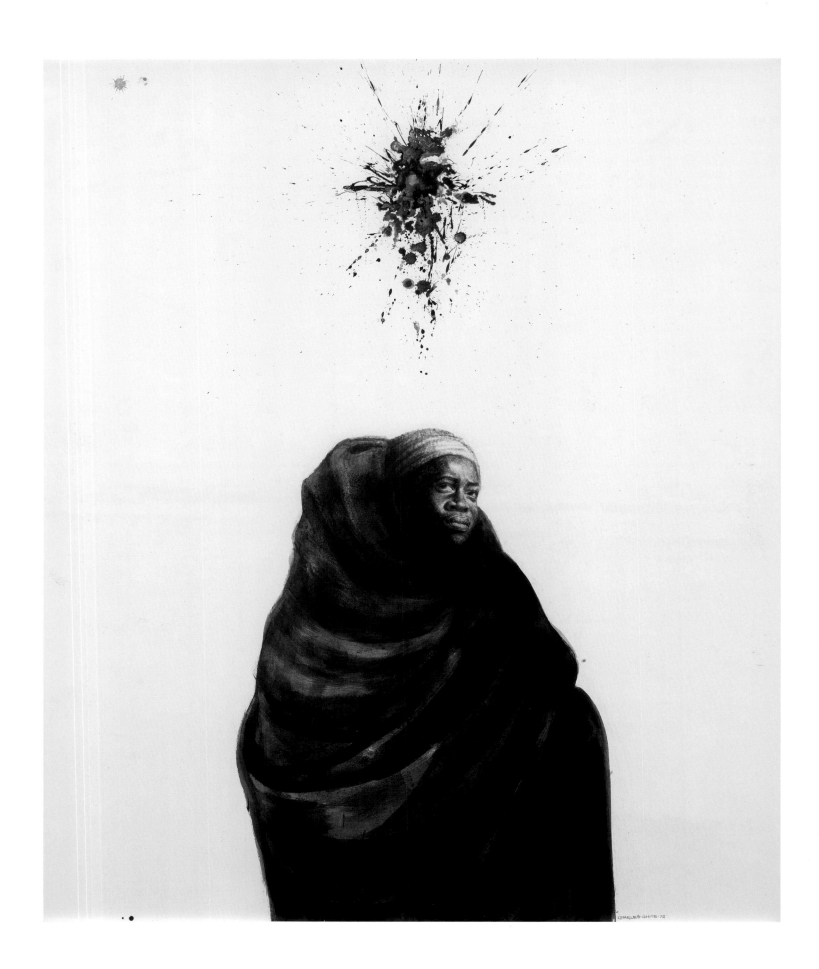

96. *Harriet*, 1972
Oil on board
Cat. 83

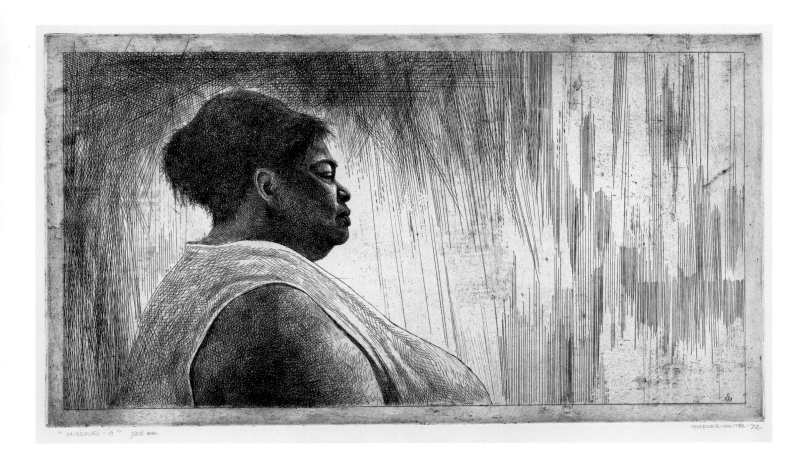

97. *Missouri C*, 1972
Etching in black on cream wove paper
Cat. 85

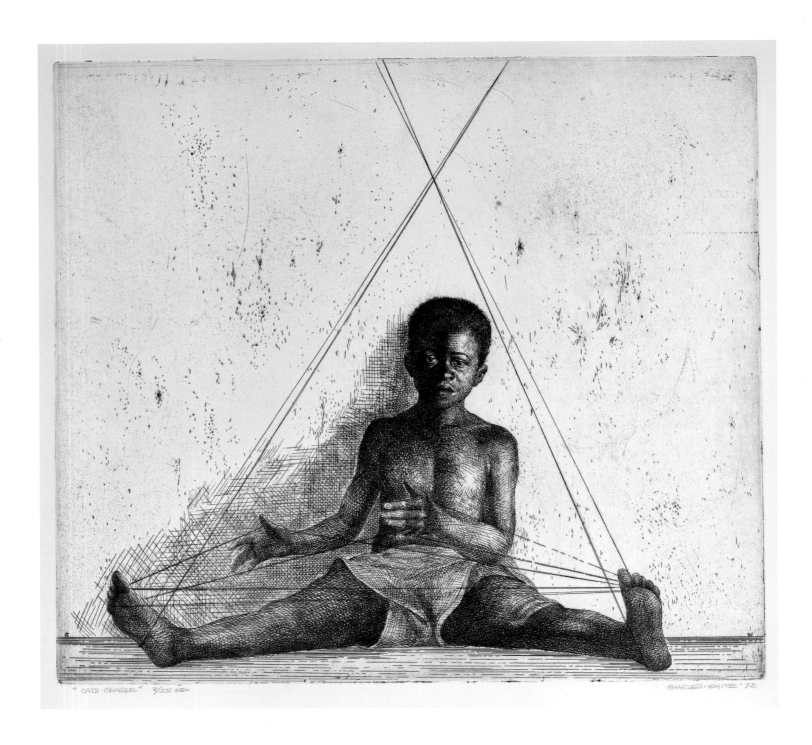

98. *Cat's Cradle*, 1972
Etching on paper
Cat. 82

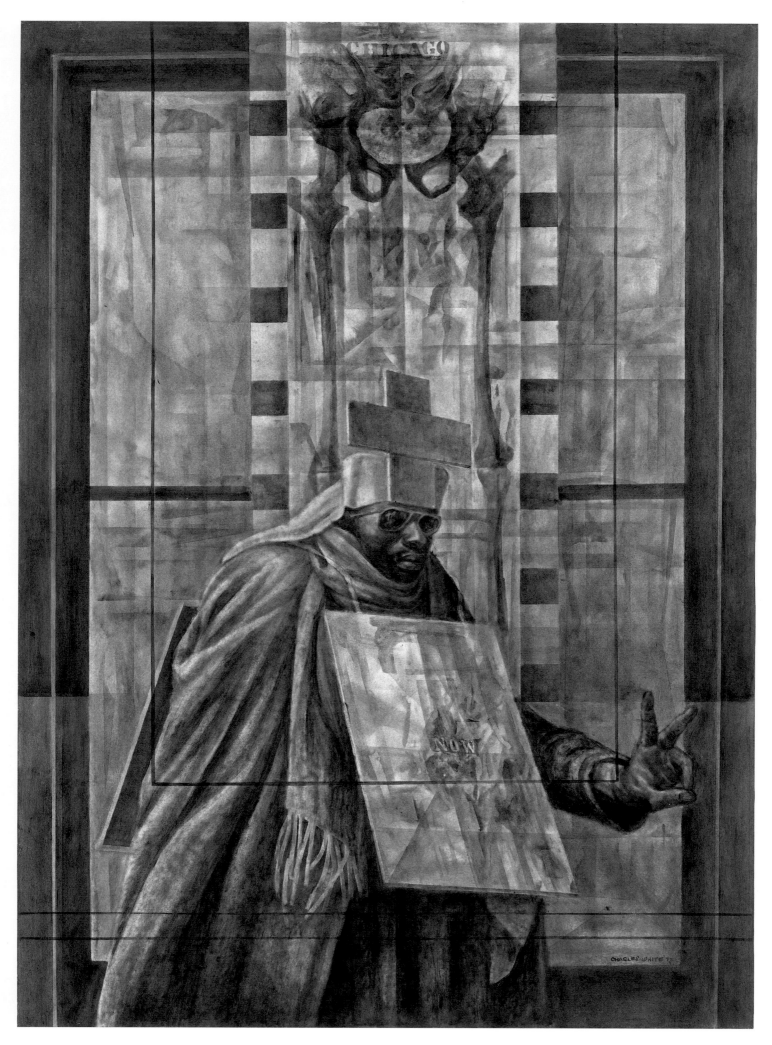

99. *Black Pope (Sandwich Board Man)*, 1973
Oil wash on board
Cat. 86

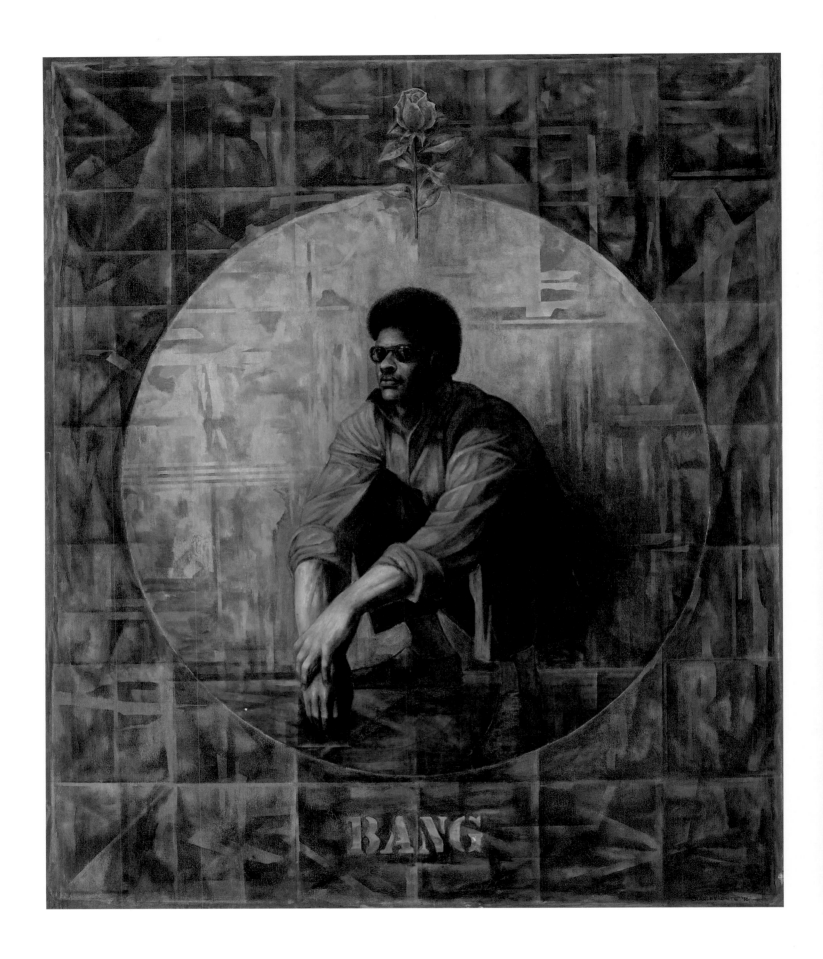

100. *Banner for Willy J.*, 1976
Oil on canvas
Cat. 87

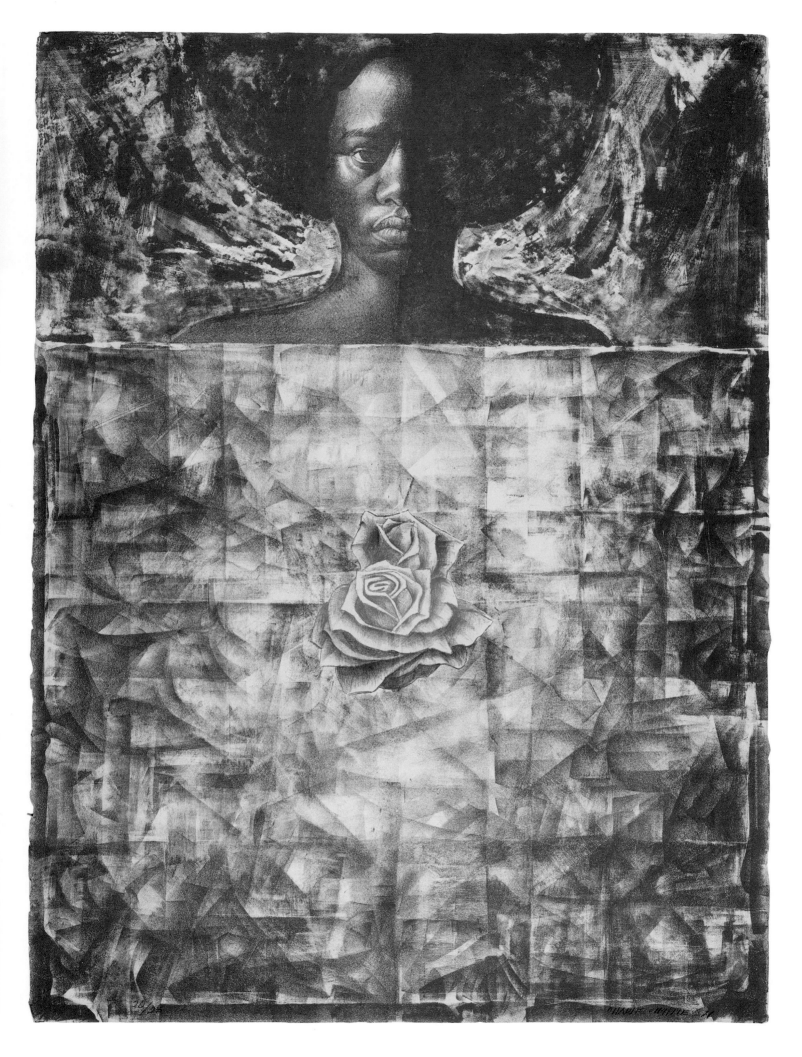

101. *Love Letter I*, 1971
Color lithograph on buff wove paper
Cat. 80

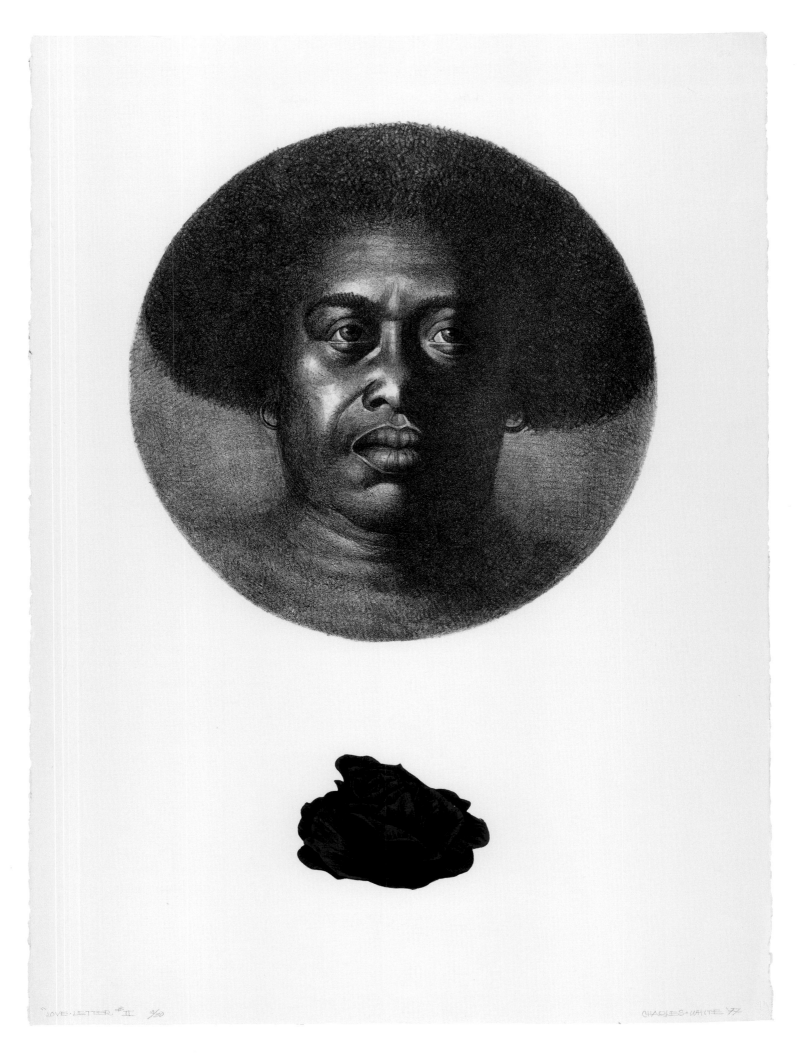

102. *Love Letter II*, 1977
Color lithograph on cream wove paper
Cat. 88

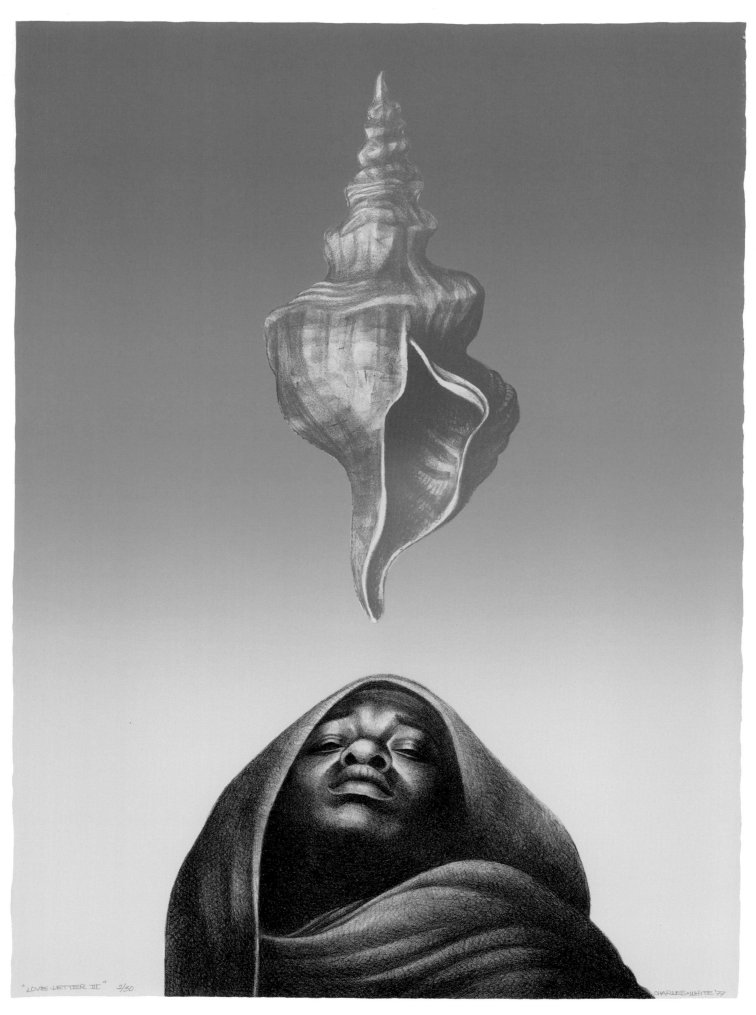

"LOVE LETTER III" 3/50

CHARLES WHITE '77

103. *Love Letter III*, 1977
Color lithograph on cream wove paper
Cat. 89

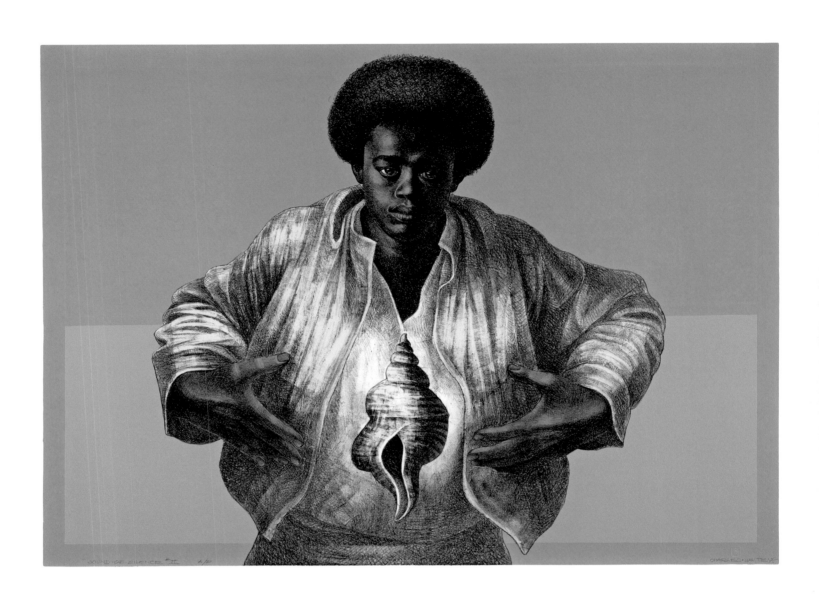

104. *Sound of Silence*, 1978
Color lithograph on white wove paper
Cat. 90

CHRONOLOGY

COMPILED BY JOHN MURPHY AND ASHLEY JAMES

1918

Apr. 2: Charles Wilbert White (CW) is born in Chicago, IL, to unmarried parents: Ethelene Gary, a domestic worker (see fig. 1), and Charles White Sr., a Pullman car porter of Native American (Creek) heritage. Ethelene had moved to Chicago from Mississippi as part of the Great Migration (1916–70), the movement of more than seven million African Americans from the South to the Northeast, Midwest, and West.

EARLY 1920S

Grows up on the South Side of Chicago at 210 E. 53rd Street (see fig. 2). CW's mother, raising him alone, often leaves him at the main branch of the Chicago Public Library while she works. Inspired by commercial illustrators like Henry Raleigh, N. C. Wyeth, and Franklin Booth, CW demonstrates an early interest in drawing, encouraged by his teachers at Burke Elementary School.[1]

1925

Alain Locke edits an anthology, *The New Negro: An Interpretation*, featuring writers and intellectuals associated with the Harlem Renaissance, a movement of black artists and writers in New York

Figs. 1–2. Ethelene Gary and baby Charlie (left); White at the age of six (right). Charles White Archives, CA.

promoting racial consciousness. The anthology, including portraits by German-born artist Winold Reiss of figures like W. E. B. Du Bois and Paul Robeson, would profoundly influence CW.[2]

1926

Feb.: Carter G. Woodson, historian and founder of the Association for the Study of Negro Life and History in 1915, initiates Negro History Week, between

the birthdays of Frederick Douglass and Abraham Lincoln. CW later participates in several group exhibitions and one-man shows to celebrate Negro History Week.

1927

Mar.: Charles White Sr. dies of pneumonia at age 43. Ethelene Gary marries Clifton Marsh, a stockyard worker and post office employee. (They separate when CW is 13.)

CW begins traveling to Ridgeland, MS, twice a year to visit his mother's relatives, and feels especially inspired by the endurance of his great-aunts.[3]

1931

Receives a scholarship through the James Nelson Raymond Lecture Fund to attend Saturday classes at the Art Institute of Chicago. He receives instruction from Dudley Crafts Watson, hears lectures by painters like Ivan Albright, and spends time in the museum's galleries admiring works by the painters El Greco and Winslow Homer and the sculptor George Grey Barnard. He attends the Saturday classes until his junior year of high school.[4]

1932

Attends the predominantly white Englewood High School.[5] Among the other black students are future artist and writer Margaret Burroughs and artist Eldzier Cortor. Works odd jobs from ages 14 to 18 as a hotel bellhop and a counter attendant in an ice cream shop. Begins painting signs and lettering posters for local businesses (such as Bronzeville's Regal Theater), but the local union creates difficulties for him to pursue this line of work independently.[6]

1933

Learns of the Art Crafts Guild, a gathering of black artists that meets every Sunday on the South Side, in the *Chicago Defender*. Burroughs, Cortor, Charles Davis, Bernard Goss, George Neal, and Charles Sebree are among attendees. CW begins exhibiting his work with the guild in churches, the YMCA and YWCA, and settlement houses. Members of the guild, along with writers like Richard Wright and Gwendolyn Brooks, are part of the Black Chicago Renaissance—a cultural movement that encourages activism and support for African American art and literature during the 1930s and 1940s.[7]

1934

June: Participates in the *Open Air Art Fair* in Chicago's downtown Grant Park, where he meets Todros Geller, known

as the dean of Jewish Chicago art. CW later takes Saturday lessons from Geller, who encourages him to work from live models rather than copy works by other artists.[8]

1936

Wins scholarships to the Chicago Academy of Fine Arts and the Frederic Mizen Academy of Art. According to CW, both schools retract their offer when administrators discover he is black.[9]

Feb.: The National Negro Congress (NNC), an organization formed to fight discrimination and promote the cause of black liberation, holds its first meeting in Chicago, drawing more than five thousand people.[10] CW later works as staff artist and serves on the editorial board of the NNC official journal, *Congress Vue* (later *Congress View*).

May: CW is awarded first prize for composition and figure painting in the Chicago *Negro Art Exhibition* sponsored by the Art Crafts Guild and the WPA's National Youth Administration.[11]

Sept.: Wins fourth place in a nationwide sketching contest sponsored by the Eberhard Faber Company. Receives a five-dollar prize and an Eberhard Faber art set.[12]

Dec.: The Chicago chapter of the Artists Union sponsors a sit-down strike at the administrative offices of the Illinois Art Project (IAP), located in the Merchandise Mart. The protest is over layoffs, lower quotas, and discriminatory hiring practices. "My first lesson on the project," CW recalled, "dealt not so much with paint as with the role of the unions in fighting for the rights of working people."[13]

Garners first significant press attention with mention in regional periodical *Midwest—a Review*.[14]

1937

Apr.: Wins second place and a cash award in pencil sketching at the Carnegie Institute's national scholastic award program. Also receives a cash award in the George Bellows Memorial Award competition.[15]

May: Awarded a scholarship by the School of the Art Institute of Chicago (SAIC) in the amount of $240, which covers tuition for one year of full-time study.[16]

Summer: Graduates from Englewood High School. Works at the Abraham Lincoln Center's summer camp in Milton Junction, WI.[17]

Sept.: Begins taking courses at SAIC in art history, drawing and composition, design and lettering, and figure drawing. Earns honorable mention in life drawing course. Supports himself during the school year by teaching part-time at Saint Elizabeth Catholic High School in Bronzeville and working as a cook and valet to artist Antonio Beneduce.[18]

1938

Feb.: Participates in *An Exhibition in Defense of Peace and Democracy*, an interracial show sponsored by the Chicago Artists' Group to generate funds for victims of fascism in Spain and China.[19]

Apr. 1: Attends a poetry reading and lecture by Langston Hughes at the Book Review and Lecture Forum, sponsored by the George Cleveland Hall Branch of the Chicago Public Library (see fig. 2, p. 25). The Hall Branch had opened in 1932 under the leadership of Vivian G. Harsh, the first African American branch head in the Chicago Public Library system. In addition to organizing the forum, Harsh begins to amass a "Special Negro Collection" dedicated to African American history and literature.[20]

Summer: Returns to work at the Abraham Lincoln Center summer camp.

Sept.: Hired for the easel division of the Works Progress Administration (WPA) Illinois Art Project (IAP). The WPA IAP, a New Deal initiative to provide relief for struggling and unemployed artists, supports visual artists in the United States between 1935 and 1943. "Looking back at my three years on the project," CW later recalls, "the most wonderful thing for me was the feeling of cooperation with other artists, of mutual help instead of competitiveness, and of cooperation between the artist and the people."[21]

Nov.: The newly formed Negro People's Theatre in Chicago performs Langston Hughes's play *Don't You Want to Be Free?* at the Abraham Lincoln Center. Hughes is present at the premiere. The play and the presence in Chicago of playwright Theodore Ward inspire CW to become involved in acting and to design sets for the Negro People's Theatre.[22]

1939

Apr.: CW's work is included in an exhibition at Howard University, Washington, DC, of art by African American artists employed by the WPA Federal Art Project (FAP).[23]

May: Serves as chairman of the artists' committee during the planning for the South Side Community Art Center (SSCAC) in Bronzeville. Proposes an exhibition and auction to raise funds for the nascent center, which will also receive funding from the WPA.[24]

Sept.: Transfers from the easel division to the mural division of the WPA IAP. Likely works as assistant to Arthur Lidov on the mural cycle for Walter S. Christopher School in Gage Park on Chicago's Southwest Side. CW recalls: "I learned a great deal . . . all about how to square the canvas, how to enlarge, how to rough it in, all these things, make all your preliminaries, do the research."[25]

Oct.: The Art Crafts Guild opens a permanent art gallery in the Black Spider's Club, 3826 S. Michigan Avenue. It is the only black-owned and black-operated art gallery in Illinois.[26]

Oct 23: *Five Great American Negroes* (pl. 7) is displayed at the first annual Artists and Models Ball, a fund-raiser for the SSCAC, held at the Savoy Ballroom, 4733 South Parkway (Grand Boulevard, now S. Martin Luther King Drive). A poll in the *Chicago Defender* on the most influential figures in African American history determined the mural's subjects.[27]

1940

Jan.: Receives national exposure through an article by Willard F. Motley in *Opportunity*.[28]

Jan.–June: Studies fresco painting at Hull-House Settlement with Edward Millman and privately with Briggs Dyer.[29]

Mar.: Richard Wright's novel *Native Son* is published. CW later executes a series of drawings based on the book, including *Native Son No. 2* (pl. 12).

Gives lecture, "The Negro in Art," with Bernard Goss at an SSCAC meeting. The *Chicago Defender* reports: "White and Goss are confident that the Negro's future in art is a bright one if he can continue to receive the encouragement and interest that he is receiving now."[30]

Apr. 18: Hired by the Associated Negro Press (ANP) to produce a 9 × 20 ft. mural for the American Negro Exposition. Completes the mural, *The History of the Negro Press* (see fig. 6, p. 28), on June 28.[31]

July 4: The American Negro Exposition opens at the Chicago Coliseum on the Near South Side. Sponsored by the State of Illinois, the exposition celebrates the 75th anniversary of the Thirteenth Amendment. The exposition includes an art show, *Exhibition of the Art of the American Negro, 1851 to 1940*, organized by Alain Locke, professor of philosophy at Howard University, and Alonzo Aden, curator of the Howard University Gallery of Art. CW's drawing *There Were No Crops This Year* (pl. 9) is awarded first place in the black-and-white category; his watercolor, *Fellow Workers, Won't You March with Us?* (1940; location unknown) receives an honorable mention.[32]

Aug. 6: After spending several months executing *The History of the Negro Press* for the ANP, CW is reinstated on the WPA IAP.[33]

1941

Mar.–Aug.: Studies privately with painter Edgar Britton, a muralist and technical director of the IAP.[34]

May 7: First Lady Eleanor Roosevelt formally dedicates the SSCAC. It is one of the more than 100 community centers established by the WPA FAP and the first center to showcase art by African Americans. CW exhibits and teaches life drawing classes there (see fig. 3).[35]

Summer: Meets Elizabeth Catlett, chair of the art department at Dillard University in New Orleans. She has an MFA from the University of Iowa, where she studied with Regionalist painter Grant Wood. She spends the summer in Chicago with roommate Margaret Burroughs, studying ceramics at SAIC and lithography at SSCAC.[36]

Fig. 3. White teaching life drawing class at the South Side Community Art Center, c. 1940–41. Charles White Papers, Archives of American Art, Smithsonian Institution, Washington, DC.

Fall: Works on a mural commission for the George Cleveland Hall Branch Library. The mural is never completed.[37]

Dec.: Marries Catlett, and they honeymoon in New York. Participates in Downtown Gallery's groundbreaking exhibition, *American Negro Art: 19th and 20th Centuries*, in New York. Fellow exhibitors include Charles Alston, Romare Bearden, Catlett, Palmer Hayden, and William H. Johnson.

1942

Jan.–June: Teaches art at Dillard University.

Mar.: CW's employment on the WPA IAP is terminated. In December, President Roosevelt disbands the WPA, and most operations end by February 1943.[38]

Apr.: Receives a grant of $2,000 from the Julius Rosenwald Fund, which began offering fellowships to African American artists, writers, scholars, and intellectuals in 1928.[39] Exhibits in Atlanta University's First Annual Exhibition of Paintings by Negro Artists of America. Initiated by art director Hale Woodruff, the exhibition would recur for nearly thirty years, promoting the work of artists such as Bearden, John Biggers, Catlett, Jacob Lawrence, and Lois Mailou Jones.

June: The draft board denies CW's request to travel to Mexico. Unable to study fresco painting in Mexico, he moves instead to New York with Catlett to conduct research at the Schomburg Collection of Negro Literature, History and Prints (now the Schomburg Center for Research in Black Culture) and study at the Art Students League with Harry Sternberg. CW and Catlett join a community of artists, activists, and intellectuals that includes Gwendolyn Bennett, Duke Ellington, Ralph Ellison, and Hughes.[40]

Summer: CW and Catlett work as arts coordinators at the interracial and coeducational Workers Children's Camp (Wo-Chi-Ca) established in Hunterdon County, NJ, in 1934 by the International Workers Order (IWO). There, CW meets camp counselor Frances Barrett (see under Jan. 1948).[41]

Fig. 4. "Meet Mr., Mrs. Charles White: An Interesting and Talented Combination," *New York Amsterdam Star-News*, Sept. 5, 1942, 15.

Fall: CW and Catlett are profiled in the *New York Amsterdam Star-News* (Sept. 5) (fig. 4).[42] They travel through Louisiana, Mississippi, Virginia, and Georgia. CW calls his time in the South "one of the deeply shaking and educative experiences of my life." He develops an appreciation for southern black culture, especially "the spirituals, blues, ballads, work songs, gospel songs, church songs and secular songs," which he called "one of the most important influences on my work." He also encounters violent prejudice: he is beaten in New Orleans for entering a segregated restaurant and is threatened at gunpoint by a streetcar conductor in Hampton, VA.[43]

1943

Jan.: CW begins work on *The Contribution of the Negro to Democracy in America* at the Hampton Institute in Hampton, VA (see fig. 5).

Apr.: Awarded a $2,000 renewal grant by the Julius Rosenwald Fund to study at the Art Students League of New York and to paint a series on the role of African American soldiers during World War II.[44] Serves on the jury of Atlanta University's Second National Exhibition of Paintings by Negro Artists (see fig. 6).

May: *Five Great American Negroes* is included in an exhibition at Fort Huachuca, Arizona, a major US Army training station with many all-black units, for an exhibition of works by black artists made under the auspices of the WPA FAP.

June 25: The Hampton mural is formally unveiled. CW participates in a panel discussion, "Art and Democracy," with Dr. Viktor Lowenfeld (Hampton Institute), James Herring (Howard University), Sternberg (Art Students League), and Woodruff (Atlanta University). The mural culminates his Rosenwald fellowship year and garners him national press attention.[45]

Summer: Petitions to have his status in the Selective Service reclassified from 1A to 2B, which would have allowed him to continue to paint as part of the war effort, but is denied. Returns to New York with Catlett.[46]

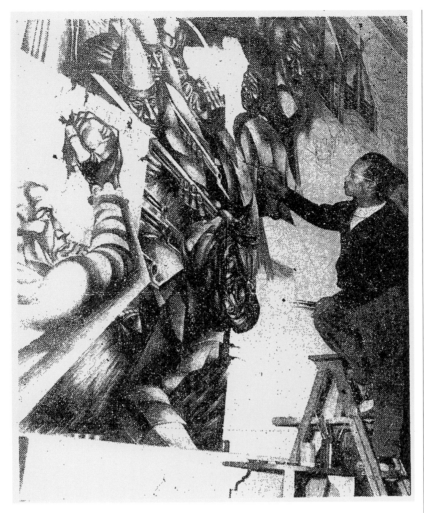

Fig. 5. White at work on Hampton Institute mural. *People's Voice*, June 19, 1943. Reel 3194, Charles White Papers, Archives of American Art, Smithsonian Institution, Washington, DC.

1944

Jan.–Mar.: CW and Catlett teach art classes at the George Washington Carver School (57 W. 125th Street), which was founded in late 1943 for poor and working people in Harlem (see fig. 7). Under the direction of Gwendolyn Bennett, a prominent writer and painter active in the Harlem Renaissance, the school attracts the support of notable radicals, artists, and progressives.[47]

Apr.–Oct.: Inducted into the US Army. Completes basic training at Camp Ellis, IL, and is assigned to a camouflage unit at Jefferson Barracks in Missouri. Serves as corporal in the all-black 1332nd Engineering Regiment for eight months; his division sandbags the flooding Ohio and Mississippi Rivers. Falls ill and spends six months convalescing in a Veterans Administration hospital in Castle Point, NY. Diagnosed with pulmonary

tuberculosis and receives a certificate of disability discharge.[48]

1945

Jan.: Receives the annual IWO Cultural Award for contributions to American culture in the field of art.[49]

Jan.–Feb.: Participates in the exhibition *The Negro Artist Comes of Age* at the Albany Institute of History and Art alongside Bearden, Catlett, Aaron Douglas, Lawrence, Norman Lewis, and Woodruff.

Feb.–June: Serves as artist in residence at Howard University.[50]

Apr. 25: Catlett is awarded a Rosenwald fellowship to produce *The Negro Woman*, a series on the role of African American women in the struggle for civil rights.

Summer: CW and Catlett oversee art program at Wo-Chi-Ca.

Fall: Publishes political cartoons as staff artist for *Congress Vue* on themes such as the Jim Crow South, the anti-poll tax bill, the need for progressive unity, and the mistreatment of African American veterans.[51]

1946

Feb.: Illustrates cover for *Daily Worker* pamphlet *Dixie Comes to New York*, which protests the murder of two black servicemen by a white Long Island

Fig. 6. Selection jury for the Second National Exhibition of Paintings by Negro Artists, Atlanta University, Apr. 1943. Left to right: White; L. P. Skidmore, director of the High Museum of Art; Jean Charlot, painter (standing); Lamar Dodd, head of the Department of Art, Georgia University; Rufus E. Clement, president of Atlanta University; Hale Woodruff, professor of art, Atlanta University. *Magazine of Art*, May 1943, 190.

Fig. 7. Ramona Lowe, "Harlem's Carver School Draws Capacity Classrooms," *Chicago Defender*, Feb. 5, 1944, 18.

The young Negro artist, Charles White, gives a little help to one of the students in his art class in the newly organized George Washington Carver school.

police officer. In May CW provides an illustration (pl. 28) for the *New Masses* article "Can a Negro Study Law in Texas?" The article is a response to black student Heman Sweatt being denied admission to the University of Texas School of Law based on race. Sweatt's case against the university would ultimately be decided in the Supreme Court (*Sweatt v. Painter*).[52] For the next several years CW contributes topical and provocative political cartoons to leftist publications including *Daily Worker*, *Freedom*, *New Masses*, and *Masses and Mainstream*.[53]

Rejoins faculty of the George Washington Carver School as an instructor.

Apr.: Joins the United Negro and Allied Veterans of America (UNAVA), a Chicago organization that supports veterans facing housing and job discrimination.[54]

Receives the $300 Edward E. Alford Award for *Two Alone* (pl. 25) at Atlanta University's Fifth Annual Exhibition of Paintings, Sculpture and Prints by Negro Artists and the $25 First Atlanta University Purchase Award for the lithograph *Hope for the Future* (pl. 24).

Catlett's Rosenwald fellowship is renewed. She and CW travel to Mexico City to work at the Escuela Nacional de Pintura y Escultura (National Academy of Painting and Sculpture) "La Esmeralda" and the famed graphic arts collective Taller de Gráfica Popular (TGP). "Mexico was a milestone," CW later recalls. "I saw artists working to create an art about and for the people. That had the strongest influence on my whole approach."[55]

1947

Feb.: CW and Catlett return to New York to finalize divorce proceedings.[56]

Mar.: The interracial group Committee for the Negro in the Arts (CNA) is founded in New York to challenge racial segregation and foster African American talent in all cultural media. Sponsors include CW, Harry Belafonte, Du Bois, Hughes, and Locke. CW actively fundraises for the CNA and helps establish a scholarship fund for young artists.[57]

Fig. 8. Artist and activist Rockwell Kent visits Wo-Chi-Ca on July 22, 1947. Artist and art counselor Ernest Crichlow can be seen on the far right. White's mural, intended for the camp's Paul Robeson Recreation Hall, is visible in the background. Charles White Archives, CA.

Apr. 14: Is the target of a "hoodlum assault" in Greenwich Village. The Civil Rights Congress protests lack of police response.[58]

May 29: IBM purchases *Hope Imprisoned* (1946; location unknown) for $450.

July 22: Rockwell Kent, artist and president of the IWO, visits Wo-Chi-Ca, where CW and Ernest Crichlow serve as art counselors for the summer. CW works on a mural (now lost) for the camp's Paul Robeson Recreation Hall (see fig. 8).[59]

Sept.: The House Un-American Activities Committee (HUAC) subpoenas members of the entertainment industry for alleged ties to Communism. Known as the Hollywood Ten, they are charged with contempt of Congress for refusing to cooperate. This includes novelist and screenwriter Dalton Trumbo, who would later become friends with CW.[60]

Sept. 9: First major solo exhibition opens at the American Contemporary

Art (ACA) Gallery in New York (the first of seven during CW's lifetime). Founded in 1932, the gallery promotes the work of American social realists and artist-activists such as Philip Evergood, William Gropper, Kent, and Alice Neel.

1948

Anton Refregier includes CW in his textbook *Natural Figure Drawing*.

Jan. 23: Undergoes several operations at Saint Anthony's Hospital in Queens to treat his tuberculosis, after which he is forced to convalesce for nearly a year and a half. Although this disease is highly contagious, Frances Barrett, a white social worker whom he had met at Wo-Chi-Ca, visits him in the hospital, kindling a romance.[61]

Invited to contribute to *Yes, the People*, the first portfolio published by the Workshop for Graphic Art in New York, a progressive interracial collective of artists modeled after the TGP.[62]

1949

Apr.: Lithograph *Youth* (1946) wins a Purchase Award at the Eighth Annual Exhibition of Paintings, Sculpture and Prints by Negro Artists sponsored by Atlanta University.

May 14: Is discharged from the hospital.

1950

Apr.: Burroughs hosts a party in Chicago in CW's honor, where he is reunited with Barrett, who travels from Detroit to attend.[63]

May 31: After a brief courtship, marries Barrett. The couple struggles to rent an apartment in New York and turns to Eastside Fair Housing Council, a program that assists interracial couples with legal aid in combatting discriminatory housing practices. They eventually find a one-bedroom apartment at 24th Street and Second Avenue. Later, they secure a more permanent residence at 710 Riverside Drive.[64]

June: The Korean War (1950–53) begins.

Begins working as an instructor at the Workshop School of Advertising and Editorial Art, where he holds a position until 1952.[65]

July: The Library of Congress purchases the lithograph *John Brown* (pl. 32) as part of a program "to acquire prints of particular significance."[66] Is one of 100 black civic leaders to sign a statement against the Korean War sponsored by the Council on African Affairs.[67]

Fall: Joins art faculty at the Jefferson School of Social Science (JSSS) at 575 6th Avenue in New York as regular instructor of painting and drawing. Colleagues there include art and music critic Sidney Finkelstein and historian Herbert Aptheker. Launched in 1944 by the Communist Party of the United States (CPUSA) as a successor to the New York Workers School, the JSSS engages in community outreach to instruct the working class about Marxism.[68]

Sept.: Attends Artists Equity Association conference, "The Artist and the Museum," in Woodstock, NY. When the Whites arrive, their hosts refuse to have an interracial couple in their home. CW delivers a talk about his experience at the Delgado Museum in New Orleans, where he had been denied admission on the basis of race, even though his work was on display there. The Artists Equity Association subsequently makes a policy recommendation to abolish segregation in all museums.[69]

1951

Feb.: CNA-sponsored solo exhibition *Negro Woman* opens at New York's ACA Gallery, garnering critical attention (see fig. 9).[70] CW becomes a contributing editor to *Masses and Mainstream*; his linocut *Man and Woman* (1951) appears on the cover of the Negro History Week special issue.

Apr.: Lithograph *John Brown* awarded the First Atlanta University Purchase Award in the Graphic Arts at Atlanta University's 10th Annual Exhibition of Paintings, Sculpture and Prints by Negro Artists.

May: Contributes pen-and-ink drawing *We March for Peace* (1951; location unknown) to Howard Fast's *May Day, 1951* pamphlet published by the United Labor and People's Committee for May Day. Other contributors to the pamphlet include Evergood, Hugo Gellert, Gropper, and Kent.[71]

Aug.: Travels to France, England, and Italy. Then visits East Germany as head of a US delegation to the Third World Festival of Youth and Students for Peace in Berlin. After, visits Czechoslovakia and Poland.[72]

Sept. 15: Arrives in Soviet Union (see fig. 10). During his three-week stay, visits the Bolshoi Theater, the Lenin Library, Moscow University, and the State Tretyakov Gallery in Moscow and travels to the Republic of Georgia to see the birthplace of Joseph Stalin. Upon his return home, participates in the drafting of "We Will Not Be a Silent Generation," a press release that protests anti-Communism in the United States.[73]

Oct.: CW's trip to the Soviet Union places him under a cloud of suspicion during the anti-Communist "witch-hunting" of the Second Red Scare (1947–56). The FBI opens an official file on him and monitors his whereabouts, associates, activities, and publications until 1965.

Nov. 4: Reports on his trip to Europe and the Soviet Union at "Rebirth of German Culture," a program sponsored by German American, Inc.[74]

Dec. 9: *Masses and Mainstream* sponsors reception in honor of CW at JSSS. CW gives a speech, "Art in the New Europe," detailing his trip to the Soviet Union.[75]

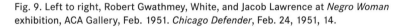

Fig. 9. Left to right, Robert Gwathmey, White, and Jacob Lawrence at *Negro Woman* exhibition, ACA Gallery, Feb. 1951. *Chicago Defender*, Feb. 24, 1951, 14.

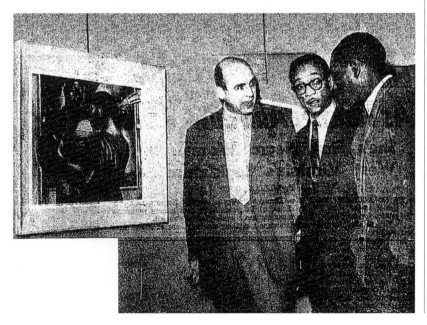

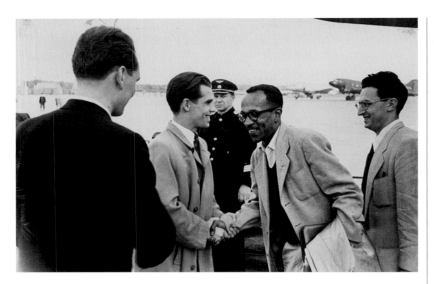

Fig. 10. Representatives of the Soviet Youth Antifascist Committee welcome White in Moscow, 1951. Charles White Archives, CA.

1952

Feb.: Subpoenaed by the Senate Committee on Internal Security to testify before the HUAC; in March this request is indefinitely postponed. No explanation is given.[76]

Feb. 3: The writing and publishing division of the socialist organization National Council of Arts, Sciences, and Professions (NCASP) holds a reception in honor of CW and Fast at the Fraternal Clubhouse, New York, to celebrate the publication of the latter's novel *Spartacus*, for which CW contributes cover art (fig. 7, p. 43).[77]

Mar.: Sponsors a national veterans art show under the auspices of the American Veterans for Peace. Publishes article, "Until the Day I Die, My Life Is Dedicated to My People." "I can't be just an artist," he writes. "I can't just paint. I must develop my ability to speak and write, and all my faculties for the fight."[78]

May: The Whitney Museum of American Art acquires the drawing *Preacher* (pl. 44).

The National Institute of Arts and Letters awards White a $1,000 grant "in recognition of a gifted artist whose work in lithography expresses a warm feeling of humanity."[79]

Summer: The Whites vacation in White Lake Lodge in the Adirondacks in New York State. There, CW meets Susan and Dr. Edmund Gordon, an interracial couple. Edmund, a preeminent psychologist and scholar, would become a lifelong friend and collector of CW's work.[80]

Aug.: Publishes "Art and Reality in the USSR" in *New World Review*.[81]

Dec. 1: Serves as guard of honor at funeral for political cartoonist Robert Minor, a Communist Party member and longtime contributor to the socialist journals *The Masses* and *New Masses*.[82]

Contracts tubercular infection that requires testicular surgery. As a result the Whites are unable to conceive.[83]

1953

Jan.: Joins artists, actors, musicians, scientists, and writers urging clemency for Ethel and Julius Rosenberg, who were sentenced to death for conspiring to commit espionage on behalf of the Soviet Union.[84]

Feb.: Sidney Finkelstein's essay "Charles White's Humanist Art" is published. He writes, "Charles White works with full confidence in the people and in a world of peace and human progress. It is this confidence that radiates from his work."[85]

Mar. 6: Speaks at NCASP-sponsored cultural freedom rally at Manhattan Towers. Describes culture as an important weapon in the African American struggle for freedom and decries the lack of representation of African Americans in popular culture and fine art.[86]

Apr. 17: Speaks at *Masses and Mainstream* fifth-anniversary event, Salute to Writers and Artists, at Manhattan Plaza.[87]

Apr. 27: *To the Future* is selected by popular ballot for purchase at Atlanta University's 12th Annual Exhibition of Paintings, Sculpture and Prints by Negro Artists, and CW is awarded $100.

May: *Masses and Mainstream* publishes *Charles White: Six Drawings* (cat. 109), featuring lithographic reproductions of *Abraham Lincoln* (pl. 42), *Harvest Talk* (pl. 43), *Hope* (1952; private collection), *Let's Walk Together* (1953; private collection), *The Mother* (1952; Hirshhorn Museum and Sculpture Garden), and *Ye Shall Inherit the Earth* (pl. 48). In the introduction Kent calls the drawings "essentially a documentation of human dignity."[88]

Aug.: Evergood's essay "Charles White: Beauty and Strength," a review of *Charles White: Six Drawings*, is published. He writes, "White is giving us a world which he wants to come—which he has faith *will* come. He sweeps aside the pernicious vapors of inequality, cruelty and death which do exist here and now."[89]

Dec. 23: Speaks at third annual National Negro Labor Council convention held at the Pershing Hotel in Chicago; argues that artists should fight for the dignity of the working class and urges an alliance between black and white artists.[90]

1954

Vanguard Records begins commissioning drawings from CW for the covers of folk, blues, and jazz albums, including its *Jazz Showcase* series produced by John Hammond and sponsored by the magazine *DownBeat*.[91]

Jan. 30: Together with Evergood, participates in panel, "McCarthyism and the Artist," at the fifth annual convention of the New York NCASP held at Steinway Hall (113 W. 57th Street).[92]

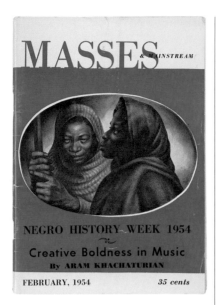

Fig. 11. White's *General Moses and Sojourner* (fig. 9, p. 81), reproduced on the cover of the Negro History Week issue of *Masses and Mainstream*, Feb. 1954.

May: Joins Provisional Committee to Restore Paul Robeson's Passport. Robeson's passport was revoked in August 1950 due to his alleged involvement in a pro-Soviet conspiracy.

Reviews *The Best Untold: A Book of Paintings* by Edward Biberman, in which he claims, "Our primary task as artists is to meet the high standards of truth and beauty set by the people. We deal with ideas. Therefore, we share a great responsibility for influencing the advance of the people's movement."[93]

Oct. 27: Receives the *Masses and Mainstream* annual William Weiner Award for his contributions to the magazine, particularly the February 1954 cover featuring his drawing of Harriet Tubman and Sojourner Truth (see fig. 11). When accepting the award, pays homage to his mother, who "has never been singled out for awards" but instead has "worked for some fifty years as a domestic worker" and "did not have the opportunity to develop her talents, to make her full potential contribution to society."[94]

Dec. 11: Speaks at the Progressive Party Forum in Pennsylvania on the subject of African American artists fighting for peace and justice.[95]

1955

The first monograph on CW, *Charles White: Ein Künstler Amerikas* by Sidney Finkelstein, is published in the German Democratic Republic (East Germany).

Jan.: Cochairs the Hugo Gellert Anniversary Committee, which plans a banquet in honor of Gellert's career as a socially conscious political cartoonist, illustrator, and muralist.[96]

Apr.: CW's autobiographical account and artist's statement, "Path of a Negro Artist," appears in *Masses and Mainstream*. He writes that his "major concern" as an artist is "to get my work before common, ordinary people, for me to be accepted as a spokesman for my people, for my work to portray them better, and to be rich and meaningful to them. A work of art was meant to belong to people, not to be a single person's private possession. Art should take its place as one of the necessities of life, like food, clothing and shelter."[97]

Apr. 18: Selected as a John Hay Whitney Foundation Opportunity Fellow for 1955–56.

Sept.: Tuberculosis reoccurs; forced to rest and limit painting to two hours a day. Defers Whitney fellowship stipend until fall of 1956.[98]

Dec. 1: In Montgomery, AL, Rosa Parks refuses to give up her seat, which leads to the Montgomery bus boycott. F. B. White recalls, "We [Frances and Charles] cheered the reports of the solidarity and determination of the black community of Montgomery when they boycotted city buses. I recalled Charlie's words, 'This is the signal to do battle. This is the way we will dismantle segregation.'"[99]

1956

Spring: Spends two months bedridden after his remaining lung becomes infected with tuberculosis. His doctor encourages rest and a dry, warm climate.[100]

Summer: The Whites vacation at the country home of Sidney and Brunetta Bernstein in Connecticut. Other guests

include Horace Cayton, coauthor of famed sociological history of Chicago *Black Metropolis: A Study of Negro Life in a Northern City*.[101]

Oct.: The Whites relocate to 1765 Summit Avenue in Pasadena, CA. They begin hosting friends including Ossie Davis, Ivan and Berlie Dixon, Miriam Makeba (pl. 57), and Sidney and Juanita Poitier.[102]

1957

F. B. White begins working at the Woodlawn Branch YWCA and is the only white person on staff; her job involves integrating its citywide services program. The Whites move to Altadena (936 Kent Street), a predominantly white community, which prompts a number of residents to move.[103]

Hired to teach life-drawing classes for the Westside Jewish Community Center at Biberman's recommendation. This marks the beginning of an ongoing relationship with Jewish organizations in the Los Angeles area.[104]

Aug. 10: Speaks on "Art Today" at a *People's World* press committee fund-raising reception in his honor.[105]

1958

Spring: The California State Association of Colored Women's Clubs sponsors an exhibition of CW's work at the Harris Hall Gallery, USC. This begins White's longstanding participation in smaller, community-oriented exhibitions throughout Southern California.[106]

Mar.: During the filming of *The Defiant Ones*, the Poitiers regularly invite the Whites to dinner at their Altadena home. CW spends time on the set (see fig. 6, p. 128).[107]

Apr.: Listed in *Ebony* magazine as a leading young artist.[108] CW's appearances in *Ebony* and *Negro Digest* throughout the 1960s and 1970s generate considerable popular interest in the artist.

June: Commissioned by United Artists to provide end titles to *Anna Lucasta*, a film starring Sammy Davis Jr. and Eartha Kitt and based on the celebrated play by

Philip Yordan. Creates a triptych of Eartha Kitt; Sammy Davis Jr.; and Rex Ingram, Frederick O'Neal, and Georgia Burke (pls. 73–75).[109]

1959

CW's drawings appear on Belafonte's television program *Tonight with Belafonte* as intertitles between performances.[110]

Nov.: Receives gold medal for *Raise Every Voice* (1959; Stadtgeschichtliches Museum, Leipzig) at the *Internationale Buchkunst-Ausstellung* (International Exhibition of Book Arts) in Leipzig, East Germany.

1960

May: *Solid as a Rock* (pl. 76) receives First Purchase Award from Atlanta University's 19th Annual Exhibition of Paintings, Sculpture and Prints by Negro Artists. Award is sponsored by popular local radio station WAOK-AM.

May 6: President Dwight D. Eisenhower signs the Civil Rights Act of 1960, designed to combat black disenfranchisement in the segregated South.

July 10: A large-scale reproduction of *Man with Outstretched Arms* (possibly *O Freedom* [1956; private collection])

is used as the backdrop for a NAACP rally in Los Angeles. Speakers and dignitaries attending the march include then senator John F. Kennedy, Dr. Martin Luther King Jr., NAACP executive secretary Roy Wilkins, and Democratic national chairman Paul Butler. The Whites help compile names and addresses of Negro community leaders for the cause—a task for which they receive personal thank-you letters from King and A. Philip Randolph, another leader of the civil rights movement.[111]

1961

Apr.: *Mother Courage* awarded first prize in the exhibition *New Vistas in American Art* at Howard University.

May 11: Judges the first annual Safety Savings and Loan Association High School Art Show.[112]

Fall: Pro-Artis Publishers of Los Angeles releases *10 / Charles White*, an affordably priced portfolio of ten offset lithographs with a foreword by Belafonte.

Nov. 5: Attends one-day exhibit of his recent prints and original work at Lincoln Avenue Methodist Church in Pasadena. Receives a scroll of commendation from the county supervisor for contributions to the arts.[113]

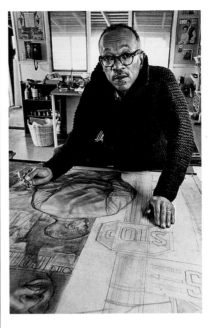

Fig. 13. White working on an NAACP recruitment poster. From Hoyt W. Fuller, "Charles White, Artist," *Negro Digest*, July 1963, 41.

Nov. 25: Interviewed by Jack Daley of local radio station KPFK in segment titled "White's Magnificent People."[114]

1962

Jan.: Contributes illustrations to the book project *Songs Belafonte Sings*. (see fig. 12).

Aug.: Sponsors the Negro in the Creative Arts, a fund-raiser for candidate Thomas M. Rees in the race for New York State Senate.[115]

Oct. 20: Receives an award for outstanding art achievement at the first Afro-American Business, Trade and Service Show of Greater Los Angeles.[116]

1963

May 11: Introduces celebrated author James Baldwin as the main speaker at an event hosted by the Pasadena chapter of the Congress of Racial Equality.[117]

July: "Charles White, Artist" appears in *Negro Digest* (see fig. 13). The article begins, "The work of Charles White has such simple, direct—and profoundly poetic—power that it is astonishing he is not world famous. Well, perhaps not so astonishing after all: the artist is a

Fig. 12. White and Harry Belafonte working on *Songs Belafonte Sings*, a TV and book project. Charles White Archives, CA.

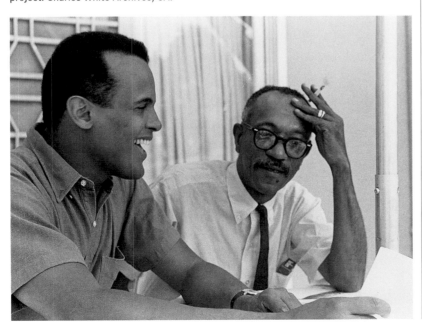

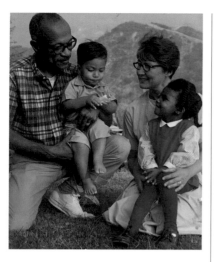

Fig. 14. The White family—Charles, Ian, Frances, and Jessica—at their California home on Risinghill Road in Altadena, c. 1966. Charles White Archives, CA.

Negro, characterized by great pride and integrity, and his subject matter is, almost invariably, his own race."[118]

Aug.: Trumbo sells the Whites an acre of hillside land in Altadena, where they start to build a home.[119]

Aug. 28: Martin Luther King Jr. delivers "I Have a Dream" speech at the Lincoln Memorial during the March on Washington for Jobs and Freedom. CW's lithographs *I Had a Dream* (1965) and *I Have a Dream* (1976) refer to this landmark event.

Sept. 15. In Birmingham, AL, four members of the Ku Klux Klan plant bombs in the Sixteenth Street Baptist Church, a predominantly black congregation that is an important meeting place for civil rights leaders. The explosion occurs shortly before Sunday morning services, killing four young girls and wounding many others. The bombing inspires CW's large-scale drawing *Birmingham Totem* (pl. 70).

Oct. 4: The Whites' adopted daughter, Jessica Frances White (see fig. 14), is born. Five days later, she is welcomed into their home.

Nov. 22: President John F. Kennedy is assassinated. F. B. White recalls that she and CW "had believed in him and in his ability to make a difference in our country and for our people."[120]

1964

Feb.: CW's first solo Heritage Gallery show, *Charles White*, opens (the first of nine there during his lifetime).

1965

Begins teaching at Otis Art Institute (now Otis College of Art and Design).[121]

CW's RCA Victor record cover of the Chicago Symphony Orchestra performing Morton Gould's *Spirituals for Orchestra* and Aaron Copland's *Dance Symphony* is nominated for a Grammy Award for Best Album Cover—Graphic Arts (see fig. 5, p. 149).

Golden State Mutual Life Insurance Company, one of the largest black-owned businesses in the country, acquires *General Moses (Harriet Tubman)* (pl. 79).[122]

May 17–June 5: ACA Gallery mounts *Charles White*, its final solo show of CW's artwork.

Aug.: President Lyndon B. Johnson signs the Voting Rights Act into law, which prohibits racial discrimination in voting. The same month, the Watts Rebellion breaks out in the Watts neighborhood of Los Angeles in response to allegations

of police brutality toward an African American motorist. The National Guard is called in to quell the unrest.

Dec. 7: The Whites adopt three-month-old Charles Ian White (see fig. 14).

1966

Illustrates the cover of Philip Sterling and Rayford Logan's *Four Took Freedom: The Lives of Harriet Tubman, Frederick Douglass, Robert Smalls and Blanche K. Bruce* (fig. 3, p. 148).

Feb. 27: Speaks at opening night of Westside Jewish Community Center exhibition *American Negro Artists*.[123]

Apr.: *Birmingham Totem* (pl. 70) is displayed in the First World Festival of Negro Arts held in Dakar, Senegal (see fig. 15), the first state-sponsored festival to promote African diasporic art, music, literature, film, theater, and dance to a global audience.

Aug.: CW's drawing *J'Accuse #10* (pl. 83) is reproduced on the cover of a special issue of *Ebony* titled "The Negro Woman."

Oct.: The Black Panther Party for Self-Defense is founded in Oakland, CA, by Huey P. Newton and Bobby Seale.

Fig. 15. Chicago poet Margaret Danner, wearing a Senegalese *boubou*, looks at White's *Birmingham Totem* at the US art exhibition in the Palace of Justice at the First World Festival of Negro Arts in Dakar, Senegal. *Negro Digest*, June 1966, 91.

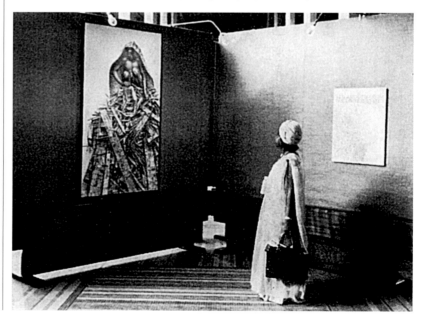

Nov. 1: Tapes segment, "The Negro and the Arts," for *Speculation*, a Community Television of Southern California program.[124]

1967

Spring: Heritage Gallery publishes *Images of Dignity: The Drawings of Charles White*.

June: *Work (Young Worker)* (pl. 47) is reproduced on the cover of *Negro Digest*. The issue includes an article on *Images of Dignity*, in which the author states: "Charles White is to painting and drawing what Langston Hughes is to literature: both men direct their art to primal human concerns, to the simple problems and pleasures, the ordinary joys and sorrows of the long journey from the cradle to the grave."[125]

July: "Charles White: Portrayer of Black Dignity" is published in *Ebony* (fig. 16), which brings widespread public attention and acclaim. CW is quoted: "I have a total commitment to people, to art, and particularly *my* people. I take pride in the fact that being black gives me an identity and a source to draw upon. I'm never without something to say."[126]

1968

Jan.: Ink drawing *Uhuru* (1964; private collection) is reproduced on the cover of Melvin Drimmer's *Black History: A Reappraisal*.

Apr. 4: Martin Luther King Jr. is assassinated in Memphis, TN. CW contributes *Seed of Love* (pl. 84) to a memorial service sponsored by UCLA. In October, he donates *Birmingham Totem* (pl. 70) to an auction-exhibition at MoMA to benefit the Southern Christian Leadership Conference.[127]

June 5: Democratic presidential candidate Robert F. Kennedy is assassinated in Los Angeles. On June 21 the vice president of the Inner City Cultural Center thanks CW for donating his print *Exodus II* for its fund-raiser and apologizes that the "occasion for which you contributed your valuable work had to be cancelled due to the national tragedy."[128]

Aug.: Contributes to exhibition *Our Past, Our Present, Our Future . . . ?* at the

Charles White:

PORTRAYER OF BLACK DIGNITY

Artist achieves fame with works on Negro themes

BY LOUIE ROBINSON

Graphic interpreter of the Negro people, painter Charles White has been internationally acclaimed for the power and beauty of work in which he expresses "a universal feeling . . . a meaning for all men." Reproduced below from book *Images of Dignity: The Drawings of Charles White*, is landscape done at age seven in which future artist displayed his precocious talent.

Fig. 16. Louie Robinson, "Charles White: Portrayer of Black Dignity," *Ebony*, July 1967, 25.

Countee Cullen Branch Library in Harlem. The exhibition is dedicated to the memories of Emmett Till and the four girls killed in the bombing of the Birmingham church.[129]

Oct. 26: Appears on *Dialogues on Art*, a weekly program hosted by Biberman airing on KNBC. Participates soon after in "Dialogues in Art," a program moderated by Biberman and sponsored by the University of California Extension's Department of Arts and Humanities.[130]

Dec. 6: "Giant of American Art Portrays: The Original Man," appears in *Muhammad Speaks*, a widely read Nation of Islam newspaper. White is quoted: "I come to each picture with the sum total of my existence. I come to it with something of my heritage, something of the history I have inherited Art is this. It's heart. It's soul. It's not talking about a theory, or an intellectual idea, I'm talking about a feeling."[131]

1969

Mar. 27: Serves as a founding member of the Black Academy of Arts and Letters,

established in Boston to "define, preserve, promote, cultivate, foster, and develop the arts and letters of black people."[132]

June 8: Participates in panel, Crisis: Black Art in White America, at the Van Nuys Branch Library in Los Angeles as part of the community discussion program Black Arts in White America.[133]

June 13: Columbia College in Chicago awards CW an honorary doctorate of arts.[134]

July: Attends premiere of Gordon Parks's *The Learning Tree*, the first Hollywood studio film directed by an African American.[135]

Oct 27: Delivers lecture, "Soul and Art," as part of Black Arts Council lecture series at LACMA.[136]

Nov. 3–4: Takes part in symposium on art, politics, and the environment at Southern Oregon College.[137]

1970

Receives a prestigious studio fellowship from the Tamarind Lithography Workshop

in Los Angeles, one of the leading printmaking workshops in the United States. There begins work on the *Wanted Poster Series* prints.[138]

Feb. 9–Mar. 10: Included in *Five Famous Black Artists*, an exhibition presented by the National Center of Afro-American Artists and the Museum of Fine Arts, Boston.

Feb. 24: Delivers lecture, "Is There a Black Esthetic?," in Fullerton Hall at the Art Institute. The SSCAC hosts a reception in CW's honor.[139]

May: Whitney Museum of American Art acquires *Wanted Poster Series #4* (fig. 8, p. 132).[140]

June 25: Speaks at the University of California–Irvine Extension series program Conversations with Artists led by Biberman.[141]

Aug. 18: FBI director J. Edgar Hoover lists academic and activist Angela B. Davis on the FBI's Ten Most Wanted fugitive list. Supporters organize the National United Committee to Free Angela Davis and All Political Prisoners and initiate a "Free Angela" campaign. CW allows his lithograph *Love Letter I* (pl. 101) to be reproduced on pre-addressed stationery for the group's letter-writing campaign.

Oct.: Selected to appear in annual journal *Outstanding Educators of America*.[142]

1971

Jan.: National Academy of Design elects CW associate and one month later awards him the Adolph and Clara Obrig Prize for *Wanted Poster Series #6* (pl. 88) in its 146th Annual Exhibition.

Jan. 26: Opening of LACMA exhibition *Three Graphic Artists*, which pairs works by CW with those of younger artists David Hammons and Timothy Washington.[143]

May: Delivers a lecture at the University of California, Riverside, on the Harlem Renaissance and another, "The Black Artist in America," at LACMA, sponsored by the Graphic Arts Council. "My aim is to communicate the black experience in terms of the essential dignity of human beings," CW says in the latter speech. "When I can do that successfully, I am reaching everyone, not just black people."[144]

Aug. 11: The Southern Christian Leadership Conference, founded in 1957 to promote civil rights through coordinated nonviolent direct action, gives CW a special award at its 14th annual convention in New Orleans. In his acceptance speech, CW says: "I sit and do a silly little thing like taking a brush, and I sit in a little cubicle that I call a studio—and I paint an image of man. Nothing I see, but something I feel . . . I try to find and search for answers to three questions: Who am I? What am I? Why?"[145]

Sept. 9: Nearly half the prisoners at the Attica Correctional Facility in Attica, NY, stage a riot and gain control of the facility. After negotiations break down, Governor Nelson Rockefeller orders the New York state police to retake the facility, leading to the deaths of nine hostages and 29 inmates. CW later paints *Homage to Attica* (1972; private collection) to commemorate the event. In the fall of 1972, White begins talks to establish a "prison arts program" through the Cummins Engine Foundation and the Los Angeles Black Arts Council.[146]

1972

Mar.: National Academy of Design awards CW the Isaac N. Maynard Prize for his painting *Homage to Langston Hughes* (1971; private collection) in its 147th Annual Exhibition.

May 26–28: Delivers keynote address at the National Conference to Assess the State of Black Art and Letters in Chicago.[147]

June 12 or 13: Records for the Scholastic Black Culture Program a narrated exploration of black art from ancient civilization to the present day, distributed by Scholastic Book Services.[148]

Fall: Publishes "Desegregation and the Richmond Story" about efforts in Richmond, VA, to desegregate the school system.[149]

1973

Feb. 16: The California Association of Teachers honors White at a luncheon in San Diego for African American, Mexican American, Asian American, and Native American authors, illustrators, and editors statewide.[150]

Mar. 1: Appears on *Black Omnibus*, a talk show hosted by actor James Earl Jones featuring African American cultural figures.

Sept. 23: Interviewed by Harry Henderson, author of *Six Black Masters of American Art*.[151]

Nov.: Radio station WBOE-FM, owned and operated by the Cleveland Board of Education, airs a radio series, "Black Art in America," that includes a two-part interview with CW.[152]

1974

Mar.: The Whites travel to East Berlin for two weeks to attend an exhibition featuring CW, Refregier, and Tecla (Selnick).

Apr.: Lectures at the Talladega College arts festival, where his work is exhibited.

Aug. 13–14: Serves on a panel of judges—including musician and producer Quincy Jones and artist Betye Saar—at the Watts Summer Festival's Black Art Awards.[153]

Oct. 13: The *Los Angeles Times* publishes a feature on CW and his wife (fig. 17). CW is quoted: "I deal in black imagery, but I hope my pictures have universal characteristics. I bring a highly emotional point of view to my work. I'm not a reporter. Instead of trying to recreate an event, I put a *reaction* on paper."[154]

Oct. 24: Compton Community College offers a special tribute to CW and animator Bill Hanna for "outstanding contributions made throughout the world."[155]

Dec. 2–5: Participates with Bearden and Crichlow in *Kindred Spirits: African Artists in Diaspora*, a Harvard University seminar sponsored by the Afro-American Studies Department organized in conjunction with an exhibition at

Fig. 17. "Frances and Charles White: They Share a Life Where Art Is Served Up with Every Meal," *Los Angeles Times*, Oct. 13, 1974, Home Q&A, N72.

Boston's Museum of the National Center of Afro-American Artists.[156]

Dec. 11: Participates in A Great Day in December, a celebration of the first 500 days in office of the first black mayor of Los Angeles, Tom Bradley.[157]

1975

Elected to the National Academy of Design. CW is the third African American to become a full member, following Henry Ossawa Tanner and Hughie Lee-Smith. For membership, CW submits the painting *Mother Courage II* (1974; National Academy Museum, New York).

Feb.: Lerone Bennett Jr.'s *The Shaping of Black America* is published with a cover image and chapter opener illustrations by CW. The two are feted in Chicago at a reception at Johnson Publishing headquarters.[158]

Apr.: CW lectures at Spelman College on occasion of his one-man exhibition there.

Apr. 8: The Committee on Research and Status of Black Women, Southern California Women's Missionary Society, AME Church, awards him charter participant status in advance of its first annual seminar, "The Black Woman: The Reality and the Myth."[159]

Summer: Judges the Bicentennial Black Achievement Exhibit.

Serves as honorary member of the steering committee for *Amistad II*, a major traveling exhibition and catalogue celebrating African American history on the occasion of the country's bicentennial.[160]

Sept. 30: Invited to serve on the Studio Museum in Harlem's inaugural national advisory council of "distinguished

painters, sculptors, print makers, photographers, designers, educators, etc., to select exhibits for the Museum for the coming years."[161]

Nov.: Designs publicity images for *Leadbelly*, a feature film directed by friend Gordon Parks, based on the life of the legendary blues musician. Paramount Pictures rejects CW's image, which is informed by research and period photographs, and opts instead for a more stereotypical portrayal of a musclebound, half-naked black man.[162]

1976

Feb.: Joins Artists for Economic Action, an organization dedicated to improving economic conditions for American artists.[163]

Aug. 1: Guest of honor at Pasadena Arts Council Reception for Artists.[164]

Sept.: Major retrospective exhibition *The Work of Charles White: An American Experience* opens at the High Museum of Art in Atlanta and travels to Montgomery, AL; Chattanooga, TN; West Palm Beach, FL; and Little Rock, AR. Attends High Museum opening and delivers lecture in the Hill Auditorium on September 5 as part of "An Afternoon with Charles White."[165]

Sept. 30: *Two Centuries of Black American Art*, guest curated by David Driskell, opens at LACMA. In addition to exhibiting artwork, CW is commissioned to create the official poster for the show, for which he produces the lithograph *I Have a Dream* (1976). CW requests that the poster be sold at an affordable price and that it be distributed free of charge in Los Angeles public schools.[166]

Nov. 3–6: Guest of honor at the Montgomery Museum of Fine Arts Black Arts Festival (see fig. 18).[167]

Nov. 16: National Advisory Board for the National Council for Black Studies makes CW a member.[168]

1977

Aug. 8–12.: Teaches morning and evening painting workshops at the Arkansas Arts Center in Little Rock, presented in conjunction with *The Work of Charles White: An American Experience*, the traveling exhibition organized by the High Museum of Art.[169]

Aug. 22: Appointed full professor and chair of the Drawing Department at Otis Art Institute.

Aug. 31: CW's mother dies at age 79. The White family travels to Chicago for the funeral.[170]

1978

Jan.: CW's mural *Mary McLeod Bethune*, commissioned by the City of Los Angeles for the Dr. Mary McLeod Bethune Regional Library in Exposition Park, is installed.[171]

Mar.: Attends international conference in Dresden as a corresponding member

Fig. 18. White is the guest of honor at three-day Black Arts Festival held at the Montgomery Museum of Fine Arts. *Montgomery Advertiser*, Nov. 6, 1976. Reel 3194, Charles White Papers, Archives of American Art, Smithsonian Institution, Washington, DC.

the German Akademie der Künste (Academy of Art).[172]

Apr. 24: California Afro-American Museum of History and Culture Advisory Board makes CW a commissioner at the invitation of California governor Jerry Brown (see fig. 19).

June: Howard University Graduate School of Arts and Sciences offers CW a three-year distinguished professorship. He accepts the position and travels to the school three days a month for several months until his deteriorating health no longer permits the taxing schedule.[173]

Fig. 19. Governor Jerry Brown introduces White and Edward "Abie" Robinson as new commissioners of the California Museum of Afro-American History and Culture (now the California African American Museum), 1978. Left to right: White, Brown, Assemblywoman Teresa Hughes, Edward "Abie" Robinson, and his wife, Gladys Lassco Robinson.

Fig. 20. Sidney Poitier remembers his friendship with White at memorial jubilee held at the Museum of Science and Industry (now the California Science Center), Los Angeles. *Ebony* 35, no. 4 (Feb. 1980): 68.

Sept.: Attends opening of *Charles White: An American Experience* at the Los Angeles Municipal Art Gallery.

Oct.: Resumes teaching at Howard University.

Dec.: Cancels classes because of flu-like symptoms.

1979

Oct. 3: Dies of congestive heart failure at age 61 in Wadsworth Veterans Hospital, Los Angeles.

Nov. 4: A memorial jubilee in tribute to Charles White is held at the Los Angeles Museum of Science and Industry (now the California Science Center) in Exposition Park. Friend Poitier celebrates CW's life, at one point joking, "Charlie was no angel in life, and I'll bet he's no angel now" (see fig. 20).[174]

1980

Fall: *Freedomways* magazine devotes an entire issue to CW, featuring essays and remembrances by Belafonte, Burroughs, and Cortor, among many others.

Oct. 25: The County of Los Angeles dedicates the Charles White Park in the artist's neighborhood of Altadena.

1. White, interview by Clothier, Sept. 14, 1979, Charles White Archives, CA; and White, undated application (mid-1950s) for John Simon Guggenheim Memorial Foundation Fellowship (hereafter Guggenheim Fellowship application), reel 3191, Charles W. White Papers, Archives of American Art, Smithsonian Institution, Washington, DC (hereafter CWP, AAA).

2. White, interview by Clothier, Sept. 20, 1979; White, "Path of a Negro Artist," 33; and F. B. White, *Reaches of the Heart*, 30–31.

3. White, interview by Clothier, Sept. 17, 1979; and F. B. White, *Reaches of the Heart*, 159–60.

4. White, interview by Clothier, Sept. 17 and 20, 1979; and "The James Nelson Raymond Lecture Fund for Children of Members and Public Schools," *Bulletin of the Art Institute of Chicago* 28, no. 6.2 (Nov. 1934): 85–89.

5. White recalled about a quarter of the students at Englewood were black; all the teachers were white. White, "Path of a Negro Artist," 34–35; see also White, Guggenheim Fellowship application (n. 1 above).

6. White, "Path of a Negro Artist," 34. White never specified which union "stymied" his trade or what exactly they did, but it was likely the Sign, Scene and Pictorial Painters Union, which had its headquarters in Chicago. It had strict rules about issues such as apprentices, membership, and regulations and likely threatened the young White with legal action.

7. White, "Path of a Negro Artist," 37. The *Defender* article in question may have been "Art Crafts Guild" from the December 10, 1932, issue.

8. White, interview by Clothier, Sept. 20 and 24, 1979.

9. White, interview by Clothier, Sept. 20, 1979; and White, Guggenheim Fellowship application (n. 1 above). See also Bernard Goss, "Art Chronicle: Ten Negro Artists on Chicago's South Side," *Midwest—a Review* (Dec. 1936): 17–19; and Willard F. Motley, "Negro Art in Chicago," *Opportunity* 18, no. 1 (Jan. 1940): 19–22. According to F. B. White, White was offered the Chicago Academy of Fine Arts prize at age 16 and the Frederic Mizen Academy of Art scholarship a year later; see F. B. White, *Reaches of the Heart*, 32–33.

10. Richard Wright, "Two Million Black Voices," *New Masses*, Feb. 25, 1936, 15; and "Universal Unrest among Black People Revealed at National Negro Congress Here," *Chicago Defender*, Feb. 22, 1936, 1.

11. "Young Negroes Exhibit Drawing and Painting" and "Art Crafts Guild Present Awards," unidentified newspaper clippings, reel 3195, CWP, AAA.

12. "Receives Five Dollars, Art Set as Fourth Prize in Sketching Contest," unidentified clipping dated Thursday, Oct. 1, 1936, reel 3195, CWP, AAA.

13. White was a member of this union, but it is not known when he joined. White, "Path of a Negro Artist," 38; and "34 Strikers 'Sit Down' in Main Office of WPA: Protest Dismissals and Plan to Fire More," *Chicago Daily Tribune*, Dec. 13, 1936.

14. Goss, "Art Chronicle: Ten Negro Artists on Chicago's South Side," 17–19.

15. "Englewood Students Win Honors, Cash in Scholastic Contest," *Chicago Defender*, Apr. 1937, clipping, reel 3195, CWP, AAA.

16. Associate Dean Norman Price to White, May 17, 1937, reel 3195, CWP, AAA.

17. The Chicago-based Abraham Lincoln Center was founded in 1905 to serve a largely African American population and to promote socialist politics. White, interview by Clothier, Sept. 20, 1979. White's two summers at the Wisconsin camp are mentioned in "Howard Art Gallery Exhibits Works of Nationally Known Young Artists," *Chicago Defender*, Apr. 29, 1939, 5.

18. Transcript, Department of Registration Records, School of the Art Institute of Chicago; and White, oral history interview by Hoag.

19. White, oral history interview by Fortess.

20. Vivian G. Harsh Research Collection, Woodson Regional Library, Chicago Public Library (hereafter CPL); and "Miss Vivian Harsh Gets Library Post," *Chicago Defender*, July 11, 1931, 4.

21. White, "Path of a Negro Artist," 38–39; and civilian personnel record for Charles W. White, Works Progress Administration, National Personnel Records Center, National Archives and Records Administration at Saint Louis.

22. "Chicago Will See Hughes' New Play," *Chicago Defender*, Nov. 5, 1938, 5; and White, interview by Clothier, Sept. 24, 1979.

23. "Howard Art Gallery Exhibits Works of Nationally Known Young Artists," *Chicago Defender*, Apr. 29, 1939, 5.

24. Sponsors committee meeting notes, May 15, 1939, SCCAC Archives.

25. White, oral history interview by Hoag.

26. "Open Art Gallery," *Chicago Defender*, Oct. 28, 1939, 15.

27. "Artists and Models Ball Draws Capacity Crowd," *Chicago Defender*, Oct. 28, 1939, 28; and "Washington Tops List of Race Leaders: Five Being Selected for Painting to Be Shown at Savoy Oct. 23," *Chicago Defender*, Oct. 14, 1939, 23.

28. Willard F. Motley, "Negro Art in Chicago," *Opportunity* 18, no. 1 (Jan. 1940): 19–22, 28–31.

29. Charles White, Rosenwald Fellowship application, 1941, Charles W. White fellowship file, Julius Rosenwald Fund Archives, box 456, file 6, John Hope and Aurelia E. Franklin Library, Special Collections and Archives, University, Nashville (hereafter Rosenwald Archives).

30. "Art and the People," *Chicago Defender*, Mar. 16, 1940, 3.

31. White to Claude Barnett, July 23, 1940, Claude Barnett Papers, Chicago History Museum; "Shows History of Negro Press," *Chicago Bee*, July 27, 1940, reel 3195, CWP, AAA; and "Exposition Mural Depicts History of Negro Press," *Chicago Defender*, Aug. 10, 1940, 5.

32. *American Negro Exposition, 1863-1940: Official Program and Guide Book* (Chicago: Exposition Authority, 1940); and Alain Locke, "The American Negro Exposition's Showing of the Works of Negro Artists," in American Negro Exposition, *Exhibition of the Art of the American Negro (1851 to 1940)* (Chicago: American Negro Exposition, 1940).

33. Civilian personnel record for Charles W. White, WPA (n. 21 above).

34. White, Rosenwald Fellowship application (n. 28 above).

35. Diana Briggs, "First Lady Spends Busy Three Hours in Chicago," *Chicago Defender*, May 17, 1941, 13; Alain Locke, "Chicago's New Southside Art Center," *Magazine of Art* 34, no. 7 (Aug.–Sept. 1941): 370–74; and Peter Pollack Papers, Scrapbook, 1939–1943, AAA.

36. White, interview by Clothier, Sept. 24, 1979; and Herzog, *Elizabeth Catlett*, 36.

37. For more on White's mural commission, see the correspondence between Vivian Harsh and Carl Roden, Carl Roden Collection, Harold Washington Library Center, Special Collections, CPL.

38. Civilian personnel record for Charles W. White, WPA (n. 21 above).

39. Director for fellowships William C. Haygood, award letter to White, Apr. 18, 1942, reel 3195, CWP, AAA.

40. See correspondence between William C. Haygood and White, White, Rosenwald Fellowship file (n. 28 above); and Herzog, *Elizabeth Catlett*, 29–30.

41. Levine and Gordon, *Tales of Wo-Chi-Ca*; and Samantha White, "Race, Class, Space, and Memory at Wo-Chi-Ca: A Look at Radical Leftist Summer Camping," *Child and Youth Services* 36, no. 1 (2015): 5–15.

42. "Meet Mr., Mrs. Charles White: An Interesting and Talented Combination," *New York Amsterdam Star-News*, Sept. 5, 1942, 15.

43. White, "Path of a Negro Artist," 39.

44. White, "Report of a Year's Progress and Plan of Work for a Renewal of a Julius Rosenwald Fellowship," Rosenwald Archives (n. 28 above); and Mrs. William C. Haygood, acting director for fellowships, to White, Apr. 21, 1943, reel 3195, CWP, AAA.

45. Hampton Institute file, reel 3191, CWP, AAA; and "Art Today: Mural by a Talented Artist," *Daily Worker*, Aug. 28, 1943, clipping, reel 3195, CWP, AAA.

46. See 1943 correspondence between Mrs. William C. Haygood, acting director of fellowships, Julius Rosenwald Foundation, and White, in White, Rosenwald Fellowship file (n. 28 above).

47. Herzog, "Art for the People: The George Washington Carver School," in Herzog, *Elizabeth Catlett*, 36–40; and Ramona Lowe, "Harlem's Carver School Draws Capacity Classrooms," *Chicago Defender*, Feb. 5, 1944, 18.

48. US Federal Bureau of Investigation (FBI), Washington, DC, file, synopsis, memorandum, Mar. 9, 1953; and White, Guggenheim Fellowship application (n. 1 above).

49. FBI file, synopsis, Mar. 9, 1953, subheading Miscellaneous, 12–13.

50. White, Guggenheim Fellowship application (n. 1 above).

51. See subject file, *Congress Vue*, reel 3191, CWP, AAA.

52. Harry Raymond, *Dixie Comes to New York: Story of the Freeport GI Slayings* (New York: Daily Worker, 1946); and Lisa Call, "Can

a Negro Study Law in Texas?" *New Masses*, May 7, 1946: 3–5.

53. For example, in February 1950 the Marxist monthly *Masses and Mainstream* (vol. 3, no. 2) published *Toward Liberation* (or *Open Gate* [1949; private collection]), *The Ingram Case* (fig. 7, p. 79), *Trenton Six* (pl. 29), and *Frederick Douglass Lives Again (The Ghost of Frederick Douglass)* [pl. 30]) in a special section, "Lift Every Voice." *Frederick Douglass Lives Again* was also illustrated; *Daily Worker*, Feb. 12, 1950. *The Ingram Case* (1949) and *Five Years Is Too Long!* (c. 1950; location unknown) were reproduced in Paul Robeson's periodical *Freedom* and on a cover of *Sing Out!* (vol. 2, no. 5 [May, 1952]; and vol. 3, no. 6 [Feb. 1953], respectively). *Trenton Six* was reproduced in the September 11, 1949, issue of *The Worker* and the March 1950 issue (vol. 1) of *Challenge*.

54. FBI file, synopsis, Mar. 9, 1953, subsection United Negro and Allied Veterans of America, 9.

55. Quoted in John Pittman, "He Was an Implacable Critic of His Own Creations," *Freedomways* 20, no. 3 (1980): 191; see also Alison Cameron, "Buenos Vecinos: African-American Printmaking and the Taller de Gráfica Popular," *Print Quarterly* 16, no. 4 (Dec. 1999): 353–67.

56. Catlett remained in Mexico. There she married fellow TGP member Francisco Mora and eventually became a Mexican citizen in 1962. Margaret Burroughs, "A Woman's Viewpoint: Negro Artists Active in Mexico," *Philadelphia Tribune*, Sept. 18, 1951, 6.

57. The CNA sponsored White's 1950 solo show at the American Contemporary Art Gallery and hosted a reception in his honor on opening night (see fig. 6, p. 78). F. B. White, *Reaches of the Heart*, 55–58; and CNA press release and reception invitation promoting White's 1950 ACA Gallery Show, reel 3195, CWP, AAA.

58. *Daily Worker*, Apr. 14, 12, cited in FBI file, supplemental correlation summary, Jan. 21, 1958.

59. Wo-Chi-Ca brochure, "Building for the Future," c. 1947, in printed material and lecture announcements, reel 3194, CWP AAA.

60. Dalton Trumbo file, reel 3193, CWP, AAA.

61. F. B. White, *Reaches of the Heart*, 13–14.

62. Workshop for Graphic Art, *Yes, the People* (New York: Workshop for Graphic Art, 1948); Angelica Kaufman, "The Graphic Workshop and Its First Portfolio," *Daily Worker*, Dec. 20, 1948, 12; and Workshop for Graphic Art, *Negro USA* (New York: Workshop for Graphic Art, 1949). The 1949 portfolio *Negro USA* featured a lithograph by White on its cover.

63. F. B. White, *Reaches of the Heart*, 16–18.

64. Ibid., 47–49. Addresses of White's known residences are listed in a memorandum in his FBI file dated March 9, 1950.

65. Workshop School of Advertising and Editorial Art file, reel 3194, CWP, AAA.

66. Paul Vanderbilt, Prints and Photographs Division of the Library of Congress, to White, July 18, 1950, reel 3192, CWP, AAA.

67. "100 Leaders Hit Intervention in Korea as War for Slavery," *Daily Worker*, July 24, 1950.

68. FBI file, correlation summary, Dec. 7, 1956.

69. F. B. White, *Reaches of the Heart*, 52–53; *The Artist and the Museum: The Report of the Third Woodstock Art Conference Sponsored by Artists Equity Association and the Woodstock Artists Association* (New York: American Artists Group, 1950); and "Museums Talk with Artists on Joint Problems: Woodstock Conference Sets Up Groundwork for New System of Co-operation," *New York Herald Tribune*, Dec. 30, 1951, 17.

70. John Pittman, "Charles White's Exciting 'Negro Woman' Show at ACA," *Daily Worker*, Feb. 26, 1951.

71. Howard Fast, *We March for Peace—May Day 1951* (New York: United Labor and People's Committee for May Day, 1951).

72. Third World Festival of Youth and Students for Peace file, reel 3193, CWP, AAA.

73. Diaries—trip to USSR, 1950 [*sic*] file, reel 3099, CWP, AAA.

74. German American, Inc., thank-you letter to White, Nov. 16, 1951, reel 3195, CWP, AAA.

75. FBI file, correlation summary, Dec. 7, 1956.

76. White, interview by Clothier, Sept. 26, 1979; FBI file subheading Miscellaneous, synopsis, Mar. 9, 1953, 14.

77. Synopsis, Mar. 9, 1953, FBI file, subsection National Council of Arts, Sciences and Professions.

78. White, "Until the Day I Die, My Life Is Dedicated to My People," *Freedom*, Mar. 1952, clipping, reel 3193, CWP, AAA; and "Veteran's Art Show Opens March 29," *Daily Worker*, Feb. 5, 1952, 7.

79. Whitney Museum director Herman More to White, May 7, 1952, reel 3195, CWP, AAA; and Leon Kroll, chairman of Committee on Grants for Arts, National Institute of Arts and Letters, award letter to White, May 28, 1952, reel 3195.

80. F. B. White, *Reaches of the Heart*, 69–70; see also Edmund W. Gordon file, reel 3191, CWP, AAA. In the handwritten notes accompanying the subject file, Frances White described Gordon, along with Crichlow, Ivan Dixon, and Carlton Moss, as one of White's closest friends.

81. The article was reprinted in the November 7, 1952, issue of the *Daily Worker*.

82. "Robert Minor's Fellow Workers Pay Tribute to a Fearless Fighter for Peace, Socialism," *Daily Worker*, Dec. 2, 1952, 8.

83. F. B. White, *Reaches of the Heart*, 71.

84. "Notables in Art Who Urge Clemency," *Daily Worker*, Feb. 16, 1953.

85. Sidney Finkelstein, "Charles White's Humanist Art," *Masses and Mainstream* 6, no. 2 (Feb. 1953): 43–46.

86. "Fight Back Rally for Culture," *Daily Worker*, Mar. 12, 1953.

87. FBI file, memorandum, Sept. 9, 1953.

88. White, *Charles White: Six Drawings*.

89. Philip Evergood, "Charles White: Beauty and Strength," *Masses and Mainstream* 6, no. 8 (Aug. 1953): 36–39, quotation on 39, emphasis in the original.

90. FBI file, memorandum, Apr. 12, 1955.

91. White's contact at Vanguard was likely Sidney Finkelstein, who worked there in

1951–73, in addition to working as an art critic. Record album covers file, reel 3099, CWP, AAA. Finkelstein was also the author of the first monograph on White.

92. FBI file, memorandum, July 7, 1955.

93. White, "Humanist Art," review of *The Best Untold: A Book of Paintings* by Edward Biberman, *Masses and Mainstream* 7, no. 5 (May 1954): 59–60. White later became friends with Biberman; see Ilene Susan Fort's essay in this volume.

94. White, "Statement," *Masses and Mainstream* 7, no. 11 (Nov. 1954): 46–47.

95. FBI file, memorandum, Apr. 28, 1953.

96. Advertisement, *Daily Worker*, Jan. 9, 1955, 13.

97. White, "Path of a Negro Artist," 43–44.

98. Correspondence between Charles F. Jones, acting program secretary for opportunity fellowships, John Hay Whitney Foundation, and White, reel 3194, CWP, AAA.

99. F. B. White, *Reaches of the Heart*, 123.

100. Ibid., 81.

101. Bernstein later produced Jean Genet's *Blacks* in New York; its playbill cover was illustrated by White. F. B. White, *Reaches of the Heart*, 86–88.

102. Esther Jones, "Artist Charles White Settles in Pasadena," *Los Angeles Sentinel*, Thursday, Nov. 8, 1956, clipping, reel 3195, CWP, AAA.

103. F. B. White, *Reaches of the Heart*, 102–4.

104. In 1963 the Friends of Jewish Secular Education bestowed upon White the Dr. Chaim Zhitlowsky Award, which honored "outstanding personalities who have made lasting contributions to Jewish secular culture." See Westside Jewish Community Center file, reel 3194, CWP, AAA; and I. Goldberg, award letter to White, Dec. 12, 1963, reel 3189.

105. FBI file, memorandum, Feb. 24, 1958.

106. White's involvement included exhibiting works and jurying shows for the Pasadena Artist Associates, the Pasadena Festival of the Arts, the Avalon Community Arts Center, and the Federation of Women's Clubs of the Verdugo District. He maintained a relationship with the YWCA and received the organization's Artist of the Year award in 1961. Although White did not identify as religious, he engaged with a number of churches in this community capacity, including the First Unitarian Church of Los Angeles. Invitation to YWCA–Woodlawn Special Christmas Program, reel 3189, CWP, AAA.

107. F. B. White, *Reaches of the Heart*, 97–98.

108. Other leading artists listed were Bearden, Cortor, Marion Perkins, and Sebree. "Leading Young Artists," *Ebony* 13 (Apr. 1958): 33–38.

109. More industry commissions followed, and his work appeared in the movies *Guess Who's Coming to Dinner* (1967) and *For Love of Ivy* (1968).

110. A lifelong friend of White's, Belafonte was the subject of a number of portraits by the artist, including *Folksinger (Voice of Jericho: Portrait of Harry Belafonte)* (pl. 72) and *J'Accuse #6* (pl. 81).

111. A. Philip Randolph and Martin Luther

King Jr. to Mr. and Mrs. White, June 9, 1960, reel 3192, CWP, AAA.

112. White continued to serve as judge for the competition through 1966. He judged a host of other community competitions in the area, including the LA City School District's Scholastic Art Exhibit (1965), Exhibit for the Handicapped, United Cerebral Palsy Association of Los Angeles County Art (1966), the Southern California Teachers Art Show (1966), the Sunday at the Bowl Festival of Art and Music (1966), the Leimert Park Festival of the Arts (1967), and the Peace Corps (1971). See correspondence with Safety Savings and Loan Association, reel 3189, CWP, AAA; see also Los Angeles City Unified School District file, reel 3192; and Pasadena Unified School District file, reel 3193.

113. Esther B. Jones, "Charles White Exhibit Enriching Experience," *Los Angeles Sentinel*, Nov. 9, 1961, C1.

114. Elsa Knight Thompson, director of public affairs, KPFA, to White, Nov. 3, 1961, reel 3192, CWP, AAA.

115. Thomas M. Rees, thank-you letter to White, Sept. 8, 1962, reel 3189, CWP, AAA.

116. Executive director Vantile E. Whitfield, award letter to White, July 23, 1962, reel 3189, CWP, AAA.

117. Event program, reel 3194, CWP, AAA. At the time, Baldwin's seminal collection of essays on American racism, *The Fire Next Time*, had just been published. White's copy, with the inscription "for Brother Charles: Hold tight / Jim Baldwin," remains in his library.

118. Hoyt W. Fuller, "Charles White, Artist," *Negro Digest* 12, no. 9 (July 1963): 40–45.

119. The house was completed by 1966; see F. B. White, *Reaches of the Heart*, 112–13.

120. F. B. White, *Reaches of the Heart*, 123.

121. White taught at Otis until his death in 1979. Over the course of his tenure, he taught and influenced a host of artists; Otis Art Institute file, reel 3189, CWP, AAA; and Esther Adler's essay in this volume.

122. Golden State's collection of African American art included work by Charles Alston, Richmond Barthé, Betye Saar, and Hale Woodruff. White's friendship with William Pajaud, a painter who worked in the publicity division, led to many collaborations with the insurance company, notably his inclusion in a complimentary calendar (for example, see fig. 4, p. 148) that reproduced artwork by African American artists. See Golden State Mutual Life, reel 3192, CWP, AAA.

123. "Charles White Will Speak at 'American Negro Art Exhibit,'" *Center News* 16, no. 9 (Feb. 1966), copy, reel 3194, CWP, AAA.

124. Executive producer of community television of Southern California Tom Burrows to White, Oct. 24, 1966, reel 3189, CWP, AAA.

125. "The Drawings of Charles White: Images of Dignity," *Negro Digest* 16, no. 8 (June 1967): 40–48, quotation on 40, 42 (picture on 41).

126. Louie Robinson, "Charles White: Portrayer of Black Dignity," *Ebony* 22, no. 9 (July 1967): 25–28, 30, 32, 34–36, quotation on 28, emphasis in the original.

127. Program for memorial service, reel 3192, CWP, AAA; Pearl Bowser, co-coordinator of benefit exhibition *In Honor of Dr. Martin Luther King, Jr.*, to White, Oct. 23, 1968; and *A Tribute to the Life of Dr. Martin Luther King, Jr.* exhibition pamphlet, reel 3192, CWP, AAA.

128. Mary Jane Hewitt, first vice president of Inner City Cultural Center, to White, June 21, 1968, reel 3189, CWP, AAA.

129. "Art Notes," *Negro Digest* 17, no. 10 (Aug. 1968): 68.

130. University of California Extension file, reel 3193, CWP, AAA.

131. Dwight Casimere, "Charles White: Giant of American Art Portrays: The Original Man," *Muhammad Speaks*, Dec. 6 and 20, 1968, copy, reel 3194, CWP, AAA.

132. "The Black Academy of Arts and Letters," *Negro Digest* 18, no. 7 (May 1969): 58, 89.

133. Harold L. Hamill, city librarian, to White, Apr. 29, 1969, reel 3189, CWP, AAA.

134. F. B. White, *Reaches of the Heart*, 149–50.

135. Marx Bercutt and Warner Brothers—Seven Arts, telegram to White, July 5, 1969, reel 3189, CWP, AAA.

136. Black Arts Council file, reel 3192, CWP, AAA.

137. Southern Oregon College file, reel 3193, CWP, AAA.

138. Tamarind Institute file, reel 3193, CWP, AAA.

139. Doris E. Saunders, "S.S. Art Center Reception for Charles White," *Chicago Defender*, Feb. 24, 1970, 18.

140. Assistant to the registrar Sybil Herschbein to White, May 12, 1970, reel 3189, CWP, AAA.

141. Program flyer, reel 3194, CWP, AAA.

142. "Additional Art News," *Los Angeles Times*, Oct. 25, 1970, clipping, reel 3194, CWP, AAA.

143. The exhibition—the first African American art show at LACMA in thirty-five years—was the outcome of pressure applied by the Black Arts Council, an organization founded in 1968 to support black artists. Members believed that White should have been offered a solo show in a larger exhibition space. Black Arts Council file, reel 3192, CWP, AAA.

144. Graphic Arts Council at LACMA file, reel 3191, CWP, AAA.

145. White, "I Paint My Folks," *Drum Major* 1, no. 2 (Winter 1971): 19–20.

146. Claude Booker, Black Arts Council president, to White, Aug. 31, 1972, reel 3189, CWP, AAA.

147. The three-day conference, sponsored by the Black Academy of Arts and Letters and underwritten by the National Foundation for the Arts and the Johnson Publishing Company, featured nearly 200 black artists, actors, writers, and students, including author John O. Killens, actress Ruby Dee, and *Ebony* editor Lerone Bennett Jr.; "Black Arts Struggle for Freedom," *Jet*, June 15, 1972, 42–44.

148. Scholastic Book Services subject file, reel 3193, CWP, AAA.

149. Charles White, "Desegregation and the Richmond Story," *CORE* (*Congress of Racial Equality*) 2, no. 3 (1972): 7.

150. Joanne Dale, chairman of Authors-Illustrators Recognition Luncheon, City of Los Angeles, Superintendent of Schools, to White, Nov. 22, 1972, reel 3189, CWP, AAA.

151. Information from Henderson's interview informed the section on White in his 1993 book coauthored with Romare Bearden, *A History of African-American Artists: From 1792 to the Present* (New York: Pantheon, 1993).

152. Ronald Day, directing supervisor of art, Cleveland Public Schools, to White, Oct. 10, 1972, reel 3192, CWP, AAA.

153. Award ceremony invitation, reel 3189, CWP, AAA.

154. "Frances and Charles White: They Share a Life Where Art Is Served Up with Every Meal," *Los Angeles Times*, Oct. 13, 1974, Home Q&A, 74, emphasis in the original.

155. Ulis Williams, director of community services, Compton Community College, to White, Oct. 17, 1974, reel 3191, CWP, AAA.

156. Invitation from seminar organizer Edmund B. Gaither and detailed program for *Kindred Spirits*, reel 3192, CWP, AAA.

157. Tom Bradley, mayor of Los Angeles, file, reel 3190, CWP, AAA.

158. "Bennett and White Feted for Black History Book," *Jet*, Mar. 6, 1975, 12–13.

159. Ernestine Henning, chairwoman RSBWC, to White, Apr. 8, 1975, reel 3189, CWP, AAA.

160. Coordinator Jimmy McDonal to White, June 5, 1975, reel 3189, CWP, AAA.

161. Richard V. Clarke, chairman of the board, Studio Museum in Harlem, to White, Sept. 30, 1975, reel 3189, CWP, AAA.

162. Leadbelly file, reel 3192, CWP, AAA.

163. Artists for Economic Action file, reel 3190, CWP, AAA.

164. The Pasadena Arts Council made him a member in 1978. Pasadena Arts Council file, reel 3193, CWP, AAA.

165. Program invitation, "An Afternoon with Charles White," High Museum of Art file, reel 3190, CWP, AAA.

166. F. B. White, *Reaches of the Heart*, 200–201; and Vondell Petry, "Black Images Portray Universal Message for Artist Charles White," unidentified newspaper, clipping, reel 3194, CWP, AAA.

167. *Montgomery Advertiser*, Nov. 6, 1976, clipping, reel 3192, CWP, AAA.

168. Herman Hudson, dean for Afro-American Affairs, Indiana University, to White, Nov. 16, 1976, reel 3190, CWP, AAA.

169. Registration form for White's painting workshop at the Arkansas Art Center, reel 3190, CWP, AAA.

170. F. B. White, *Reaches of the Heart*, 209.

171. Ibid., 212.

172. Ibid., 216–20.

173. Edward D. Hawthorne, dean of the Graduate School of Arts and Sciences, Howard University, Washington, DC, to White, Nov. 30, 1978, reel 3191, CWP, AAA.

174. "Memorial Tribute," *Los Angeles Sentinel*, Nov. 1, 1979, A14; see also "A Jubilee for Charlie: Stars and friends celebrate life of Charles White," *Ebony* 35, no. 4 (Feb. 1980): 68–70, 72–73.

SELECTED INVENTORY OF
CHARLES WHITE'S LIBRARY

COMPILED BY ASHLEY JAMES

Charlie's studio was to occupy the entire top floor. He would finally have enough room for easel painting and print making with a separate library, or "think" room, which would house the collection of art books and periodicals that were as much a part of his life as the pencil or brush.
—Frances Barrett White, *Reaches of the Heart*

This bibliography represents an effort to document the books and periodicals that White owned and used during his lifetime. By no means a definitive list, this selected inventory records only those texts that were in his possession at the time of his death and remain in the Charles White Archives. Many volumes show signs of his use— fingerprints, smudges—while others contain photographic source material for his art.

Abramson, Doris E. *Negro Playwrights in the American Theatre, 1925–1959.* New York: Columbia University Press, 1967, 1969.

Alexis, Stéphen. *Black Liberator: The Life of Toussaint Louverture.* Translated by William Spring. London: Ernest Benn Limited, 1949.

Allen, James S. *Reconstruction: The Battles for Democracy (1865–1876).* New York: International Publishers, 1937.

Alswang, Betty, and Ambur Hiken. *The Personal House: Homes of Artists and Writers.* New York: Whitney Library of Design, 1961.

American Artists' Congress. *America Today: A Book of 100 Prints.* New York: Equinox Cooperative Press, 1936.

American Oil Company. *American Travelers Guide to Negro Monuments.* Chicago: American Oil Company, 1963.

Appel, Karel. *Karel Appel.* Amsterdam: Offsetbedrijf Augustin and Schoonman C.V., 1961.

Aptheker, Herbert, ed. *A Documentary History of the Negro People in the United States.* Preface by W. E. B. Dubois. New York: Citadel Press, 1951.

Art Directors Club. *Eleventh Annual of Advertising Art.* New York: Book Service Co., 1932.

——. *Twenty-Ninth Annual of Advertising and Editorial Art.* New York: Pitman Publishing, 1950.

Artforum 7, no. 1 (Sept. 1968).

Art Institute of Chicago. *Catalogue of "A Century of Progress": Exhibition of Paintings and Sculpture; Lent from American Collections.* Edited by Daniel Catton Rich. Exh. cat. Chicago: Art Institute of Chicago, 1933.

Arts Magazine: Ideas in Contemporary Art 49, no. 4 (Dec. 1974).

Bacon, Francis, and David Sylvester. *Francis Bacon.* New York: Pantheon Books, 1975.

Baldwin, James. *The Fire Next Time.* New York: Dial Press, 1963.

Baltimore Museum of Art. *Paintings, Sculpture and Drawings in the Cone Collection.* Rev. ed. Baltimore: Baltimore Museum of Art, 1967.

Bartsch, Ernst. *Neger, Jazz und tiefer Süden.* Leipzig: F. A. Brockhaus, 1956.

Baskett, Mary W. *The Art of June Wayne.* New York: Harry N. Abrams, 1970.

Beardsley, Aubrey. *The Early Work of Aubrey Beardsley.* With a prefatory

note by Henry Currie Marillier. New York: Dover, 1967.

Beecher, John. *All Brave Sailors: The Story of the SS* Booker T. Washington. New York: L. B. Fisher Publishing, 1945.

Belous, Russell E., and Robert A. Weinstein. *Will Soule: Indian Photographer at Fort Sill, Oklahoma, 1869–74*. Los Angeles: Ward Ritchie Press, 1972.

Benton, Thomas Hart. *An Artist in America*. New York: Robert M. McBride, 1937.

Biberman, Edward. *The Best Untold: A Book of Paintings by Edward Biberman*. New York: Blue Heron Press, 1953.

Biddle, George. *An American Artist's Story*. Boston: Little, Brown, 1939.

The Black Photographers Annual. New York: Black Photographers Annual, 1973.

Bloor, Ella Reeve. *We Are Many: An Autobiography*. With an introduction by Gurley Flynn. New York: International Publishers, 1940.

Blume, Johannes Bernhard, and John Christophe Ammann. *Bernhard Blume, Jürgen Klauke, Falko Marx, Rune Mields, C. O. Paeffgen, H. G. Prager*. Cologne: Kölnischer Kunstverein, 1975.

Bolle, Jacques, and Yves Delacre. *Herrscher des Urwalds*. Berlin: Verlag Ullstein, 1959.

Bond, Fredrick W. *The Negro and the Drama*. Washington, DC: Associated Publishers, 1940.

Botkin, Benjamin A. *Lay My Burden Down: A Folk History of Slavery*. Chicago: University of Chicago Press, 1945.

Bowles, Paul, and Peter W. Haeberlin. *Yallah*. New York: McDowell, Obolensky, 1957.

Bridgman, George Brant. *Constructive Anatomy*. Pelham, NY: Bridgman, 1928.

——. *Features and Faces*. Pelham, NY: Bridgman, 1932.

——. *Fifty Figure Drawings: A Selected Group of the Best Figure Drawings Submitted by the Fifty Best Drawing Jury*. Pelham, NY: Bridgman, 1929.

——. *One Hundred Figure Drawings*. Pelham, NY: Bridgman, 1935.

Brooklyn Museum. *Paintings and Drawings by David Levine and Aaron Shikler*. Exh. cat. New York: Brooklyn Museum, 1971.

Brooks, Gwendolyn. *In the Mecca*. New York: Harper and Row, 1968.

——. *Selected Poems*. New York: Harper and Row, 1963.

——. *The Wall: For Edward Christmas*. Detroit: Broadside Press, 1967.

Brown, Sterling. *The Negro in American Fiction*. Washington, DC: Associates in Negro Folk Education, 1937.

——. *Southern Road*. Illustrations by E. Simms Campbell. New York: Harcourt, Brace, 1932.

Bulliet, C. J. *Art Masterpieces in a Century of Progress Fine Arts Exhibition at the Art Institute of Chicago*. 2 vols. Chicago: North-Mariano Press, 1933.

Caldwell, Erskine, and Margaret Bourke-White. *You Have Seen Their Faces*. New York: Modern Age Books, 1937.

Cameron, Angus, and Peter Parnall. *The Nightwatchers*. New York: Four Winds Press, 1971.

Carawan, Guy, Candie Yellan, and Robert Yellen. *Ain't You Got a Right to the Tree of Life?: The People of Johns Island, South Carolina—Their Faces, Their Words, and Their Songs*. New York: Simon and Schuster, 1966.

Carlson, Charles X. *The Simplified Essentials of Oil Painting*. New York: Melior Books, 1943.

Carnegie Institute. *Pittsburgh International Exhibition of Contemporary Painting*. Exh. cat. Pittsburgh: Carnegie Institute, 1952.

Cartier-Bresson, Henri. *The Face of Asia*. With an introduction by Robert Shaplen. New York: Viking Press, 1972.

Cartier-Bresson, Henri, and Han Suyin. *From One China to the Other*. Edited by Robert Delpire. New York: Universe Books, 1956.

Cayton, Horace R. *Long Old Road*. New York: Trident Press, 1965.

Celant, Germano. *Art Povera*. New York: Praeger, 1969.

Cheney, Sheldon. *Expressionism in Art*. New York: Tudor, 1939.

——. *A Primer of Modern Art*. New York: Liveright, 1935.

Chinese Woodcutters' Association. *Woodcuts of War-Time China, 1937–1945*. Shanghai: Kaiming Book Co., 1946.

Civil Rights Congress. *We Charge Genocide*. New York: Civil Rights Congress, 1951.

Clarke, John Henrik, Esther Jackson, Ernest Kaiser, and J. H. O'Dell, eds. *Black Titan: W. E. B. Du Bois; An Anthology by the Editors of Freedomways*. Boston: Beacon Press, 1970.

Cole, Ernest, and Thomas Flaherty. *House of Bondage: A South African Black Man Exposes in His Own Pictures and Words the Bitter Life of His Homeland*. London: Ridge Press, 1967.

Conrad, Barnaby. *The Death of Manolete*. Boston: Riverside Press, 1958.

Conrad, Earl. *Harriet Tubman*. Washington, DC: Associated Publishers, 1943.

Contemporary Photographer 6, no. 2 (1968). (See fig. 1.)

Covell, Jon C. *Japanese Landscape Painting*. New York: Crown Publishers, 1962.

Craven, Thomas, ed. *A Treasury of American Prints: A Selection of One Hundred Etchings and Lithographs by the Foremost Living American Artists*. New York: Simon and Schuster, 1939.

Cripps, Thomas. *Black Film as Genre*. Bloomington: Indiana University Press, 1978.

Cullen, Countee. *On These I Stand: An Anthology of the Best Poems of Countee Cullen*. New York: Harper and Brothers, 1927.

Fig. 1. Dan Weiner's photograph *South Africa, 1954* was White's source for *Dream Deferred II* (1969) (pl. 86). From "Dan Weiner, 1919–1959," in "The Concerned Photographer," special issue, *Contemporary Photographer* 6, no. 2 (1968): 71.

Fig. 2. White's personal copy of
Roy DeCarava and Langston Hughes,
The Sweet Flypaper of Life.

Curtis, Anna L. *Stories of the
Underground Railroad*. Foreword by
Rufus M. Jones. Illustrated by
William Brooks. New York: Island
Workshop Press Co-op, 1941.

Dabbs, Edith. *Face of an Island: Leigh
Richmond Miner's Photographs of
Saint Helena Island*. New York:
Grossman Publishers, 1971.

Dain, Martin J. *Faulkner's County:
Yoknapatawpha*. New York: Random
House, 1964.

Darbois, Dominique. *African Dance:
A Book of Photographs*. Text by
Vladimír Vašut. Prague: Artia, 1962.

Davidson, Basil. *Report on Southern
Africa*. London: Jonathan Cape, 1952.

Davis, Margo Baumgarten, and Gregson
Davis. *Antigua Black: Portrait of
an Island People*. San Francisco:
Scrimshaw Press, 1973.

DeCarava, Roy, and Langston Hughes.
The Sweet Flypaper of Life. New York:
Simon and Schuster, 1955. (See fig. 2.)

De Erdely, Francis. *Vallarta Sketches*.
Los Angeles: Columbia Lithograph
Co., 1960.

Descharnes, Robert, Clovis Prevost, and
Francesc Pujols. *Gaudí: The Visionary*.
New York: Viking Press, 1971.

Diebenkorn, Richard, and Robert T.
Buck Jr. *Richard Diebenkorn:
Paintings and Drawings, 1943–1976*.
Exh. cat. Buffalo: Albright-Knox Art
Gallery, 1976.

Doerner, Max, and Eugen Neuhaus.
*The Materials of the Artist and Their
Use in Painting with Notes on the
Techniques of Old Masters*. New York:
Harcourt, Brace, 1934.

Douglass, Frederick. *Fredrick Douglass:
Selections from His Writings*. Edited
and with an introduction by Philip
Sheldon Foner. New York:
International Publishers, 1945.

Du Bois, W. E. B. *Black Reconstruction:
An essay toward a history of the part
which black folk played in the attempt
to reconstruct democracy in America,
1860–1880*. New York: Harcourt,
Brace, 1935.

——. *Color and Democracy: Colonies and
Peace*. New York: Harcourt, Brace,
1945.

——. *In Battle for Peace: The Story of
My 83rd Birthday*. New York:
Masses and Mainstream, 1952.

——. *John Brown*. New York: International
Publishers, 1962.

——. *The Souls of Black Folk: Essays and
Sketches*. Chicago: McClurg, 1918.

——. *The Souls of Black Folk: Essays and
Sketches*. New York: Blue Heron
Press, 1953.

——. *The World and Africa: An Inquiry
into the Part Which Africa Has Played
in World History*. New York: Viking
Press, 1947.

[Du Bois], Shirley Graham. *There Was
Once a Slave . . . : The Heroic Story of
Fredrick Douglass*. New York: Julian
Messner, 1947.

Dunbar, Paul Laurence. *Folks from Dixie*.
Illustrations by E. W. Kemble. New
York: Dodd, Mead, 1898.

——. *Poems of Cabin and Field*.
Photographs by the Hampton
Institute Camera Club and decora-
tions by Alice Morse. New York:
Dodd, Mead, 1895–96.

——. *"The Strength of Gideon" and Other
Stories*. Illustrations by E. W. Kemble.
New York: Dodd, Mead, 1900.

——. *The Uncalled*. New York: Dodd,
Mead, 1898.

Eakins, Thomas. *Thomas Eakins: His
Photographic Works*. Exh. cat.
Philadelphia: Pennsylvania Academy
of the Fine Arts, 1969.

Ede, H. S. *Savage Messiah: Gardier-Brzeska*.
New York: Literary Guild, 1931.

Editors of *Life* Magazine. *The Epic of
Man*. New York: Time, Inc., 1961.

Eitner, Lorenz. *Géricault*. Exh. cat.
Los Angeles: Los Angeles County
Museum of Art, 1971.

Elgar, Frank. *Van Gogh: Peintures*. Paris:
Éditions du Chêne, 1947.

Elliot, George P. *Dorothea Lange*.
Exh. cat. New York: Museum of
Modern Art, 1966.

Erni, Hans, and Frank Thiessing, eds.
Erni: Elements of Future Painting.
Zurich: Zollikofer for Meyer and
Thiessing, 1948.

Evans, Walker. *Walker Evans: American
Photographs*. With an essay by
Lincoln Kirstein. New York: Museum
of Modern Art, 1938.

Everett, Michael. *A Natural History of
Owls*. London: Hamlyn Publishing
Group, 1977.

Evergood, Philip. *20 Years Evergood*.
Exh. cat. New York: ACA Gallery;
New York: Simon and Schuster, 1946.

Exman, Eugene. *The World of Albert
Schweitzer*. Photographs by Erica
Anderson. New York: Harper and
Brothers, 1955. (See fig. 3.)

Famous Photographers 3, no. 10 (1970).

Famous Photographers 3, no. 11 (1970).

Fauset, Arthur Huff. *Sojourner Truth:
God's Faithful Pilgrim*. Chapel Hill:
University of North Carolina Press,
1938.

Fawcett, Robert. *On the Art of Drawing:
An Informal Textbook*. New York:
Watson-Guptill Publications, 1958.

Ferguson, Blanche E. *Countee Cullen
and the Negro Renaissance*.
New York: Dodd, Mead, 1966.

Filmus, Tully. *Tully Filmus*. With an
introduction by Alfred Werner.
Cleveland: World Publishing Co.,
1963.

Finlayson, Donald Lord. *Michelangelo:
The Man*. New York: Tudor, 1936.

Firpo, Patrick, Lester Alexander, and
Claudia Katayanagi. *Copyart:
The First Complete Guide to the
Copy Machine*. New York: R. Marek
Publishers, 1978.

Fondation Maeght. *La Fondation
Marguerite et Aimé Maeght à
l'occasion du dixième anniversaire de
la fondation Marguerite et Aimé
Maeght*. Paris: Maeght Éditeurs, 1974.

Franklin, Joe. *Classics of the Silent
Screen: A Pictorial Treasury*.
Secaucus, NJ: Citadel Press, 1959.

Frasconi, Antonio, and Fritz Eichenberg.
The House That Jack Built / La

maison que Jacques a bâtie.
New York: Harcourt, Brace, 1958.

Frazier, E. Franklin. *The Negro Family in Chicago.* Chicago: University of Chicago Press, 1932.

Freed, Leonard. *Black in White America.* New York: Grossman Publishers, [1969].

Freedberg, Sydney J. *Raphael: The Stanza della Segnatura in the Vatican, 1508–1511.* The Metropolitan Museum of Art Miniatures. New York: Book-of-the-Month Club, 1953.

Freedomways: A Quarterly Review of the Freedom Movement 11, no. 2 (second quarter, 1971).

Frieden der Welt / Mira-mir / Peace for the World / Paix au monde: Internationale Grafik. Exh. cat. Dresden: Verlag der Kunst, 1959.

Friedan, Betty. *The Feminine Mystique.* New York: W. W. Norton, 1963.

Fujikake, Shizuya. *Japanese Wood-Block Prints.* Tokyo: Japan Travel Bureau, 1959.

Gabrielson, Walter. *Pop Dawson: The Formative Years.* Drawings by Walter Gabrielson. Pasadena, CA: Dawson Aircraft, 1971.

Gamboa, Fernand, Carl O. Schniewind, and Hugh L. Edwards. *Posada: Printmaker to the Mexican People.* Exh. cat. Chicago: Art Institute of Chicago, 1944.

Gardi, René. *Kirdi: Unter den*

Fig. 3. White used this photograph by Erica Anderson as a source for *Oh, Mary, Don't You Weep* (1956) (pl. 51). From Eugene Exman, *The World of Albert Schweitzer*, 38.

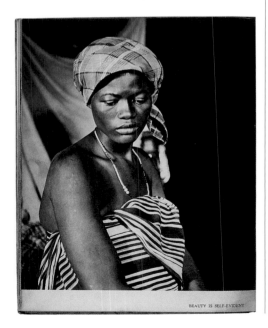

BEAUTY IS SELF-EVIDENT

heidnischen Stämmen in den Bergen und Sümpfen NordKameruns. Bern: Alfred Scherz Verlag, 1955. (See fig. 4.)

Genet, Jean. *The Blacks: A Clown Show.* New York: Grove Press, 1960.

Goffin, Robert. *Horn of Plenty: The Story of Louis Armstrong.* Translated by James F. Bezou. New York: Allen, Towne and Heath, 1947.

Goldscheider, Ludwig. *The Paintings of Michelangelo.* London: Phaidon Press; New York: Oxford University Press, 1939.

Goldstein, Harriet Irene, and Vetta Goldstein. *Art in Every-Day Life.* New York: Macmillan, 1940.

Goodrich, Lloyd. *Art of the United States, 1670–1966.* Exh. cat. New York: Whitney Museum of American Art, 1966.

——. *Winslow Homer.* Exh. cat. New York: Whitney Museum of American Art, 1973.

Gregory, James M. *Frederick Douglass: The Orator; Containing an Account of His Life, His Eminent Public Services, His Brilliant Career as Orator, Selections from His Speeches and Writings.* Introduction by W. S. Scarborough. Springfield, MA: Willey, 1893.

Guggenheim, Hans. *Dogon World: A Catalogue of Art and Myth for You to Complete.* New York: Wunderman Foundation, 1974.

Haas, Ernst. *The Creation.* New York: Viking Press, 1971.

Haas, Robert Bartlett, Paul Harold Slattery, Verna Arvey, William Grant Still, Louis Kaufman, and Annette Kaufman, eds. *William Grant Still and the Fusion of Cultures in American Music.* With an introduction by Howard Hanson and Frederick Hall. Los Angeles: Black Sparrow Press, 1972.

Haight, Anne Lyon, Monroe Wheeler, and Jean Charlot. *Portrait of Latin America As Seen by Her Print Makers / Retrato de la América latina por sus artistas gráficos.* New York: Hastings House, 1946.

Hall, Norman, and Basil Burton, eds. *Photography Year Book 1959.* London: Photography Magazine, 1958.

Handy, W. C. *Father of the Blues: An Autobiography.* Edited by Arna Bontemps. New York: Macmillan, 1944.

Hannah, John A. *Freedom to the Free: 1863–1963 Century of Emancipation;*

15

Fig. 4. White used this photograph as a source for *General Moses (Harriet Tubman)* (1965) (pl. 79). From René Gardi, *Kirdi: Unter den heidnischen Stämmen in den Bergen und Sümpfen NordKameruns*, 15.

A Report to the President by the United States Commission on Civil Rights. Washington, DC: US Government Printing Office, 1963.

Harris, Ann Sutherland, and Linda Nochlin. *Women Artists, 1550–1950.* New York: Alfred A. Knopf, 1976.

Haywood, Harry. *Negro Liberation.* New York: International Publishers, 1948.

Helm, Mackinley. *Angel Mo' and Her Son, Roland Hayes.* Boston: Little, Brown, 1942.

Henderson, Edwin Bandcroft. *The Negro in Sports.* Washington, DC: Associated Publishers, 1939.

Hendricks, Gordon. *The Life and Work of Thomas Eakins.* New York: Grossman Publishers, 1974.

Henry, Francoise. *The Book of Kells: Reproductions from the Manuscript in Trinity College.* New York: Knopf, 1974.

Heyward, Du Bose. *Mamba's Daughters: A Novel of Charleston.* New York: Literary Guild, 1929.

Hochschule für Architektur. *Für den Frieden: Arbeiten von Studenten der Hochschule für Architektur; III. Weltfestspiele der Jugend und*

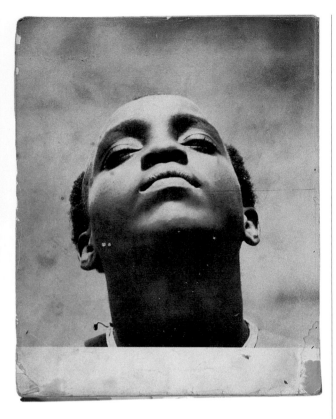

Fig. 5. This photograph by André Cauvin reproduced in the 1945 book *Congo* was likely White's source image for the drawing *Spirituals* (1965; location unknown [see fig. 5, p. 149]). From John Latouche and André Cauvin, *Congo*, 194.

Studenten für den Frieden, in Berlin, 5–19 August 1951. Weimar: Hochschule für Architektur, 1951.

Hochschule für Grafik und Buchkunst. *Kunst ist Waffe im Kampf für den Frieden: Geschenk an die III. Weltfeltspiele der Jugend und Studenten für der Frieden im August 1951 in Berlin, der Hauptstadt Deutschlands*. Leipzig: Hochschule für Grafik und Buchkunst, 1951.

Hoffman, Malvina. *Heads and Tales*. New York: Bonanza Books, 1936.

———. *Sculpture Inside and Out*. New York: W. W. Norton, 1939.

Holt, Rackham. *George Washington Carver: An American Biography*. Garden City, NY: Doubleday, Doran, 1943.

Horne, Lena. *In Person, Lena Horne: As Told to Helen Arstein and Carlton Moss*. New York: Greenberg, 1950.

Huggler, Max. *The Drawings of Paul Klee*. Alhambra, CA: Borden, 1965.

Hughes, Langston. *The Big Sea: An Autobiography*. New York: Alfred A. Knopf, 1945.

———. *Fields of Wonder*. New York: Alfred A. Knopf, 1947.

———. *Simple Takes a Wife*. New York: Simon and Schuster, 1953.

———. *Tambourines to Glory*. New York: John Day, 1958.

———. *The Ways of White Folks*. New York: Alfred A. Knopf, 1944.

Hughes, Langston, and Arna Bontemps, eds. *The Poetry of the Negro, 1746–1949*. Garden City, NY: Doubleday, 1949.

Hughes, Langston, and Milton Meltzer. *A Pictorial History of the Negro in America*. New York: Crown Publishers, 1956.

Hundertwasser, Friedensreich, and Manfred Bockelman. *Rainy Day*. Greenwich: New York Graphic Society, 1974.

Hunnex, Milton D. *Philosophies and Philosophies*. San Francisco: Chandler Publishing, 1961.

IBM Corporation. *Contemporary Art of the United States: Collection of the International Business Machine Corporation*. Exh. cat. N.p.: n.p., 1940.

Isaacs, Edith J. R. *The Negro in the American Theatre*. New York: Theatre Arts, 1947.

Jacobson, J. Z. *Art of Today: Chicago, 1933*. Chicago: L. M. Stein, 1933.

Jeffers, Robinson. *Medea: Freely Adapted from the "Medea" of Euripides*. New York: Random House, 1946.

Jewell, Edward Alden. *Georges Rouault*. Paris: Hyperion, 1947.

Johnson, Charles S. *Patterns of Negro Segregation*. New York: Harper and Brothers, 1943.

Johnson, Jack. *Jack Johnson—in the Ring—and Out*. Chicago: National Sports Publishing Co., 1927.

Johnson, James Weldon, and Aaron Douglas. *God's Trombones: Seven Negro Sermons in Verse*. New York: Viking Press, 1929.

Josephson, Matthew. *Life among the Surrealists: A Memoir*. New York: Holt, Rinehart and Winston, 1962.

Kaemmerer, Ludwig. *Kaethe Kollwitz: Griffelkunst und Weltanschauung, ein Kunstgeschichtlicher Beitrag zur Seelen-und Gesellschaftskunde*. Dresden: E. Richter, 1923.

Kemble, Frances Anne. *Journal of Residence on a Georgian Plantation in 1838–1839*. New York: Harper and Brothers, 1863.

Kent, Sister Mary Corita, Harvey Cox, and Samuel A. Eisenstein. *Sister Corita*. Philadelphia: Pilgrim Press, 1968.

Kertész, André. *André Kertész: Sixty Years of Photography, 1912–1972*. Edited by Nicolas Ducrot. New York: Grossman Publishers, 1972.

King, Martin Luther, Jr., et al. *Dr. Martin Luther King, Jr., Dr. John C. Bennett, Dr. Henry Steele Commager, and Rabbi Abraham Heschel Speak on the Vietnam War*. New York: Clergy and Laymen Concerned about Vietnam, 1967.

Kirstein, Lincoln, and Beaumont Newhall. *The Photographs of Henri Cartier-Bresson*. Exh. cat. New York: Museum of Modern Art, 1947.

Kokoschka, Oskar. *Oskar Kokoschka: A Retrospective Exhibition*. With an introduction by James S. Plaut and a letter from the artist. Exh. cat. New York: Chanticleer Press, 1948.

Kollwitz, Käthe. *"Ich will werken in dieser Zeit": Auswahl aus den Tagebüchern und Briefen, aus Graphik, Zeichnungen und Plastik*. Berlin: Verlag Gebr. Mann, 1952.

———. *Käthe Kollwitz: Ausstellung 8 März bis 29 April 1951*. Exh. cat. Berlin: Deutsche Akademie der Künste, 1951.

———. *Radierungen: Unsignierte Abzuge von den verstahlten Originalplatten; Lithographien; Holzschnitte (Reproduktionen); Mappen/ Bildkarten*. N.p.: n.p., 1960.

Kollwitz, Käthe, and Harri Nündel. *Käthe Kollwitz: Blätter über den Bauernkrieg*. Leipzig: Insel-Verlag, 1975.

Lackner, Stephan E., and Jason D. Wong. *Max Beckmann Graphics: Selected from the Ernest and Lilly Jacobson Collection*. Exh. cat. Tucson, AZ: Tuscon Art Center, 1973.

Larkin, Oliver W. *Art and Life in America*. New York: Rinehart, 1949.

Latouche, John, and André Cauvin. *Congo*. New York: Willow, White, 1945. (See fig. 5.)

Lebrun, Rico. *Rico Lebrun Drawings*. Foreword by James Thrall Soby. Berkeley: University of California Press, 1961.

Levine, David. *Artists, Authors, and Others: Drawings by David Levine*. With an introduction by David P. Moynihan. Exh. cat. Washington, DC: Smithsonian Institution Press, 1976.

Levitt, Helen. *A Way of Seeing: Photographs of New York*. With an

essay by James Agee. New York: Viking Press, 1965.

Lewitt, Sol. *Photogrids: Sol Lewitt*. New York: Paul David Press/Rizoli, 1977.

Lieberman, William S. "Picasso His Graphic Art" and "Redon Drawings and Lithographs." Special issue, *Bulletin of The Museum of Modern Art* 19, no. 2 (Winter 1952).

Linton, Ralph, Paul S. Wingert, and Rene D'Harnoncourt. *Arts of the South Seas*. Exh. cat. New York: Museum of Modern Art, 1946.

Lock, Mary Land. *Shadows of the Swamp*. Illustrations by Jacques de Tarnowsky. Dallas: Kaleidograph Press, 1940.

Locke, Alain. *The New Negro: An Interpretation*. New York: Albert and Charles Boni, 1927.

Lukas, Jan. *Light and Shade*. London: Lincolns-Prager, 1947.

Mack, Gerstle. *Gustave Courbet*. New York: Knopf, 1951.

———. *Toulouse-Lautrec*. New York: Knopf, 1942.

Madian, Jon. *Beautiful Junk: A Story of the Watts Towers*. Photographs by Barbara Jacobs and Lou Jacobs, Jr. Boston: Little, Brown, 1968.

Marchiori, Giuseppe. *Renato Guttuso*. Milan: Edizioni d'Arte Moneta, 1952.

Marsh, J. B. T. *The Story of the Jubilee Singers: With Their Songs*. Boston: Houghton, 1880.

Marshall, Paule. *Brown Girl, Brownstones*. New York: Random House, 1959.

Melville, Herman. *On the Slain Collegians: Selections from the Poems of Herman Melville*. Edited by Antonio Frasconi. New York: Farrar, Straus and Giroux, 1971.

Merriam, Eve. *Montgomery, Alabama; Money, Mississippi; and Other Places: A Pamphlet in Poetry*. New York: Cameron Associates, 1956.

Miller, Dorothy Canning. *Americans 1942: 18 Artists from 9 States*. Exh. cat. New York: Museum of Modern Art, 1942.

Miller, Elizabeth W., ed. *The Negro in America: A Bibliography*. Foreword by Thomas F. Pettigrew. Cambridge, MA: Harvard University Press, 1966.

Miller, Henry. *To Paint Is to Love Again*. Alhambra, CA: Cambria, 1960.

Montagu, Ashley. *Statement on Race*. New York: Henry Schuman, 1951.

Moon, Bucklin, ed. *Primer for White Folks*. Garden City, NY: Doubleday, Doran, 1945.

Mueller, Hans Alexander. *How I Make Woodcuts*. New York: American Artists Group, 1945.

Murray, Florence, ed. *The Negro Handbook, 1949*. New York: Macmillan, 1949.

Nagel, Otto. *Die Selbstbildnisse der Käthe Kollwitz*. Berlin: Henschel Verlag, 1965.

National Academy of Design. *154th Annual Session*. National Academy of Design, School of Fine Arts, 1978–79.

National Art Society. *American Art Today: New York World's Fair*. New York: National Art Society, 1939.

National Museum of Modern Art. *Dai nanakai Tokyo kokusai hanga biennare ten* [Seventh Tokyo international print biennale exhibition]. Exh. cat. National Museum of Moden Art, Tokyo, 1970–71.

Nebbia, Ugo. *Michelangelo: Bildhauer, Maler, Architekt, Dichter*. Leipzig: Johannes Asmus Verlag, 1940.

Neilson, Winthrop, and Frances Neilson. *Seven Women: Great Painters*. New York; London: Chilton Book Co., 1969.

Nevelson, Louise, and Diana MacKown. *Dawns + Dusks: Louise Nevelson*. New York: Scribner's Sons, 1976.

Newhall, Nancy Wynne. *This Is the Photo League*. New York: Photo League, 1948.

Niver, Kemp R. *Mary Pickford, Comedienne*. Los Angeles: Locare Research Group, 1969.

Nkrumah, Kwame. *Ghana: The Autobiography of Kwame Nkrumah*. New York: Thomas Nelson and Sons, 1957.

Northrup, Herbert R. *Organized Labor and the Negro*. New York: Harper and Brothers, 1944.

Nundel, Harri, and Maria Ruger. *Graphik Slowenischer Partisanen: Ausstellung Akademie der Künste der DDR*. Exh. cat. Berlin: Akademie der Künst der DDR, 1976.

Ottley, Roi, and William J. Weatherby, eds. *The Negro in New York: An Informal Social History*. Preface by James Baldwin. New York: Oceana Publication, 1967.

Owens, William. *A Slave Mutiny: The Revolt on the Schooner Amistad*. New York: John Day, 1953.

Paige, Leroy (Satchel). *Pitchin' Man: Satchel Paige's Own Story*. As told to Hal Lebowitz. Cleveland: Meckler, 1948.

Palfi, Marion. *Suffer Little Children*. New York: Oceana Publications, 1952.

Paton, Alan. *Cry, the Beloved Country*. New York: Charles Scribner's Sons, 1948.

Patterson, Haywood, and Earl Conrad. *Scottsboro Boy*. Garden City, NY: Doubleday, 1950.

Picasso: Forty Nine New Lithographs, Together with Honoré Balzac's "The Hidden Marterpiece" in the Form of an Allegory. New York: Lear, 1947.

Picasso Linoleum Cuts: Bacchanals, Women, Bulls and Bullfighters. Introduction by Wilhelm Boeck. New York: Harry N. Abrams, 1962.

Poland: Monatsschrift Polen 10 (Oct. 1963).

Pommeranz-Liedtke, Gerhard. *Leonardo da Vinci: Zur Fünfhundertsten Wiederkehr seines Geburtstages, 1452/1952*. Exh. cat. Berlin: Deutsche Akademie der Künste, 1952.

Portfolio: The Annual of the Graphic Arts (1951).

Portfolio: A Magazine for Graphic Arts 1, no. 1 (Winter 1950).

Powell, Adam Clayton. *Marching Blacks: An Interpretive History of the Rise of the Black Common Man*. New York: Dial Press, 1945.

Quarles, Benjamin. *The Negro in the Civil Wars*. Boston: Little, Brown, 1953.

Ramsey, Rita. *Home Lessons in Tap Dancing*. New York: E. P. Dutton, 1932.

Reade, Winwood W. *Savage Africa*. New York: Harper and Brothers, 1864.

Repin, Il'ia Efimovich. *70 reproduktsii s kartin i risunkov*. Moscow: Gosudarstvennoe Izdatel'stvo "Iskusstvo," 1951.

Ricciardi, Mirella. *Vanishing Africa*. New York: Reynal, 1971.

Rivera, Diego. *Diego Rivera: 50 años de su labor artística; Exposición de homenaje nacional*. Exh. cat. Mexico City: Departamento de Artes Plásticas, Instituto Nacional de Bellas Artes, 1951.

Rivera, Diego, and Bertram D. Wolfe. *Portrait of Mexico: Paintings by Diego Rivera*. New York: Covici-Friede, 1937.

Robeson, Eslanda Goode. *Paul Robeson, Negro*. New York: Harper and Brothers, 1930.

Robeson, Paul. *Here I Stand*. Boston: Beacon Press, 1971.

———. *Paul Robeson: Itt állok*. Budapest: Európa Könyvkiado, 1958.

Robinson, Jackie. *Jackie Robinson: My Own Story*. As told to Wendell Smith. New York: Greenberg, 1948.

Rodman, Selden. *Portrait of the Artist as an American: Ben Shahn; A Biography with Pictures*. New York: Harper and Brothers, 1951.

Roger-Marx, Claude. *Vuillard et son temps*. Paris: Éditions Arts et Métiers Graphiques, 1946.

Rood, John *This, My Brother*. Introduction by Meridel Le Sueur. Illustrations by Charles Sebree. Chicago: Midwest Federation of Arts and Professions, 1936.

Rosenberg, Jakob. *Rembrandt*. Cambridge, MA: Harvard University Press, 1948.

Rubin, William S. *Dada, Surrealism, and Their Heritage*. Exh. cat. New York: Museum of Modern Art, 1968.

Rubissow, Helen. *Art of Russia: Paintings of the Russian People*. New York: Philosophical Library, 1946.

Rudolph, Nancy. *Workyards: Playgrounds Planned for Adventure*. New York: Teachers College Press, 1974.

Schider, Fritz, and Max Auerbach. *An Atlas of Anatomy for Artists*. New York: Dover, 1947.

Fig. 6. White used the bottom photograph, *Passengers. Boblo boat*, by Alwyn Scott, as a source for *Missouri C* (1972) (pl. 97). From Turner, *Photographs of the Detroit People*, no. 46, n.p., bottom.

46- (Above) Dance area. Boblo boat.
46- (Below) Passengers. Boblo boat.

Schmitt, Gladys. *Rembrandt: A Novel*. New York: Dell, 1962.

Schreiner, Olive. *Trooper Peter Halket of Mashonaland*. Boston: Roberts Brothers, 1897.

Schuh, Gotthard, and Max-Pol Fouchet. *Instants volés, instants donnés*. Lausanne, Switzerland: La Guilde du Livre, 1956.

Schulthess, Emil. *Africa*. New York: Simon and Schuster, 1959.

Semak, Michael. *If This Is the Time / Tant qu'il y a la vie*. Image 4. Montreal: National Film Board of Canada, 1971.

Silvera, John D. *The Negro in World War II*. Baton Rouge, LA: Military Press, 1946.

Simon, Howard. *500 Years of Art in Illustration: From Albrecht Dürer to Rockwell Kent*. Garden City, NY: Garden City Publishing, 1949.

Sloan, John. *Gist of Art*. New York: American Artists Group, 1939.

Smith, Lillian. *Strange Fruit*. New York: Reynal and Hitchcock, 1944.

Smith, Samuel Denny. *The Negro in Congress, 1870–1901*. Chapel Hill: University of North Carolina Press, 1940.

Smith, W. Eugene. *W. Eugene Smith: His Photographs and Notes*. Afterword by Lincoln Kirstein. New York: Aperture, 1969.

Sorlier, Charles. *The Ceramics and Sculptures of Chagall*. With a preface by André Malraux. Monaco: Éditions André Sauret, 1972.

Soyer, Moses. *Painting the Human Figure*. Edited by Robert W. Gill. New York: Watson-Guptill Publications, 1964.

Steadman, David W., and David S. Rubin. *Black and White Are Colors: Paintings of the 1950s–1970s*. Exh. cat. Claremont, CA: Galleries of the Claremont Colleges, 1979.

Steichen, Edward. *Memorable LIFE Photographs*. Foreword and comment by Edward Steichen. Exh. cat. New York: Museum of Modern Art, 1951.

Steinbeck, John. *America and Americans*. New York: Viking Press, 1966.

Steinbeck, John, Rose Harvan Kline, and Alexander Hammid. *The Forgotten Village: With 136 Photographs for the Film of the Same Name*. New York: Viking Press, 1941.

Stermer, Dugald, and Susan Sontag. *The Art of Revolution: 96 Posters from Cuba*. London: Pall Mall Press, 1970.

Sterne, Emma Gelders. *His Was the Voice: The Life of W. E. B. DuBois*. Foreword by Ronald Stevenson. New York: Crowell-Collier Press, 1971.

Stevenson, Robert Alan Mowbray. *Rubens: Paintings and Drawings*. New York: Oxford University Press, 1939.

Stix, Hugh, Marguerite Stix, and Tucker R. Abbott. *The Shell: Five Hundred Million Years of Inspired Design*. New York: Harry N. Abrams, 1968.

Stoss, Veit, and Szczesny Dettloff. *Wit Stwosz: Ołtarz krakowski*. Warsaw: Pánstwowy Instytut Wydawniczy, 1951.

Sweeney, James Johnson. *Henry Moore*. Exh. cat. New York: Museum of Modern Art, 1946.

Swift, Hildegarde Hoyt. *North Star Shining: A Pictorial History of the American Negro*. Illustrations by Lynd Ward and lithographs by George C. Miller. New York: William Morrow, 1947.

Taylor, John Vernon, and Hans O. Leuenberger. *Afrikanische Passion / The Passion in Africa*. Munich: Chr. Kaiser Verlag, 1957.

Thompson, Robert Farris. *Black Gods and Kings: Yoruba Art at UCLA*. Los Angeles: University of California Press, 1971.

Treiman, Joyce, Lester Duncan Longman, and Maurice E. Bloch. *Joyce Treiman*. Los Angeles: Hennessy and Ingalls, 1978.

Turbeville, Deborah. *Wallflower*. New York: Congreve Pub., 1978.

Turner, Alwyn Scott. *Photographs of the Detroit People*. N.p.: n.p., 1970. (See fig. 6.)

Ulanov, Barry. *Duke Ellington*. New York: Creative Age Press, 1946.

U.S. Camera (1971).

"The USA at War." Special issue, *U.S. Camera* (1945).

U.S. Camera (1950).

U.S. Camera (1951).

U.S. Camera (1952).

U.S. Camera (1953).

United States, WPA, Division of Professional and Service Projects. *Fresco Painting: A Circular Presenting the Technique of Fresco Painting. . .* W.P.A. Technical Series Art Circular 4. Washington, DC: Federal Works Agency, WPA, Division of Professional and Service Projects, 1940.

University of California, Los Angeles, Afro-American Studies Center.

Workshop in Afro-American History and Culture (July 14–August 1. 1969), Afro-American Studies Center. Los Angeles: UCLA Afro-American Studies Center, 1969.

University of Illinois, Urbana, College of Fine and Applied Arts and Krannert Art Museum. *Eleventh Exhibition of Contemporary American Painting and Sculpture.* Exh. cat. Urbana: University of Illinois Press, 1963.

Vallentin, Antonina. *This I Saw: The Life and Times of Goya.* New York: Random House, 1949.

Van Loon, Hendrik Willem, and Grace Castagnetta. *The Arts.* New York: Simon and Schuster, 1939.

Van Vechten, Carl. *The Blind Bow-Boy.* New York: Alfred A. Knopf, 1923.

——. *Firecrackers.* New York: Alfred A. Knopf, 1925.

——. *Fragments: From an Unwritten Autobiography.* New Haven, CT: Yale University Library, 1955.

——. *Lords of the Housetops: Thirteen Cat Tales.* New York: Alfred A. Knopf, 1921.

——. *Peter Whiffle: His Life and Works.* New York: Alfred A. Knopf, 1922.

Van Zandt, Franklin K. *Boundaries of the United States and the Several States.* Washington, DC: US GPO, 1976.

Vargas, Alberto, and Austin Reid. *Vargas.* New York: Harmony Books, 1978.

Vuchetich, E. V. *Pamiatnik voinam sovetskoi armii pavsim pri sturme Berlina: Velikaia otechestvennaia voina, 1941–1945.* Moscow: Gosudarstvennoe Izdatel'stvo Izobrazitel'nogo Iskusstva, 1953.

Waetzoldt, Wilhelm. *Dürer and His Times.* New York: Phaidon Press, 1950.

Warner, James A. *The Gentle People: A Portrait of the Amish.* Exh. cat. [Soudersburg, Pa.]: Mill Bridge Museum; New York: Grossman, 1969.

Washington, Booker T. *An Autobiography: The Story of My Life and Work.* Introduction by Dr. J. L. M. Curry. Naperville, IL: J. L. Nichols, 1901.

——. *Up from Slavery: An Autobiography.* Garden City, NY: Sun Dial Press, 1937.

Watkins, Sylvestre C., ed. *Anthology of American Negro Literature.* Introduction by John C. Fredrick. New York: Modern Library, 1944.

Weller, Allen S. *University of Illinois Contemporary American Painting.* Exh. cat. Urbana, IL: College of Fine and Applied Arts, 1950.

Welty, Eudora. *One Time, One Place: Mississippi in the Depression.* New York: Random House, 1971. (See fig. 7.)

Wengenroth, Stow. *Making a Lithograph.* How to Do It 11. New York: Studio Publications, 1936.

Werner, Alfred. *Pascin.* New York: Harry N. Abrams, 1962.

Weyer, Edward Moffat. *Primitive Peoples Today.* Garden City, NY: Doubleday, 1959.

Wheeldin, Donald C. *Afro-American History: A Course Outline.* San Francisco: Pacifica Gallery, 1970.

Whitman, Walt. *Leaves of Grass.* New York: Doubleday, Doran, 1940.

——. *Specimen Days.* Boston: D. R. Godine, 1971.

Wilhelm-Lehmbruck-Museum. *Ansgar Nierhoff.* Exh. cat. Duisburg, Germany: Wilhelm-Lehmbruck-Museum Duisberg, 1975.

Wilson, Angus. *Anglo-Saxon Attitudes.* New York: Viking Press, 1956.

Wingert, Paul S. *The Sculpture of William Zorach.* New York: Pitman Publishing, 1938.

Woodson, Carter Godwin. *African Myths Together with Proverbs.* Washington, DC: Associated Publishers, 1928.

——. *The Education of the Negro prior to 1861: A History of the Education of the Colored People of the United States from the Beginning of Slavery to the Civil War.* Washington, DC: Associated Publishers, 1919.

——. *The History of the Negro Church.* 2nd ed. Washington, DC: Associated Publishers, 1945.

Wright, Barton. *The Unchanging Hopi: An Artist's Interpretation in Scratchboard Drawings and Text.* Flagstaff, AZ: Northland Press, 1975.

Wright, Harold Bell. *The Re-Creation of Brian Kent.* Illustrations by J. Allen St. John. Chicago: Book Supply Co., 1919.

Wright, Richard, and Edwin Rosskam. *12 Million Black Voices: A Folk History of the Negro in the United States.* New York: Viking Press, 1941.

Writers' Program of the WPA in the State of Virginia. *The Negro in Virginia.* New York: Hastings House, 1940.

Young, A. S. *Negro Firsts in Sports.* Chicago: Johnson Publishing, 1963.

Young, Henry J. *Major Black Religious Leaders since 1940.* Nashville, TN: Parthenon Press, 1979.

Fig. 7. White used this photograph by Eudora Welty as a source for *Mother Courage II* (1974; National Academy Museum, New York). From Welty, *One Time, One Place: Mississippi in the Depression,* frontispiece.

SELECTED EXHIBITION HISTORY

Compiled by John Murphy with Stacy Kammert

Cat. indicates a published record of the exhibition (catalogue, brochure, pamphlet, or checklist); *cat.* followed by a number indicates the catalogue number in that publication. *No cat.* indicates that the exhibition had no known or available published record. Titles, dates, media, catalogue numbers, and the order of artworks are reproduced as they appear in the exhibition catalogue; misspellings and incorrect attributions are reproduced to reflect what was represented in the catalogue. In the absence of a catalogue, information has been culled from other available sources such as exhibition reviews. *Incomplete list* means that there may have been more works exhibited than those included here. In some cases, no catalogue exists but archival correspondence has confirmed the complete list of artworks in the exhibition.

1934

Chicago, Grant Park, Chicago Artists' Equity, *Open Air Art Fair*, June 30–July 12, 1934, no cat.

1935

Chicago, Union Park Field House, Art Crafts Guild, *Third Annual Exhibition*, May 31–June 9, 1935, no cat. (Incomplete list).

Mulatto Madonna

1936

Chicago, South Parkway YMCA, *Chicago Negro Art Exhibition*, May 1936, no cat.

Chicago, South Side Settlement House, *Chicago Negro Art Exhibition*, Sept. 1936, no cat.

1937

Chicago, Paragon Studios, *Margaret Taylor, Bernard Goss and Charles White*, Nov. 7–21, 1937, no cat.

1938

Chicago Artists Group Galleries, *An Exhibition in Defense of Peace and Democracy: Dedicated to the Peoples of Spain and China*, Feb. 5–19, 1938, cat.

Despair

Chicago, South Parkway YWCA, Feb.–June 1938, no cat. (Incomplete list).

Nude; *Tone Poet*

Art Institute of Chicago, *A.I.C. Evening School Exhibition*, Mar. 19–Apr. 1, 1938, cat.

Negro's Head, charcoal

Chicago Artists Group Galleries, *Group Exhibition* [Negro art exhibition], Apr. 2–23, 1938, no cat. (Incomplete list).

Gossip, oil

Art Institute of Chicago, *1938 Annual School Exhibition of Student Work*, June 9–July 10, 1938, cat.

Five unknown works [cats. 172, 848, 901, 902, 909]

1939

Chicago, Hull-House Settlement, Butler Art Gallery, [Negro art exhibit (?)], 1939, no cat. (Incomplete list).

Evangelist; *Gussie*; *Lust for Bread*; *Mirror*; *Through the Years of Poverty a Passionate Tune of Woe Was Born*

Washington, DC, Howard University, Gallery of Art, *WPA/FAP Negro Exhibition*, Apr. 15–May 31, 1939, no cat. (Incomplete list).

Gussie

Chicago, Savoy Hotel, Artists and Models Ball, Oct. 23, 1939, cat.

Five Great American Negroes, mural

1940

Chicago, American Negro Exposition, Tanner Art Galleries, *Exhibition of the Art of the American Negro, 1851 to 1940*, July 4–Sept. 2, 1940, cat.

Through the Years of Poverty a Passionate Tune of Woe Was Born, oil [cat. 129]; *Fellow Workers Won't You March with Us*, watercolor [cat. 156; honorable mention in Watercolor Painting]; *There were no Crops This Year*, conté crayon [cat. 207; First Award in Black and White]

Chicago, American Negro Exposition, Associated Negro Press display, July 4–Sept. 2, 1940. No cat.

The History of the Negro Press, mural

Chicago, Thomas Kelly High School, WPA Illinois Art Project, *December Exhibitions*, Dec. 1940, cat.

Mirror, c. 1940, oil

Chicago, South Side Community Art Center, *Opening Exhibition of Paintings by Negro Artists of the Illinois Art Project, Work Projects Administration*, Dec. 15, 1940–Jan. 28, 1941, cat.

Through the Years of Poverty a Passionate Tune of Woe Was Born, oil [cat. 38]; *Desolate*, oil [cat. 39]

Washington, DC, Library of Congress, *Creative Art of the American Negro*, Dec. 18, 1940–Jan. 31, 1941, cat.

Five Great Americans, oil; *Card Players*, oil; *There Were No Crops This Year*, conte crayon

1941

Washington, DC, Howard University, Gallery of Art, *Exhibition of Negro Artists of Chicago*, Feb. 1–25, 1941, cat.

Fatigue, oil

Chicago, South Side Community Art Center, *We Too Look at America: Exhibition of Paintings, Sculpture, Drawings*, May 1941, cat.

Fatigue, oil [cat. 28]; *Fellow Workers*, watercolor [cat. 58]

Chicago, South Side Community Art Center, Gallery B, *Pages from the Artists' Sketch Book*, June 15–30, 1941, cat.

Chicago, South Side Community Art Center, *Mural Sketches by Artists of the WPA Art-Craft Project*, Sept. 15–Oct. 15, 1941, cat.

> *The Fight for Freedom* [cat. 48]

New York, Downtown Gallery, *American Negro Art: 19th and 20th Centuries*, Dec. 9, 1941–Jan. 3, 1942, cat.; Providence, RI, Brown University, Faunce House Gallery (dates unknown).

> *Fatigue*, oil [cat. 47]; *No Crops This Year*, 1940, crayon [cat. 48]

1942

Atlanta University, *Exhibition of Paintings by Negro Artists of America*, Apr. 19–May 10, 1942, cat.

> *This, My Brother*, oil [cat. 69]

Art Institute of Chicago, *The Twenty-First International Exhibition of Watercolors*, May 14–Aug. 23, 1942, cat.

> *Native Son No. II*, ink [cat. 534]

New York, American Contemporary Art Gallery, *Young Artists Group Show*, Sept. 28–Oct. 10, 1942, cat.

> *Native Son*, ink [cat. 29]

1943

Northampton, MA, Smith College Museum of Art, and the Institute of Modern Art, Boston, *Paintings, Sculpture by American Negro Artists*, Feb. 18–Mar. 7, 1943, cat.

> *Despair*, tempera; *The Embrace*, tempera; *There Were No Crops This Year*, conte crayon

Fort Huachuca, AZ, Officers Mountainview Club, *Exhibition of the Work of 37 Negro Artists*, May 16–22, 1943, cat.

> *Five Great Americans*, mural [cat. 83]

Detroit, MI, Prince Hall Masonic Temple, *Mid-West Conference on the Problems of the War and the Negro People*, May 23–30, 1943, no cat.

Art Institute of Chicago, *Negro Artists of Chicago: Exhibition of Paintings and Sculpture in the Room of Chicago Art*, June 17–Aug. 2, 1943, cat.

> *The Embrace*

Hampton (VA) Institute, *The Contribution of the Negro to Democracy in America*, June 26, 1943.

> *The Contribution of the Negro to Democracy in America*, mural

Washington, DC, Barnett-Aden Gallery, *American Paintings for the Home*, Oct. 16, 1943–Jan. 31, 1944, no cat.

1944

Washington, DC, Barnett-Aden Gallery, *The Negro in Art*, Feb. 1944, no cat.

New York, George Washington Carver School, *Art for the People*, Feb. 27–Mar. 18, 1944, cat.

> *Negro Soldier–I've Got to Go*

Newark (NJ) Museum, *American Negro Art*, Apr. 11–May 3, 1944, cat.

> *The Role of the Negro in the Development of Democracy in America*, mural sketch; *Sojourner Truth and Booker T. Washington*, mural sketch

Hampton (VA) Institute, *New Names in American Art*, Apr.; Baltimore Museum of Art, May; Washington, DC, G Place Gallery, June 13–July 14, cat.; University of Chicago, Renaissance Society, Oct. 6–31, 1944, cat.

> *Negro Soldier–I've Got to Go* [cat. 3 (Washington, DC); cat. 35 (Chicago)]

1945

Albany (NY) Institute of History and Art, *The Negro Artist Comes of Age*, Jan. 3–Feb. 11, 1945, cat.; Brooklyn Museum of Art, Nov. [6]–25; Providence, Rhode Island School of Design, Jan. 1946.

> *The Embrace*, 1942, tempera [cat. 64]; *Headlines*, montage, pen, ink, and gouache [cat. 65]

Atlanta University, *Fourth Annual Exhibition of Paintings, Sculpture and Prints by Negro Artists*, Apr. 1–29, 1945, cat.

> *Expectancy*, oil [cat. 47d]

Chicago, South Side Community Art Center, *Chicago Collectors Exhibit of Negro Art*, Apr. 8–May 3, 1945, cat.

> *Fatigue*, oil [cat. 1a]; *The Prayer*, tempera [cat. 18]; *Black Messiah*, oil [cat. 76]

Newark, NJ, Artists of Today Gallery, *Exhibition of Paintings and Sculpture by Negro Artists*, Oct. 1–14, 1945, cat.

> *War Worker; Headlines*

1946

San Francisco Museum of Art, San Francisco Art Association, *Tenth Annual Drawing and Print Exhibition*, Feb. 13–Mar. 10, 1946, cat.

> *Awaiting His Return*, lithograph [cat. 201; honorable mention]; *Hope for the Future*, lithograph [cat. 202]

Atlanta University, *Fifth Annual Exhibition of Paintings, Sculpture and Prints by Negro Artists*, Mar. 31–Apr. 28, 1946, cat.

> *Two Alone*, oil [cat. no 49; Edward E. Alford Purchase Award for Best Portrait or Figure Painting]; *Hope for the Future*, lithograph [cat. 80; First Atlanta University Purchase Award]

Detroit, Urban League, 10th Anniversary Convention of National Negro Congress, *A Tribute to the American Negro*, May–June 1946, no cat. (Incomplete list).

> *Headlines*

New York, Veteran Artists League, American Contemporary Art Gallery, *1st Exhibition*, July 1–15, 1946, cat.

> *Negro Woman*, oil [cat. 31]

1947

Washington, DC, Howard University, Gallery of Art, *Exhibition of Graphic Arts and Drawings by Negro Artists*, Jan. 5–Feb. 29, 1947, no cat.

New York, American Contemporary Art Gallery, *Exhibition of Recent Paintings by Charles White*, Sept. 8–20, 1947, cat.

> *Bunk Blows Again* [cat. 1]; *Blues on Four Strings* [cat. 2]; *Blues Serenade* [cat. 3]; *A Song of Protest* [cat. 4]; *Two Heads* [cat. 5]; *Sarah* [cat. 6]; *Stack-O-Lee* [cat. 7]; *Blues Singer No. 1* [cat. 8]; *Headlines* [cat. 9]; *Native Son No. 3* [cat. 10]; *War Worker* [cat. 11]; *General Moses* [cat. 12]; *Letter from the Front* [cat. 13]; *Centralia Madonna* [cat. 14]; *Native Son No. 2* [cat. 15]; *Solo* [cat. 16]; *Head* [cat. 17]; *Blues Singer No. 2* [cat. 18]; *Indian Woman* [cat. 19]; *Songs* [cat. 20]; *Strings* [cat. 21]

Washington, DC, Barnett-Aden Gallery, *Recent Paintings by Charles White: Fourth Anniversary Exhibition*, Oct.–Nov. 1947, no cat. (Incomplete list).

Blues on Four Strings; *Centralia Madonna*; *Native Son, No. 2*; *Negro Head*; *Strings*

1948

New York, American Contemporary Art Gallery, *Equity Exhibition*, Mar. 22–Apr. 3, 1948, cat.

Harmonica Player [cat. 33]

Chicago, South Side Community Art Center, *Second Annual Collectors' Exhibit*, June 6–July 1, 1948, cat.

Native Son [cat. 15]; *Awaiting His Return* [cat. 17]; *Fatigue* [cat. 118]

Washington, DC, Barnett-Aden Gallery, *Contemporary American Paintings from the Permanent Collection*, Aug. 1–Sept. 30, 1948, no cat. (Incomplete list).

Negro Youth

1949

New York, RoKo Gallery, *Negro Artists*, Feb. 5–28, 1949, no cat. (Incomplete list).

Harmonica Player

Atlanta University, *Eighth Annual Exhibition of Paintings, Sculpture and Prints by Negro Artists*, Apr. 3–May 1, 1949, cat.

Guitar Player; *Youth*

Norfolk, VA, Museum of Arts and Sciences, *Contemporary Painting: 32 Americans (from the Permanent Collection, IBM Corp.)*, May 1–22, 1949, cat.

Hope Imprisoned

1950

New York, American Contemporary Art Gallery, *Charles White*, Feb. 12–25, 1950, cat.

Ingram Case [cat. 1]; *Trenton Six* [cat. 2]; *Frederick Douglass Lives Again* [cat. 3]; *The Awakening* [cat. 4]; *Blues Singer* [cat. 5]; *Flute Player* [cat. 6]; *Gabriel Prosser* [cat. 7]; *Harriet Tubman* [cat. 8]; *The Children* [cat. 9]; *Awaiting His Return* [cat. 10]; *John Brown* [cat. 11]; *We Have Been Believers* [cat. 12]

New York, Whitney Museum of American Art, *Annual Exhibition of Contemporary American Sculpture, Watercolors and Drawings*, Apr. 1–May 28, 1950, cat.

Trenton Six, pen and ink [cat. 181]

1951

New York, American Contemporary Art Gallery, *Charles White [Negro Woman]*, Feb. 12–24, 1951, cat.

Bessie Smith [cat. 1]; *Gospel Singers* [cat. 2]; *Adolescence* [cat. 3]; *Our Land* [cat. 4]; *Lift Every Voice* [cat. 5]; *We Listen, We Learn, We Question . . .* [cat. 6]; *"General Moses"* [cat. 7]; *Bessie Smith* [cat. 8]; *Man and Woman* [cat. 9]; *Hear Now, Our Story* [cat. 10]; *Child and Woman* [cat. 11]; *Youth* [cat. 12]; *Mother* [cat. 13]; *Juba* [cat. 14]; *My Mother and My Grandmother* [cat. 15]

Atlanta University, *Tenth Annual Exhibition of Paintings, Sculpture and Prints by Negro Artists*, Apr. 1–29, 1951, cat.

We Listen, We Learn, We Question, tempera [cat. 69]; *John Brown*, lithograph [cat. 122; First Atlanta University Purchase Award]

East Berlin, Deutsche Akademie der Künste, *Internationale Kunstausstellung [International Exhibition of Arts]*, Aug. 5–19, 1951, cat.

Porträt einer Negerin; *Porträt eines revolutionären Führers*; *John Brown, der Führer der Bewegung gegen das Sklaventum der Neger*; *Porträt eines Freiheitskämpfers der Unabhängig-keitsbewegung der Neger*; *Frédéric Douglas, ein bedeutender Führer der Unabhängigkeitsbewegung der Neger*; *Eine Revolutionärin der Negerbewegung*; *Die Negerin als Mutter*; *Mann und Frau*

New York, Committee on the Art of Democratic Living (organizer): *Art of Democratic Living*, Louisville, KY, J. B. Speed Art Museum, Oct. 1–22, 1951; Art Institute of Zanesville (OH), Nov. 4–25, 1951; Museum of Fine Arts of Houston, Dec. 9–23, 1951; Philadelphia, Gimbel Brothers Little Gallery, Mar. 2–23, 1952; Art Alliance of Altoona (PA), Apr. 6–27, 1952; Detroit Round Table, June 1–30, 1952, cat.

Douglass Lives Again [cat. 33]

New York, National Institute of Arts and Letters, American Academy of Arts and Letters, Art Gallery, *Exhibition of Works by Candidates for Grants in Art for the Year 1952*, Nov. 30–Dec. 16, 1951, cat.

Our Land

New York, American Contemporary Art Gallery, *Five Artists*, Dec. 24, 1951–Jan. 5, 1952, cat.

Women of the South [cat. 18]; *I Accuse* [cat. 19]; *Gideon* [cat. 20]; *Frederick Douglass* [cat. 21]

1952

New York, Whitney Museum of American Art, *Annual Exhibition of Contemporary American Sculpture, Watercolors and Drawings*, Mar. 13–May 14, 1952, cat.

Preacher, brush and ink [cat. 186]

New York, National Institute of Arts and Letters, American Academy of Arts and Letters, Art Gallery, *Exhibition of Work by Newly Elected Members, Recipients of Honors, and Childe Hassam Fund Purchases*, May 29–June 29, 1952, cat.

John Brown, lithograph [cat. 89]; *Harriet Tubman*, linoleum cut [cat. 93]; *Head of a Man*, lithograph [cat. 101]; *Man and Woman*, linoleum cut [cat. 102]; *My Mother and Grandmother*, drawing [cat. 103]; *Frederick Douglass*, lithograph [cat. 104]; *Juba*, 1951, ink [cat. 105]; *Hear Now, Our Story*, linoleum cut [cat. 106]

New York, Metropolitan Museum of Art, *American Water Colors, Drawings and Prints*, Dec. 5, 1952–Jan. 25, 1953, cat.

The Mother [First Prize]

1953

New York, American Contemporary Art Gallery, *Charles White: Recent Paintings*, Feb. 9–28, 1953, cat.

Dawn of Life, drawing [cat. 1]; *Ye Shall Inherit the Earth*, drawing [cat. 2]; *Harvest Talk*, drawing [cat. 3]; *Goodnight Irene*, oil [cat. 4]; *Lincoln*, drawing [cat. 5]; *Young Woman*, drawing [cat. 6]; *The Preacher*, drawing [cat. 7]; *The Mother*, drawing [cat. 8]; *Lovers*, oil [cat. 9]; *Frederick Douglass*, lithograph [cat. 10]; *Gideon*, lithograph [cat. 11]; *To the Future,*

oil [cat. 12]; *Let's Walk Together*, drawing [cat. 13]

Atlanta University, *Twelfth Annual Exhibition of Paintings, Sculpture and Prints by Negro Artists*, Mar. 29–Apr. 26, 1953, cat.

> *To the Future*, oil [cat. 95; Second Atlanta University Purchase Award]; *Man and Woman*, linoleum cut [cat. 138]

New York, Whitney Museum of American Art, *Annual Exhibition of Contemporary American Sculpture, Watercolors and Drawings*, Apr. 9– May 29, 1953, cat.

> *Young Woman*, sepia chalk [cat. 183]

Dallas Museum of Fine Arts, *1st Annual Dallas National Print Exhibition*, June 7–Aug. 2, 1953, cat.

> *Head of Gideon*, lithograph [cat. 155]

New York, National Institute of Arts and Letters, American Academy of Arts and Letters, Art Gallery, *Exhibition of American Drawings*, Dec. 4–23, 1953, cat.

> *Mother and Child* [cat. 57]

1954

Washington, DC, Smithsonian Institution Traveling Exhibition Service (organizer): *Contemporary American Drawings*, 1954–55, no cat.; Wilmington, DE, Miami Beach, FL, Tuscaloosa, AL, Raleigh, NC, Manchester, NH, Ann Arbor, MI, Chattanooga, TN.

> *Mother and Child*

Warsaw, Palace of Culture, *Wystawa Prac Postepowych Artystów*, Feb. 1954, cat.

> *Plastyków*, lithograph; *Portret Lincolna*, lithograph; *Glowa murzyna*, lithograph; *Grupa murzynów*, lithograph; *Macierzy stwo*, lithograph

Philadelphia, Pyramid Club, *Fourteenth Annual Exhibition of Paintings, Prints, Water Colorings, Sculpture*, Feb. 27– Mar. 28, 1954, cat.

> *Farmer* [cat. 1]; *Gideon* [cat. 2]; *General Moses and Sojourner* [cat. 3]; *Solid as a Rock* [cat. 4]; *This Land Is Ours* [cat. 5]; *Songs of Life* [cat. 6]; *Young Worker* [cat. 7]

Art Institute of Chicago, Society for Contemporary American Art, *14th Annual Exhibition*, June 2–20, 1954, cat.

> *Maternity* [cat. 37]

Washington, DC, Barnett-Aden Gallery, *Paintings by New York Artists*, Oct. 1954– Jan. 15, 1955, cat.

> *Women of the South*

1955

New York, Whitney Museum of American Art, *Annual Exhibition of Paintings, Sculpture, Watercolors, Drawings*, Jan. 12–Feb. 20, 1955, cat.

> *Woman*, ink [cat. 206]

New York, American Contemporary Art Gallery, *Four Artists*, Apr. 1, 1955, no cat. (Incomplete list).

> *Woman*, ink

Atlantic City, NJ, Hotel Dennis, *9 Young Artists: John Hay Whitney Opportunity Fellowship Winners*, Aug. 1–21, 1955.

1956

New York, American Contemporary Art Gallery, *Negro History Week Exhibition*, Feb. 1956, no cat.

Washington, DC, Howard University, Gallery of Art, *Exhibition of Prints from the Graphic Arts Workshop of Robert Blackburn*, Feb. 6–Mar. 2, 1956, cat.

> *John Brown*, lithograph [cat. 47]; *Gideon*, lithograph [cat. 48]

New York, Whitney Museum of American Art, *Annual Exhibition of Contemporary American Sculpture, Watercolors and Drawings*, Apr. 18– June 10, 1956.

> *Mary, Don't You Weep*, pen and ink [cat. 224]

Ann Arbor, MI, University of Michigan Museum of Art, *Eight New York Painters*, July 1–31, 1956, cat.

> *General Moses and Sojourner*, drawing [cat. 31]; *I Been Rebuked and I Been Scorned*, drawing [cat. 32]; *Mother and Child*, drawing [cat. 33]

1957

Hollywood, CA, Municipal Art Gallery, Barnsdall Park, *Artists Equity Association: Southern California Chapter*, Oct. 3–Nov. 1, 1957, cat.

> *Heritage*, ink [cat. 115]; *Mother and Child*, crayon [cat. 116]

1958

New York, American Contemporary Art Gallery, *Charles White*, Mar. 17–Apr. 5, 1958, cat.; Los Angeles, University of Southern California, Harris Hall, Apr. 27–May 4, 1958.

> *Take My Mother Home #1*, drawing [cat. 1]; *Take My Mother Home #2*, drawing [cat. 2]; *Sometimes I Feel Like a Motherless Child*, drawing [cat. 3]; *Voice of Jericho (Portrait of Harry Belafonte)*, drawing [cat. 4]; *Old Ship of Zion*, drawing [cat. 5]; *Mahalia*, drawing [cat. 6]; *I've Been 'Buked and I've Been Scorned*, drawing [cat. 7]; *Mary Don't You Weep*, drawing [cat. 8]; *O Freedom*, drawing [cat. 9]; *Folksinger*, print [cat. 10]; *My God is a Rock*, print [cat. 11]; *Triumph*, print [cat. 12]; *Just a Closer Walk with Thee*, print [cat. 13]

1959

Long Beach (CA) Museum of Art, *Arts of Southern California—V: Prints*, Feb. 8– Mar. 4, 1959, cat.; Scranton, PA, Everhart Museum, Apr.–May 1959; Helena, Historical Society of Montana, Oct.–Nov. 1959; Eugene, University of Oregon, Nov.–Dec. 1959; Montgomery (AL) Museum of Fine Arts, Mar.– Apr. 1960; Columbus (GA) Museum of Art, July 1960; Racine, WI, Wustum Museum, Oct.–Nov. 1960; Ithaca, Cornell University, New York State College, Nov.–Dec. 1960; Art Center in La Jolla (CA), Feb.–Mar. 1960; Glendale, CA, Brand Library, Mar.–Apr. 1960; Boulder, University of Colorado, May 1960; Portland (ME) Museum of Art, Feb. 1961; Seattle, University of Washington, Apr. 1961; Anchorage, Alaska Methodist University, Dec. 1961–Jan. 1962.

> *Folk Singer*, linocut [cat. 71]; *Solid as a Rock*, linocut [cat. 72]

Leipzig, German Democratic Republic (East Germany), *Internationale Buchkunst-Ausstellung: Frieden der Welt* [International Book Art Exhibition: World Peace], Aug. 1–Sept. 30, 1959, cat.

> *Erhebt jede Stimme*

New York, American Contemporary Art Gallery, *31 American Contemporary Artists*, Sept. 1959, cat. (Incomplete list).

> *Mary, Don't You Weep, Don't You Mourn*

Los Angeles, Pacific Town Club,
Sept. 12–13, 1959, cat.

> *Anna Lucasta* [cat. 1]; *Mother and
> Child* [cat. 2]; *Triumph* [cat. 3]; *Folk
> Singer* [cat. 4]; *Solid as a Rock*
> [cat. 5]; *Just a Closer Walk With Thee*
> [cat. 6]; *Dawn* [cat. 7]; *Prophet No. 1*
> [cat. 8]; *Prophet No. 2* [cat. 9];
> *Prophet No. 3* [cat. 10]; *John Henry*
> [cat. 11]; *Booker T. Washington*
> [cat. 12]; *The Glory of the Days Is In
> Her Face* [cat. 13]; *I'm on My Way,
> I'll Journey On* [cat. 14]

1960

Atlanta University, *Nineteenth Annual
Exhibition of Paintings, Sculpture and
Prints by Negro Artists*, May 1–29, 1960,
cat.

> *Just a Closer Walk with Thee*, 1959,
> linocut [cat. 143]; *Solid as a Rock*,
> 1958, linocut [cat. 144]

Washington, DC, Barnett-Aden Gallery,
*17th Anniversary Exhibition: American
Contemporary Art, 1930 to 1960*,
Oct. 14–Nov. 1960, cat.

1961

Washington, DC, Howard University,
Gallery of Art, *New Vistas in American
Art*, Mar.–Apr. 1961, cat.

> *Harvest Talk*, drawing [cat. II]; *Mother
> Courage*, color print [cat. 84; First
> Award]

New York, American Contemporary Art
Gallery, *Charles White*, Sept. 18–Oct. 7,
1961, cat.

> *Let the Light Enter*, drawing [cat. 1];
> *Mayibuye Afrika*, drawing [cat. 2];
> *Go Tell It On The Mountain*, drawing
> [cat. 3]; *Flying Fish*, drawing [cat. 4];
> *Southern News; Late Edition*, drawing
> [cat. 5]; *Awaken from the Unknowing*,
> drawing [cat. 6]; *Birth of Spring*,
> drawing [cat. 7]; *C'est l'Amour*,
> drawing [cat. 8]; *Nocturne*, drawing
> [cat. 9]; *Move on Up a Little Higher*,
> drawing [cat. 10]; *Dawn*, drawing
> [cat. 11]; *Mother Courage*, print
> [cat. 12]; *I've Known Rivers*, print
> [cat. 13]; *Exodus*, print [cat. 14];
> *She Who Walks in the Morning*, print
> [cat. 15]

New York, National Institute of Arts
and Letters, American Academy of Arts
and Letters, Art Gallery, *Exhibition of
Paintings Eligible for Purchase under the
Childe Hassam Fund*, Nov. 18–Dec. 3,
1961, cat.

1962

East Berlin, Deutschen Akademie der
Künste zu Berlin, *Charles White*, 1962,
cat.

> *Hoffnung auf einen neuen Tag*;
> *Erntegespräch*; *Abraham Lincoln*;
> *Das Licht des Lebens*; *Rüstungsarbeiter*;
> *"Ihr sollt die Erben der Erde sein!"*;
> *Evangeliensänger*; *Blues-Sänger*;
> *Ermüdeter Arbeiter*; *"Freiheit, Jetzt!"*;
> *Der Bauer*; *Junger Arbeiter*; *Traum von
> einem glücklicheren Morgen*; *"Laßt
> uns züsemmen marschieren"*; *Die
> sechs Trentoner*

Pasadena (CA) Art Museum, Pasadena
Society of Artists, *Thirty-Eighth Annual
Exhibit*, May 13–June 17, 1962, cat.

> *Juba*, drawing [cat. 9]

Beverly Hills, CA, residence of Mr. and
Mrs. Jack Sylvester, *Negro and Creative
Arts Exhibition*, Aug. 12, 1962, no cat.
(Incomplete list).

> *Juba*

1963

San Diego Art Institute, *Twentieth
Century Realists*, Feb. 2–26, 1963, cat.

> *Exodus*, linoleum cut [cat. 99];
> *I've Known Rivers*, linoleum cut
> [cat. 100]; *Mother Courage*, linoleum
> cut [cat. 101]; *C'est L'Amour*,
> drawing [cat. 102]; *One Shall Live in
> Two*, drawing [cat. 103]; *Roots*,
> drawing [cat. 104]

New Orleans, Xavier University,
*Emancipation Proclamation Centennial
National Art Exhibition*, June 23–27,
1963, cat.

Rome, Galleria ACA, *Realisti Americani*,
Nov. 9–Dec. 14, 1963, cat.

> *Juba*, charcoal [cat. 18]

1964

Los Angeles, Heritage Gallery, *Charles
White*, Feb. 3–28, 1964, cat.
(Incomplete list).

> *Cat's Cradle*; *Go Not Silently Into
> the Night*; *I'm on My Way to Canaan*;
> *Lovers*; *Roots*; *Triumph*; *Uhuru*

Los Angeles, Occidental College, *The Art
of Charles White: Lithographs, Linocuts
and Drawings*, Mar. 22–Apr. 3, 1964;

Los Angeles, School of Fine Arts of the
University of Judaism, Apr. 12–30, 1964,
cat.

> *Uhurah*, 1963, Chinese ink [cat. 1];
> *Triumph*, 1956, lithograph [cat. 2];
> *I'm Going to Lay Down My Heavy
> Load*, 1964, Chinese ink [cat. 3];
> *Birmingham Totem*, 1963–64,
> Chinese ink [cat. 4]; *Lovers*, 1964,
> Chinese ink [cat. 5]; *Go Tell It to the
> Mountain*, 1961, charcoal and crayon
> [cat. 6]; *I'm On My Way to Canaan*,
> 1963, charcoal [cat. 7]; *Go Not
> Silently Into the Night*, 1963, Chinese
> ink [cat. 8]; *Cat's Cradle*, 1963–64,
> Chinese ink [cat. 9]; *Micah*, 1963,
> lithograph [cat. 10]; *Two Shall Live As
> One*, 1962, Chinese ink [cat. 11];
> *Take My Mother Home*, 1957, Chinese
> ink [cat. 12]; *Micah*, 1964, linoleum
> cut [cat. 13]; *Young Woman*, 1964,
> lithograph [cat. 14]; *I've Known
> Rivers*, 1963, linoleum cut [cat. 15];
> *Afrika Mayibuye*, 1961, charcoal
> [cat. 16]; *Harvest*, 1964, lithograph
> [cat. 17]; *Mother Courage*, 1963,
> linoleum cut [cat. 18]; *Roots*, 1963,
> Chinese ink [cat. 19]; *Solid as a Rock*,
> 1963, linoleum cut [cat. 20]; *Just a
> Closer Walk with Thee*, 1959,
> linoleum cut [cat. 21]; *C'est L'Amour*,
> 1959, Chinese ink [cat. 22]

Madison, NJ, Fairleigh Dickinson
University, *Some Negro Artists*,
Oct. 20–Nov. 20, 1964, cat.

Pasadena, CA, American Friends
Service Committee, *The 980 Art Show*,
Dec. 6–13, 1964, no cat.

1965

Rockford (IL) College, Festival of the
Arts, *Creativity and the Negro*, Mar. 3–7,
1965, cat. (Incomplete list).

> *Cat's Cradle*

New York, American Contemporary Art
Gallery, *Charles White*, May 17–June 5,
1965, cat.

> *Birmingham Totem*, drawing [cat. 1];
> *General Moses*, drawing [cat. 2];
> *Paper Shelter*, drawing [cat. 3]; *In
> Memoriam*, drawing [cat. 4]; *Uhurah*,
> drawing [cat. 5]; *Cat's Cradle*,
> drawing [cat. 6]; *Juba #2*, drawing
> [cat. 7]; *I'm On My Way to Canaan*,
> drawing [cat. 8]; *Saturday's Child*,
> drawing [cat. 9]; *Nobody Knows My
> Name #1*, drawing [cat. 10]; *Standing
> Figure*, drawing [cat. 11]; *Roots*,

drawing [cat. 12]; *Nobody Knows My Name #2*, drawing [cat. 13]; *I've Known Rivers*, print [cat. 1]; *Harvest*, print [cat. 2]; *Young Woman*, print [cat. 3]; *Juba*, print [cat. 4]; *I Had a Dream*, print [cat. 5]

Leipzig, East Germany, *Graphik aus Fünf Kontinenten: Sonderschau der Internationale Buchkunstausstellung*, July 3–Aug. 8, 1965, cat.

Ernte, lithograph; *Micah*, linocut [first prize]

Los Angeles, Heritage Gallery, *Prints, Past and Present: Charles White and Ernest Lacy*, July 26–Aug. 21, 1965, cat. (Incomplete list).

Awake; *Back*; *Rights Marchers*

1966

Los Angeles, Otis Art Institute, *Second Biennial Invitational Drawing Exhibition*, Jan. 20–Mar. 6, 1966, cat.

Paper Shelter; *Saturday's Child*

Dakar, Senegal, *Ten Negro Artists from the United States: First World Festival of Negro Arts / Dix artistes negres des États-Unis: Premier festival mondial des arts negres*, Apr. 1–24, 1966, cat.

Birmingham Totem [cat. 18]

Claremont, CA, Scripps College, Lang Art Gallery, *Contemporary Art: The Human Image*, Apr. 19–May 18, 1966, cat.

Young Woman, lithograph

Ashland, Southern Oregon State College, Britt Gallery, [Charles White exhibition], May 16–22, 1966, no cat.

New York, Harlem Cultural Council, *The Art of the American Negro*, June 27–July 26, 1966, no cat.

Los Angeles, University of California Art Galleries, Dickson Art Center, *The Negro in American Art*, Sept. 11–Oct. 16, 1966, cat.; Davis, University of California, Nov. 1–Dec. 15, 1966; Fine Arts Gallery of San Diego, Jan. 6–Feb. 12, 1967; Oakland (CA) Art Museum, Feb. 24–Mar. 19, 1967.

Saturday's Child, Chinese ink on board

Los Angeles, Heritage Gallery, *J'Accuse!*, Nov. 14–Dec. 3, 1966, no cat. (Incomplete list).

Base Concerto; *J'Accuse: No. 1*; *J'Accuse: No. 2*; *J'Accuse: No. 3*; *J'Accuse: No. 4*; *J'Accuse: No. 5*; *J'Accuse: No. 6*; *J'Accuse: No. 7*; *J'Accuse: No. 8*; *J'Accuse: No. 9*; *J'Accuse: No. 10*; *J'Accuse: No. 11*; *J'Accuse: No. 18*; *Paper Shelter*; *Spirituals*

Pasadena, CA, American Friends Service Committee, *The 980 Art Show*, Dec. 6–18, 1966, no cat.

1967

East Berlin, Altes Museum, *Intergrafik 67: Internationale Grafik-Ausstellung*, May 23–July 30, 1967, cat.; Karlovy Vary, Czechoslovakia; Budapest; Warsaw, Palace of Culture; Oslo, Kunsternes Hus, June 1–23, 1968; Moscow, Pushkin State Museum of Fine Arts; Leningrad, State Hermitage Museum (dates unknown).

Exodus II, 1966, color lithograph

Washington, DC, Howard University, College of Fine Arts, Gallery of Art, *Charles White Drawings*, Sept. 22–Oct. 25, 1967, cat.; Baltimore, Morgan State University, Carl Murray Fine Arts Center, Nov. 1–24, 1967; Nashville, TN, Fisk University, Art Gallery, Ballentine Hall, Dec. 4, 1967–Jan. 4, 1968.

Cat's Cradle; *General Moses*; *Go Not Silently Into the Night*; *Harvest*; *Head*; *I'm On My Way to Canaan*; *In Memoriam*; *J'Accuse: No. 1*; *J'Accuse: No. 2*; *J'Accuse: No. 3*; *J'Accuse: No. 4*; *J'Accuse: No. 5*; *J'Accuse: No. 6*; *J'Accuse: No. 7*; *J'Accuse: No. 8*; *J'Accuse: No. 9*; *J'Accuse: No. 18*; *Lovers*; *Mayibuye Afrika*; *Nobody Knows My Name #1*; *Nobody Knows My Name #2*; *Nocturne*; *Now I Lay Down My Heavy Load*; *Paper Shelter*; *Saturday's Child*; *Spirituals*; *Three Round Heads*; *To a Dark Girl*; *Two Shall Live As One*; *Uhurah*; *Ye Shall Inherit the Earth*

New York, Forum Gallery, *The Portrayal of the Negro in American Painting*, Sept. 26–Oct. 6, 1967, cat.

Sojourner Truth and Booker T. Washington (Study for Hampton Mural), 1943, charcoal [cat. 29]

New York, City University of New York, Great Hall, City College, *The Evolution of Afro-American Artists: 1800–1950*, Oct. 16–Nov. 5, 1967, cat.

John Brown, lithograph; *Birmingham Totem*, drawing; *Mother Courage*, linoleum cut; *Head of a Negro Youth*, drawing

1968

Hanover, NH, Dartmouth College, Hopkins Center, *6 Black Artists*, Jan. 10–31, 1968, cat.

Dawn, 1960, pencil; *Exploding Star*, 1965, charcoal

Los Angeles, Otis Art Institute, *Otis Art Institute Faculty Exhibit*, Mar. 14–Apr. 28, 1968, cat.

I've Known Rivers, charcoal

New York, Larcada Gallery, *Exhibition and Sale of American and Soviet Printmakers*, May 3–5, 1968, cat.

Exodus II, color lithograph

Los Angeles Municipal Art Gallery, Barnsdall Art Park, *Sixteenth Annual All City Art Festival, 1968*, June 19–July 14, 1968, cat.

Juba, lithograph [cat. 99]

Oakland (CA) Museum, Kaiser Center Gallery, *New Perspectives in Black Art*, Oct. 5–26, 1968, cat.

Silent Song, drawing

New York, Museum of Modern Art, *In Honor of Dr. Martin Luther King, Jr.*, Oct. 31–Nov. 3, 1968, no cat.

Birmingham Totem

Los Angeles, Heritage Gallery, *"I Have a Dream": Charles White*, Nov. 11–29, 1968, cat.

Harriet Tubman, 1964, ink and charcoal; *Frederick Douglass*, 1964, ink and charcoal; *Robert Smalls*, 1965, ink and charcoal; *Blanche K. Bruce*, 1965, charcoal; *Harriet was Put to Work Outdoors*, 1967, ink; *Harriet was Hired as a Field Hand*, 1965, ink; *Harriet Led Over 300 Slaves to Freedom and Never Lost a Passenger*, 1964, ink; *Harriet Went South Time After Time*, 1965, ink; *Till He Was Six Frederick Lived Happily with his Grandmother Betsey Bailey*, 1964, ink; *After Attempting to Escape, Frederick Douglass Was Put in Jail*, 1964, ink; *Frederick Douglass was Hired Out to a Shipyard*, c. 1964, ink; *The Emancipation Proclamation*, c. 1964, ink; *Frederick Douglass Visited Abraham Lincoln at the White House*, 1965, ink; *Little Robert Found*

Beaufort to His Liking, 1964, ink; *By the Time He was Fifteen He Was a Forman in Charge of a Crew of Stevadores*, 1965, ink; *Alone in a Small Boat He Practiced the Art of Navigating*, 1965, ink; *Robert Spoke to Hannah About Running Away in the Planter*, 1965, ink; *Robert Smalls Hired Two Tutors and Studied Morning and Night*, 1965, ink; *Robert Smalls Became One of South Carolina's Most Important Republican Leaders*, 1965, ink; *Bruce of Mississippi was the First and Only Negro Senator to Serve the Full Six-Year Term*, c. 1965, ink; *Study for The Wall*, 1968, charcoal and sepia conte; *The Wall*, 1968, oil wash; *Study for Dream Deferred*, 1968, oil wash; *Dream Deferred I*, 1968, ink; *The Brother*, 1968, oil wash and charcoal; *Brother II*, 1968, ink; *Nat Turner—Yesterday, Today and Tomorrow*, 1968, ink; *I Have a Dream #3*, 1968, charcoal; *I Have Seen Black Hands* or *I Have a Dream IV*, 1968, charcoal, ink, collage; *I Have a Dream V*, 1968, charcoal, ink and collage; *Vision*, 1968, oil wash; *Seed of Heritage*, 1968, ink

Charlotte, NC, Johnson C. Smith University, James B. Duke Library, *Encounters*, Nov.–Dec. 1968, cat.

Frederick Douglass, lithograph [cat. 48]; *John Brown*, lithograph [cat. 49]; *Juba*, lithograph [cat. 50]; *Head*, lithograph [cat. 51]; *Exodus II*, color lithograph [cat. 52]

Baltimore, Morgan State College, Murphy Fine Arts Center, *Salute to the Barnett Aden Gallery*, Nov. 24–Dec. 20, 1968, cat.

Folk Singer, woodcut [cat. 26]; *John Brown*, lithograph [cat. 27]

Greensboro, North Carolina Agricultural and Technical State University, Taylor Gallery, F. D. Bluford Library, [Black art (?)], Dec. 7–20, 1968, no cat.

1969
Tuscaloosa, AL, Stillman College, Batchelor Hall, *Prints by Charles White*, Feb. 1969, no cat.

Madison, University of Wisconsin, Union Main Gallery, *12 Black American Artists*, Feb. 2–17, 1969, cat.

Exodus II, lithograph; *Head*, lithograph

New York, American Contemporary Art Galleries, *Art on Paper*, Feb. 17–Mar. 8, 1969, no cat.

Santa Ana, CA, Charles M. Bowers Memorial Museum, *The Art of Charles White*, Mar. 1–30, 1969, cat. (Incomplete list).

J'Accuse #6; *J'Accuse #9*

Boston, National Center of Afro-American Artists, [*All Black Exhibit*], Apr. 10–27, 1969, no cat.

Nat Turner, Yesterday, Today and Tomorrow, 1968, ink

Riverside (CA) Art Association, *The 1969 La Cienega Artists*, Sept. 14–Oct. 5, 1969, cat.

Juba [cat. 37]; *Exodus II* [cat. 38]; *Figure* [cat. 39]; *12 Portfolios of Lithographs*, sculpture [cat. 47]

New York, New Center Art School, *American Drawings of the Sixties, A Selection*, Nov. 11, 1969–Jan. 10, 1970, cat.

Dream Deferred, 1969, ink [cat. 147]

Flint (MI) Community Schools, *Black Reflections: Seven Black Artists*, Dec. 1969, cat.

1970
Roxbury, MA, National Center of Afro-American Artists and Elma Lewis School of Fine Arts, *Five Famous Black Artists*, Feb. 9–Mar. 10, 1970, cat.

Centralia Madonna, 1949, drawing; *C'est L'Amour*, 1959, crayon on paper; *I Lay Down My Heavy Load*, ink and charcoal on board; *I'm On My Way to Canaan*, 1964, charcoal on board; *J'Accuse: No. 2*, 1965, charcoal drawing on paper; *J'Accuse: No. 4*, 1966, ink and charcoal on paper; *The Mother*, 1952, pen and ink on paper; *Nat Turner, Yesterday, Today and Tomorrow*, 1968, ink on paper; *The Preacher*, 1952, ink on board

La Jolla (CA) Museum of Art, *Dimensions of Black*, Feb. 15–Mar. 29, 1970, cat.

Frederick Douglas, lithograph [cat. 196]; *General Moses*, 1965, Chinese ink and dry brush [cat. 197]

Chicago, South Side Community Art Center, [Works from the permanent collection of the SSCAC], Feb. 24–Mar. 15, 1970, no cat.

New York, Forum Gallery, *Charles White: Paintings, Drawing, Prints*, Mar. 14–Apr. 4, 1970, cat. (Incomplete list).

Dream Deferred; *Elijah*; *Seed of Love*; *Wanted Poster #6*

New York, United Negro College Fund and the Center for African and African-American Studies of Atlanta University, Equal Opportunity Building, *Homage to Alain Locke: An Art Exhibition*, May 7–15, 1970, cat.

I'm On My Way to Canaan

Washington, DC, Howard University, Gallery of Art, *Howard University Gallery of Art Presents Painting and Sculpture from the Gallery Collection and the Dedication of the James A. Porter Gallery of African-American Art*, Dec. 4, 1970, cat.

Native Son #2, 1942, ink [cat. 24]

East Berlin, Altes Museum, *Intergrafik 70*, Dec. 4, 1970–Feb. 21, 1971, cat.

Wanted Poster Series #12a, 1970, color lithograph

Atlanta, Spelman College, John D. Rockefeller, Jr., Fine Arts Building, *Prints by Norma Morgan and Charles White*, Dec. 6, 1970–Jan. 22, 1971, cat.

Head, lithograph; *Bessie*, linocut; *Untitled*, lithograph; *Young Woman*, lithograph; *Exodus I*, linocut; *Juba*, lithograph; *I Had a Dream*, lithograph; *Frederick Douglass*, lithograph; *John Brown*, lithograph; *Exodus II*, color lithograph; *Matriarch*, drypoint; *Blanch K. Bruce*, line drawing; *Frederick Douglass in Jail*, ink line drawing; *Folksinger*, linocut

1971
Chicago, Illinois Bell Telephone Company (organizer), *Black American Artists/71*, Jan. 12–Feb. 5, 1971, cat.; Springfield, IL, Feb. 20–Mar. 21, 1971; Valparaiso, IN, May 1–29, 1971; Peoria, IL, June 6–July 3, 1971; Rockford, IL, July 11–Aug. 7, 1971; Quincy, IL, Aug. 16–Sept. 10, 1971; Kalamazoo (MI) Institute of Arts, Oct. 10–31, 1971; Iowa City, University of Iowa Museum of Art, Nov. 2, 1971–Jan. 2, 1972.

Wanted Poster Series No. 14, 1970, lithograph [cat. 128]

Los Angeles County Museum of Art, *Three Graphic Artists: Charles White, David Hammons, Timothy Washington*, Jan. 26–Mar. 7, 1971, cat.; Santa

Barbara (CA) Museum of Art, Mar. 20–Apr. 18, 1971, Monterey (CA) Peninsula Museum of Art, as *3 Black American Artists*, Sept. 1–Oct. 3, 1971, cat.

> *Roots*, 1964, ink drawing [cat. 1]; *Now I Lay Down My Heavy Load*, 1964, Chinese ink [cat. 2]; *Micah*, 1964, linocut [cat. 3]; *I'm On My Way to Canaan*, 1964, charcoal drawing [cat. 4]; *Saturday's Child*, 1965, ink drawing [cat. 5]; *J'Accuse #1*, 1966, charcoal drawing [cat. 6]; *J'Accuse #2*, 1966, charcoal drawing [cat. 7]; *J'Accuse #5*, 1966, charcoal drawing [cat. 8]; *J'Accuse #7*, 1966, charcoal drawing [cat. 9]; *J'Accuse #8*, 1966, charcoal drawing [cat. 10]; *Paper Shelter*, 1967, mixed-media drawing [cat. 11]; *I Have a Dream Series #3*, 1968, charcoal drawing [cat. 12]; *I Have a Dream Series #5*, 1968, charcoal drawing [cat. 13]; *Seed of Love*, 1969, ink drawing [cat. 14]; *Wanted Poster Series #7*, 1970, oil drawing [cat. 15]; *Wanted Poster Series #10*, 1970, oil drawing [cat. 16]; *Wanted Poster Series #16*, 1970, oil drawing [cat. 17]; *Wanted Poster Series #17*, 1971, oil drawing [cat. 18]

Honolulu Academy of Arts, *1st Hawaii National Print Exhibition*, Feb. 4–Mar. 7, 1971, cat.

> *Wanted Poster #13*, 1970, lithograph [cat. 163]

New York, National Academy of Design, *146th Annual Exhibition: Oil Painting, Sculpture, Graphic Arts, Watercolor*, Feb. 25–Mar. 21, 1971, cat.

> *Wanted Poster Series #6* [cat. 69; Adolph and Clara Obrig Prize]

New York, Whitney Museum of American Art, *Contemporary Black Artists in America*, Apr. 6–May 16, 1971, cat.

> *Wanted Poster Series #6*, 1969, oil on board [cat. 78]

Champaign, University of Illinois, Krannert Art Museum, *Charles White: Drawings, Lithographs, Drypoints*, Apr. 25–May 16, 1971, cat.

> *Wanted Poster Series No. 5*, 1969, oil on paper; *The Bird Flies High But Always Returns to Earth*, 1969, oil on board; *Elmina Castle*, 1969, ink; *Wanted Poster Series No. 8*, 1970, oil on board; *J'Accuse No. 6*, 1966, charcoal; *Wanted Poster Series L-11*, 1970, lithograph; *Wanted Poster Series L-11A*, 1970, lithograph; *Wanted Poster Series L-12*, 1970, lithograph; *Wanted Poster Series L-12A*, 1970, lithograph; *Wanted Poster Series L-13*, 1970, lithograph; *Wanted Poster Series L-14*, 1970, lithograph; *Wanted Poster Series L-15*, 1970, lithograph; *Love Letter Read*, 1971, lithograph; *Love Letter*, 1971, lithograph; *Night of Dreams*, 1971, lithograph; *Exodus II*, 1966, lithograph; *Juba*, 1965, lithograph; *I Had a Dream*, 1965, lithograph; *Head*, 1967, lithograph; *Jessica*, 1970, drypoint; *Elijah*, 1970, drypoint; *Nocturne*, 1970, drypoint; *Matriarch*, 1970, drypoint; *Melinda*, 1970, drypoint

Newark (NJ) Museum, *Black Artists: Two Generations*, May 13–Sept. 6, 1971, cat.

> *Sojourner Truth and Booker T. Washington*, c. 1944, pencil drawing [cat. 28]

Leipzig, East Germany, *Figura: Bilder zur Literatur, Internationale Buchkunst-Ausstellung [International Book Art Fair]*, May 29–July 4, 1971, cat.

> *1619–19??*, 1970, color lithograph

Long Beach (CA) Museum of Art, *American Portraits—Old and New*, Aug. 22–Sept. 19, 1971, cat.

> *Harry Belafonte, J'Accuse #6*, 1966, charcoal on paper [cat. 46]

1972

Los Angeles, SCLC Black Expo 72, *Black Motion*, 1972, cat. (Incomplete list).

> *Wanted Poster Series #7*

New York, Pratt Graphics Center Gallery, *The Black Experience in Prints*, Feb. 5–22, 1972, cat.

> *Frederick Douglass*, 1951, lithograph

New York, National Academy of Design, *147th Annual Exhibition: Oil Painting, Sculpture, Graphic Arts, Watercolor*, Feb. 24–Mar. 19, 1972, cat.

> *Homage to Langston Hughes* [cat. 126; Isaac N. Maynard Prize]

Brno, Czechoslovakia, Moravská Galerie, *International Exhibition of Illustration and Book Design*, June 14–Sept. 17, 1972, cat.

> *After Attempting to Escape, Frederick Douglass Was Put in Jail*, 1964, ink [cat. 974]

Los Angeles, Otis Art Institute, *Four Faculty O.A.I.: DeGroat, Green, Kanemitsu, White*, Aug. 13–Sept. 24, 1972, cat. (Incomplete list).

> *Homage to Attica*, ink wash

New York, American Contemporary Art Gallery, *Looking West*, Sept. 19–Oct. 14, 1972, cat.

> *Elmina Castle*, 1969, ink [cat. 49]

Winston-Salem, NC, Benton Convention Center, *Reflections: The Afro-American Artist*, Oct. 8–15, 1972, cat.

> *Head of a Man*, 1942, watercolor [cat. 86]; *Gideon*, lithograph [cat. 87]

1973

Ann Arbor, MI, Artrain, Inc. (organizer): traveling exhibition, 1973, no cat.

> *Wanted Poster Series #17*, 1971, oil and pencil

Rancho Cucamonga, CA, Chaffey College, Wignall Museum and Gallery, *Bernie Casey, Suzanne Jackson, Charles White*, Feb. 1973, no cat.

Santa Ana, CA, Charles W. Bowers Memorial Museum, *2 Black American Artists*, Feb. 4–25, 1973, cat. (Incomplete list).

> *Wanted Poster Series, L-15*

Bradley University, Peoria (IL) Art Guild, *14th Bradley National Print Show*, Mar. 4–Apr. 1, 1973, cat.

> *Missouri C*, etching

Los Angeles, Westside Jewish Community Center, *Californians Collect Californians*, Mar. 11–Apr. 4, 1973, no cat.

Los Angeles, Heritage Gallery, *Charles White*, May 6–31, 1973, cat. (Incomplete list).

> *Harriet*, 1972, oil wash; *Mississippi*, 1972, oil wash on board; *Patience Y*, 1971, charcoal; *Untitled* or *Black Pope*, 1973, oil wash; *Willy J*, 1973, charcoal and collage

Teaneck, NJ, New York Cultural Center at Fairleigh Dickinson University, *Blacks: USA*, Sept. 26–Oct. 28, 1973, cat.

> *Wanted Poster Series #7*, 1969, oil wash

Atlanta, High Museum of Art, *Highlights from the Atlanta University Collection of Afro-American Art*, Oct.–Nov. 1973, cat.; Baltimore Museum of Art, Jan. 15–Feb. 24, 1974; Jacksonville (FL) Art Museum, Mar. 15–Apr. 15, 1974; Saint Paul, Minnesota Museum of Art, June 1–July 15, 1973; Winston-Salem, NC, Delta Fine Arts; Boston, Museum of the National Center of Afro-American Artists; New York, Studio Museum in Harlem; Chicago, DuSable Museum of African American History.

To the Future, oil [cat. 60]; *Solid as a Rock*, lithograph [cat. 61]

1974

Washington, DC, Smithsonian Institution, Anacostia Neighborhood Museum, *The Barnett-Aden Collection*, Jan. 20–May 6, 1974; Corcoran Gallery, Washington, DC, Jan. 10–Feb. 9, 1975, cat.

Head of a Man, oil [cat. 116]

Nyack, NY, Rockland Center for the Arts, *Africa in Diaspora*, Mar.–Apr. 1974, cat.

East Berlin, *Ausstelung der Amerikanischen Künstler, Anton Refregier/ Tecla Selnik / Charles White*, Mar. 1–27, 1974, cat.

Bessie, 1950; *Harriet*, 1973; *Mississippi*, 1973; *Missouri C*, 1972/3; *Geduld Y*, 1971; *Lilly C*, 1973; *Blatt aus der "Steckbrief-Serie,"* 1970; *Liebesbrief*, 1971; *Blatt aus der "Steckbrief-Serie,"* 1970; *Frederick Douglass wird bei der Werft angeheuert*, 1965/67

Talladega (AL) College, *Fine Arts Festival*, Apr. 16–21, 1974, no cat.

Sacramento, CA, Crocker Art Gallery Association and E. B. Crocker Art Gallery, *West Coast 74: Black Image*, Sept. 13–Oct. 13, 1974, cat.; Los Angeles Municipal Art Gallery, Jan. 22–Feb. 16, 1975.

Harriet, oil wash; *Patience Y*, charcoal

Ithaca, NY, Cornell University, Herbert F. Johnson Museum of Art, *Directions in Afro-American Art*, Sept. 17–Oct. 17, 1974, cat.

Birmingham Totem, 1964, ink and charcoal [cat. 121]

Boston, Museum of the National Center of Afro-American Artists, *Kindred Spirits: An African Diaspora*, Nov. 17–Dec. 8, 1974, cat.

Lilly C; *Mississippi*; *Nat Turner*,

Yesterday, Today, and Tomorrow; *Pope X*; *Wanted Poster, L-14*

1975

Stockton, CA, College of the Pacific, Pioneer Museum, Haggin Art Galleries, *Selected Visions: Black Expressions*, Jan. 12–Mar. 12, 1975, cat. (Incomplete list).

The Bird Flies High But Always Returns to Earth, 1969, oil wash; *Lily C*, 1973, etching; *Untitled [Black Pope]*, 1973, oil wash; *Wanted Poster Series #8*, 1970, oil wash

New York, National Academy of Design, *150th Annual Exhibition: Oil Painting, Sculpture, Graphic Arts, Watercolor*, Feb. 22–Mar. 16, 1975, cat.

Mother Courage II, 1974, oil [cat. 85; Adolph and Clara Obrig Prize]

New York, Kennedy Galleries, *Hundredth Anniversary Exhibition of Paintings and Sculptures by 100 Artists Associated with the Art Students League of New York*, Mar. 6–29, 1975, cat.

Wanted Poster 4, 1969

Atlanta, Spelman College, John D. Rockefeller, Jr., Fine Arts Building, *Drawings and Prints by Charles White*, Apr. 8–29, 1975, cat.

Wanted Poster Series No. 8, 1970, oil on board [cat. 1]; *Mississippi*, 1973, oil wash [cat. 2]; *Nude*, 1970, charcoal [cat. 3]; *Frederick Douglas–Emancipation Proclamation*, 1967, ink drawing [cat. 4]; *Frederick Douglas in Jail*, 1967, ink drawing [cat. 5]; *Frederick Douglas Hired to Shipyards*, 1967, ink drawing [cat. 6]; *Blanche K. Bruce*, 1967, ink drawing [cat. 7]; *Robert Smalls Speaking to Hannah*, 1967, ink drawing [cat. 8]; *Pope X*, 1973, etching [cat. 9]; *Lilly C*, 1972/73, etching [cat. 10]; *Missouri C*, 1972/73, etching [cat. 11]; *Cat's Cradle*, 1972/3, etching [cat. 12]; *Wanted Poster Series No. L-12A*, 1970, lithograph [cat. 13]; *Wanted Poster Series No. L-14*, 1970, lithograph [cat. 14]; *Frederick Douglas*, 1974, etching [cat. 15]; *Exodus II*, 1966, lithograph [cat. 16]; *Love Letter*, 1971, lithograph [cat. 17]; *Juba*, 1965, lithograph [cat. 18]; *Wanted Poster Series No. L-15*, 1970, lithograph [cat. 19]; *Evening Song*, 1970,

lithograph [cat. 20]; *Wanted Poster Series No. L-11*, 1970, lithograph [cat. 21]; *Profile*, 1974, etching [cat. 22]; *Head*, 1967, lithograph [cat. 23]; *John Brown*, 1949, lithograph [cat. 24]

Los Angeles, California State Museum of Science and Industry, *Selected Pieces from the Golden State Mutual Afro-American Art Collection*, Apr. 12–May 25, 1975, cat.

General Moses, chinese ink and dry brush

New York, Associated American Artists Gallery, *One Hundred Prints by 100 Artists Associated with the Art Students League of New York: 1875–1975*, Apr. 22–May 17, 1975, cat.

Exodus II, 1966, color lithograph

Nashville, TN, Fisk University, Carl Van Vechten Gallery, *Amistad II, Afro-American Art*, May 1975, cat.

Exodus, woodcut [cat. 71]

San Francisco, James Willis Gallery, *Charles White's Drawings and Graphics*, May 10–June 9, 1975, cat.

The Bird Flies High But Always Returns to Earth, 1969, oil wash; *Birmingham Totem*, 1964, ink and charcoal; *Female Torso*, 1970, charcoal; *Harriet*, 1972, oil wash; *John Henry*, 1975, oil wash; *Mississippi*, 1972, oil wash; *Patience Y*, 1971, charcoal; *Untitled or Black Pope*, 1973, oil wash; *Wanted Poster Series #8*, 1970, oil wash

Boston, Museum of Fine Arts, *Jubilee: Afro-American Artists on Afro-America*, Nov. 14, 1975–Jan. 4, 1976, cat.

Cat's Cradle, 1972, etching; *Missouri C*, 1972, etching

1976

Los Angeles, Municipal Art Gallery, *Tribute to Dr. Martin Luther King, Jr.*, Jan. 15–Feb. 15, 1976, cat.

Birds Fly High, 1969, oil wash drawing; *Wanted Poster Series #8*, 1970, oil wash on board; *Untitled*, 1973, oil drawing; *Children's Games #1*, 1975, oil drawing; *Birmingham Totem*, 1964, ink and charcoal; *I Have a Dream (Vision)*, 1968, oil wash

New Muse Community Museum of

Brooklyn, New York, *The Black Artists in the WPA: 1933–1943*, Feb. 15–Mar. 30, 1976, cat.

Wanted Poster #4, 1969, oil wash

New York, Forum Gallery, *Works on Paper*, July 1976, no cat.

San Jose (CA) Museum of Art, *20th Century Black Artists*, Sept. 3–Oct. 8, 1976, cat.

Prophet I, 1976, lithograph; *Frederick Douglass*, 1950, etching; *Wanted Poster Series L-12A*, 1970, lithograph; *Missouri C*, 1973, etching; *Cat's Cradle*, 1973, etching

Atlanta, High Museum of Art, *The Work of Charles White: An American Experience*, Sept. 4–Oct. 3, 1976, cat.; Montgomery (AL) Museum of Fine Arts, Oct. 23–Dec. 5; Chattanooga, TN, Hunter Museum of Art, Feb. 17–Mar. 31, 1977; West Palm Beach, FL, Art Museum of the Palm Beaches, Inc., Apr. 22–May 29, 1977; Little Rock, Arkansas Art Center, July 22–Aug. 14, 1977; Los Angeles, Municipal Art Gallery, Sept. 1–Oct. 9, 1977.

Homage to Sterling Brown, 1972, oil on canvas; *Mother Courage II*, 1974, oil on canvas; *C'est L'amour*, 1959, charcoal and crayon; *Roots*, 1964, Chinese ink; *Cat's Cradle*, 1964, Chinese ink; *"Now I Lay Down My Heavy Load,"* 1964, Chinese ink; *"I'm on My Way to Canaan,"* 1964, charcoal; *Uhuru*, 1964, ink; *Birmingham Totem*, 1964, ink and charcoal; *J'Accuse #1*, 1966, charcoal; *J'Accuse #5*, 1966, charcoal; *J'Accuse #18*, 1966, charcoal; *Untitled*, 1967, charcoal; *Silent Song*, 1968, charcoal; *Nat Turner, Yesterday, Today, Tomorrow*, 1968, drybrush drawing; *I Have a Dream Series*, 1968, charcoal, ink, collage; *I Have a Dream Series #4*, 1968, mixed media; *I Have a Dream Series #11*, 1968, oil drawing; *Vision*, 1968, oil drawing; *Wanted Poster Series #4*, 1969, oil drawing; *Wanted Poster Series #10*, 1969, oil drawing; *Wanted Poster Series #7*, 1970, oil drawing; *Wanted Poster Series #8*, 1970, oil drawing; *Wanted Poster Series #17*, 1971, oil drawing; *Patience Y*, 1972, charcoal; *Homage to Attica*, 1972, ink; *Harriet X*, 1973, oil drawing; *Untitled*, 1973, oil drawing; *Mississippi*, 1973, oil

drawing; *John Henry*, 1975, oil wash; *Children's Games I*, 1975, oil drawing; *Children's Games II*, 1976, oil drawing; *Frederick Douglass*, 1950, lithograph; *Juba*, 1965, lithograph; *Exodus II*, 1966, color lithograph; *Evening Song*, 1970, lithograph; *Wanted Poster Series L-14*, 1970, lithograph; *Love Letter*, 1971, color lithograph; *Cat's Cradle*, 1972/73, etching; *Missouri C*, 1972/73, etching; *Lilly C*, 1973, etching; *Prophet II*, 1976, color lithograph

New York, National Academy of Design, *Henry Ward Ranger Fund Exhibition*, Sept. 22–Oct. 9, 1976, no cat. (Incomplete list).

Banner for Willie J, 1976, oil

East Berlin, Museum für Deutsche Geschichte, *Intergrafik 76*, Sept. 30–Dec. 5, 1976, cat.

Prophet I, 1976, color lithograph [cat. 1]; *Prophet II*, 1976, color lithograph [cat. 2]

Los Angeles County Museum of Art, *Two Centuries of Black American Art*, Sept. 30–Nov. 21, 1976, cat.; Atlanta, High Museum of Art, Jan. 8–Feb. 20, 1977; Dallas, Museum of Fine Arts, Mar. 30–May 15, 1977; Brooklyn Museum, June 25–Aug. 21, 1977.

Sojourner Truth and Booker T. Washington, 1943, Wolf pencil on paper [cat. 172]; *Exodus #1*, 1949, linocut [cat. 173]; *Take My Mother Home*, 1950, Chinese ink and colored ink [cat. 174]; *I Have a Dream #11*, 1968, oil on board [cat. 175]; *The Brother*, 1968, ink drawing [cat. 176]; *Seed of Love*, 1969, ink drawing [cat. 177]; *The Prophet #1*, 1975–76, color lithograph [cat. 178]; *The Prophet #2*, 1975–76, color lithograph [cat. 179]

Purchase, Neuberger Museum, State University New York, *American Drawings and Watercolors from the Collection of Susan and Herbert Adler*, Dec. 4, 1976–Jan. 8, 1977, cat.

Dawn, 1960, pencil [cat. 43]

1977

Battle Creek (MI) Civic Art Center, *American Black Art: The Known and the New*, Jan. 9–Feb. 13, 1977, cat.; Alpena, MI, Jesse Besser Museum, Feb. 18–27,

1977; Midland (MI) Center for the Arts, Mar. 5–28, 1977.

Harvest, 1964, lithograph [cat. 58]

Los Angeles Mission College Gallery, *Charles White Lithographs*, Jan. 31–Feb. 8, 1977, cat. (Incomplete list).

Uhuru, 1964, ink; *I Have a Dream*, 1976; *Cat's Cradle*, 1964, Chinese ink

Leipzig, East Germany, *Figura 2: Künstler drucken, Internationale Buchkunst-Ausstellung*, May 6–June 5, 1977, cat.

Ich habe einen Traum, 1976, lithograph

Oklahoma City, Oklahoma Art Center, *Manscape '77*, May 6–June 5, 1977, cat.

Elmina Castle, 1969, oil [cat. 75]

Pittsburgh, University of Pittsburgh, Frick Fine Arts Museum, *Black American Art from the Barnett-Aden Collection*, Sept. 17–Oct. 23, 1977, cat.

Head of a Man [cat. 31]

Fine Arts Gallery of San Diego, *Invitational American Drawing Exhibition*, Sept. 17–Oct. 30, 1977, cat.

Study for *Children's Games*, 1975–76, charcoal

Miami, Florida International University, North Miami Campus, *Contemporary Black Art*, Sept. 23–Oct. 2, 1977; Tamiami Campus, Oct. 4–22, 1977, cat.

Blues, 1971, lithograph [cat. 43]; *Elmina Castle*, 1969, ink and wash [cat. 44]; *Elijah*, 1969, drypoint etching [cat. 45]; *Love Letter*, 1971, lithograph [cat. 46]

Valencia, CA, College of the Canyons, *12 Artists / 12 Drawings*, Nov. 2–24, 1977, cat.

New York, Studio Museum in Harlem, *New York / Chicago WPA and the Black Artist*, Nov. 13, 1977–Jan. 8, 1978, cat.; Chicago Cultural Center, as *WPA and the Black Artist: Chicago and New York*, Mar. 22–Apr. 23, 1978.

The Drinker, 1937, tempera; *Nude*, 1941; *Spiritual*, 1941, oil; *Female Head*, 1937, crayon [Chicago only]; *A Man to Remember*, 1936, oil [Chicago only]

1978

Los Angeles Public Library, Exposition Park, *Mural Commission of Mary McLeod Bethune*, 1978, cat.

Cartoon for Mural, 1978, pencil on tracing paper; *Guitar Player*, 1978, ink and charcoal; *Mary McLeod Bethune*, 1978, ink and charcoal; *Seated Woman Facing Left*, 1978, ink and charcoal; *Seated Child with Book*, 1978, ink and charcoal; *Sounds of Silence*, 1978, color lithograph

Cypress (CA) College Fine Arts Gallery, *Charles White*, Jan. 1978, no cat. (Incomplete list).

Male Torso, 1965, conté crayon and ink wash; *Female Nude*, 1965, conté crayon and ink wash; *Untitled* or *Black Pope*, 1973, oil wash; *Wanted Poster Series #8*, 1970, oil wash

Normal, Illinois State University, Center for the Visual Arts Gallery, *Charles White Prints*, Feb. 1–Mar. 5, 1978, cat.

Head, 1967 [cat. 1]; *I Have a Dream*, 1976 [cat. 2]; *John Brown*, 1949, [cat. 3]; *Exodus II*, 1966 [cat. 4]; *Love Letter*, 1971 [cat. 5]; *Love Letter II*, 1977 [cat. 6]; *Evening Song*, 1970 [cat. 7]; *Wanted Poster Series L-11*, 1970 [cat. 8]; *Wanted Poster Series L-12*, 1970 [cat. 9]; *Wanted Poster Series L-14*, 1970 [cat. 10]; *Wanted Poster Series L-15*, 1970 [cat. 11]; *Mayor Thomas Bradley*, 1974 [cat. 12]; *Prophet* II, 1975 [cat. 13]; *Love Letter III*, 1977 [cat. 14]; *Pope X*, 1972 [cat. 15]; *Missouri C*, 1972 [cat. 16]; *Cat's Cradle*, 1972/73 [cat. 17]

Washington, DC, *Migrations: A National Exhibition of African-American Printmakers*, Aug. 28–Sept. 23, 1978, cat.

Wanted Poster Series L-14, 1970, lithograph [cat. 73]; *Wanted Poster Series L-11a*, 1970, lithograph [cat. 74]; *Wanted Poster Series L-11b*, 1970, lithograph [cat. 75]

Malibu, CA, Pepperdine University, *Charles White: Lithographs and Etchings*, Sept. 17–Oct. 13, 1978, cat. (Incomplete list).

Love Letter II, 1977; *Love Letter III*, 1977; *Male Torso*, 1965, conté crayon and ink wash

New York, National Urban League, Gallery 62, *Golden Opportunity*, Sept. 18–Nov. 30, 1978, cat.

Youth, 1960, charcoal

1979

Los Angeles, Museum of African American Art, *Visions of a Spirit*, Mar. 16–Apr. 12, 1979, cat. (Incomplete list).

Love Letter I, 1971, color lithograph; *Wanted Poster Series #11*, lithograph

Huntsville (AL) Museum of Art, *Black Artists/South*, Apr. 1–July 29, 1979, cat.

Children's Games II, 1976, oil drawing [cat. 199]; *Love Letter*, 1971, color lithograph [cat. 200]; *Sojourner Truth and Booker T. Washington*, 1943, Wolff pencil on paper [cat. 201]; *Preacher*, 1952, ink on cardboard [cat. 202]; *Solid As a Rock*, 1959, block print [cat. 203]; *Black American's Contribution to Democracy*, 1943, photo reproduction of the original mural [cat. 204]

Los Angeles, Heritage Gallery, *Charles White*, Apr. 2–Oct. 3, 1979, cat.

Prophet II, 1976, color lithograph; *Sound of Silence*, 1978, color lithograph; *Hasty B.*, lithograph; *Untitled*, lithograph; *Bessie*, 1954, color linoleum cut; *Gideon*, 1951, lithograph; *Mayor Tom Bradley*, 1975, lithograph; *We Have Been Believers*, 1949, lithograph; *Love Letter*, 1971, color lithograph; *Head*, 1967, lithograph; *Love Letter II*, 1977, color lithograph; *Untitled*, linoleum cut; *Vision*, 1973, silver plate; *Pope X*, 1972, etching; *Bearded Man*, linoleum cut; *Melinda*, 1969, etching; *John Brown*, 1949, lithograph; *Love Letter III*, 1977, color lithograph; *Jessica*, 1969, etching; *Matriarch*, 1969, etching; *Elijah*, 1969, etching; *Wanted Poster Series L-14*, 1970, lithograph; *Exodus II*, 1966, color lithograph; *Wanted Poster Series L-12*, 1970, color lithograph; *Evening Song*, 1970, lithograph; *Nocturne*, 1969, etching; *Prophet I*, 1976, color lithograph; *Frederick Douglass*, 1974, etching; *I Had a Dream*, 1965, lithograph

Pittsburgh, PA, Selma Burke Art Center, *Black Artists: Romare Bearden / Charles White*, June 5–23, 1979, cat.

Untitled or *Black Pope*, 1973, oil wash; *Wanted Poster Series #8*, 1970, oil wash

New York, Studio Museum in Harlem, *Impressions/Expressions: Black American Graphics*, Oct. 7, 1979–Jan. 6, 1980, cat.; Washington, DC, Howard

University, Gallery of Art, Feb. 10–Mar. 28, 1980.

Gideon, 1956, lithograph; *Hope for the Future*, 1946, lithograph

New York, National Academy of Design, *From All Walks of Life: Paintings of the Figure from the National Academy of Design*, Nov. [9], 1979–Feb. 2, 1980, cat.; Chattanooga, TN, Hunter Gallery of Art, Aug. 31–Oct. 12, 1980; Phoenix (AZ) Museum of Art, Jan. 10–Feb. 22, 1981; Saint Petersburg, FL, Museum of Fine Arts, Mar. 14–Apr. 26, 1981; West Palm Beach, FL, Norton Gallery, May 16–June 28, 1981; Museum of Albuquerque (NM), July 18–Aug. 30, 1981; Wilmington, Delaware Art Museum, Sept. 19–Nov. 1, 1981; Columbus (OH) Gallery of Fine Arts, Nov. 21, 1981–Jan. 3, 1982; Nashville (TN) Botanical Gardens, Jan. 23–Mar. 7, 1982; Mobile, AL, Museum of Fine Arts of the South, Mar. 27–May 9, 1982.

Matriarch, 1967, oil on canvas

Chicago, School of the Art Institute of Chicago, *100 Artists 100 Years*, Dec. 23, 1979–Jan. 20, 1980, cat.

Mississippi, 1972, oil wash [cat. 109]

1980

Hampton (VA) Institute, *Charles White Retrospective: 1940–1960*, 1980, cat.

Dr. George Washington Carver, 1943, charcoal and wolff crayon; *The Mother*, 1952, ink and charcoal; *Native Son No. 2*, 1942, ink; Study for *Adolescence*, 1950, charcoal; Study for Hampton Mural, *Sojourner Truth and Booker T. Washington*, 1943, charcoal

East Berlin, *Intergrafik '80*, Feb. 5–Mar. 31, 1980, cat.

Klang der Stille II, 1978, color lithograph

Washington, DC, Corcoran Gallery, *National Conference of Artists Honors Ten African American Artists*, Apr. 1980, cat.

Head of a Man, 1942, tempera; *J'Accuse: No. 1*, 1965, charcoal and wolff crayon; *Roots*, 1964, Chinese ink

New York, Whitney Museum of American Art, *The Figurative Tradition and the Whitney Museum of American*

Art: Paintings and Sculpture from the Permanent Collection, June 24–Sept. 28, 1980, cat.

Wanted Poster Number Four, 1969, oil on composition board

New York, Gallery 1199, *An Exhibition of the Art of Charles White*, Sept. 10–Dec. 6, 1980, cat.

I Had a Dream, 1965, lithograph [cat. 1]; *Young Woman*, 1963, lithograph [cat. 2]; *Exodus II*, 1966, lithograph [cat. 3]; *Elijah*, 1969, etching [cat. 4]; *Melinda*, 1969, etching [cat. 5]; *Nocturne*, 1969, etching [cat. 6]; *Jessica*, 1969, etching [cat. 7]; *Wanted Poster Series L-15*, 1970, lithograph [cat. 8]; *Wanted Poster Series L-10A*, 1970, lithograph [cat. 9]; *Wanted Poster Series L-10B*, 1970, lithograph [cat. 10]; *Wanted Poster Series L-12*, 1970, lithograph [cat. 11]; *Love Letter I*, 1970, lithograph [cat. 12]; *Evening Song*, 1970, lithograph [cat. 13]; *Wanted Poster Series L-14*, 1970, lithograph [cat. 14]; *Missouri C*, 1972, etching [cat. 15]; *Lilly C*, 1973, etching [cat. 16]; *Frederick Douglass*, 1973/74, etching [cat. 17]; *Prophet II*, 1977, lithograph [cat. 18]; *Love Letter III*, 1977, lithograph [cat. 19]; *Sound of Silence*, 1978, lithograph [cat. 20]; *Mother Courage #2*, 1974, oil on canvas [cat. 21]; *Sojourner Truth and Booker T. Washington*, 1943, pencil drawing on board [cat. 22]; *Preacher*, 1952, ink on cardboard [cat. 23]; *Night Song*, 1970, lithograph [cat. 24]; *The Mother*, 1952, pen, ink, and pencil [cat. 25]; *Head of a Young Girl*, 1960, charcoal on paper [cat. 26]; *Gideon*, 1951, lithograph [cat. 27]; *Two Heads*, 1946, gouache [cat. 28]; *Mother and Child*, pen and ink [cat. 29]; *Abe Lincoln*, 1952, pen, ink and charcoal [cat. 30]; *Mahalia Jackson*, drawing [cat. 31]; *4 Took Freedom—Frederick Douglass*, ink drawing [cat. 32]; *Love Letters*, lithograph [cat. 33]; *A Tribute to Sterling Brown*, 1972, oil on canvas [cat. 34]; *Mayibuye Afrika*, 1961, charcoal [cat. 35]; *Untitled*, 1946, pen and ink [cat. 36]; *Untitled*, oil on canvas [cat. 37]; *Paul Robeson*, 1973, oil wash [cat. 38]; *Hope*, 1961, charcoal [cat. 39]; *Flying Fish*, 1961, charcoal and crayon [cat. 40]

1981

Los Angeles, Heritage Gallery, *Homage to Charles White*, 1981, no cat.

Cloaked Woman; *Combo*; *Crispus Attucks*; *The Embrace*; *Freedom*; *Freedom Soldiers*; *Landscape*; *Man with Guitar*; *Mater Dolorosa*; *Profile of a Young Woman*; *Seated Woman, Hands Clasped*; *Sharecropper*; *Soldier*; *Standing Woman*; Study for *Lovers;* Study for *Nat Turner, Yesterday, Today and Tomorrow*; *Two Women*; *Watching*; *Woman in Kimono*; *Woman with a Rose*; *Woman with Folded Arms*; *Young Man, Right Arm Extended*; *Young Woman Standing*

Los Angeles, Museum of Afro-American History and Culture, *Ten California Artists Salute the Los Angeles Bicentennial*, Oct. 2–Nov. 14, 1981, cat.

1982

New York, Studio Museum in Harlem, *Images of Dignity: A Retrospective of the Works of Charles White*, June 20–Aug. 31, 1982, cat.; Ithaca, NY, Cornell University, Herbert F. Johnson Museum, Sept. 15–Oct. 24, 1982; Boston, Museum of National Center of Afro-American Artists, Nov. 9, 1982–Jan. 3, 1983; Orangeberg, South Carolina State College, I. P. Stanback Museum, Jan. 16–Mar. 16, 1983; Hartford, CT, Wadsworth Atheneum, Apr. 1–June 12, 1983.

Lovers #1 (The Embrace), 1942, tempera [cat. 1]; *Head of a Man*, 1942, oil [cat. 2]; *The Jester*, 1943, oil [cat. 3]; *Soldier*, 1944, tempera [cat. 4]; *Awaiting his Return*, 1946, lithograph [cat. 5]; *Freeport*, 1946, ink and charcoal [cat. 6]; *Mater Dolorosa*, 1946, oil [cat. 7]; *Can a Negro Study Law in Texas*, 1946, charcoal and ink [cat. 8]; *Sharecropper*, 1946–47, oil [cat. 9]; *Frederick Douglas's Ghost*, c. 1947, ink [cat. 10]; *The Mother*, 1952, ink and charcoal [cat. 11]; *The Preacher*, 1952, ink on cardboard [cat. 12]; *Lovers (My Man) Study*, 1953, charcoal on paper [cat. 13]; *Bessie Smith*, 1954, tempera on masonite [cat. 14]; *Take my Mother Home*, 1957, ink [cat. 15]; *Untitled (Man with an Out Stretched Arms)*, 1959, charcoal on paper [cat. 16]; *Dawn*, 1960, oil on panel [cat. 17]; *Landscape*, 1960, oil on panel [cat. 18]; *Mayibuye Afrika*, 1961,

charcoal [cat. 19]; *Birmingham Totem*, 1964, ink and charcoal [cat. 20]; *General Moses*, 1965, Chinese ink [cat. 21]; *J'Accuse #1*, 1965, charcoal and wolff crayon [cat. 22]; *Unfinished Painting #1*, c. 1965–66, oil on canvas [cat. 23]; *Nat Turner—Yesterday, Today and Tomorrow*, 1968, ink on board [cat. 24]; *I Have Seen Black Hands (I Have a Dream #4)*, 1968, charcoal and ink collage [cat. 25]; *Nocturne*, 1969, etching [cat. 26]; *Wanted Poster Series #4*, 1969, oil on composition board [cat. 27]; *Wanted Poster Series #6*, 1969, oil wash on board [cat. 28]; *Wanted Poster Series #10*, 1970, oil wash on board [cat. 29]; *Night Song*, 1970, lithograph [cat. 30]; *Love Letter #1*, 1971, color lithograph [cat. 31]; *Pope X*, 1972, etching [cat. 32]; *Homage to Sterling Brown*, 1972, oil [cat. 33]; *Mother Courage II*, 1974, oil [cat. 34]; *Prophet #1*, 1975, color lithograph [cat. 35]; *Love Letter II*, 1977, color lithograph [cat. 36]; *Love Letter III*, 1977, color lithograph [cat. 37]; *Sound of Silence*, 1978, lithograph [cat. 38]; *At the Table*, 1978, charcoal [cat. 39]

CHECKLIST OF
THE EXHIBITION

All works are by Charles White.

The checklist is organized into works exhibited by White during his lifetime, personal photographs taken by White, and reproductions of his unique works.

The works listed here were shown at all or some of the exhibition venues:

The Art Institute of Chicago
June 8, 2018–September 3, 2018

The Museum of Modern Art
October 7, 2018–January 13, 2019

Los Angeles County Museum of Art
February 17, 2019–June 9, 2019

1. *Self-Portrait*, 1935
Black crayon on cardboard; 41.4 × 28.1 cm (16 5/16 × 11 1/16 in.)
Private collection

2. Sketchbook, 1937–42
Charcoal, pastel, ink, graphite, pen and inks and watercolor on ivory wove paper; overall: 26 × 20.5 cm (10 1/4 × 8 1/16 in.)
The Art Institute of Chicago, Purchase, Ada Turnbull Hertle Fund, Director's Fund, Olivia Shaler Swan Memorial Endowment Fund, Hugh Leander and Mary Trumbull Adams Memorial Endowment Fund; and funds provided by Mary P. Hines, Mr. and Mrs. Robert S. Hartman, Ruth Hartman through the Regenstein Foundation, Marshall Field, Denise and Gary Gardner, John Nichols, Sandra and Deven Rand, Amina J. Dickerson, Jean Rudd and Lionel E. Bolin, Esther Sparks Sprague, Lynn Evans in memory of Beatrice Barnett Evans and John W. Evans, Jr., James T. Parker, Patricia Pratt in memory of Marion White Pratt Lindsay, Edwin T. White, Jr., Daniel Schulman, Frederick G. and Joele Jones Michaud, 2006.259

3. *John Brown*, 1938
Charcoal on paper; 74.9 × 53.3 cm (29 1/2 × 21 in.)
Spelman College Museum of Fine Art, Atlanta, Gift from the collection of George and Joyce Wein

4. *Untitled (Seated Woman)*, c. 1939
Monotype in oil on paper; 35.6 × 26.7 cm (14 × 10 1/2 in.)
Merrill C. Berman Collection
(New York only)

5. *Card Players*, 1939
Oil on canvas; 76.2 × 91.4 cm (30 × 36 in.)
Saint Louis Art Museum, Gift of the Federal Works Agency, Works Projects Administration, 364:1943

6. *Five Great American Negroes*, 1939
Oil on canvas; 152.4 × 393.7 cm (60 × 155 in.)
Howard University Gallery of Art, Washington, DC

7. *Kitchenette Debutantes*, 1939
Watercolor on paper; 68.5 × 57 cm (27 × 22 7/16 in.)
Private collection

8. *Preacher*, 1940
Tempera on board; 77.5 × 54.6 cm (30 1/2 × 21 1/2 in.)
The Davidsons, Los Angeles, CA

9. Study for *Struggle for Liberation (Chaotic Stage of the Negro, Past and Present)*, 1940
Tempera on illustration board; 41.3 × 98.1 cm (16 1/4 × 38 5/8 in.)
Michael Rosenfeld Gallery LLC, New York

10. *There Were No Crops This Year*, 1940
Graphite on paper; 73 × 48.9 cm (28 3/4 × 19 1/4 in.)
Private collection

11. *Untitled (Four Workers)*, 1940
Tempera on paperboard; 50.8 × 76.2 cm (20 × 30 in.)
Private collection

12. *Spiritual*, 1941
Oil on canvas; 91.4 × 76.2 cm (36 × 30 in.)
South Side Community Art Center, Chicago

13. *Hear This*, 1942
Oil on canvas; 56 × 76.8 cm (22 × 30 in.)
The Harmon and Harriet Kelley Foundation for the Arts

14. *Native Son No. 2,* 1942
Ink on paper; 121.9 × 91.4 cm (48 × 36 in.)
Howard University Gallery of Art, Washington, DC

15. *This, My Brother*, 1942
Oil on canvas; 61 × 91.4 cm (24 × 36 in.)
The Art Institute of Chicago, Pauline Palmer Prize Fund, 1999.224

16. *Paul Robeson* (Study for *Contribution of the Negro to Democracy in America*), 1942–43
Carbon pencil over charcoal, with additions and corrections in white gouache, and border in carbon pencil, on cream drawing board; 63.2 × 48.4 cm (24 7/8 × 19 1/16 in.)
Princeton University Art Museum, Princeton, NJ, Museum purchase, Kathleen Compton Sherrerd Fund for Acquisitions in American Art, x1992–12
(Chicago and New York only)

17. *Denmark Vesey* (Study for *Contribution of the Negro to Democracy in America*), 1943
Charcoal and white gouache on illustration board; 53.3 × 49.5 cm (21 × 19 1/2 in.)
On loan from the Carolina Art Association/Gibbes Museum of Art, Charleston, SC

18. *Sojourner Truth and Booker T. Washington* (Study for *Contribution of the Negro to Democracy in America*), 1943
Pencil on illustration board; 95.6 × 71 cm (37 ⅝ × 28 in.)
Collection of the Newark Museum, Purchase 1944 Sophronia Anderson Bequest Fund

19. Study for *Contribution of the Negro to Democracy in America*, 1943
Tempera on board; 45.1 × 67 cm (17 ¾ × 26 ⅜ in.)
Mr. and Mrs. Salz

20. *Headlines*, 1944
Ink, gouache, and newspaper on board; 50.8 × 40.6 cm (20 ×16 in.)
William M. and Elisabeth M. Landes

21. *Soldier*, 1944
Tempera on Masonite; 76.2 × 63.5 cm (30 × 25 in.)
Huntington Library, Art Collections, and Botanical Gardens, San Marino, CA, Gift of Sandra and Bram Dijkstra, 2013.23.1

22. *Worker*, 1944
Linocut on paper; 38.7 × 27.6 cm (15 ¼ × 10 ⅞ in.)
Estate of Norman Lewis, c/o Michael Rosenfeld Gallery LLC, New York

23. *Hope for the Future*, 1945
Lithograph on paper; image: 33.5 × 27.2 cm (13 ³⁄₁₆ × 10 ¹¹⁄₁₆ in.); sheet: 48 × 32.3 cm (18 ⅞ × 12 ¹¹⁄₁₆ in.)
The Museum of Modern Art, New York, John B. Turner Fund, 88.2013

24. *Mother (Awaiting His Return),* 1945
Lithograph on paper; image: 40.1 × 31.3 cm (15 ¹³⁄₁₆ × 12 ⁵⁄₁₆ in.); sheet: 48.2 × 39.8 cm (19 × 15 ¹¹⁄₁₆ in.)
Private collection

25. *War Worker*, 1945
Tempera on board; 59.4 × 44.4 cm (23 ⅜ × 17 ½ in.)
Montclair Art Museum purchase; prior gifts of Mr. and Mrs. Warren F. Van Thunen, the Estate of Francis Herbert Peaty, Mrs. Siegfried Peierls and Acquisition Fund

26. Likely printed and published by Taller de Gráfica Popular (Mexican, founded 1937)
Black Sorrow (Dolor Negro), 1946
Lithograph on paper; image: 52.7 × 33.5 cm (20 ¾ × 13 ³⁄₁₆ in.); sheet: 61.8 × 50 cm (24 ⁵⁄₁₆ × 19 ¹¹⁄₁₆ in.)
Philadelphia Museum of Art, Purchased with the James D. Crawford and Judith N. Dean Fund, 2003

27. *Can a Negro Study Law in Texas*, 1946
Charcoal and ink, with white heightening, on paper; 60.5 × 40.5 cm (24 × 16 in.)
John L. Warfield Center of African and African American Studies, The University of Texas at Austin

28. *The Return of the Soldier (Dixie Comes to New York)*, 1946
Ink with additions on board; 50.2 × 37.2 cm (20 × 14 ½ in.)
Prints and Photographs Division, Library of Congress, Washington, DC (New York and Los Angeles only)

29. *Two Alone*, 1946
Oil on board; 64.8 × 48.3 cm (25 ½ × 19 in.)
Clark Atlanta University Art Collection

30. *Frederick Douglass (The Ghost of Frederick Douglass II)*, c. 1948
Pen and ink over graphite, with touches of white gouache, on illustration board; 50.8 × 75.9 cm (20 × 29 ⅞ in.)
New Jersey State Museum, Purchase, FA 1986.3.I (New York only)

31. *Untitled (Bearded Man)*, c. 1949
Linocut in black on cream wove paper; image: 19.9 × 15.3 cm (7 ¹³⁄₁₆ × 6 in.); sheet: 30.5 × 23.8 cm (12 × 9 ⅜ in.)
The Art Institute of Chicago, gift of C. Ian White, 2017.332 (Chicago only)
The Museum of Modern Art, New York, John B. Turner Fund, 89.2013 (New York and Los Angeles only)

32. *Frederick Douglass Lives Again (The Ghost of Frederick Douglass),* 1949
Pen and ink over pencil on illustration board; 49.53 × 74.3 cm (19 ½ × 29 ¼ in.)
Sheldon Museum of Art, University of Nebraska-Lincoln, Olga N. Sheldon Acquisition Trust, U-5509.2008

33. *John Brown*, 1949
Lithograph on paper; sheet, 47.9 × 40 cm (18 ⅞ × 15 ¾ in.)
Lent by The Metropolitan Museum of Art, Gift of Reba and Dave Williams, 1999.529.184 (Chicago and New York only)

34. *Trenton Six,* 1949
Ink over graphite underdrawing on paperboard; 55.7 × 75.9 cm (21 ¹⁵⁄₁₆ × 29 ⅞ in.)
Amon Carter Museum of American Art, Fort Worth, TX (Chicago and New York only)

35. *Bessie Smith*, 1950
Tempera on panel; 61.8 × 50.8 cm (24 ¹⁵⁄₁₆ × 20 in.)
Private collection

36. *Frederick Douglass*, 1950
Lithograph on paper; image: 57.5 × 42.9 cm (22 ⅝ × 16 ⅞ in.); sheet: 66.4 × 50.5 cm (26 ⅛ × 19 ⅞ in.)
Los Angeles County Museum of Art, Gift of Sylvia and Frederick Reines

37. *The Children*, 1950
Ink and graphite on paper; 75.6 × 50.8 cm (29 ¾ × 20 in.)
Smithsonian American Art Museum, Washington, DC, Gift of Julie Seitzman and museum purchase through the Luisita L. and Franz H. Denghausen Endowment

38. *Exodus I: Black Moses (Harriet Tubman),* 1951
Linocut on paper; image: 51.8 × 60.6 cm (20 ⅜ × 23 ⅞ in.); sheet: 62.6 ×74.7 cm (24 ⅝ × 29 ⁷⁄₁₆ in.)
Philadelphia Museum of Art, Bequest of Mrs. Rose Weiss, 2009

39. Printed by Robert Blackburn (American, 1920–2003)
Gideon, 1951
Lithograph in black on ivory wove paper; image: 33.8 × 26 cm (13 ⁵⁄₁₆ × 10 ¼ in.); sheet: 50.9 × 39 cm (20 ¹⁄₁₆ × 15 ⅜ in.)
The Art Institute of Chicago, Margaret Fisher Fund, 2017.300 (Chicago only)
Prints and Photographs Division, Library of Congress, Washington, DC (New York and Los Angeles only)

40. *Gospel Singers,* 1951
Tempera on board; 50.8 × 61 cm (20 × 24 in.)
Private collection

41. *Our Land*, 1951
Tempera on panel; 61 × 50.8 cm (24 × 20 in.)
Private collection

42. *Abraham Lincoln*, 1952
Wolff crayon and charcoal on paperboard; 68.6 × 54.6 cm (27 × 21 ½ in.)
Private collection

43. *Goodnight Irene,* 1952
Oil on canvas; 119.4 × 61 cm (47 × 24 in.)
The Nelson-Atkins Museum of Art, Kansas City, MO, Purchase: acquired through a lead gift provided by Sarah and Landon Rowland through The Ever Glades Fund; major support provided by Lee Lyon, in memory of Joanne Lyon; Sprint; James and Elizabeth Tinsman; Neil D. Karbank, and The Sosland

Family; Generous support provided by John and Joanne Bluford; The Stanley H. Durwood Foundation; Gregory M. Glore; Maurice Watson; Anne and Cliff Gall, Dr. Sere and Mrs. MaryJane Myers and Family; Gary and Debby Ballard; Dr. Loretta M. Britton; Catherine L. Futter, in memory of Mathew and Erna Fetter; Jean and Moulton Green, Jr., in honor of Rose Bryant; Dr. Willie and Ms. Sandra A J. Lawrence; Randall and Helen Ferguson; Dr. Valerie E. Chow and Judge Jon R. Gary (Ret.); Gwendolyn J. Cooke, Ph.D.; Dwayne and Frieda Crompton; Leodis and N. June Davis; Kimberly C. Young; Tom and Karenbeth Zacharias; Jim Baggett and Marguerite Ermeling; Rose Bryant; Tasha and Julián Zugazagoitia; Antonia Boström and Dean Baker; Sarah Beeks Higdon; Kathleen and Kevin Collison; Katelyn Crawford and John Kupstas; Kimberly Hinkle and Jason Menefee; Stephanie and Brett Knappe; Jan and Michael Schall; and Michele Valentine, in memory of Marcella Hillerman

44. *Preacher*, 1952
Pen and ink and graphite pencil on board; 54.3 × 74.6 cm (21 3/8 × 29 3/8 in.)
Whitney Museum of American Art, New York, Purchase, 52.25 (Chicago and New York only)

45. *Harvest Talk*, 1953
Charcoal, Wolff crayon, and graphite, with stumping and erasing, on ivory wood-pulp laminate board; 66 × 99.2 cm (26 × 39 1/16 in.)
The Art Institute of Chicago, restricted gift of Mr. and Mrs. Robert S. Hartman, 1991.126

46. *Work (Young Worker)*, 1953
Wolff crayon and charcoal on illustration board; 111.8 × 71.1 cm (44 × 28 in.)
Private collection

47. *Ye Shall Inherit the Earth*, 1953
Charcoal on paper; 99.1 × 66 cm (39 × 26 in.)
Anonymous loan

48. *Young Farmer*, 1953
Linocut on paper; image: 66 × 48.3 cm (26 × 19 in.); sheet: 73 × 50.4 cm (28 3/4 × 19 13/16 in.)
Museum of Fine Arts, Boston, Lee M. Friedman Fund and The Heritage Fund for a Diverse Collection

49. *Young Farmer*, 1953
Linocut on paper laid on board; 76.8 × 57.2 cm (30 1/4 × 22 1/2 in.)
Collection Harold Davis, M.D.

50. *Bessie Smith*, 1954
Linocut printed in green and black on cream Japanese paper; image: 30.5 × 22.8 cm (12 × 9 in.); sheet: 44.5 × 30.4 cm (17 1/2 × 11 15/16 in.)
Harvard Art Museums/Fogg Museum, Bequest of William S. Liberman, by exchange (Chicago and New York only)

51. *Mahalia*, 1955
Charcoal and Conté crayon on board; 126.6 × 106.7 cm (50 × 42 in.)
Collection Pamela and Harry Belafonte (New York only)

52. *I've Been 'Buked and I've Been Scorned*, 1956
Compressed and vine charcoal with carbon pencil and charcoal wash splatter over traces of graphite pencil on illustration board; 113.4 × 89.9 cm (44 5/8 × 35 3/8 in.)
Blanton Museum of Art, The University of Texas at Austin, Gift of Susan G. and Edmund W. Gordon to the units of Black Studies and the Blanton Museum of Art at the University of Texas at Austin (New York and Los Angeles only)

53. *Oh, Mary, Don't You Weep*, 1956
Graphite and pen and ink on board; 99.7 × 102.9 cm (39 1/4 × 41 1/2 in.)
Crystal Bridges Museum of American Art, Bentonville, AR, 2015.22 (Chicago and New York only)

54. *Folksinger (Voice of Jericho: Portrait of Harry Belafonte)*, 1957
Ink and colored ink with white additions on board; 131.8 × 86.5 cm (52 × 34 in.)
Collection Pamela and Harry Belafonte (New York only)

55. *Eartha Kitt* (from *Anna Lucasta*), 1958
Wolff crayon over traces of brown pencil on illustration board; 112.6 × 63 cm (44 5/16 × 24 13/16 in.)
Private collection

56. *Rex Ingram, Fred O'Neal, and Georgia Burke* (from *Anna Lucasta*), 1958
Wolff crayon on paper; 103.8 × 81.5 cm (40 7/8 × 32 1/8 in.)
The Davidsons, Los Angeles, CA

57. *Sammy Davis Jr.* (from *Anna Lucasta*), 1958
Charcoal on board; 137.2 × 81.3 cm (54 × 32 in.)
David C. Driskell Center for the Study of the Visual Arts and Culture of African Americans and the African Diaspora, University of Maryland, Gift from the Sandra and Lloyd Baccus Collection, 2012.13.209

58. *Solid as a Rock (My God is Rock)*, 1958, printed 1959 (Chicago impression), 1958 (New York impression)
Linocut in black ink on cream laid Japanese paper; Chicago impression: 113 × 48.8 cm (44 1/2 × 19 3/16 in.); New York impression: image: 97 × 38 cm (38 3/16 × 14 15/16 in.); sheet: 104.5 × 45.2 cm (41 1/8 × 17 3/16 in.)
The Art Institute of Chicago, through prior bequest of Vera Berdich, the Stanley Field Fund, and restricted gift of Denise Gardner, 2017.105 (Chicago only)
The Museum of Modern Art, New York, John B. Turner Fund with additional support from Linda Barth Goldstein and Stephen F. Dull, 112.2010 (New York and Los Angeles only)

59. *Voice of Jericho (Folksinger)*, 1958
Linocut on paper; image: 91.7 × 45.8 cm (36 1/8 × 18 1/16 in.); sheet: 100.3 × 54 cm (39 1/2 × 21 1/4 in.)
The Baltimore Museum of Art: Friends of Art Fund; BMA 1999.84 (Chicago only)

60. *Awaken from the Unknowing*, 1961
Compressed and brown and gray vine charcoal with scratching out, blending, and erasing on cold-pressed illustration board; 78.7 × 142.2 cm (31 × 56 in.)
Blanton Museum of Art, The University of Texas at Austin, Gift of Susan G. and Edmund W. Gordon to the units of Black Studies and the Blanton Museum of Art at the University of Texas at Austin (Chicago and New York only)

61. *Birmingham Totem*, 1964
Ink and charcoal on paper; 181.5 × 101.8 cm (71 7/16 × 40 1/16 in.)
High Museum of Art, Atlanta, Purchase with funds from Edith G. and Philip A. Rhodes and the National Endowment for the Arts, 1978.3

62. *Micah*, 1964
Linocut on paper; 134 × 62.2 cm (52 3/4 × 24 1/2 in.)
Mott-Warsh Collection, Flint, MI

63. *General Moses (Harriet Tubman)*, 1965
Ink on paper; 119.3 × 172.7 cm (47 × 68 in.)
Private collection

64. *J'Accuse #1*, 1965
Charcoal and Wolff crayon on illustration board; 132.1 × 88.9 cm (52 × 35 in.)
Private collection

65. *J'Accuse #6*, 1966
Charcoal on paper; 106.7 × 132.1 cm
(42 × 52 in.)
Private collection

66. *J'Accuse #7*, 1966
Charcoal on paper; 99.7 × 130.8 cm
(39 ¼ × 51 ½ in.)
Private collection

67. *J'Accuse #10 (Negro Woman)*, 1966
Charcoal on paper; 71.1 × 71.1 cm
(28 × 28 in.)
Courtesy Charles M. Young Fine Prints &
Drawings, LLC, Portland, CT
(Chicago only)

68. Ceramic sculpture, 1968
Ceramic, paint, and twigs; 36.8 × 31.8 ×
31.8 cm (14 ½ × 12 ½ × 12 ½ in.)
Private collection (New York only)

69. Ceramic sculpture, 1968
Ceramic and paint; 40 × 24.8 × 10.2 cm
(15 ¾ × 9 ¾ × 4 in.)
Private collection (New York only)

70. *Nat Turner, Yesterday, Today,
Tomorrow*, 1968
Drybrush and ink on board; 129.5 ×
198.1 cm (51 × 78 in.)
National Center of Afro-American
Artists, Boston, MA

71. *Dream Deferred II*, 1969
Oil wash, ink, and Wolff crayon on
paper; 95.3 × 149.9 cm (37 ½ × 59 in.)
Collection of the Colby College Museum
of Art, Waterville, ME, The Lunder
Collection, 2009.128

72. *Elmina Castle*, 1969
Ink on board; 163.8 × 82.5 cm
(64 ½ × 32 ½ in.)
Private collection

73. *Seed of Love*, 1969
Ink on paper; 129.5 × 91.4 cm
(51 × 36 in.) Los Angeles County
Museum of Art, Museum Acquisition Fund

74. *Wanted Poster Series #6*, 1969
Oil wash brushed and stenciled with
masking out over traces of graphite
pencil on commercial laminated board;
149.9 × 68.6 cm (59 × 27 in.)
Blanton Museum of Art, The University
of Texas at Austin, Gift of Susan G. and
Edmund W. Gordon to the units of Black
Studies and the Blanton Museum of Art
at the University of Texas at Austin
(Chicago and New York only)

75. *She Does Not Know Her Beauty*, 1970
Oil on board; 101.6 × 71.1 cm (40 × 28 in.)
Mott-Warsh Collection, Flint, MI

76. *Wanted Poster Series #10*, 1970
Oil wash brushed and stenciled with
masking out over traces of graphite
pencil on commercial laminated board;
101.6 × 152.4 cm (40 × 60 in.)
Blanton Museum of Art, The University
of Texas at Austin, gift of Susan G. and
Edmund W. Gordon to the units of Black
Studies and the Blanton Museum of
Art at the University of Texas at Austin
(New York and Los Angeles only)

77. Printed by Larry Thomas
Published by Tamarind Lithography
Workshop
Wanted Poster Series #11, 1970
Lithograph in brown on buff wove paper;
image/sheet:57.3 ×40.9 cm(22 ⁹⁄₁₆ ×
16 ⅛ in.)
The Art Institute of Chicago, Margaret
Fisher Fund, 2017.294 (Chicago only)
The Museum of Modern Art, New York,
Gift of Kleiner, Bell & Co., 370.1970a
(New York only)
Los Angeles County Museum of Art,
Museum Purchase with County Funds
(Los Angeles only)

78. Printed by Larry Thomas
Published by Tamarind Lithography
Workshop
Wanted Poster Series #11a, 1970
Lithograph in brown on buff wove paper;
image/sheet: 57.3 × 40.8 cm
(22 ⁹⁄₁₆ × 16 ¹⁄₁₆ in.)
The Art Institute of Chicago, Margaret
Fisher Fund, 2017.295 (Chicago only)
The Museum of Modern Art, New York,
Gift of Kleiner, Bell & Co., 370.1970b
(New York only)
Los Angeles County Museum of Art,
Museum Purchase with County Funds
(Los Angeles only)

79. Printed by Eugene Sturman
Published by Tamarind Lithography
Workshop
Wanted Poster Series #12, 1970
Lithograph in brown on white wove
paper; image/sheet: 63.9 × 94.2 cm
(25 ³⁄₁₆ × 37 ¹⁄₁₆ in.)
The Art Institute of Chicago, Margaret
Fisher Fund, 2017.296 (Chicago only)
The Museum of Modern Art, New York,
Gift of Kleiner, Bell & Co., 373.1970
(New York only)
Los Angeles County Museum of Art,
Museum Purchase with County Funds
(Los Angeles only)

80. Printed by William Law III
Published by Tamstone Group
Love Letter I, 1971

Color lithograph on buff wove paper;
image/sheet: 76.5 × 57 cm
(30 ⅛ × 22 ⁷⁄₁₆ in.)
The Art Institute of Chicago, Margaret
Fisher Fund, 2017.289 (Chicago only)
The Museum of Modern Art, New York,
John B. Turner Fund, 90.2013.1
(New York and Los Angeles only)

81. *Wanted Poster Series #17*, 1971
Oil and pencil on poster board; 152.4 ×
76.2 cm (60 × 30 in.)
Collection of the Flint Institute of Arts,
Flint, MI, Gift of Mr. and Mrs. B. Morris
Pelavin, 1971.43

82. *Cat's Cradle*, 1972
Etching on paper; 60.3 × 66 cm (23 ¾ ×
26 in.)
Private collection

83. *Harriet*, 1972
Oil on board; 135.4 ×120 cm (53 ⁵⁄₁₆ ×
47 ¼ in.)
John L. Warfield Center of African and
African American Studies, The University
of Texas at Austin (New York and
Los Angeles only)

84. *Mississippi*, 1972
Oil wash on board; 152 × 120 cm
(59 ¹³⁄₁₆ × 47 ¼ in.)
Private collection

85. Printed by Joseph Mugnaini and
Hugo Mugnaini
Missouri C, 1972
Etching in black on cream wove paper;
image/plate: 50.1 × 91.2 cm (19 ¾ ×
35 ¹⁵⁄₁₆ in.); sheet: 70.7 × 100.2 cm
(27 ⅞ × 39 ⁷⁄₁₆ in.)
The Art Institute of Chicago, Margaret
Fisher Fund, 2017.303 (Chicago only)
The Museum of Modern Art, New York,
Purchase, 235.1976 (New York and
Los Angeles only)

86. *Black Pope (Sandwich Board Man)*,
1973
Oil wash on board; 152.4 × 111.4 cm
(60 × 43 ⅞ in.)
The Museum of Modern Art, New York,
Richard S. Zeisler Bequest (by
exchange), The Friends of Education of
The Museum of Modern Art, Committee
on Drawings Fund, Dian Woodner, and
Agnes Gund, 36.2013

87. *Banner for Willy J.*, 1976
Oil on canvas; 147.3 × 127 cm
(58 × 50 in.)
Mr. and Mrs. Richard Wyatt, Sr.

88. Printed and published by Edward
Hamilton

Love Letter II, 1977
Color lithograph on cream wove paper;
image: 59.2 × 40.5 cm (23 5⁄16 ×
15 15⁄16 in.); sheet: 76.5 × 57 cm
(30 1⁄8 × 22 7⁄16 in.)
The Art Institute of Chicago, Margaret
Fisher Fund, 2017.290

89. Printed and published by Edward
Hamilton
Love Letter III, 1977
Color lithograph on cream wove paper;
image/sheet: 76.3 × 57.4 cm
(30 1⁄16 × 22 5⁄8 in.)
The Art Institute of Chicago, Margaret
Fisher Fund, 2017.291

90. Printed by David Panosh
Published by Hand Graphics, Ltd.
Sound of Silence, 1978
Color lithograph on white wove paper;
image/sheet: 63.8 × 89.7 cm
(25 1⁄8 × 35 5⁄16 in.)
The Art Institute of Chicago, Margaret
Fisher Fund, 2017.314

Photographs

Photographs are courtesy of a private
collection.

91. Ethelene Gary Marsh, 1950
Black-and-white photograph;
8.4 × 11.4 cm (3 5⁄16 × 4 1⁄2 in.)

92. Frances Barrett White, 1950
Black-and-white photograph;
12.1 × 8.6 cm (4 3⁄4 × 3 3⁄8 in.)

93. Jacob Lawrence, 1950
Black-and-white photograph;
8.6 × 11.4 cm (3 3⁄8 × 4 1⁄2 in.)

94. Boy playing on street, 1950s
Black-and-white photograph;
7.8 × 10.8 cm (3 1⁄16 × 4 1⁄4 in.)

95. Boys on the street with
photographer behind, 1950s
Black-and-white photograph;
8.3 × 11.8 cm (3 1⁄4 × 4 5⁄8 in.)

96. Drawing class, 1950s
Black-and-white photograph;
8.6 × 11.3 cm (3 3⁄8 × 4 7⁄16 in.)

97. March in New York, 1950s
Black-and-white photograph;
8.3 × 12.1 cm (3 1⁄4 × 4 3⁄4 in.)

98. March in New York, 1950s
Black-and-white photograph;
8.3 × 12.1 cm (3 1⁄4 × 4 3⁄4 in.)

99. March to outlaw anti-Semitism, 1950s
Black-and-white photograph;

8.6 × 11.4 cm (3 3⁄8 × 4 1⁄2 in.)

100. Margaret Burroughs, 1950s
Black-and-white photograph;
8.6 × 12.1 cm (3 3⁄8 × 4 3⁄4 in.)

101. Miriam Makeba, 1950s
Black-and-white photograph;
11.4 × 16.5 cm (4 1⁄2 × 6 1⁄2 in.)

102. Musician in Washington Square
Park, 1950s
Black-and-white photograph;
8.3 × 11.8 cm (3 1⁄4 × 4 5⁄8 in.)

103. Newsstand and pedestrians, 1950s
Black-and-white photograph;
7.8 × 10.8 cm (3 1⁄16 × 4 1⁄4 in.)

104. Protest onlookers, 1950s
Black-and-white photograph;
8.3 × 11.4 cm (3 1⁄4 × 4 1⁄2 in.)

105. Roy DeCarava, 1950s
Black-and-white photograph;
8.3 × 11.8 cm (3 1⁄4 × 4 5⁄8 in.)

106. Street artist, 1950s
Black-and-white photograph;
7.8 × 10.8 cm (3 1⁄16 × 4 1⁄4 in.)

107. Woman reading *Jet* magazine, 1950s
Black-and-white photograph;
7.8 × 10.8 cm (3 1⁄16 × 4 1⁄4 in.)

108. Harry Belafonte and Mr. and Mrs.
David Stone Martin, 1957
Black-and-white photograph;
8.3 × 11.4 cm (3 1⁄4 × 4 1⁄2 in.)

Reproductions

109. *Charles White: Six Drawings*, 1953
Portfolio of six offset lithographs
New York: Masses and Mainstream
The Art Institute of Chicago, Ryerson
and Burnham Libraries, Special
Collections

110. *Jimmy Rushing Sings the Blues*,
Vanguard Records, 1955
The Museum of Modern Art, New York
(New York only)

111. *Contemporary American
Masterpieces: Gould: Spirituals for
Orchestra; Copland: Dance Symphony*,
RCA Records, 1965
The Museum of Modern Art, New York
(New York only)

112. *Ebony* magazine
Special issue: *The Negro Woman*
(August 1966)
The Museum of Modern Art, New York

113. *Calendar*, 1969

Golden State Mutual Life Insurance
Company, Los Angeles
Golden State Mutual Life Insurance
Company Records, UCLA Library
Special Collections, Charles E. Young
Research Library

114. Lerone Bennett Jr.
The Shaping of Black America
(Chicago: Johnson Publishing, 1975)
The Museum of Modern Art, New York
(New York only)

SELECTED BIBLIOGRAPHY

Archival Collections

Charles White Archives, CA.

Charles W. White FBI file. US Federal Bureau of Investigation, Washington, DC, file 100-HQ-384671. Accessed through Freedom of Information Act (FOIA).

Charles W. White fellowship file. Julius Rosenwald Fund Archives, box 456, file 6. John Hope and Aurelia E. Franklin Library, Special Collections and Archives, Fisk University, Nashville, TN.

Charles W. White Papers, c. 1930–1982. Archives of American Art, Smithsonian Institution, Washington, DC.

Civilian personnel record for Charles W. White. Works Progress Administration, National Personnel Records Center, National Archives and Records Administration at Saint Louis.

Gedeon, Lucinda H. Research material on Charles W. White (c. 1977–97). Archives of American Art, Smithsonian Institution, Washington, DC.

Publications

Adler, Esther. *Charles White: Black Pope.* New York: Museum of Modern Art, 2017.

Ahmed, Sara. *Living a Feminist Life.* Durham, NC: Duke University Press, 2017.

Alurista. *Florícanto en Aztlán.* Los Angeles: Chicano Cultural Center, University of California, 1971.

American Negro Exposition. *Exhibition of the Art of the American Negro (1851 to 1940).* Exh. cat. Chicago: [American Negro Exposition], 1940.

Aptheker, Herbert. "Rediscovered Treasure." *New Masses* 42 (Feb. 10, 1942): 26.

Ater, Renée. "Creating a 'Usable Past' and a 'Future Perfect Society': Aaron Douglas's Murals for the 1936 Texas Centennial Exposition." In *Aaron Douglas: African American Modernist*, edited by Susan Earle, 95–113. Exh. cat. New Haven, CT: Yale University Press; Lawrence: Spencer Museum of Art, University of Kansas, 2007.

Barnwell, Andrea D. *Charles White.* David C. Driskell Series of African American Art 1. San Francisco: Pomegranate, 2002.

——. "Sojourner Truth or Harriet Tubman? Charles White's Depiction of an American Heroine." In *The Walter O. Evans Collection of African American Art*, edited by Andrea D. Barnwell, 55–66. Seattle: University of Washington Press, 1999.

Barter, Judith A., Sarah. E. Kelly, Denise Mahoney, Ellen E. Roberts, and Brandon Rudd. *American Modernism at the Art Institute of Chicago: From World War I to 1955.* With contributions by Jennifer M. Downs. Chicago: Art Institute of Chicago / New Haven, CT: Yale University Press, 2009.

Bennett, Lerone, Jr. *The Shaping of Black America.* Chicago: Johnson Publishing, 1975.

Bogle, Donald. *Toms, Coons, Mulattoes, Mammies, and Bucks: An Interpretive History of Blacks in American Films.* Revised edition. New York: Viking, 1991.

Bone, Robert, and Richard A. Courage. *The Muse in Bronzeville: African American Creative Expression in Chicago, 1932–1950.* New Brunswick, NJ: Rutgers University Press, 2011.

Brooks, Van Wyck. "On Creating a Usable Past." *The Dial*, Apr. 11, 1918, 337–41.

Burroughs, Margaret G. "He Will Always Be a Chicago Artist to Me." In "Charles White: Art and Soul," special issue, *Freedomways* 20, no. 3 (1980): 151–54.

Burt, Laura. "Vivian Harsh, Adult Education, and the Library's Role as Community Center." "Women Pioneers in the Information Sciences Part 1, 1900–1950," special issue, *Libraries and the Cultural Record* 44, no. 2 (2009): 234–55.

Byrd, Rudolph P., and Beverly Guy-Sheftall, eds. *TRAPS: African American Men on Gender and Sexuality.* Bloomington and Indianapolis: Indiana University Press, 2001.

Campt, Tina M. *Image Matters: Archive, Photography, and the African Diaspora in Europe.* Durham, NC: Duke University Press, 2012.

Carbone, Teresa A. "Exhibit A: Evidence and the Art Object." In *Witness: Art and Civil Rights in the Sixties*, edited by Kellie Jones and Teresa A. Carbone, 81–109. Exh. cat. New York: Brooklyn Museum/New York: Monacelli Press, 2014.

Clark, Kenneth. *The Nude: A Study in Ideal Form.* Washington, DC:

Trustees of the National Gallery of Art, 1956.

Conwell, Donna, and Glenn Phillips. "*Duration Piece*: Rethinking Sculpture in Los Angeles." In *Pacific Standard Time: Los Angeles Art, 1945–1980*, edited by Rebecca Peabody, Andrew Perchuck, Glenn Phillips, and Rani Singh, 186–230. Los Angeles: Getty Research Institute, 2011.

Cooks, Bridget R. *Exhibiting Blackness: African Americans and the American Art Museum*. Amherst: University of Massachusetts Press, 2011.

Cooper, Esther Victoria. "The Negro Domestic Worker in Relation to Trade Unionism." MA thesis, Fisk University, 1940.

Cortor, Eldzier. "He Was at Home Creatively in Any Locale." In "Charles White: Art and Soul," special issue, *Freedomways* 20, no. 3 (1980): 149–50.

Downs, Linda Bank. *Diego Rivera: The Detroit Industry Murals*. New York: Detroit Institute of Arts / New York: W. W. Norton, 1999.

Driskell, David. Foreword to Andrea D. Barnwell, *Charles White*. David C. Driskell Series of African American Art 1. San Francisco: Pomegranate, 2002.

Duncan, Michael. *L.A. Raw: Abject Expressionism in Los Angeles, 1945–1980; From Rico Lebrun to Paul McCarthy*. Exh. cat. Pasadena, CA: Pasadena Museum of California Art / Santa Monica, CA: Foggy Notion Books, 2012.

Dyer, Geoff. "The Intimacy behind Jazz's Seminal Image." On Photography, *New York Times Magazine*, May 9, 2017, www.nytimes.com/2017/05/09/magazine/the-intimacy-behind-jazzs-seminal-image.html.

———. *The Ongoing Moment*. Knopf Doubleday, 2009.

Elliot, Jeffrey. "Charles White: Portrait of an Artist." *Negro History Bulletin* 41, no. 3 (May–June 1978): 825–28.

Ellison, Ralph. "Practical Mystic." *New Masses*, Aug. 16, 1938, 25–26.

Fauset, Arthur Huff. *Sojourner Truth: God's Faithful Pilgrim*. Chapel Hill: University of North Carolina Press, 1938.

Fine, Ruth. *Gemini G.E.L.: Art and Collaboration.* Exh. cat. Washington, DC: National Gallery of Art / New York: Abbeville Press, 1984.

Fisher, Maisha T. *Black Literate Lives:*

Historical and Contemporary Perspectives. New York: Routledge, 2009.

Galassi, Peter. *Roy DeCarava: A Retrospective*. Exh. cat. New York: Museum of Modern Art / New York: Harry N. Abrams, 1996.

Gardner, Helen. *Art through the Ages: An Introduction to Its History and Significance*. Rev. ed. New York: Harcourt, Brace, 1936.

Gedeon, Lucinda H. "Introduction to the Work of Charles W. White with a Catalogue Raisonné." MA thesis, University of California, Los Angeles, 1981.

Gellman, Erik S. "Chicago's Native Son: Charles White and the Laboring of the Black Renaissance." In *The Black Chicago Renaissance*, edited by Darlene Clark Hine and John McCluskey, Jr., 147–64. Urbana: University of Illinois Press, 2012.

Goggin, Jacqueline. "Countering White Racist Scholarship: Carter G. Woodson and *The Journal of Negro History*." *Journal of Negro History* 68, no. 4 (Autumn 1983): 355–75.

Greenberg, Clement. *Art and Culture: Critical Essays.* Boston: Beacon Press, 1961.

Grieve, Victoria. *The Federal Art Project and the Creation of Middlebrow Culture*. Urbana: University of Illinois Press, 2009.

Grigsby, Darcy Grimaldo. *Enduring Truths: Sojourner's Shadow and Substance*. Chicago: University of Chicago Press, 2015.

Griffin, Farah Jasmine. *Harlem Nocturne: Women Artists and Progressive Politics during World War II*. New York: Basic Books, 2013.

Hemingway, Andrew. *Artists on the Left: American Artists and the Communist Movement, 1926–1956*. New Haven, CT: Yale University Press, 2002.

Heroes: Gone but Not Forgotten; The Art of Charles White (1918–1979). Exh. cat. Los Angeles: Heritage Gallery / Los Angeles: Landau Traveling Exhibitions, 2012.

Herzog, Melanie Ann. *Elizabeth Catlett: An American Artist in Mexico*. Seattle: University of Washington Press, 2000.

Hills, Patricia, ed. *Modern Art in the USA: Issues and Controversies of the Twentieth Century*. Upper Saddle River, NJ: Prentice Hall, 2001.

———. *Painting Harlem Modern: The Art of*

Jacob Lawrence. Berkeley: University of California Press, 2009.

Hine, Darlene Clark, and John McCluskey, Jr., eds. *The Black Chicago Renaissance*. Urbana: University of Illinois Press, 2012.

Horne, Gerald. *A Communist Front? The Civil Rights Congress, 1946–1956*. London and Toronto: Associated University Presses, 1988.

"Images of Dignity: The Drawings of Charles White." *Negro Digest* 16 (June 1967): 40–48.

James, Erica Moiah. "Charles White's *J'Accuse* and the Limits of Universal Blackness." *Archives of American Art Journal* 55, no. 2 (2016): 4–25.

Jones, Alfred Haworth. "The Search for a Usable American Past in the New Deal Era." *American Quarterly* 23, no. 5 (Dec. 1971): 710–24.

Jones, Kellie. *South of Pico: African American Artists in Los Angeles in the 1960s and 1970s*. Durham, NC: Duke University Press, 2017.

Karlstrom, Paul J. "Art School Sketches: Notes on the Central Role of Schools in California Art and Culture." In *Reading California: Art, Image, and Identity, 1900–2000*, edited by Stephanie Baron, Sheri Bernstein, and Ilene Susan Fort, 85–109. Los Angeles: Los Angeles County Museum of Art, 2000.

Kennedy, Elizabeth, ed. *Chicago Modern, 1893–1945: Pursuit of the New*. Exh. cat. Chicago: Terra Museum of American Art, 2004.

Kersten, Andrew E. "African Americans and World War II." *OAH Magazine of History* 16, no. 3 (Spring 2002): 13–17.

Knepper, Cathy D. *Jersey Justice: The Story of the Trenton Six*. New Brunswick, NJ: Rivergate Books, 2011.

Krauss, Rosalind. *Willem de Kooning Nonstop: Cherchez la femme*. Chicago: University of Chicago Press, 2015.

LeFalle-Collins, Lizzetta. "African-American Modernists and the Mexican Muralist School." In Lizzetta LeFalle-Collins and Shifra M. Goldman, *In the Spirit of Resistance: African-American Modernists and the Mexican Muralist School*, 27–67. Exh. cat. New York: American Federation of Arts, 1996.

———. "Contribution of the American Negro to Democracy." *International*

Review of African American Art 12, no. 4 (1995): 38–41.

Lemons, Gary. "A New Response to 'Angry Black (Anti) Feminists': Reclaiming Feminist Forefathers, Becoming Womanist Sons." In *Men Doing Feminism*, edited by Tom Digby, 275–90. New York and London: Routledge, 1998.

Levine, June, and Gene Gordon. *Tales of Wo-Chi-Ca: Blacks, Whites and Reds at Camp.* San Rafael, CA: Avon Springs Press, 2002.

Lewis, David Levering. "Parallels and Divergences: Assimilationist Strategies of Afro-American and Jewish Elites from 1910 to the Early 1930s." In *Bridges and Boundaries: African Americans and American Jews*, edited by Jack Salzman, 17–35. Exh. cat. New York: George Braziller / New York: Jewish Museum, 1992.

Locke, Alain. "The American Negro Exposition's Showing of the Works of Negro Artists." In American Negro Exposition, *Exhibition of the Art of the American Negro (1851 to 1940).* Chicago: [American Negro Exposition], 1940.

——. "The Negro: 'New' or Newer: A Retrospective Review of the Literature of the Negro for 1938." *Opportunity: Journal of Negro Life* 17, nos. 1–2 (Jan.–Feb. 1939): 4–10, 36–42.

——, ed. *The New Negro: An Interpretation.* New York: Albert and Charles Boni, 1925. Reprint, New York: Arno Press / New York: New York Times, 1968.

Lusaka, Jane. "Seeking Cultural Equity: The Visual Record of Robert H. McNeill." In *Visual Journal: Harlem and D.C. in the Thirties and Forties*, edited by Deborah Willis and Jane Lusaka, 61–74. Washington, DC: Center for African American History and Culture / Washington, DC: Smithsonian Institution Press, 1996.

Madsen, Annelise K. "Revising the Old and Telling Tales: 1930s Modernism and the Uses of American History." In *America after the Fall: Painting in the 1930s*, edited by Judith A. Barter, 89–113. Exh. cat. Chicago: Art Institute of Chicago / New Haven, CT: Yale University Press, 2016.

McDuffie, Erik S. "'No small amount of change could do': Esther Cooper Jackson and the Making of a Black Left Feminist." In *Want to Start a Revolution? Radical Women in the Black Freedom Struggle*, edited by Dayo F. Gore, Jeanne Theoharis, and Komozi Woodard, 25–46. New York: New York University Press, 2009.

——. *Sojourning for Freedom: Black Women, American Communism, and the Making of Black Left Feminism.* Durham, NC: Duke University Press, 2011.

Mérida, Carlos. *Frescoes in National Preparatory School by Orozco, Rivera and Others: An Interpretative Guide with 20 Reproductions.* Mexican Art Series, vol. 1. Mexico City: Frances Toor Studios, 1937.

Morgan, Stacy I. *Rethinking Social Realism: African American Art and Literature, 1930–1953.* Athens: University of Georgia Press, 2004.

Motley, Willard F. "Negro Art in Chicago." *Opportunity: Journal of Negro Life* 18, no. 1 (Jan. 1940): 19–22, 28–31.

Muchnic, Suzanne. "Samella Lewis." In Muchnic, *Samella Lewis and the African American Experience.* West Hollywood, CA: Louis Stern Fine Arts, 2011.

Muñoz, José Esteban. *Cruising Utopia: The Then and There of Queer Futurity.* New York: New York University Press, 2009.

Natanson, Nicholas. *The Black Image in the New Deal: The Politics of FSA Photography.* Knoxville: University of Tennessee Press, 1992.

——. "Robert H. McNeill and the Profusion of Virginia Experience." In *Visual Journal: Harlem and D.C. in the Thirties and Forties*, edited by Deborah Willis and Jane Lusaka, 97–123. Washington, DC: Center for African American History and Culture; Washington, DC: Smithsonian Institution Press, 1996.

Newkirk, Pamela. "Fredi Washington's Forgotten War on Hollywood." Women and Migration(s) Conference, June 27–29, 2017, Villa La Pietra, New York University, Florence, Italy.

Noriega, Chon A., and Pilar Tompkins Rivas. "Chicano Art in the City of Dreams: A History in Nine Movements." In *L.A. Xicano*, edited by Chon A. Noriega, Terezita Romo, and Pilar Tompkins Rivas, 71–102. Los Angeles: UCLA Chicago Studies Research Center Press, 2011.

Oehler, Sarah Kelly. *They Seek a City: Chicago and the Art of Migration, 1910–1950.* Exh. cat. Chicago: Art Institute of Chicago / New Haven, CT: Yale University Press, 2013.

Park, Marlene, and Gerald E. Markowitz. *Democratic Vistas: Post Offices and Public Art in the New Deal.* Philadelphia: Temple University Press, 1984.

Parks, Gordon. *Camera Portraits: The Techniques and Principles of Documentary Portraits.* New York: Franklin Watts, 1948.

——. *A Choice of Weapons.* New York: Harper and Row, 1966.

——. *Voices in the Mirror.* New York: Anchor Books, 1991.

Penn, I. Garland. *The Afro-American Press and Its Editors.* Springfield, MA: Willey, 1891.

Perine, Robert. *Chouinard: An Art Vision Betrayed.* Encinitas, CA: Artra, 1985.

Plagens, Peter. *Sunshine Muse: Contemporary Art on the West Coast.* New York: Praeger, 1974.

Rhor, Sylvia. "Every Walk of Life and Every Degree of Education: Museum Instruction at The Art Institute of Chicago, 1879–1955." *Art Institute of Chicago Museum Studies* 29, no. 1 (2003): 20–45.

Richardson, Beulah. *A Black Woman Speaks: Of White Womanhood, of White Supremacy, of Peace; A Poem.* New York: American Women for Peace, 1951.

Ritter, Rebecca E. *Five Decades: John Biggers and the Hampton Tradition.* Hampton, VA: Hampton University Museum, 1990.

Robertson, Breanne. "Pan-Americanism, Patriotism, and Race Pride in Charles White's Hampton Mural." *American Art* 30, no. 1 (Spring 2016): 52–71.

Sawin, Martica. "Charles White." *Arts* 32, no. 7 (Apr. 1958): 62.

Schomburg, Arthur A. "The Negro Digs Up His Past." *Survey Graphic*, Mar. 1, 1925, 670–72.

Schulman, Daniel. "African American Art and the Julius Rosenwald Fund." In *A Force for Change: African American Art and the Julius Rosenwald Fund*, edited by Daniel Schulman, 51–80. Chicago: Spertus Museum / Evanston, IL: Northwestern University Press, 2009.

Sims, Lowery Stokes. "Elizabeth Catlett: A Life in Art and Politics." In *Elizabeth Catlett Sculpture: A Fifty-Year Retrospective*, edited by Lucinda H. Gedeon, 11–25. Exh. cat. New York: Neuberger Museum of Art, 1998.

Smith, Judith E. *Becoming Belafonte: Black Artist, Public Radical.* Austin: University of Texas Press, 2014.

Smith, Peter. "Lowenfeld Teaching Art: A European Theory and American Experience at Hampton Institute." *Studies in Art Education* 29, no. 1 (Autumn 1987): 30–33.

Spillers, Hortense J. "Mama's Baby Papa's Maybe: An American Grammar Book." *Diacritics* 17, no. 2 (Summer 1987): 64–81.

Sterling, Philip, and Rayford Logan. *Four Took Freedom: The Lives of Harriet Tubman, Frederick Douglass, Robert Smalls, and Blanche K. Bruce.* Garden City, NY: Zenith Books, Doubleday, 1967.

Theisen, Olive Jensen. *The Murals of John Thomas Biggers: American Muralist, African American Artist.* Exh. cat. Hampton, VA: Hampton University Museum, 1996.

Tolson, Nancy. "Making Books Available: The Role of Early Libraries, Librarians, and Booksellers in the Promotion of African American Children's Literature." *African American Review* 32, no. 1 (Spring 1998): 9–16.

Tucker, Anne Wilkes. "The Photo League." *Creative Camera* (July/ Aug. 1983): 1012–17.

——. *This Was the Photo League: Compassion and the Camera from the Depression to the Cold War.* Chicago: Stephen Daiter Gallery; Houston: John Cleary Gallery, 2001.

Tyler, Anna M. "Planting and Maintaining a 'Perennial Garden': Chicago's South Side Community Art Center." *International Review of African American Art* 11, no. 4 (1994): 31–37.

Warner, Malcom. *The Prints of Harry Sternberg.* Exh. cat. San Diego: San Diego Museum of Art, 1994.

Washington, Mary Helen. "Alice Childress, Lorraine Hansberry, and Claudia Jones: Black Women Write the Popular Front." In *Left of the Color Line: Race, Radicalism and Twentieth-Century Literature of the United States*, edited by Bill Mullen, 183–204. Chapel Hill: University of North Carolina Press, 2003.

——. *The Other Blacklist: The African American Literary and Cultural Left of the 1950s.* New York: Columbia University Press, 2014.

White, Charles. Artist statement. *Wanted Poster Series.* Portfolio of drawings. Los Angeles: Heritage Gallery, 1970.

——. *Charles White: Six Drawings.* New York: Masses and Mainstream, 1953.

——. *Images of Dignity: The Drawings of Charles White.* Foreword by Harry Belafonte, introduction by James Porter, commentary by Benjamin Horowitz. Exh. cat. [Los Angeles]: W. Ritchie Press, 1967.

——. Interview by Peter Clothier, Sept. 14, 17, 20, 24, and 26, 1979. Charles White Archives, CA.

——. *Charles White: Let the Light Enter; A Selection of Drawings, 1942–1970.* Exh. cat. New York: Michael Rosenfeld Gallery, 2009.

——. Oral history interview by Betty Hoag, Mar. 9, 1965. Archives of American Art, Smithsonian Institution.

——. Oral history interview by Karl Fortess, Apr. 8, 1969. Archives of American Art, Smithsonian Institution.

——. "Path of a Negro Artist." *Masses and Mainstream* 8, no. 4 (Apr. 1955): 33–44.

White, Frances Barrett. *Reaches of the Heart.* With Anne Scott. New York: Barricade Books, 1994.

Widener, Daniel. *Black Arts West: Culture and Struggle in Postwar Los Angeles.* Durham, NC: Duke University Press, 2010.

Young, Joseph E. *Three Graphic Artists: Charles White, David Hammons, Timothy Washington.* Exh. cat. Los Angeles: Los Angeles County Museum of Art, 1971.

Zeidler, Jeanne. "1993: Anniversary Year for Three Renowned Paintings." *International Review of African American Art* 10, no. 3 (1993): 20–22, 60–63.

INDEX

Page numbers for figures in text are italicized.

PHOTOGRAPHY CREDITS

Plates

Pl. 3: Photography by Michael David Rose.
Pl. 5: Image courtesy Saint Louis Art Museum.
Pls 6, 23: © Courtesy of the Huntington Art Collections, San Marino, California.
Pls. 7, 12, 20: Photography by Gregory R. Staley.
Pls. 8, 11: Photography by Jamie Stukenberg, Professional Graphics, Inc.
Pls. 9, 74, 100: Photography by Natalja Kent.
Pls. 10, 18, 19, 82: Photo courtesy of Michael Rosenfeld Gallery LLC, New York, NY.
Pls. 16, 34: Art Resource, NY.
Pl. 17: Image courtesy of the Gibbes Museum of Art/Carolina Art Association.
Pls. 21, 52–69: Digital image © 2018, MoMA, NY.
Pls. 22, 38, 42, 81, 98: Photography by Brad Flowers.
Pls. 28, 96: Photography by Paul Bardagjy.
Pls. 24, 99: Digital Image © The Museum of Modern Art/Licensed by SCALA/Art Resource, NY.
Pl. 30: Photo © Sheldon Museum of Art.
Pls. 31, 84: Digital Image © 2018. Museum Associates/LACMA. Licensed by Art Resource, NY.
Pl. 32: Image copyright © The Metropolitan Museum of Art. Image source: Art Resource, NY.
Pls. 35, 87: Photo © Museum Associates/LACMA.
Pl. 36: Imaging Department © President and Fellows of Harvard College.
Pl. 37: Courtesy Jonathan Boos, photography by Gavin Ashworth.
Pls. 38, 42, 81, 98: Photography by Brad Flowers.
Pl. 45: Photograph © 2018 Museum of Fine Arts, Boston.
Pl. 46: Digital Image © The Museum of Modern Art/Licensed by SCALA/Art Resource, NY.
Pls. 47, 49, 72: Photography by Christopher Burke Studio.
Pl. 48: Courtesy Princeton University Art Museum.
Pls. 50, 78, 89: Photography by Milli Aplegren.
Pl. 51: Photography by Edward C. Robison III.
Pl. 71: Photography by Mitro Hood.
Pl. 73: Photography by Gregory R. Staley, courtesy of David C. Driskell Center.
Pls. 77, 94: Pop Mod Photo.
Pl. 79: Courtesy of Swann Auction Galleries.
Pl. 85: Photography by Hakim Raquib.
Pl. 95: Image courtesy of Hammer Museum, Los Angeles. Photography by Ed Glendinning.

Figures

P. 18, fig. 4: Photo: M. Lee Fatherree.
P. 19, fig. 5: De Agostini Picture Library/Bridgeman Images.
P. 26, fig. 4; p. 28, fig. 6: Digital Image © The Museum of Modern Art/Licensed by SCALA/Art Resource, NY. Photography by John Wronn.
P. 27, fig. 5: Hulton Archive.
P. 29, fig. 7: Bridgeman Images.
P. 30, fig. 8: Artwork courtesy of and copyright The Gordon Parks Foundation. Image http://rosenwald.fisk.edu/.
P. 40, fig. 1: Image courtesy of Hammer Museum, Los Angeles. Photography by Ed Glendinning.
P. 71, fig. 2; 124, fig. 1; p. 137, fig. 12; p. 153, fig. 9; p. 156, fig. 12: Digital Image © 2018 Museum Associates/LACMA. Licensed by Art Resource, NY.
P. 74, fig. 4; p. 75, fig. 5: Courtesy of and copyright The Gordon Parks Foundation.
P. 78, fig. 6; 81, fig. 8; 128, fig. 6; 136, fig. 11; 148, fig. 3; 149, fig. 5; 150, fig. 6; 153, fig. 10; 192, figs. 1–2; 197, fig. 8; 199, fig. 10; 200, fig. 11; 201, figs. 12–13; 202, fig. 14; 206, figs. 19–20; 211, fig. 1; 212, fig. 2; 213, fig. 3; 215, fig. 5; 216, fig. 6; 217, fig. 7: Photography by Natalja Kent.
P. 81, fig. 9; 135, fig. 10: Photography by Milli Aplegren.
P. 82, fig. 10: Art © Catlett Mora Family Trust/Licensed by VAGA, New York, NY.
P. 87, fig. 1: Courtesy of and copyright The Gordon Parks Foundation.
P. 87, fig. 1; 88, fig. 3; 89, fig. 4; 90, figs. 5–6; 91, fig. 7; 92, figs. 8–10: Digital image © 2018, MoMA, NY.
P. 125, fig. 3: Digital Image © The Museum of Modern Art/Licensed by SCALA/Art Resource, NY.
P. 126, fig. 4: © Rico Lebrun Estate. Digital Image © 2018 Museum Associates/LACMA. Licensed by Art Resource, NY.
P. 127, fig. 5: Biberman Estate, courtesy of Gallery Z, Los Angeles. Photography by Natalja Kent.
P. 142, fig. 1: Courtesy of Swann Auction Galleries.
P. 154, fig. 10: Courtesy of the artist. Photography by Tom Bonner, MTA Metro Art Program.